egypt

4000 YEARS OF ART

JAROMIR MALEK

For Jane, Ph. and E., as always

Phaidon Press Limited
Regent's Wharf
All Saints Street
London N1 9PA

Phaidon Press Inc
180 Varick Street
New York, NY 10014

www.phaidon.com

First published 2003
© 2003 Phaidon Press Limited
ISBN 0 7148 4200 1

A CIP catalogue record for this book
is available from the British Library

Designed by Karl Shanahan

Printed in China

The author wishes to thank
Bernard Dod, Deirdre O'Day, Sarah
McLaughlin and Karl Shanahan
for their admirable professionalism
which made writing this book
a pleasure.

CONTENTS

WHAT IS SO SPECIAL about the art of ancient Egypt? In the history of human achievement, Egyptian art and architecture are distinguished by unusual artistic conventions and breathtaking masterpieces. A close connection with the society they served made them unique: the Egyptians believed that works of art and architecture were essential for the smooth functioning of that society and, indeed, of the world itself. These ideas are very far from our own concepts of the role which art plays in our lives. They derived from the ability of art to convey fundamental ideological concepts in a visual and easily comprehensible form and, as the ancient Egyptians hoped, to perpetuate them eternally. This was enormously significant in a society of very limited literacy.

The arts of Egypt can be followed reliably over more than four millennia during which its civilization – the longest-lasting in the world – developed, flourished and eventually declined. Evidence for material cultures which can be directly linked to pharaonic civilization can be found from around 5500 BC, the beginning of the very long Predynastic period, which preceded the 1st royal dynasty inaugurated in about 2972 BC, traditionally the beginning of the Egyptian recorded history. The earliest objects which can, perhaps a little loosely, be described as works of art date from about 4500 BC.

Complex ideas concerning religion, the hierarchical order of society and the belief in life after death were at the root of many Egyptian works of art. The mere expression of an idea by artistic means made it efficacious and capable of functioning in its own right through what, for want of a better term, we might describe as 'magic'. This ideological content of many Egyptian artefacts, certainly those associated with temples and tombs, ensured their consistency of values, and also acted as a restraining force on experimentation and the adoption of new motifs. The fundamentally religious character of most surviving Egyptian art is thus intimately connected with one of its most remarkable features, its immense stability over very long periods of time.

The Egyptians approached the gods, who were believed to represent the ultimate universal powers, through observable

forms of the divine. Many of these, such as statues and images on the walls of temples, were works of art. Others might be drawn from the natural world, including animals and even human beings such as the king himself. The arts were able to convey in visual form abstract concepts underlying the king's role in society and his relationship to the gods. This process, it was thought, preserved the fundamentals of the Egyptian world and the desired state of affairs for ever more. The arts also created the necessary context for belief in the afterlife which was so important for all Egyptians. This made the meaning of works of art heavily dependent on their content, the 'message' they conveyed. 'Official' art and architecture (architectural structures, statues, wall reliefs and paintings, and also other items of temple and funerary equipment) were concerned with temples and tombs, and to a lesser extent with secular buildings, such as palaces and residences.

But apart from the 'officially' commissioned works there were many objects, usually small and of everyday use, where the connection with ideology was less keenly felt. Egyptian religion was highly stratified and the religious dogma of the temples was not the same as the beliefs of ordinary people. The religious aspects of some less official creations (if present at all) were therefore different from formally sanctioned achievements, as were the circumstances in which they were produced. Many of these works are real masterpieces and can justly take their place next to 'high art'. They expressed people's spontaneous feelings, the love of attractive and beautiful things which so often comes through in even the most mundane things of everyday life such as textiles, pottery and items of personal adornment.

What sort of land was it that could nurture and sustain such a remarkable civilization? Early farming communities along the river Nile owed their living to the unusually benign combination of geographical and climatic features in the north-eastern corner of the African continent. But these conditions alone would not have been enough had it not been for an exceptionally gifted and competent population amalgam which derived from local Nilotic inhabitants, immigrants from the Saharan region to the west, and arrivals from western Asia.

These people discovered the most efficient way of exploiting the natural environment and developed the technology and a highly centralized organization of society in order to do so.

The Nile was the main factor affecting the lives of people inhabiting its banks. The land suitable for agriculture stretched in a long but very thin line from the first Nile cataract at Aswan deep in the south to the area around Memphis (south of present Cairo), and then it flared out as the immensely fertile expanse of the Nile Delta, delimited in the north by the shores of the Mediterranean. Savannah-type areas separated the cultivated land from the inhospitable deserts. Many of the characteristic features of Egyptian thinking, such as seeing a whole as a combination of two mutually complementing opposites, or regarding history and time itself as a series of episodes each with a beginning and an end, were due to this unusual environment.

Egypt was self-sufficient in almost all the natural resources required by a highly developed ancient civilization and flourishing arts. The most common building material, limestone, is widespread and occurs throughout the country. Deposits vary in quality and were quarried selectively. But limestone was not ideally suited for the making of rock-cut tombs and their walls were almost always treated by the application of mud plaster before they received carved or painted decoration.

Geologically, limestone is replaced by sandstone in the southernmost part of the country, upstream from Esna. Granite and granodiorite occur in the Aswan region and the Eastern Desert (between the Nile and the Red Sea), quartzite near Cairo and Aswan and in both the Eastern and Western (Libyan) Deserts, basalt in the Faiyum Oasis, travertine (Egyptian alabaster) near El-Amarna in Middle Egypt, siltstone (greywacke, less correctly schist) and steatite (soapstone) in the Eastern Desert, and rock crystal in the Western Desert and Sinai. Gneiss (diorite) was brought from quarries north-west of Abu Simbel in Nubia.

The deserts and the Sinai peninsula in the north-east also provided semiprecious stones (carnelian, felspar, amethyst, turquoise). The brilliantly blue lapis lazuli, however, reached Egypt by trade from as far as Badakhshan in north-eastern

Afghanistan. Obsidian was probably imported from Ethiopia.

Egypt was famous for its gold which came from the mines in the Eastern Desert and Nubia. Copper was mined in Sinai and the Eastern Desert and some was also imported, for example from Cyprus. Although silver occurs in Egypt, it seems that much of it came from abroad, perhaps from Greece and Asia Minor. Iron deposits are known throughout Egypt and also in Sinai. Galena, a mineral producing lead, is found in the Eastern Desert. Nile silt which was used in pottery-making occurs throughout Egypt, and marl clay is found mainly in the southern part, upstream from Esna.

Wood from Egyptian trees, such as sycamore, acacia, persea, tamarisk, willow, Christ's thorn, and the dom and date palm, was used in cabinet-making, the manufacture of coffins, the making of small sculptures, and for other purposes. The lack of length and straightness were obstacles for their extensive use in architecture. High-quality wood (fir, pine, cedar, cypress, juniper, yew, box) had to be imported from the Syro-Palestinian region in the north-east and Nubia in the south. Hard wood (carob, ebony) came from Nubia and Ethiopia.

The predictability of the river's annual rhythm of an inundation followed by a dry period allowed farmers to plan ahead. The renewed fertility of the land after the inundation receded made it possible to produce a surplus and so freed a substantial section of the population for other tasks, including craft-working, artistic production and rudimentary administration, early in Egyptian history. But this surplus also resulted in inequality among the inhabitants as its benefits became unequally shared. This was a decisive factor in the creation of many works of art because the wealth of certain social groups produced a demand for luxury goods. But the line separating prosperity and want in ancient Egypt was thin, and unusual river conditions, such as too high or too low inundations, spelt famine and disaster.

The society which appeared when Egypt was unified under one ruler some time around 3000 BC was profoundly unequal but contained some surprising features which ameliorated the extremes, for example the unquestioned duty of the wealthy and powerful to look after the needs of the poor and weak. At the top of the social hierarchy was the king, the pharaoh. Strictly speaking, the designation 'pharaoh' should not be used before the reign of King Akhenaten but, for the sake of convenience, I shall not be pedantic. The pharaoh's position straddled the human and divine spheres, and while this made him very special, it also created considerable difficulties. Although he himself was not a fully fledged god on a par with the traditional deities of the Egyptian pantheon, communication with the gods was his prerogative. His responsibilities were awesome. The gods who conferred dominion over Egypt upon him at his coronation held him responsible for maintaining the world order and ensuring that it did not descend into chaos. The Egyptians saw in their king a guarantor of their welfare in this world and also in the afterlife.

The majority of the Egyptian population consisted of peasants. They may have worked on the land owned by the king, or by a temple, a funerary cult establishment or an important official. The peasants were not free to leave and seek employment elsewhere; the concept of free movement of labour was not known in Egypt. There was no difference between state and royal property, and for a long time there were few, if any, independent landowning farmers. Country estates were self-sufficient in most of their needs. Their surpluses were creamed off in the form of state taxes or disposed of in a complex system of redistribution; some of them were traded by barter for products which the estate itself could not provide. Ancient Egypt did not use money.

Most of the estates had, in addition to their land and agricultural labourers, workshops which processed the produce, such as bakeries, breweries and slaughterhouses, and also establishments for producing manufactured items needed by the people working on the land, e.g. clothes and footwear. In some, there were also craftsmen and artists involved in the production of works of art and architecture, such as builders, carpenters and cabinet-makers, potters, sculptors, painters, jewellers and metalworkers. Some of their workshops, especially those attached to the royal palace, or to an establishment administering a pyramid or a royal tomb and adjacent cemeteries, developed into proper specialized artistic

ateliers. But the artists were just as firmly tied to their workshops, and so to their owner, as the peasants. There were no free independent artists working in ancient Egypt.

Understanding the tradition of workshops is essential for the study of artistic developments. Those under the direct control of the royal palace were the trend-setters and invariably established forms which were then imitated by others working for less exalted clienteles. The degree of conformity was very high during the periods of centralized government but relaxed considerably at times of political instability. Some works of art may have been made in élite workshops and presented by the king to non-royal persons; these shared the high standard of royal works of art. But the majority of creations intended for non-royal persons were made in workshops which specialized in their production. New artists were trained initially as assistants to masters and were concerned with less important aspects of the work. Skills were often handed down in the family. There is no evidence that women were involved in the production of 'official' works of art.

The Egyptians did not share our modern understanding of artistic creativity, and regarded artists as very highly skilled craftsmen. There are no ancient Egyptian words which would translate easily as 'art' and 'artist'. Because Egyptian tomb and temple art was functional, artists were not encouraged to experiment. Severe deviation from the norm might have endangered the potency and religious efficacy of their works. Creativity was understood as a new way of presenting the known elements rather than a radically new approach.

Although men working on tomb and temple monuments operated within closely defined constraints of religion, state ideology and ideas about life after death, their talent still shines through their work, if only one is prepared to look for it. Most masterpieces are anonymous and do not record the name of their creators. The small number of those whose names we know include such giants as Imhotep, the builder and almost certainly architect of the first pyramid (40–1), the sculptor Men who directed the carving of the Memnon colossi (167), and his son Bak who probably sculpted the colossal statues of Akhenaten at Karnak (175). The identity of the artists who

worked on the magnificent royal tombs in the Valley of the Kings, on the west bank at Thebes (present Luxor), and their own burial places at Deir el-Medina will, no doubt, be revealed in detail before long in comparative studies of the wall paintings which are being undertaken at present.

Grave goods, especially pottery (15, 16, 19, 20), stone vessels, small statuettes (18, 22), and everyday items linked to personal adornment such as beads, combs (17), amulets, and palettes for grinding materials used in the preparation of cosmetics (14), represented the artistic achievements of much of the Predynastic period (c.5500–3100 BC). Some of these, such as statuettes and scenes painted on pottery and funerary shrouds (21), conveyed ideas about the afterlife and were specially made for funerary purposes. Their precise interpretation is still a matter of debate. Knife handles decorated with scenes carved in relief (24) were status symbols which attested to the growing stratification of the society.

The antecedents of some of the 'pharaonic' artistic conventions can be traced to these early periods. They include the arrangement in registers (16, 19, 20), the filling of the space between the outlines of figures (19–21) and the placing of the contents above or next to the enclosed space (19).

Some art historians still feel uneasy about the transition from the art of the Predynastic period (also known as prehistoric, c.5500–3100 BC) to the art of dynasty 0 (3100–2972 BC, also late Predynastic) and the dynastic period proper (1st to 31st dynasties, also pharaonic or historic, c.2972–332 BC). The main reason is the enormous acceleration of artistic development which took place in the space of little more than one century, between about 3100 BC and the beginning of the 1st dynasty.

From about 3100 BC spectacular reliefs began to be carved on votive palettes (26–8, 30–3) and maceheads (29). These were gifts made by the king to temples, perhaps on the occasion of religious festivals. It is clear that their decoration was meant to be interpreted; art as a carrier of ideas had arrived. Some of these works display 'pharaonic' conventions. But it would be wrong to suggest that pharaonic arts appeared already fully developed and without any antecedents. This

might imply that the impetus for this came from outside Egypt. Such a view would see artistic development in isolation and as unconnected with dramatic changes which were taking place in the organization of Egyptian society and with rising living standards. These changes in society were not driven by spectacular technological advances but rather by a much more efficient use of existing agricultural and other techniques on a large scale. While artistic contacts with other areas of the ancient Near East (especially the late Uruk and Djemdet Nasr cultures of southern Mesopotamia) undeniably occurred during the late Predynastic period, they were the consequence of developments in Egypt, not their cause. The main reasons for the enormous quickening of development in the arts were their ability to convey concepts which were at the root of the new social order and the growing demand by newly created privileged and exceptionally wealthy groups of people for prestigious and luxury goods.

The Egyptian religious beliefs which militated against radical innovation ensured that artistic conventions, such as the method of representing human figures and their relative sizes, the way three-dimensional objects were translated into two-dimensional depictions and the emphasis on symmetry (29–31), once established, remained standard for the rest of Egyptian history. The development of sculpture in the round is less clear because of the scarcity of surviving evidence. But we know that statuettes were made for shrines of deities (25) and that there were others, carved in ivory, which formed parts of furniture.

There is no doubt about the smooth artistic transition from the final stage of the Predynastic period (nowadays often called dynasty 0) to the 1st dynasty. Political events, especially the unification of the country under one ruler and the founding of a new state capital in the Memphite area (south of present Cairo), further accelerated artistic progress. Attention now inevitably focuses more and more on the arts of privileged social groups. Simple items of personal adornment of ordinary people and their modest funerary goods continued to exist (and would so for the rest of Egyptian history) but most of the masterpieces shown in this book were connected with a

relatively limited group of people. During the Early Dynastic period (2972–2647 BC, 1st and 2nd dynasties) these were the king and the closest members of his family who also represented the country's administrative élite. Their large tombs at Abydos, Saqqara and several other sites were built of unbaked mud bricks. Such constructions provided essential training grounds for future managers of pyramid projects. The tombs have yielded early examples of remarkable jewellery (35), furniture and other small items of daily use (37), although we should be aware that some may have been specially made as funerary goods. The manufacture of vessels in a variety of stones, many very hard (34, 38), produced some spectacular examples. Relief carving was confined almost exclusively to gravestones (36) because, as yet, there was no scope for employing it elsewhere. The first examples of royal sculpture date from the end of this period and come from a temple (39).

The Old Kingdom (2647–2124 BC, 3rd to 8th dynasties) was introduced by an event which the Egyptians themselves regarded as momentous: the building of the first pyramid under the direction of King Djoser's architect, Imhotep (40–1, 45). The impact of pyramid building (52–3, 58) on Egyptian society was enormous. The construction of pyramids was a triumph of the stupendous vision which conceived the idea in the first instance, the courage needed in order to try and turn it into reality, and the perseverance and managerial skills which brought it to completion. The sheer scale of the project required a better management of labour resources, more efficient food production and a more thorough tax system. The country's administration became much more professional and all-embracing.

This was another period which witnessed huge acceleration in the arts. Pyramid temples as well as tombs of members of the royal family, officials and priests were now decorated with scenes carved in relief in stone or painted on walls (48–51, 66, 72–8, 80, 84–5) as well as on stelae (44, 56). These played an essential role in beliefs concerning the afterlife, for the scenes and objects depicted guaranteed the continuation of ordinary life and provided for the material needs of the deceased.

Statues of the king were made for his pyramid and sun

temples as well as for shrines of deities (43, 59, 64–5, 67, 87, 90). They represented another physical manifestation of his *ba*, the 'personality', needed for his afterlife and his continued participation in various ritual occasions. Similar thinking was behind the making of statues placed in tombs (47, 57, 68–70, 79, 86). The Great Sphinx at Giza (60–1), the reserve heads (62) and servant statuettes (63) represent specialized uses of three-dimensional sculpture. Spectacular sculptures were made for temples of deities. Some of these were manifestations which made the gods approachable (88–9); the arts played an essential part in contact with the divine.

The funerary goods of almost all pyramids and tombs were plundered in antiquity, and so it is rarely that we are afforded glimpses of spectacular Old Kingdom jewellery (54), furniture (55) and items of everyday use which were made for the top echelons of Egyptian society. High-quality stone vessels still continued to be made, mostly for funerary purposes (42, 81).

The eventual collapse of the Old Kingdom was mainly due to features inherent in the system itself. The king's control of the main economic resource, the land, had been weakened by gifts which he and his predecessors had to make to temples of the gods, funerary establishments and members of his administration. The situation was exacerbated by climatic changes which introduced a more arid climate and resulted in a series of inadequate inundations. There also were dynastic feuds within the royal family. The political disintegration of the country created two opposing kingdoms centred on Heracleopolis (Ihnasiya el-Medina) in the north and Thebes (Luxor) in the south. The previous artistic uniformity of the country disappeared and works of regional workshops now acquired their own individual characteristics (91–3).

The king who succeeded in restoring the unity of the country around 2040 BC was Nebhepetre Mentuhotep II, and the period which followed is known as the Middle Kingdom (c.2040–1648 BC, mid-11th to 13th dynasties). While Middle Kingdom rulers tried to re-create the situation which had existed during the Old Kingdom, circumstances had changed and there was no going back. The same was true of the arts. Mentuhotep II's funerary temple at Deir el-Bahri (139 left) had

an unusual design which drew on Theban as well as traditional Memphite architectural traditions. The difference between his statues and the royal sculpture of the Old Kingdom could hardly be greater (94), and the same is true of the relief decoration of his reign (95–7).

Some time after 1980 BC, during the 12th dynasty, completely new ideas appeared in royal statues. The reasons for their introduction have not yet been fully explained. The idealizing features of royal statues (105) were now replaced by naturalistic sculptures, especially in the case of Kings Senwosret III (113) and Amenemhet III (118–20). This, of course, does not necessarily mean that the statues were true portraits, although a relationship, however tenuous, between the king's appearance and his statues is likely.

Some unusual statues took the definition of what could be portrayed to its limits (132). Most sculptures made for lesser personages lack the naturalism of royal sculptures (112), but there are exceptions of high quality (133).

Most shrines and temples of the Middle Kingdom disappeared during later rebuilding activities (106). Apart from royal statues, there are few other objects which can be assigned to them with any certainty (126).

Tombs of regional administrators were now made in the areas where they exercised their authority, and were decorated with exquisite paintings (114) or reliefs (115–17). There was considerable emphasis on the decoration of coffins (121) and the so-called models, wooden three-dimensional representations of subjects which had previously been seen almost exclusively on tomb walls (98–9, 101–3, 108). Jewellery (110–11, 124–5) and the beautifully crafted cosmetic articles of the Middle Kingdom (122–3) have an exceptionally strong appeal to our modern aesthetic sensitivity. There are clear signs that clothing was no longer purely utilitarian but became subject to the dictates of fashion (100). Articles of everyday life now began to be highly decorative and acquired various playful forms (104).

A grid of fixed proportions which artists used during the preliminary measuring out of representations of people became standard during the Middle Kingdom. The height of a standing

figure was the equivalent of eighteen squares (the top of the eighteenth square touched the forehead). The top of the sixth square intersected the knee, the eleventh the waist, the twelfth the elbows, the fourteenth the armpits, and the sixteenth the shoulders.

For the first time since the late Predynastic period, artistic contacts with areas abroad, the Syro-Palestinian region and perhaps Crete, are strong enough to cause us some difficulties in establishing the direction of cultural influences (109, 131).

The decline of the Middle Kingdom was unspectacularly slow and long, and this was reflected in the arts where large building enterprises undertaken by the state and ambitious works of art gradually ceased to be made. Small pieces, especially those made in faience, reflected more popular religious beliefs (127–9). Bronze statuettes of non-royal persons (130) became more common.

It would be interesting to see what Egyptian society would have transformed itself into had it not been for the intervention of the Hyksos in c.1648 BC. These were originally immigrants from the Syro-Palestinian region but some of them had lived in the Egyptian eastern Delta for several generations. The period of the Hyksos overlordship (c.1648–1540 BC) produced few works of art although the sensational discovery of Minoan frescoes (134) at Tell el-Daba (ancient Avaris), the former Hyksos capital, may in spite of their later date be due to possible Hyksos contacts with Crete.

Contemporary propaganda may have presented the resurgence of Thebes under kings of the late 17th dynasty (after c.1560 BC) and the eventual defeat of the Hyksos by King Ahmose (c.1540 BC) as a reassertion of the native Egyptians against the foreign invaders but it was, in fact, the triumph of one family of ambitious local rulers over another. The 18th dynasty, inaugurating the period known as the New Kingdom (1540–1069 BC), would scale new peaks of political, economic and artistic achievement. Egypt became an important player on the Near Eastern stage because of its diplomacy as well its military power.

The temples of Amun at Karnak (138, 142–3) and Luxor witnessed building activities on a massive scale, and these were mirrored by similar enterprises for the benefit of other gods elsewhere. Royal tombs were cut in the cliffs in the Valley of the Kings, on the west bank across the Nile (147). They were now physically separated from the temples for the royal funerary cults lined up in the plain along the Nile. The most spectacular temple was built for Queen Hatshepsut (139, right). Nearby, tombs for non-royal persons were splendidly decorated in relief or painting (148–9, 152–3). Statues (135–6, 141, 145, 151, 154), elements of personal adornment (140), metalwork (144), glassware (146) and pottery (150, 155) attest to the level of prosperity and sophistication of taste of the privileged groups among Egyptian society.

The peace and prosperity which Egypt enjoyed peaked during the long reign of King Amenhotep III. This was reflected in the perfection, occasionally affected by blandness, of architecture (166), statuary (168–70), reliefs and paintings in temples and tombs (156–7, 159–60, 162, 164, 171–3). The glorification of the king in monumental sculpture (161) and architecture scaled heights previously unknown. The king's funerary temple with his huge seated statues, known as the Colossi of Memnon (167), epitomized this. Even more indicative of good times was the fact that objects of everyday life, such as furniture, jewellery, cosmetic implements (163), metal vessels and pottery (158, 165), often became minor works of art and clear evidence of the living standards enjoyed by the growing affluent section of Egyptian society.

But stormy times were looming ahead. Although brought about by political changes, the crisis was mainly ideological: some of the traditional religious concepts, especially those concerning the role of the king in society and his relationship to the gods, had been overtaken by developments and outdated. Egypt was now a superpower operating in completely new conditions on an international stage. The wealth and influence of its temples and their priesthood reached unprecedented heights and threatened to destabilize the traditional order.

King Amenhotep IV abandoned the traditional religious beliefs, promulgated the worship of one deity, the impersonal sun disc, and changed his name to Akhenaten, 'The Radiance of the Sun Disc'. The changes in religious ideas profoundly

affected the architecture and art of temples and tombs.

This was the only time in Egyptian history when the rules governing art were thrown away and new ones introduced. The method of figural representation, established at the very beginning, was drastically altered. The most extreme cases are representations of the king and his queen, Nefertiti, in statues (175) as well as reliefs (176, 178–9) made in the early years of Akhenaten's reign. Yet the Amarna period (so called because Akhenaten's new capital was at El-Amarna, in Middle Egypt) produced some of the most remarkable depictions of female beauty (180, 190–1, 194) and family happiness (178, 181).

The temples for the new state deity, the Aten, were built quickly and decorated with scenes previously not known in such surroundings (183). The king and his family were the subject of most statues made during the Amarna period (184, 193); non-royal monuments were few (187). There was a large variety of minor works of art employed in the decoration of new buildings at El-Amarna such as wall and floor paintings (192), painted and inlaid faience tiles (188), glassware (189) and other objects (186, 195).

The changes introduced during the Amarna period were too dependent on the personal efforts of the king and his consort Nefertiti to survive them, and there was too much at stake for those who did not fully share their convictions. With the deaths of the two protagonists the situation swiftly reverted to its former self, although neither Egyptian religion nor arts remained unaffected by the Amarna 'heresy'. The former Amarna artists created the spectacular relief decoration in tombs at Saqqara (196–7, 215).

The best-known monument of the immediately post-Amarna period is the tomb of King Tutankhamun discovered and excavated by Howard Carter in the Valley of the Kings in 1922 (198–213). Tutankhamun is the only Egyptian king of the third and second millennia BC whose tomb was found virtually intact. The tomb is world famous for the spectacular treasures included among its funerary goods, but its contribution to our knowledge of Egyptian technology is likely to prove to be even more valuable.

During the two centuries which followed the end of the 18th

dynasty in c.1295 BC the dominating feature was the very long reign of Ramesses II. A penchant for the colossal seems to be present in most of the king's building activities, including the temple of Amun at Luxor (234–5). The temples which he made at Abu Simbel in Nubia amaze by their audacity and their architect's ability to translate the design of a free-standing temple into a rock-cut structure (236, 238–40). The king's funerary temple, known as the Ramesseum, is on the Theban west bank (246) and his tomb and those of the other Ramessids are nearby in the Valley of the Kings (220–1, 247, 254, 260, 262–3). Ramesses II's favourite queen, Nofretari, was buried in a beautifully decorated tomb in the Valley of the Queens (230, 232–3), also on the Theban west bank. The funerary temple of another Ramessid king, Ramesses III, at Medinet Habu is the best-preserved at Thebes (250–3). But conspicuous monumentality is balanced out by some of the most charming examples of tomb paintings, found at Deir el-Medina (228, 233–4, 248, 261, 264), the site associated with the workmen engaged in the construction of the royal tombs in the Valley of the Kings, and in other parts of the Theban necropolis (243). Surprisingly, only sections of the large corpus of Ramessid sculpture (225, 245) have been studied in any detail. The less formal aspects of drawing and painting can be found in sketches on ostraca, smooth limestone flakes (224, 244, 248), or papyri (256–7). Spectacularly decorated tombs continued to be built at Saqqara (218–19). The variety of items of funerary equipment (229, 241, 249, 255), as well as objects of daily life (226), is unprecedented in Egyptian history. During the Ramessid period the possession of works of art extended further down the social scale of Egyptian society than at any time before.

Temple building was reduced and large decorated tombs all but ceased after c.1069 BC, during the Third Intermediate period when Egypt was again politically divided. The reasons for the disintegration of the system are not easy to pinpoint with any precision. The main problem seems to have been the inability of the ruling dynasty to check the ambitions of local princes and priesthoods, especially in the Delta which now began to play a major role in Egyptian economy and commerce.

The artistic emphasis shifted onto various items of tomb equipment such as stelae (267, 283), coffins (277), papyri (265), funerary canopy covers (264), or imitations of canopic jars (266). The discovery of the intact tombs of several kings of the 21st and 22nd dynasties at Tanis (San el-Hagar) provided some astonishing coffins (272–3), funerary masks (274–5), vessels (268–9, 271) and jewellery (276, 280, see also 281) made of gold and silver. These compare very favourably with objects found in the tomb of King Tutankhamun, even though the contents of these tombs were less extensive.

Statues and statuettes made in metal, usually bronze but also gold or silver (279), became probably more common than those made of stone. An outstanding series of sculptures made for priestesses known as the god's wives of Amun was made in Theban workshops (282). Small bronze statuettes, especially those of deities, many of them zoomorphic, were being made in large numbers as votive items presented to temples by pilgrim devotees. Faience vessels of the Third Intermediate period are innovative in their forms and accomplished in their decoration, often carried out in relief (278). In spite of the prevailing political situation during the Third Intermediate period, high artistic standards were maintained.

The intervention of Nubian (also Kushite) kings, first in the affairs of Upper Egypt around 730 BC, and then the whole country around 715 BC, introduced the Late period. This was characterized by another return to political unity under one pharaoh. Sculptures of kings of the 25th dynasty (285) and their non-royal contemporaries (286) are remarkable for their naturalism (showing people 'as they are', though not necessarily aspiring to real portraiture). The reasons for preferring such a trend instead of the usual idealizing approach are not clear. One possible explanation is that the situation was unusual: for the first time in Egyptian history, the sculptors were asked to make sculptures of rulers of foreign extraction. But such representations were short-lived and replaced by the standardized 'Saite smile' (290) of the sculptures of the 26th (Saite) dynasty, after 664 BC.

Almost all Late period statues were made for temples (286, 290–1, 299, 303–5, 307); for the rest of Egyptian history tomb sculptures would be unusual (296). Small sculptures were among objects donated to temples by pious visitors (292, 306, 309, 311). There was also a spectacular revival of relief decoration in rock-cut tombs at Thebes (287–9) as well as in their free-standing counterparts in the Memphite area and in the Delta (312–14). The variety of both funerary and everyday life objects which attest to the aesthetic feelings of the ancient Egyptians at this period is enormous, from inlays (284) to vessels (298), pectorals (294), coffins (295), sarcophagi (302, 310) and funerary bead shrouds (300–1). Ushebtis, small figurines usually made of faience, were the earliest mass-produced works of art (315).

The grid of fixed proportions which artists used in their preliminary sketches in order to ensure uniformity of representations of people was modified during the Late period. Twenty-one squares (rather than the previous eighteen) were now used to accommodate the height of the standing figure and the internal measurements were adjusted accordingly.

The impression of the great variety and richness of works of art of the Late period is only partly due to the better chances of their survival. There is little doubt that there was a genuine increase in artistic production intended for all levels of society.

Pharaonic Egypt came to an end with the conquest by Alexander the Great in 332 BC but Egyptian art continued to flourish, albeit in much more complex conditions, throughout the Ptolemaic period. The Greek rulers of the Ptolemaic dynasty were anxious to present themselves as true successors of Egyptian pharaohs and pacify the local population and its most influential section, the priesthood (329). Temples to Egyptian deities continued to be built and their appearance was little affected by the changed political situation and the presence of foreign artistic traditions in the country (320, 333–7, 341). The cults of sacred animals were still supported (330), and religious festivals attracted pilgrims in unprecedented numbers. Small royal busts and plaques with representations of kings, deities (331) or other subjects may be connected with such occasions. Animal cults were especially popular (316, 322, 328, 340).

Sculptors making statues in the Egyptian naturalistic (327,

342, 345–7, 349) or idealizing (326) traditions now worked side by side with others who created sculptures in the Greek style, and the two artistic approaches may have influenced each other (339). The mixing of Egyptian and Greek in tomb decoration was rare (317). Most items of tomb equipment such as coffins (318–19), statuettes of deities linked to burial (324–5) and papyri (344) remained purely Egyptian, but some began to display foreign representational conventions which would later characterize the arts of the Roman period (348). The technique of employing inlays in glass (318–19, 323) or other materials (338) was very popular.

After Octavian's defeat of the navy of Mark Antony and Queen Cleopatra VII at Actium in September 31 BC Egypt became part of the Roman Empire. For a while the arts continued as before: Egyptian temples were built (321, 350, 353) and burial customs retained some of the characteristic pharaonic features (351–2, 357). But the ideological basis of Egyptian art, which had already been seriously weakened, was dealt a fatal blow by the spread of Christianity. The religious background which had previously ensured homogeneity and continuity had disappeared. Artistic influences from abroad became much more intensive. The new arts of Roman and later Byzantine Egypt derived from native and foreign traditions (354, 356) modified by the demands of the Egyptian Coptic (Christian) religion. This is a different kind of art, as fascinating as its pharaonic predecessors and in many respects even more complex, but it lies outside the limits of this book. We shall stop following the arts of Egypt around 200 AD.

The world's fascination with Egyptian art began even before the ancient civilization came to an end. The Romans who became crucially involved in its later history took many monuments and works of art back to their homelands. Their own artists made imitations of Egyptian works, some of them so convincingly successful that these days we find it difficult to tell them from the real thing. Aspects of Egyptian religion spread over large areas of the Roman empire, and rudimentary elements of Egyptian art accompanied them. But it was the European Renaissance which witnessed an enormous upsurge in the interest in things Egyptian. These came to be admired

and sometimes imitated by artists creating in their own traditions. In this way, certain features of Egyptian art, often reinterpreted and modified beyond immediate recognition, were significant in the formation of what we now regard as our own Western cultural heritage and tradition.

Interest in Egyptian art was kept alive by events which came from various spheres of endeavour. Travellers to the Holy Land and areas linked to the biblical stories, including Egypt, left significant accounts of Egyptian monuments and even brought Egyptian works of art to Europe in the 1600s. Napoleon's military expedition in 1798 may have been ill-fated but the work of its savants and their publication of the monumental *Description de l'Egypte* put the European knowledge of ancient Egypt on a more reliable basis. It also provided material for the scientific study of ancient Egypt and significantly influenced European decorative arts. Jean-François Champollion's explanation of the principles of the hieroglyphic script in 1822 can be regarded as the birth of modern Egyptology. Howard Carter's discovery of the tomb of King Tutankhamun in 1922 created unprecedented enthusiasm for ancient Egyptian civilization and this was directly reflected in contemporary arts.

Interest in Egyptian art has not abated; if anything, it is increasing. Modern artists search far and wide for their inspiration and ancient Egypt is a frequent choice. Their perception of this civilization is usually taken from indirect and sometimes unreliable sources such as films and television. In a way, there is now a second, fictitious, ancient Egyptian tradition which exists almost independently of the original.

Ancient Egypt and its arts continue to appear at the most unexpected places in our lives. As our modern world is getting more complex and hectic and as the certainties of life are disappearing, we instinctively search for a world of stability, tranquillity and spiritual certainty. Rightly or wrongly, and most likely misguidedly, ancient Egyptian civilization seems to provide such a refuge, and its arts and architecture are the most attractive way of approaching it.

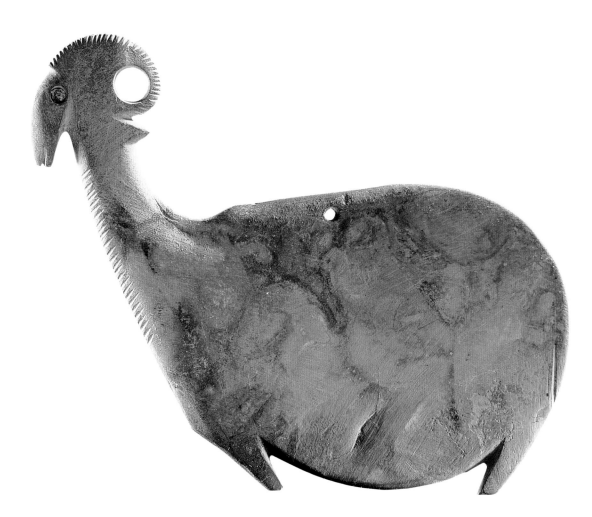

Sheep palette,
from a grave at Naqada

*c.*4000 BC. Siltstone, w. 18.3 cm, 7¼ in.
Ashmolean Museum, Oxford

Stone palettes used for the
preparation of cosmetics, especially
eye paint, were often among
Predynastic grave goods. They are
some of the earliest objects which
attest to the aesthetic feelings of
ancient Egyptians. Many of these
palettes are strictly utilitarian, mere
flat thin slabs of stone, oval or
rhomboid in shape. Others acquired
playful forms, often of an animal,
turtle or fish. It is difficult to discern
any other reason for this than pure
pleasure at the creature's vitality,
elegance and natural beauty.
Religious considerations probably
did not play any part in the choice of
the subject. The animal is reduced
to little more than a silhouette,
sometimes enhanced by engraved
lines along the edges of the palette.
Comparable minimalistic pictures of
animals are known from
contemporary rock drawings and
pottery. The eyes of the animals on
these zoomorphic palettes are
sometimes hollowed out and inlaid,
using adhesive, with shell beads.
These are the earliest examples of
the inlaid eyes which, employing
mostly white and black stones
mounted in copper settings, are
such a striking feature of many Old
Kingdom statues (e.g. 68 and 70).

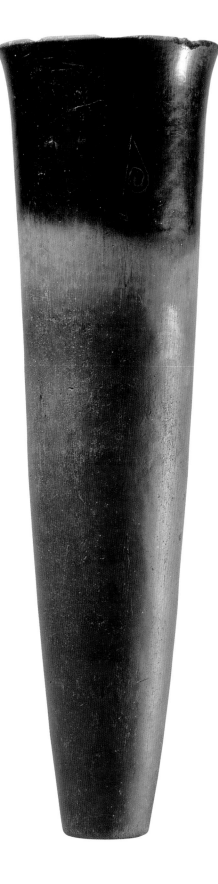

Black-topped beaker, from a grave at Naqada

*c.*3600 BC. Pottery, h. 32.5 cm, 12¾ in.
Ashmolean Museum, Oxford

The most elegant forms of Egyptian
pottery were probably produced
during the Predynastic period.
Some of the objects placed in
graves had been used by the
deceased persons in their lifetime
(see 199), but others were made
exclusively for the burial. Already in
the Predynastic period there were
establishments which specialized
in the manufacture of items for
funerary purposes, in particular
pottery. These were the pre-
decessors of the necropolis
workshops of the pharaonic period.
Funerary pottery tended to be more
inventive and more decorative than
the functional domestic ware,
although the two categories may
have overlapped. The decoration
of this beaker consists of a broad
band of a metallic black colour near
its top which is set off against the
haematite red ochre applied to
the body. It seems certain that
the pattern was at first created
accidentally, by placing the pot
upside down into a layer of carbon
and ash during firing. The subdued
elegance of such ware became
very popular, and pots with
perfectly formed black tops were
made on purpose, probably for
everyday as well as funerary use.

Beaker with sheep and goats, from a grave at Naqada

*c.*3600 BC. Pottery, h. 25.3 cm, 10 in.
Ashmolean Museum, Oxford

The earliest Egyptian two-dimensional representations can be found painted on early Predynastic pottery and incised or hammered into rock surfaces. Drawings of animals had a longer tradition than representations of people. At first, human beings occurred infrequently and when they did it was usually because of their connection with animals (e.g. as hunters or trappers in rock drawings). The desert sheep and goats drawn in monochromatic white on the red surface of this beaker have their bodies covered with linear hatching, a technique which makes them stand out from the background and appears to lend them an extra dimension. The artist no doubt tried to convey the impression of the hairy coat of the animal. This technique contrasts with that used to fill in the space between the outlines of triangular shapes which frame the animals above and below. These triangles probably represent a rocky landscape and stand on a base line which may be seen as the precursor of the divisions of registers in pharaonic art (see 29). The beaker was made for inclusion among funerary goods; it is unlikely that such a vessel would have been in daily use.

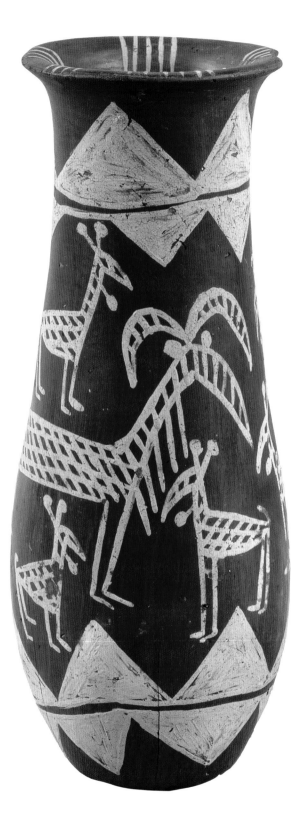

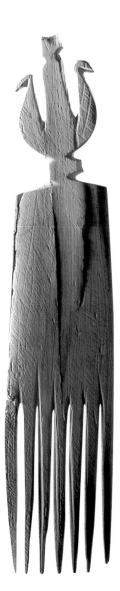
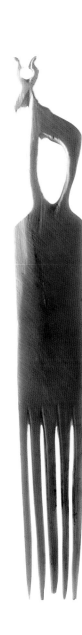
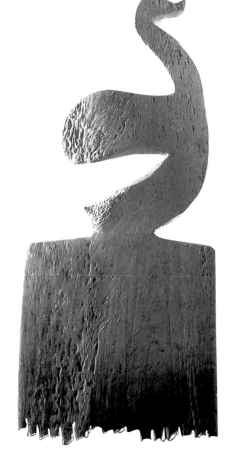

Three decorative combs, from graves at Naqada

*c.*3500 BC. Bone, h. 10.7 (bird),
17 (gazelle) and 12.8 cm (two birds),
4¹⁄₄, 6⁵⁄₈ and 5 in.
Ashmolean Museum, Oxford

Egyptian works of art can be
assigned to one of three partly
overlapping categories: decorative
objects of everyday life, funerary art
intended for graves and tombs, and
the art of the shrines and temples of
gods. During the Predynastic period,
the art of everyday life consisted
mostly of objects associated with
personal adornment. The inspiration
was often drawn from the animal
world and the only reasons for it
appear to have been the beauty of
the animal or bird and perhaps the
desire to enhance the person's
attraction to match it. Magic and
rudimentary religious beliefs were,
however, never far away and
prompted the wearing of amulets.
The beautifully observed miniature
flat silhouettes of animals on
top of ivory or bone combs are
reminiscent of those which lent
their form to some cosmetic
palettes (see 14). Here, however,
the artist had more freedom
when choosing the subject because
the only practical consideration to
bear in mind was that the animal
was to form part of the comb's
handle. The elegance of these
figures far surpasses those on
cosmetic palettes.

A woman mourner, from a grave at El-Mamariya

*c.*3400 BC. Painted terracotta,
h. 33.8 cm, 13 in.
Brooklyn Museum of Art, New York

In Egyptian art, especially sculpture in the round, the material always exercised considerable influence over the form. Late Predynastic figurines of women with their arms gracefully raised above their head and an unarticulated peg-like lower body are sometimes called 'bird deities'. The modelling of their heads makes them appear as though they had a beak, and so were bird-headed. This is almost certainly a misnomer. Similar female figures can be found painted on late Predynastic pottery in the context of symbolic boat journeys. These women probably are mourners, either members of the deceased's family or professional mourners showing their grief at the departure of the deceased by raising their arms above their heads in a universal gesture of lamentation (see 171, 289 and 324). This was the reason for their inclusion in graves. These figurines were made of baked clay which allowed their arms to be freed from the rest of the body. However, with a few exceptions, terracotta never became popular with later pharaonic sculptors, probably because of its relatively limited durability when compared with stone.

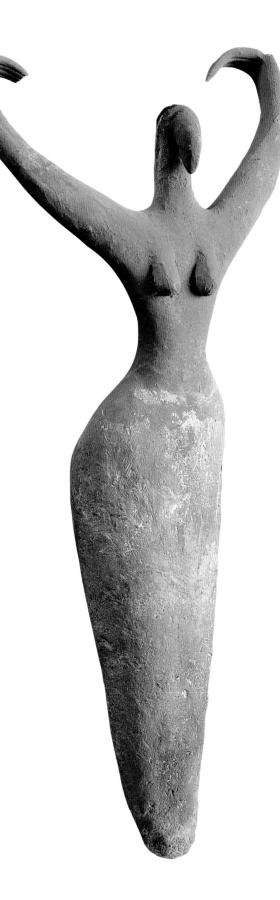

Painted jars,
from graves at Naqada and Abadiya

c. 3300–3100 BC. Pottery,
h. 20, 8.9, 18.8 and 10.2 cm,
7 ⁷⁄₈, 3¹⁄₂, 7 ³⁄₈ and 4 in.
Ashmolean Museum, Oxford

Boats painted in monochromatic red over light brown can often be seen on late Predynastic pottery.

This is not unexpected in a country where dependence on the river was absolute, but these are more than just depictions of the local environment. The boats are probably taking the deceased on a symbolic pilgrimage to a shrine of the deity who presided over the realm of the dead. They are sizeable craft, with decorated prows, and they are propelled by

many oars. Amidships are two cabins, often with a standard, and sometimes a human figure, perhaps the deceased himself, standing on one of the cabins. This was meant to indicate a person inside the cabin. It is an early example of a typical feature of pharaonic representations, showing the invisible contents of a closed space (eg a box, here a

cabin) above it (see also 96, 281, 316). The figures are shown here as dark silhouettes, anticipating the approach adopted in later painted reliefs. The pattern on the vase on the left in the illustration imitates the mottled appearance of stone.

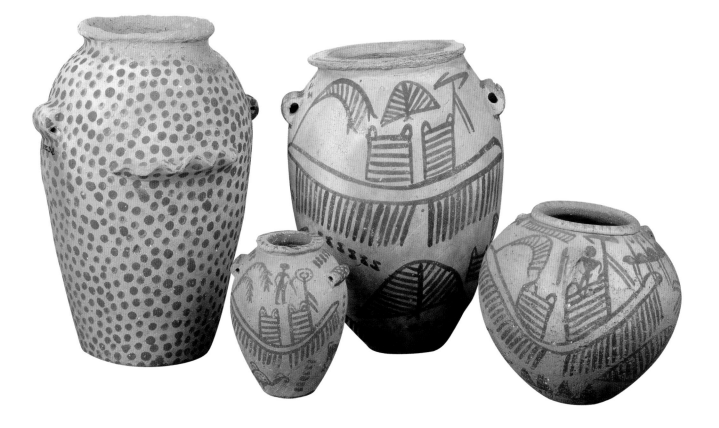

Rectangular basin with desert animals and a boat, from a grave at Abydos

*c.*3300 BC. Pottery,
l. 13.2 cm, 5¼ in.
British Museum, London

Boats painted on late Predynastic pottery are often shown surrounded by animals and plants and sometimes people on the river banks. The parallel horizontal lines on the long side of this basin probably indicate the shore where desert animals came to drink. The S-shaped forms may represent vegetation. The gazelles differ from later pharaonic representations only in their relative unsophistication, but not in the way they are shown (see 82). They are placed on a base line, which is such a characteristic feature of later pharaonic reliefs. A boat is depicted on the short side of the basin. Apart from rock drawings, pottery was almost uniquely the medium on which such scenes were represented during the Predynastic period; examples of these subjects on walls of a burial chamber or on a funerary shroud (21) are exceptional. It was only when tomb chapels began to be decorated during the Old Kingdom that the artist was allowed greater scope for his work.

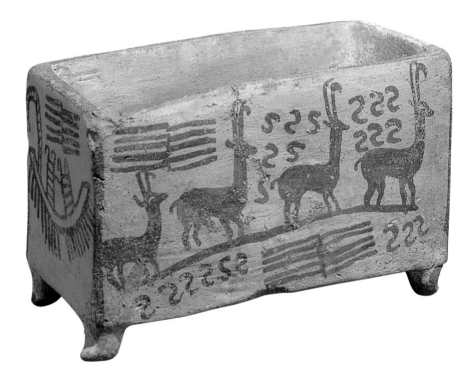

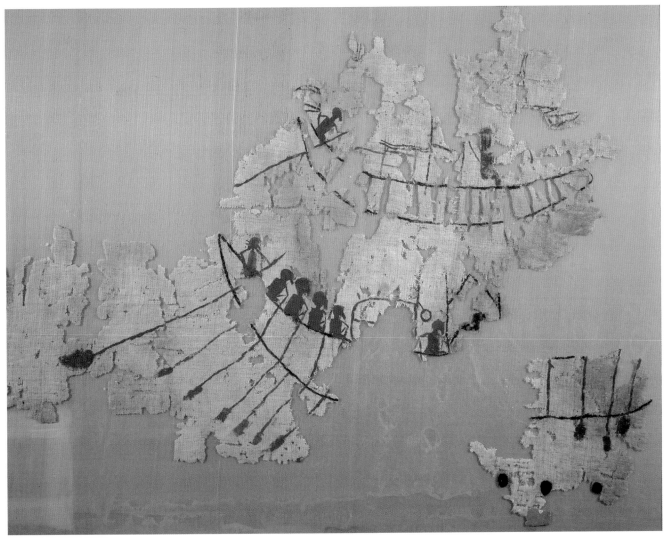

Boats, fragments of a shroud from a grave at Gebelein

*c.*3300 BC. Linen cloth,
l. 50 cm, 19¾ in.
Museo Egizio, Turin

Representations of boat voyages and female mourners, commonly encountered on late Predynastic pottery (see 19 and 20), also appear painted in reddish brown, white and black (other colours may be lost) on fragments of a funerary shroud found at Gebelein. Various activities, including the harpooning of a hippopotamus and the netting of fish, are taking place during the boats' progress. Similar scenes continued to be included in the repertoire of Old Kingdom tomb chapels, and their position there suggests that they had special significance. The conventions of later pharaonic art, unfortunately, make direct comparisons difficult. The 'mobility' of the desired theme, which appears here on a piece of textile rather than on a rock drawing, a pot or, even more exceptionally, a tomb wall, was going to be one of the characteristics of funerary arts during the pharaonic period. As on contemporary pottery, the inside space between the outlines of human figures is filled with a uniformly undifferentiated colour. This technique, not dissimilar from that used in modern colouring books, eventually led to the painted reliefs of the pharaonic period.

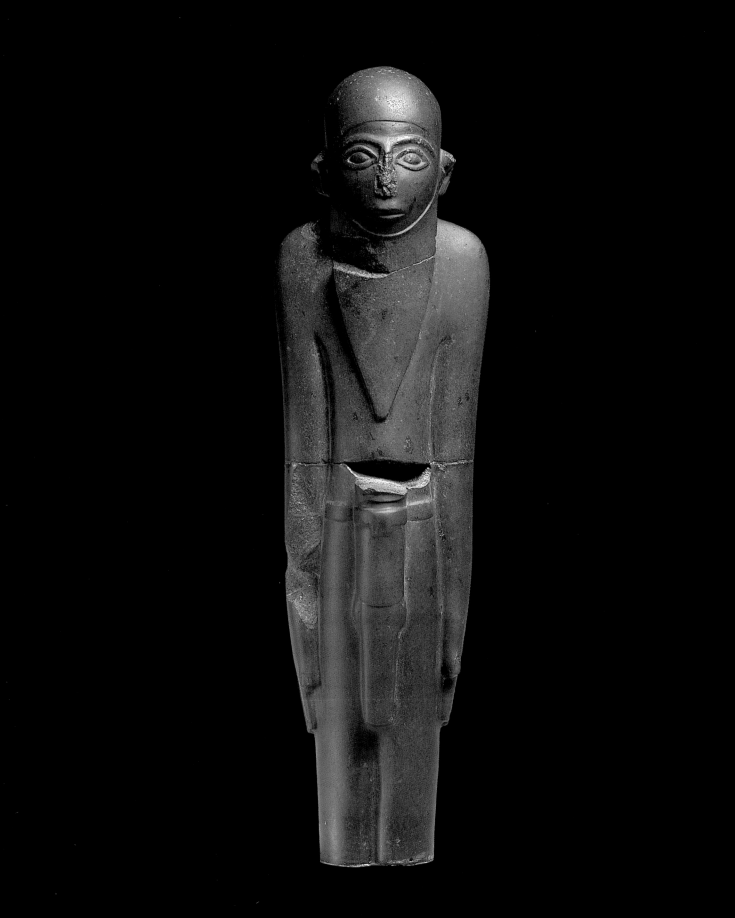

Bearded man,
said to come from Naqada

*c.*3250 BC. Basalt, h. 39 cm, 15 in.
Ashmolean Museum, Oxford

Statuettes of bearded men, mostly
carved in ivory but exceptionally
also in stone, are known from
the late Predynastic period. They
appear to have little in common
with pharaonic works of art. This
is certainly true of the artistic
conventions employed in their
creation. Only the narrow
dolichocephalic (long-skulled)
head is, as a rule, portrayed in
detail; the rest of the body is left
unarticulated. These figures have
large ears, staring eyes which are
sometimes inlaid, and a prominent
nose. The Ashmolean statue,
known as 'MacGregor Man' after
its previous owner, is one of the
largest and finest among these
sculptures and, unusually, shows
the man's body in its entirety.
It was carved with maximum
economy of effort, with its arms
held close alongside the body and
the legs not separated. We do
not know whether the feet were
indicated or not because the lower
legs of the statue are lost. The
long triangular beard of the man is
similar to that worn by subjugated
people on votive palettes (26–8,
30–1). These pieces represent the
early stages of Egyptian three-
dimensional sculpture. They
were the matrix onto which
the conventions of pharaonic
representations were grafted
around the beginning of the 1st
dynasty of Egyptian kings.

Knife with a decorative handle, from a grave at Gebel el-Araq

*c.*3250 BC. Raised relief in hippopotamus ivory, flint blade, h. 25.5 cm, 10 in. Louvre, Paris

Did Egyptian art receive influences from abroad at the time when its pharaonic character was formed and, if so, how significant were they? No work of art is more crucial for this question than the knife from Gebel el-Araq. Knife handles were beside palettes (see 26–8, 30–3) and maceheads (29) the earliest objects with scenes carved on them in relief. The Gebel el-Araq knife handle contains non-Egyptian elements, especially the main motif of the 'master of the beasts' wearing a distinctly foreign hat and a long cloak who is subduing two lions on one side of the handle. Less compellingly foreign is the lion attacking an antelope and also the battle scenes and boats on the other side. The representations of fighting men do not display pharaonic conventions, but there is no reason to regard the arrangement in registers as a foreign import (see 16). In the late Predynastic period the demands of the rising privileged groups in Egypt attracted artistic imports, possibly even foreign artists who came to create in Egypt. The late Uruk and Djemdet Nasr cultures (*c.*3450-2900 BC) in southern Mesopotamia may have supplied such artistic influences.

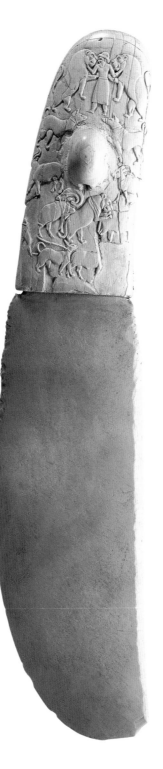
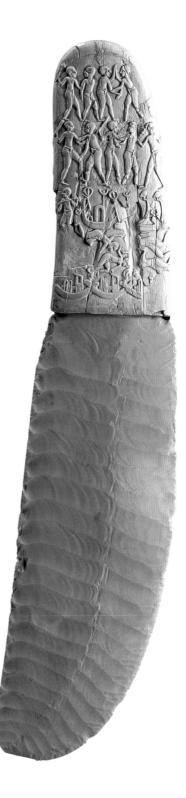

Frog,
location of discovery not known

*c.*3100 BC. Travertine (alabaster)
h. 15.4 cm, 6 in.
Cleveland Museum of Art

The Egyptian pantheon was
complex and multi-layered. Its
largest component consisted of
local gods worshipped in specific
areas of the country. These, in
addition to a host of semi-divine
beings associated with the family,
household and crops, played the
most important part in the lives of
ordinary people. Modest shrines of
local gods certainly existed already
in the Predynastic period but they
were a far cry from temples built
later. At first, most of the local
deities were worshipped in a
zoomorphic form, as animals
or birds (see also 311). Pious
worshippers seeking divine favours
often presented small images of
the deity to their local shrine. This
frog is one of the largest and most
accomplished of such sculptures
and must have been given by a
person of considerable importance.
The frog was linked to the goddess
Heket and was associated with
childbirths, but also with rebirth
and life after death. The statuette
shows that the ability to carve
accomplished three-dimensional
images in stone existed well before
the beginning of the pharaonic era.
It seems that an attempt was made
to exploit the natural veining of
the stone, something which rarely
happened during the pharaonic
period when such a feature would
have been covered by paint.

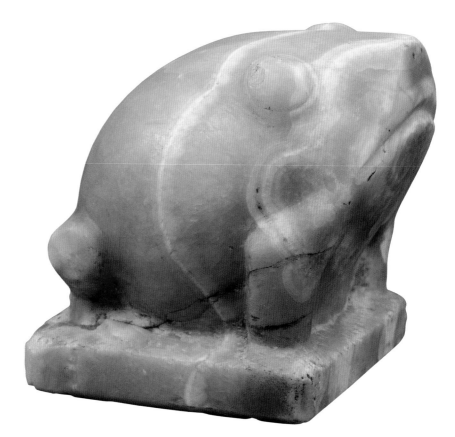

The king as a bull goring a foe, votive palette, probably from the temple at Abydos

*c.*3050 BC. Raised relief in siltstone, h. 26.5 cm, 10½ in. Louvre, Paris

Egyptian art often used codes in order to express ideological concepts and religious ideas. Stone palettes were used for the grinding of minerals employed in body make-up for religious as well as practical reasons. It was, therefore, perfectly logical that such objects were regarded as suitable gifts to be presented to shrines of deities. These palettes, however, were no longer intended for practical use. Instead, their importance lay in the scenes carved on them in bold raised relief. The early rulers to whom the scenes refer are shown in the form of wild and ferocious animals, such as bulls and lions, while their victims are human. It was one of the innovations which immediately preceded the rise of the 1st dynasty of kings that the ruler began to be represented as a human being. This change was probably inspired by religious rather than purely artistic reasons. On this palette, the brutal strength and ruthlessness of the king in the guise of an enraged bull is conveyed by the pose and the tensed leg muscles of the animal. This image is artistically far superior to the early anthropomorphic representations of kings, as on the macehead of King 'Scorpion' (29) or the palette of Narmer (30–1).

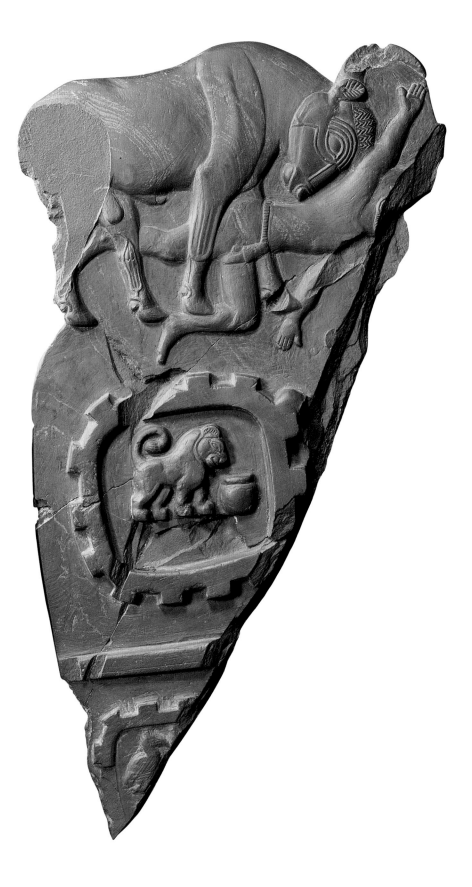

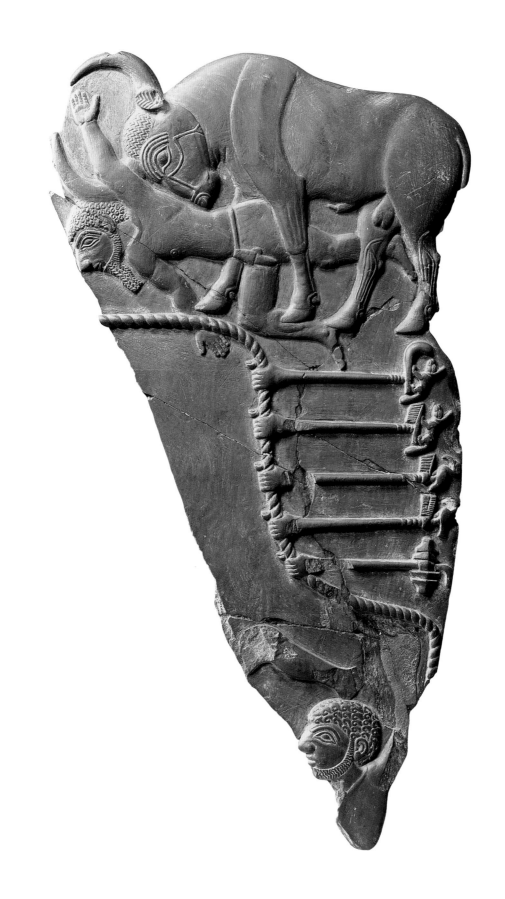

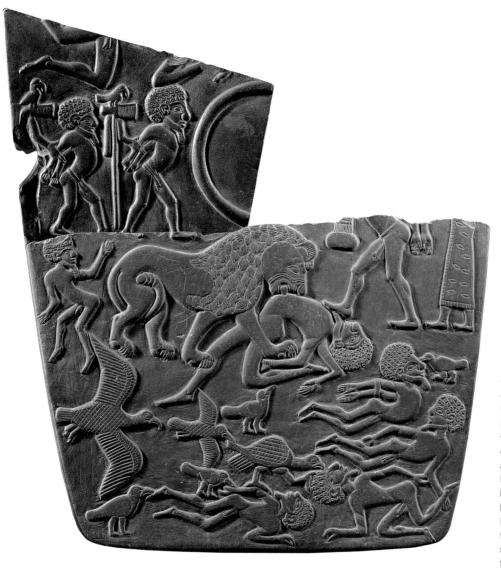

The king as a lion devouring a slain foe, votive palette, probably from the temple at Abydos

*c.*3050 BC. Raised relief in siltstone, h. 32.8 cm, 13 in. The upper part in the Ashmolean Museum, Oxford, the lower part in the British Museum, London

None of the votive palettes conveys the message of the inevitable triumph of the king over his enemies more powerfully than the so-called 'Battlefield Palette'. The scene shows the grim aftermath of a battle. The bodies of enemies, contorted in their death throes, are strewn over the battlefield. They are being feasted upon by a lion, symbolizing the king himself, and by a whole flock of vultures. Not yet restricted by the division of scenes into registers, the artist showed the battlefield in a panoramic view, something which was much later attempted on temple walls by Ramessid artists (see 250). Those enemies lucky to have been taken alive are being led away, their arms tied behind their backs, by deities of Egyptian districts which had helped the king in his fight. They are shown in their zoomorphic (animal) forms, as birds perching on top of standards. Such scenes are sometimes explained as depicting historical events, but this interprets the object too literally and is almost certainly wrong. The purpose of this work of art was to ensure that the desired state of affairs shown on it continued in perpetuity. It was a much more general statement than a mere historical record.

**King 'Scorpion', macehead,
probably founding a shrine for a god,
from the temple at Hierakonpolis
(Kom el-Ahmar)**

*c.*3000 BC. Raised relief in
limestone, h. 25 cm, 9⅞ in.
Ashmolean Museum, Oxford

Many of the conventions of
pharaonic two-dimensional
representation are already present
on the macehead of King
'Scorpion'. 'Scorpion' may have
been the predecessor of King
Narmer whose celebrated palette
(30–1) the macehead then
predates. It was no longer
a weapon as it had been in
the Predynastic period but a
ceremonial object conveying
a religious concept through the
representations carved on it. The
scenes are divided into horizontal
registers, strips separated by
base lines on which figures
stand. Similar lines are used for
subdivisions of registers. The
king is shown with his face (his
forehead, nose, lips and chin) in
profile, his eye which is nearer the
viewer in front view (the other eye
is not visible), his shoulders in front
view, his waist in a three-quarter
view, his legs and feet again in
profile, and his left foot advanced.
Relative sizes of figures are
unrealistic; those which are more
important are shown larger.
The symmetry of the scenes is
obscured because much of the
macehead is missing. The surface
of the macehead is spherical while
that of Narmer's palette is flat,
but that does not affect the two-
dimensional representations
carved on it.

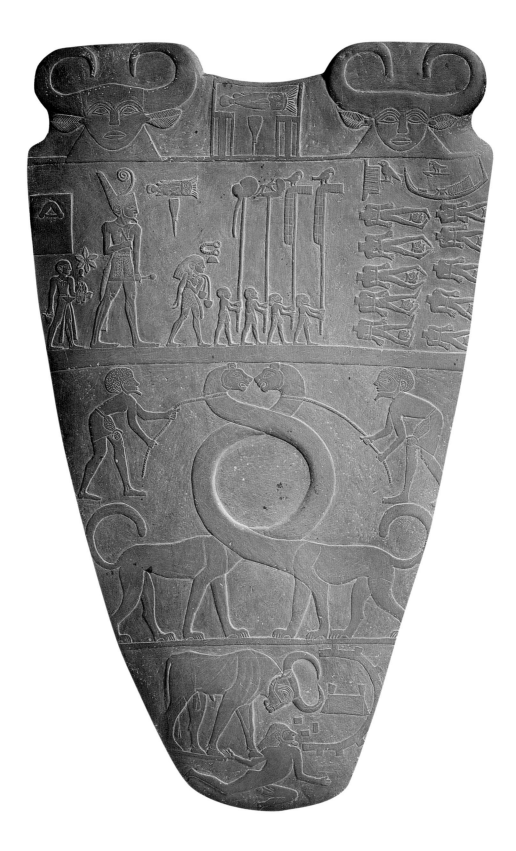

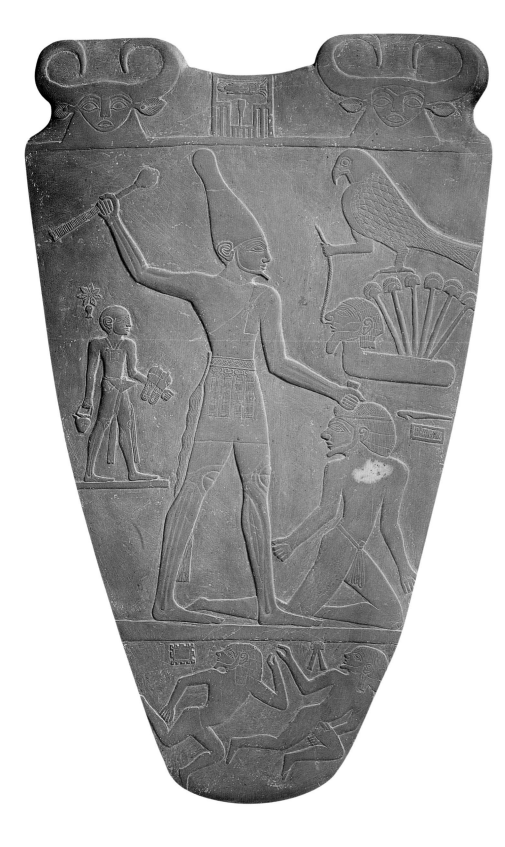

King Narmer triumphant, votive palette from the temple at Hierakonpolis (Kom el-Ahmar)

*c.*2990 BC. Raised relief in siltstone, h. 64 cm, 25¹⁄₄ in Egyptian Museum, Cairo

The palette of King Narmer is usually hailed as the earliest work of art which displays most of the elements of Egyptian two-dimensional representations. In this, however, it may have been preceded by the macehead of King 'Scorpion' (29). The design of the palette makes an extensive use of another important characteristic of Egyptian art, symmetry. The perception of completeness as a synthesis of two complementary, and sometimes confrontational, elements permeated all thinking. Many components of works of art as well as architecture have a counterpart which is symmetrically designed and placed according to an imaginary central axis. Egyptian symmetry is, however, never reduced to a true mirror image; absolute symmetry is, in fact, avoided, as is the repetition of identical features in general. A number of examples of contrasting symmetry can be observed on Narmer's palette. The king wears the squat 'red' crown on one side, but the conical 'white' crown on the other. There are two cow-headed goddess flanking the *serekh* (see 36) with the king's Horus name. The two long-necked lions, each restrained by a lion tamer, frame the depression on the palette's main side.

The king as a lion subduing the forces of nature, votive palette from the temple at Hierakonpolis (Kom el-Ahmar)

*c.*2990 BC. Raised relief in siltstone, h. 43 cm, 17 in.
Ashmolean Museum, Oxford

In Egyptian works of art the boundaries between reality and fantasy sometimes appear to be blurred. The two canines framing this late Predynastic palette gave it its name, the 'Two Dogs Palette'. On both sides there is a mêlée of wild animals. The two lions on one of the sides refer, no doubt, to the king (see also 28). Among the animals on the same side there is a griffin, a creature with the head and wings of a bird of prey and the body of a lion. Close to it is a jackal, or a man wearing a jackal mask, playing the flute. Such a mélange of meticulously observed nature and a myth occurs later in tomb paintings at Beni Hasan during the Middle Kingdom and on small objects during the Ramessid period (249). Because the animals are not arranged in registers, the palette is sometimes thought to predate the macehead of King 'Scorpion' (29) and the palette of King Narmer (30–1) where such divisions already exist. This is almost certainly an oversimplification. The mixture of wild and mythical animals and their seemingly haphazard distribution without the restrictions imposed by a common base line convey beautifully the notion of the chaotic forces of nature successfully tamed by the king in the form of two lions.

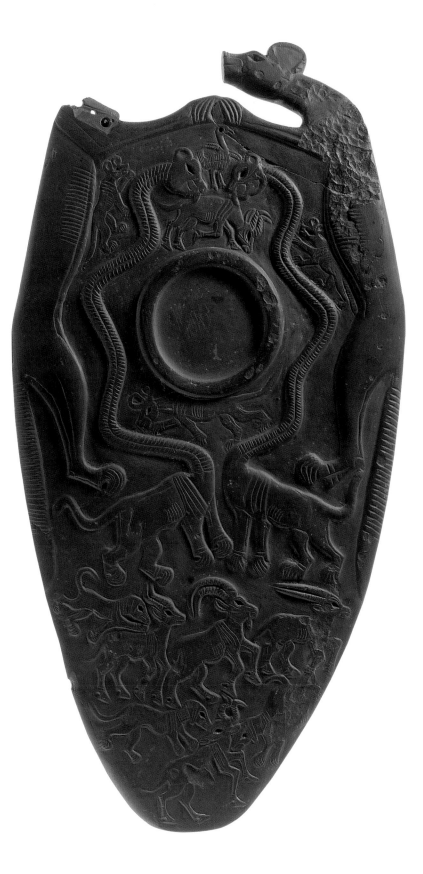

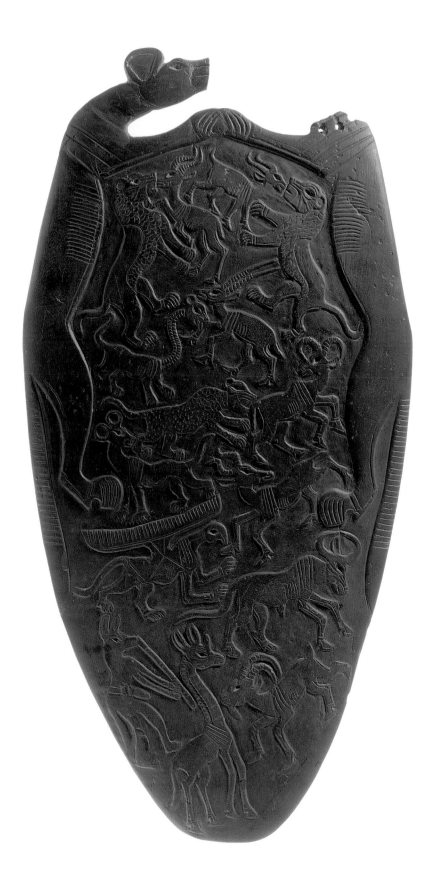

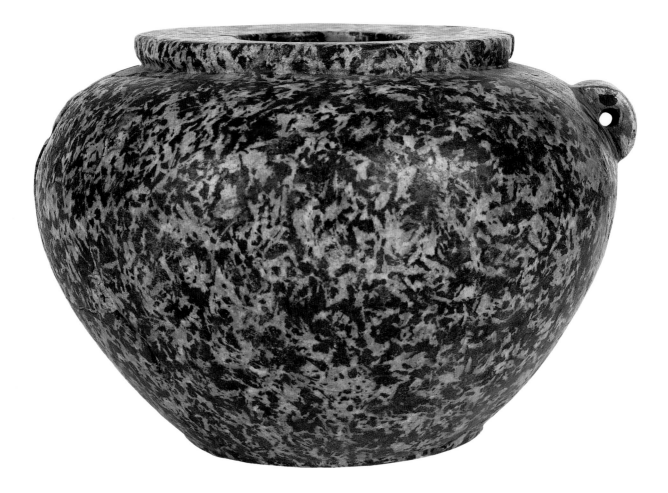

Squat jar, from Abydos

*c.*2900 BC. Breccia, h. 12.5 cm, 9 in.
Musées Royaux d'Art et d'Histoire,
Brussels

The manufacture of stone vessels
was one of the earliest specialized
crafts which appeared in Egypt.
The word for a 'craftsman', *hemuu*,
was written with a sign of a stone-
worker's drill and was also used in
context where we would prefer the
word 'artist'. The Egyptians felt that
'craftsmen' and 'artists' belonged
to the same category of highly
skilled workers, and there is no
precise Egyptian equivalent of
our word for 'art'. The making of
stone vessels reached a very high
standard in the late Predynastic
period and especially during the
first dynasties. A variety of hard
stones was used, including
travertine (alabaster), basalt,
diorite, granite, breccia, porphyry,
serpentine, siltstone and steatite.
The forms vary from simple but
beautifully proportioned vessels,
such as this one, to imitations in
stone of containers originally made
in different materials (see 38). The
stone-worker's tools were simple
and included different types of
hand-held drills, copper chisels and
stone polishers used in conjunction
with quartz sand. Even a vessel of
a relatively simple form, such as
this jar with a tubular handle (drilled
horizontally for insertion of a rope
for suspension or to facilitate
carrying; another handle on the
oposite side has been lost),
probably took about a day to
complete. Most of these vessels
come from funerary contexts and
would have contained precious oils
and unguents.

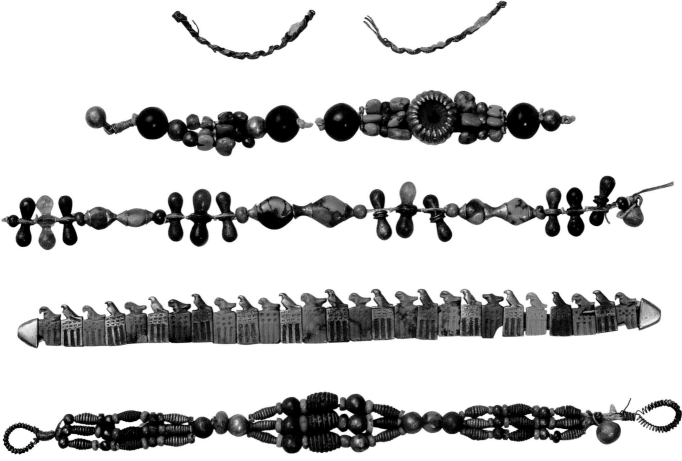

Bracelets from the tomb of King Djer at Umm el-Qaab (Abydos)

c.2900 BC. Gold, lapis lazuli, turquoise and amethyst, l. of the serekh bracelet 15.6 cm, 6 in. Egyptian Museum, Cairo

Finds of ancient jewellery are infrequent and the surviving items must amount to a mere fraction of what once existed. Almost nothing remains of the finest jewellery made during the first two dynasties of the pharaonic era. These bracelets are the exceptions which confirm the rule. There is no doubt that they are bracelets because they were found, overlooked by robbers, on the arm of a mummy in the tomb of King Djer. Because of the destruction of the tomb there is some uncertainty about the owner of the arm: was it the king himself? Or a female member of the royal family? The serekh bracelet (the 2nd from bottom) consists of thirteen gold and fourteen turquoise plaques in the form of the serekh (see 36) which diminish in size towards the fastenings and are strung in an alternating fashion. The gold plaques were probably made of sheet metal in two parts and their details punched and chased. There are numbers on the bases of the plaques indicating their correct position in the bracelet. The turquoise was cut with a saw and the details of the plaques drilled and engraved. There are two horizontal threading holes in the plaques.

Stela of King Wadji, from his tomb at Umm el-Qaab (Abydos)

*c.*2880 BC. Raised relief in limestone, h. including restored base 143 cm, 56¹⁄₄ in. Louvre, Paris

The earliest examples of two-dimensional relief decoration occurred on relatively small objects such as palettes (26–8, 30–3), knife handles (24) and maceheads (29) towards the end of the Predynastic period. The earliest opportunity to employ the technique on a larger scale occurred on stelae (gravestones) in royal tombs of the 1st dynasty at Abydos. The only decoration is the king's name which proclaims him as a manifestation of the god Horus. The name, in this case consisting of a single hieroglyph of a rearing cobra, was written inside a *serekh*, a form which probably imitated the appearance of the temple of Horus, less likely the royal palace (see also 40). The building is seen in a typical Egyptian composite view which persisted through the rest of Egyptian history: the niched façade is its front view, while the area above it, where the name is written, is a view of the same building from above. The *serekh* is surmounted by a hawk representing the god Horus. The perfection of execution is in the tradition of the votive palettes and in stark contrast to the rather hesitant reliefs on the macehead of King 'Scorpion' and the palette of King Narmer.

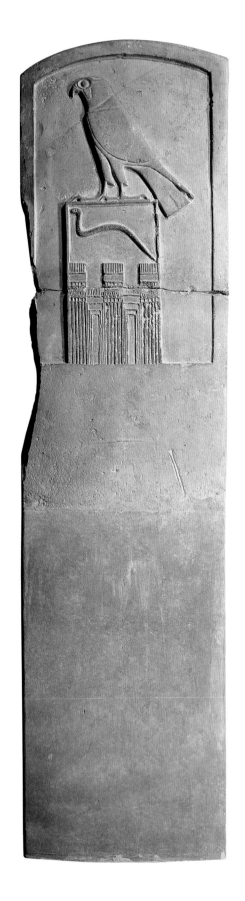

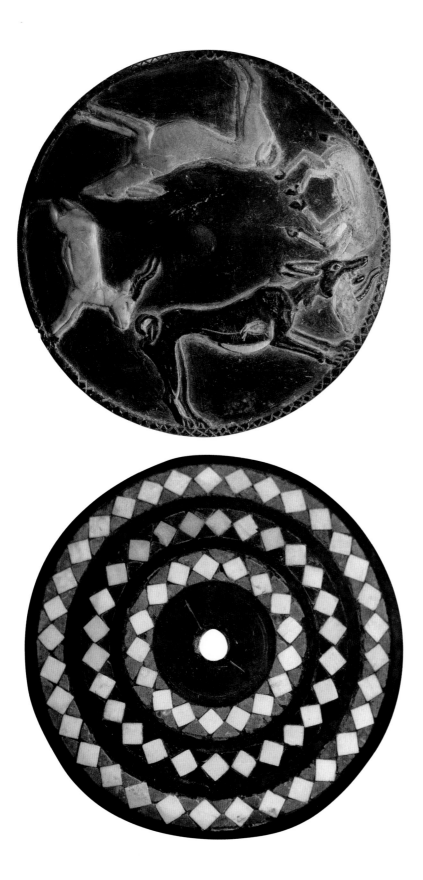

Gaming discs
from the tomb of Hemaka at Saqqara

*c.*2850 BC. Hunting scene: steatite and travertine (alabaster), d. 8.7 cm, 3½ in. Diamond pattern: siltstone, a red stone and ivory, d. 9.8 cm, 3¾ in. Egyptian Museum, Cairo

The rapidly growing stratification of Egyptian society towards the end of the Predynastic period and during the 1st dynasty created a very wealthy group of people, mostly members of the royal family and their close relatives. There was a tremendous increase in demand for prestigious items, which resulted in the appearance of specialist workshops. The tomb of Hemaka, an important local administrator under King Den, contained a box with 45 discs made of various types of stone, horn, ivory or copper. Their purpose is not certain, but a game of some sort seems the likeliest. Most of them are plain but a few have inlays in ivory, stone or paste in colours contrasting with that of the disc. The subjects vary from concentric rings formed by small diamond-shaped inlays to birds and animals, including hounds hunting gazelle. The figures of animals and birds are in raised relief, either inlaid or carved in the disc, and the overall effect can be compared to that of a relief cameo. The bodies of the gazelles in the hunting scene are inlaid but their horns and hooves are carved in the disc itself. Luxurious items like these must have been far beyond the means of the majority of ordinary Egyptians.

Stone vessel imitating a basket, from a tomb at Saqqara

*c.*2700 BC. Siltstone, l. 22.7 cm, 9 in.
Egyptian Museum, Cairo

Objects made of vegetal matter were often imitated in more durable materials (stone or precious metals) in tombs. Skeuomorphism, substitution of materials, was very common in Egyptian funerary arts. The craftsman tried to adhere closely to the original form but in doing so he had to overcome the challenge of a completely different medium, especially one as recalcitrant as hard stone. The aim was to replace more perishable items of everyday life by those which would last forever in the afterlife, although they would never be put to practical use. There are numerous parallels for this concept in architecture (41). Basketry, mostly employing palm leaf and grass, but also rushes and other fibrous materials, was an important industry which supplied many items of everyday use. This is a faithful imitation in stone of a basket resembling a flat tray. The hieroglyphs for 'gold' written on its upper edge suggest that the original item may have been used to hold jewellery and its counterpart in stone was intended to function in a similar way in the afterlife.

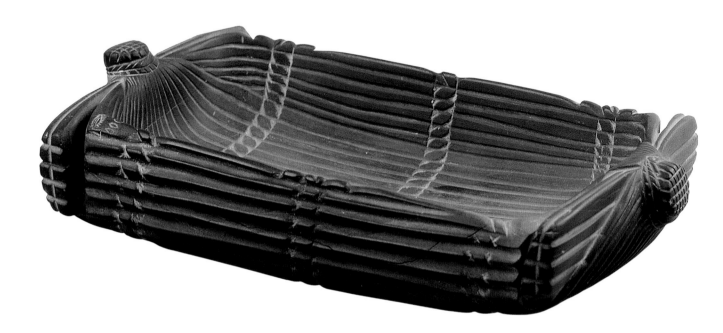

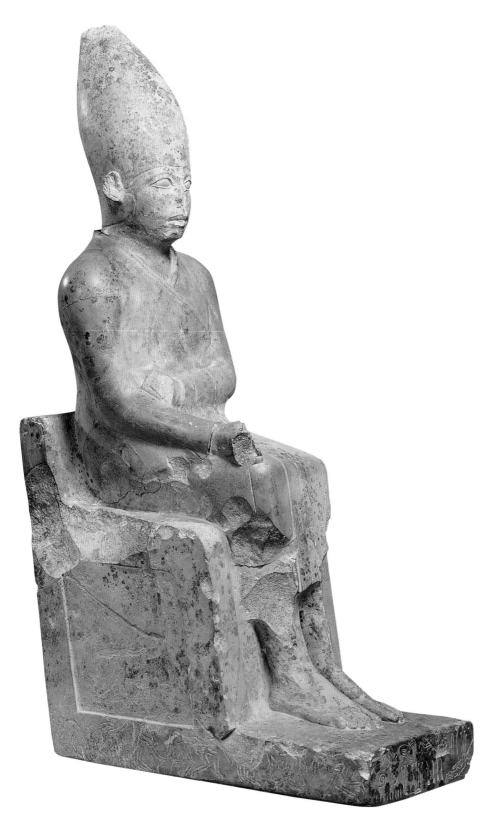

King Khasekhem, from the temple at Hierakonpolis (Kom el-Ahmar)

*c.*2650 BC. Limestone,
h. 62 cm, 24½ in.
Ashmolean Museum, Oxford

The pharaonic conventions found in two-dimensional works (reliefs and paintings) appeared on mace-heads (29) and palettes (26–8, 30–3) of kings who ruled just before the beginning of the 1st royal dynasty. The corresponding birth of the conventions of three-dimensional representations cannot, unfortunately, be observed in a similar way. The earliest Egyptian king whose statues are known is Khasekhem who reigned some three hundred years later. The differences between Predynastic statuettes (see 22) and Khasekhem's sculptures are so great that connections are not easy to see. The two stone statues (one of limestone, the other of siltstone) of Khasekhem were found in the shrine of the hawk-god Horus whose manifestation the king was thought to be. He is shown in an attire worn during jubilee festivals when the powers of the king were renewed. His feet are symbolically placed on the bodies of slain enemies engraved on the base of the statue, a situation the King wished to be perpetuated for eternity, which was the reason for the creation of the statue. The position of the left arm which is placed on the chest remained characteristic of cloaked statues.

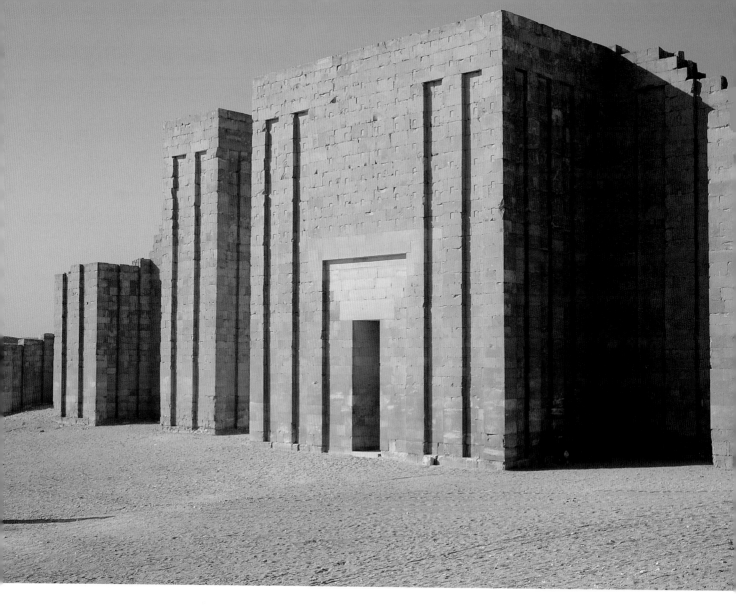

The enclosure wall surrounding the Step Pyramid of King Djoser at Saqqara

*c.*2610 BC. Limestone, 544 x 277 m, 1790 x 910 ft, h. 10.5 m, 33 ft.

The design of the massive enclosure wall around Djoser's Step Pyramid precinct (41) is based on a complex pattern of multiple niches, sometimes described as a 'palace façade'.

This is a convenient term but the assumption that this imitated the external appearance of the royal palace is doubtful. Such a wall, built of mud bricks, has been found surrounding the early temple precinct of the god Horus at Hierakonpolis (Kom el-Ahmar). Also the *serekh* in which the king's Horus name is usually written displays the same pattern (see 36). Brick-built tombs of royal relatives

at Saqqara and Naqada during the 1st dynasty had similar façades. A skeuomorphic adoption of this motif for a stone-built enclosure wall of the king who was regarded as a manifestation of the god Horus was very appropriate. The intricate geometrical design may have been one of the artistic and architectural motifs introduced from southern Mesopotamia during the late Predynastic period.

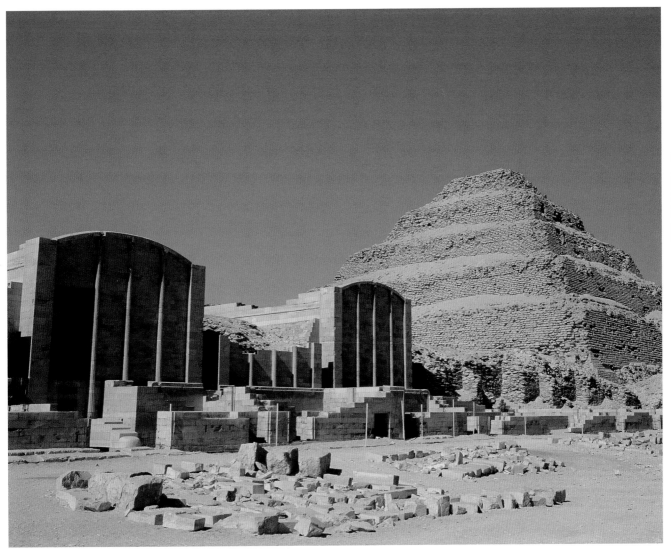

The Step Pyramid and adjacent buildings of King Djoser at Saqqara

*c.*2610 BC. Limestone,
h. of pyramid 60 m, 197 ft

Stone was perceived as the material least likely to suffer from the depredations of time. Because of this, some of the earliest structures in stone, especially those connected with the Step Pyramid of Djoser at Saqqara, were skeuomorphic imitations of buildings in mud brick, wood or vegetal materials such as papyrus (see also 38). They contain such bizarre features as stone stake fences and half-opened doors. Replicas of the temporary shrines and chapels which were normally erected in wood and vegetal materials for the celebration of the king's 30-year jubilee festivals were created in stone near the vicinity of the pyramid for similar occasions which the king hoped to enjoy in the afterlife. The purpose of the festivals was to renew the king's entitlement to rule. The challenge of working in stone contributed significantly to the rapid progress of stone architecture, which soon developed its own forms independent of prototypes in other materials. Djoser's Step Pyramid was the earliest example of an original architectural form in stone. It was created by a gradual enlargement in size as well as height of a tomb on a rectangular plan.

Jar with a cord net pattern, from the Step Pyramid of King Djoser at Saqqara

Perhaps *c.*2610 BC. Travertine
(alabaster), h. 63.5 cm, 25 in.
Egyptian Museum, Cairo

The appearance of the skills
required in monumental stone
building some time after 2630 BC
seems to have been so sudden as
to defy explanation. But Egyptian
craftsmen were familiar with
different types of stone and were
already able to work in it with
accuracy and sensitivity at the end
of the Predynastic period, and
certainly at the beginning of the
pharaonic era. There was also a
good deal of experience in building
site management as the result of
the construction of huge brick-built
tombs, and some knowledge of the
quarrying and transport of stone. All
these skills were brought together
and magnified many times during
the construction of the first step
pyramid under King Djoser (40–1)
and in the increased production of
statues (43) and reliefs carved in
stone which followed. This stone
jar was found in the rock-cut
galleries under the Step Pyramid of
Djoser at Saqqara but its date may
be anything between about 3000
and 2610 BC. The transport of
heavy vessels and their contents,
whether made of pottery or other
material, was facilitated by means
of a cord net (this may have also
reduced the possibility of an
accidental breakage). This vessel
imitates such an arrangement,
with the rope faithfully reproduced
in stone.

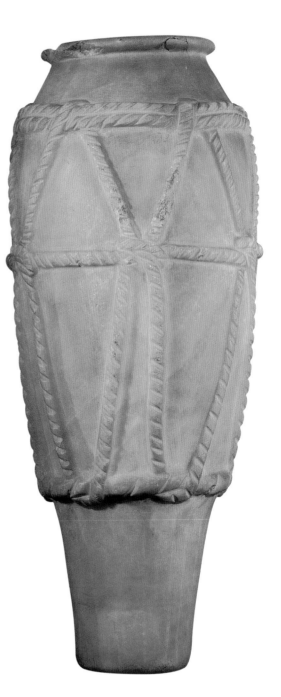

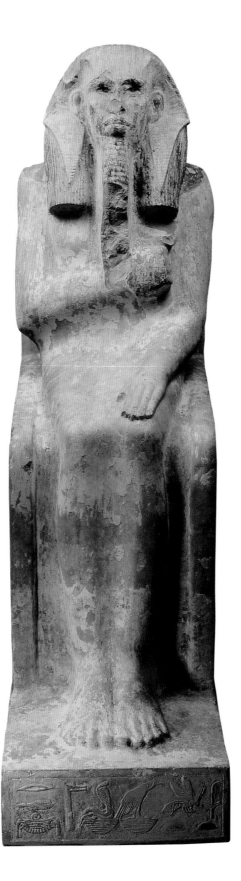

King Djoser, from his Step Pyramid at Saqqara

*c.*2610 BC. Limestone, h.142 cm, 55 in.
Egyptian Museum, Cairo

A closed and inaccessible room (called *serdab*, from Arabic for 'cellar') in the temple next to the Step Pyramid at Saqqara contained a life-size statue of King Djoser. The king is seated, wearing a royal *nemes* headcloth, a heavy wig and a ceremonial beard, and is enveloped in a festival cloak. This is the earliest royal statue found in a funerary context. Egyptian views on the spiritual and material aspects of human existence, and on life and death, were reassuring. Everybody had a spiritual element, called *ba*, sometimes translated as 'soul' but perhaps better as 'personality' (see also 277). A material manifestation, a visible form, was needed in order 'to exist on earth', as the Egyptians would have put it, and this was during life provided by one's body. If certain conditions were fulfilled, then death was but a transition from one form of existence to another, from this world to the afterlife. The soul continued to exist but the need for a physical manifestation applied even after death. Strenuous attempts were, therefore, made to preserve the body but other solutions were possible: the physical form could also be provided by a statue. These were the origins of Egyptian tomb sculpture and the explanation of Djoser's statue in a sealed room.

Hesyre as a scribe, panel from his tomb at Saqqara

*c.*2610 BC. Raised relief in wood,
114 x 40 cm, 44 x 15¾ in.
Egyptian Museum, Cairo

In pharaonic times, relief was
mostly used on tomb and temple
walls and on stelae (gravestones).
It was, therefore, predominantly
carved in stone. There were few
opportunities for working in wood.
The chief royal scribe Hesyre lived
under King Djoser and his tomb
chapel incorporated a series of
wooden panels placed in niches.
The soft material encouraged the
artist to excel in the modelling
of facial features and the body.
Hesyre's eyes are of the typical
pharaonic stylized shape, far
removed from the symmetrically
shaped eyes of King Khasekhem
(39) only one or two generations
earlier. His large and bony nose is
delicately modelled, with a clearly
defined nostril, and there is a hint
of a nasolabial fold running from the
side of the nose to the corner of
the mouth. The eyebrow, indicated
by a raised band, is stylized; the
trim moustache is marked in a
similar way. The collar-bone is
shown prominently. The legs
display the heaviness which
characterizes so many pharaonic
representations (see 94). The feet
are, intentionally, shown as though
they were two left feet, in order
to be able to show both big toes.
These panels must have been
carved by the best artists of their
time and they rival in quality reliefs
made for the king himself.

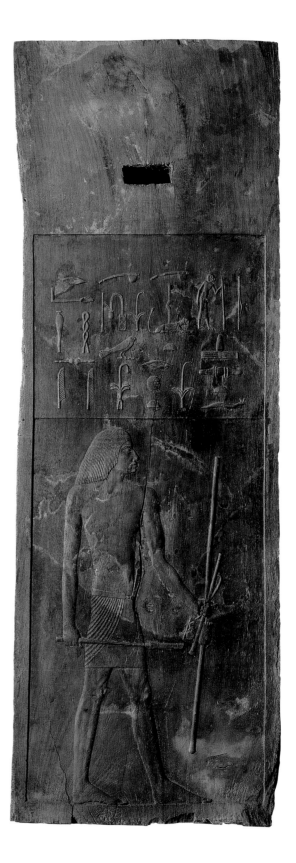

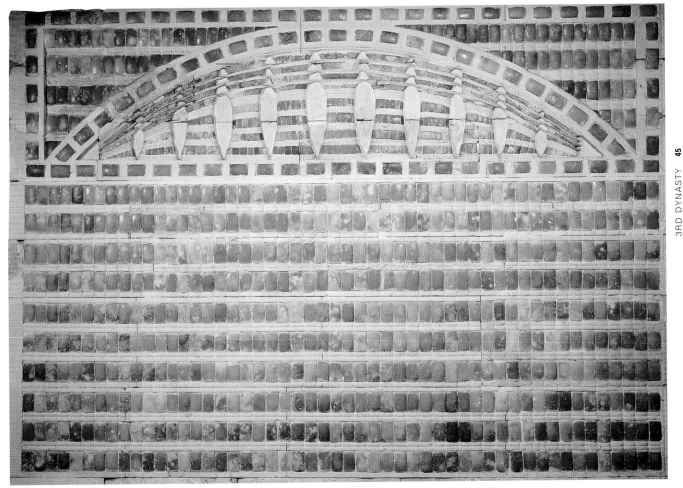

Faience panel,
from the Step Pyramid of
King Djoser at Saqqara

c.2610 BC. Faience,
181 x 203 cm, 71¼ x 79 in.
Egyptian Museum, Cairo

Some of the walls in the
subterranean rooms of the Step
Pyramid of King Djoser are
covered with faience (see 127)

tiles. The tiles are slightly convex
on the outside and measure about
5.8 x 3.6 cm (2¼ x 1½ in). They
form patterns which imitate walls
and partitions made of reeds
tightly bound with cords. Some of
the tiles are arranged in straight
horizontal rows separated by
narrow ledges cut into the
limestone background. They are
also used in arches and linings of
niches which are probably to be

understood as doors. These are
replicas of the walls of shrines and
kiosks which provided the setting
for the celebration of the king's
jubilee festival (see 41). Here,
they were to perform the same
function in the king's afterlife. The
back of each tile has a projection
which was set in plaster in
emplacements cut into the wall.
Groups of tiles were joined by a
thread probably made of papyrus

but this was just a temporary
measure while the plaster set.
The bluish green colour of the
faience was probably thought
particularly appropriate because
of its similarity to the material
which the tiles imitate.

Prince Rahotep and his wife Nofret, from their tomb at Maidum

*c.*2550 BC. Painted limestone,
h. 121 and 122 cm, 47 and 48 in.
Egyptian Museum, Cairo

The special interest of the seated statues of Rahotep and his wife Nofret lies in the almost perfect preservation of their original colouring. Practically all Old Kingdom statues were painted, although their colours (black/grey, white, red/brown, green, blue and yellow) sometimes seem to us to be rather harsh; there was rarely any shading or great subtlety. The application of colour did not take into account the material of the sculpture, and even statues in beautifully textured and naturally coloured hard stones were painted. This was a pharaonic convention which may not have existed in earlier times (25). It was only towards the end of the pharaonic period and under the Ptolemies that natural characteristics of the material, such as veining, were allowed to show through. Our perception of Egyptian sculpture is based on the experience of colourless statues which have lost their original tones and so is a biased view. The colour conventions of statues were the same as those of reliefs and paintings, with the bodies of men reddish brown, as befitted people exposed to the sunlight for much of the day, and those of women yellowish, the colour of the complexion of people spending most of their time indoors or with their skin shielded from the sun.

A sower,
from the tomb chapel of the
woman Itet at Maidum

*c.*2550 BC. Wall painting on plaster, 41 x 91 cm, 16 x 35 in. Manchester Museum

Before the very fine decoration in the tomb chapel of Itet, the wife of Prince Nefermaet at Maidum, was painted (see also 49–51), the brick-built wall received two coats of mud plaster, the first rather coarse, the second finer. The paint was made from naturally occurring pigments (gypsum for white, carbon for black, ochres for red, brown and yellow; green may be crushed malachite unless it is an artificial pigment made from ground frit) mixed with water and a binding agent, such as egg white. Other colours are overlays: brown is red over black, and orange is red over yellow. This fragment comes from a scene of sowing and ploughing. The sower scatters the seed which he carries in a small bag around his neck; in his other hand he holds a whip. Behind him, there are two oxen pulling a plough with which the soil is turned over to cover the seed. The full palette of colours known from the Old Kingdom is present: the background colour for these scenes is bluish grey, the sower's body brown-red, his cropped hair black, and the floral fillet and lotus flowers suspended from a ribbon around his neck green, his basket with seeds yellow and his whip white. The hide of one of the oxen is dark brown, almost black, that of the other animal is light brown.

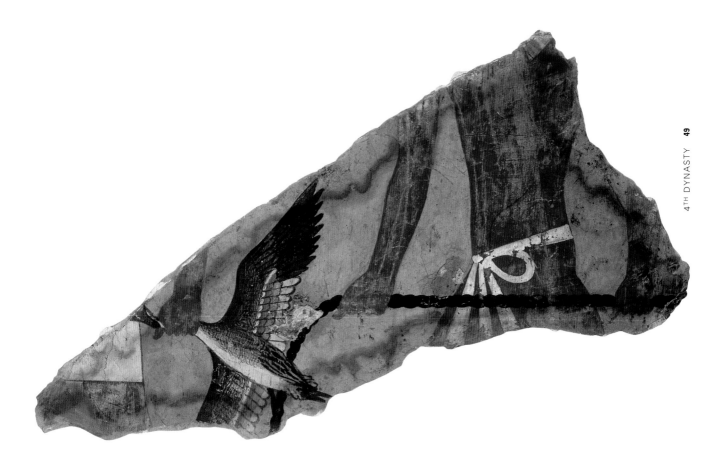

The hand of a man holding a duck, and the torso of another man trapping wild fowl, from the tomb chapel of the woman Itet at Maidum

*c.*2550 BC. Wall painting on plaster, l. 59cm, 23 ¼ in. British Museum, London

The famous 'Geese of Maidum' (see 50–1) belonged to a much larger composition, now surviving only in fragments. Its main element was a group of three men holding a rope with which they closed a clap net as soon as wild birds had been enticed to settle in it. They were preceded by another man holding a duck in each hand. The captured duck on a fragment in the British Museum is such an astonishingly accomplished piece of painting that it is hard to believe that less than a century separates it from the beginning of the Old Kingdom and the earliest examples of painted tomb decoration. When compared with the best Old Kingdom reliefs cut into stone, these paintings display a much wider and more subtle range of colours and a greater finesse of detail. But shortly after the decoration of the tomb of Prince Nefermaet and his wife Itet had been completed, painting was relegated to a distant second place by the enormous rise in popularity of painted reliefs. Perhaps our judgement is too modern and our surprise at this development does not sufficiently take into account the importance of durability in the creation of these masterpieces.

**Geese,
from the tomb chapel of the
woman Itet at Maidum**

*c.*2550 BC. Wall painting on plaster,
27 x 172 cm, 10 x 67³⁄₄ in.
Egyptian Museum, Cairo

After about 2610 BC stone
became the first choice among
building materials for royal
monuments meant to last for
eternity. But the construction of
tombs in unbaked bricks did not
disappear. The cores of many non-
royal mastabas (the term comes
from modern Arabic for 'bench')
continued to be built of bricks.
Extensive wall relief carved in
stone appeared only when large
areas of tomb chapels began to be
lined with slabs of stone. Before
that, mud-plastered walls in parts
of tomb chapels were decorated
with exquisite painted scenes.
Their complexity and sophistication
of design suggest that reliefs
carved in stone and painted may
have inherited a great deal from
earlier painted tomb decoration.
This, in its turn, may have imitated
paintings in contemporary royal
palaces and perhaps even houses.
This is one explanation of how
scenes of daily life which are only
indirectly connected with tomb
provisioning came to be included
in tomb repertoire, but there are
others (see 78). This painting once
formed a small sub-register in a
large scene of men netting birds
(see 49).

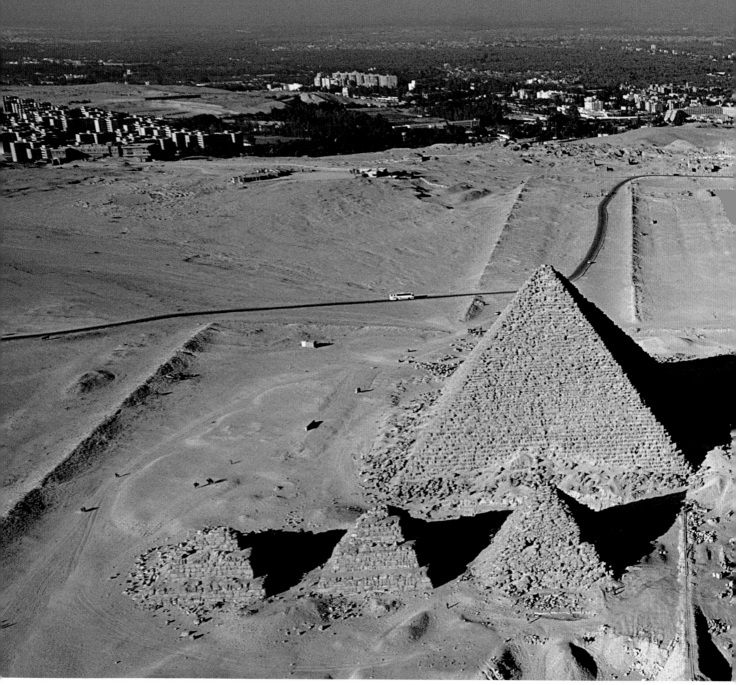

The three pyramids of Kings Khufu, Khephren and Menkaure at Giza

c.2530-2460 BC. Limestone and granite, with other materials in the adjacent temples, original h. 146, 143.5 and 65.5 m, 479, 471 and 215 ft

Egyptian pyramids (see also 58) are still popularly perceived as embodying arcane knowledge and containing mysterious properties. The mutual relationship on the ground between the three Giza pyramids is unequivocal and can be expressed in mathematical terms. It could not have appeared accidentally. This, however, raises the question of whether it was foreseen from the outset so that the later kings followed a predefined pattern (e.g. a reflection of the positions of stars in the sky) and whether such a concept was known. Egyptian understanding of history was different from ours. Each reign was seen as self-contained, a 'complete' history in its own right. The king's coronation brought an end to a fictitious period of chaos, and his death represented a descent into another period of uncertainty. The new king often contributed to the buildings of his predecessors or restructured existing temples, but there is no evidence of planning beyond his own death and so beyond the end of 'history'. It seems most likely that the relationship between the Giza pyramids is due to the surveying techniques used in their planning, but was not in itself meant to be significant.

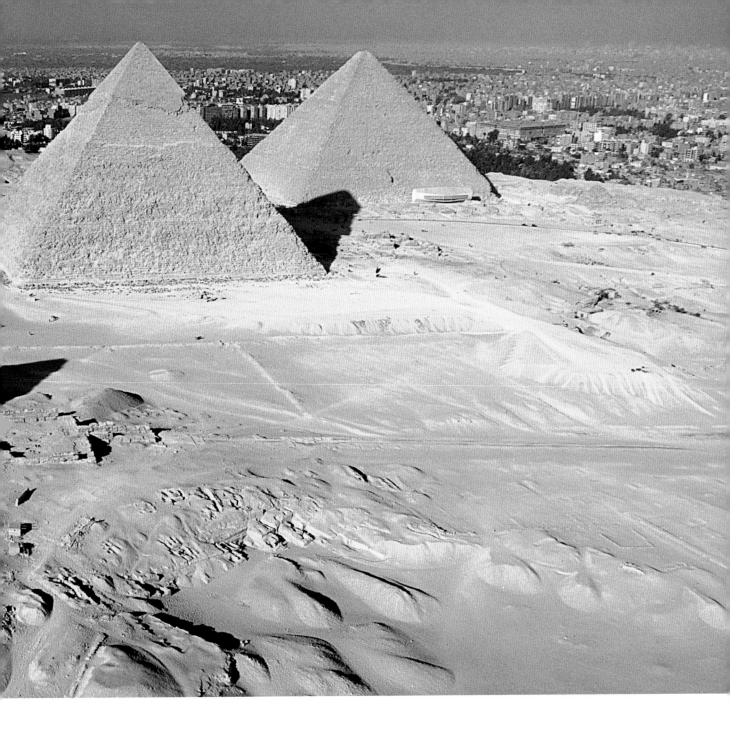

Bracelets of Queen Hetepheres, from a cache at Giza

*c.*2530 BC. Silver, turquoise, jasper, carnelian, lapis lazuli, w. 8 cm, 3 in. Egyptian Museum, Cairo

A cache of funerary equipment of King Khufu's mother, Hetepheres, was found close to her son's pyramid at Giza. We may not yet fully understand the circumstances which prompted the creation of this deposit – if it is a tomb, then the most important item, the Queen's mummy, is not present. But there is no doubt that most of the objects in the cache were used by the Queen in her lifetime, especially furniture and jewellery. A wooden box covered with gold foil contained twenty silver bracelets (bangles) in the form of rings without any special means of fastening. This was very valuable jewellery: silver was rare in Egypt because much of it had to be imported (see also 272–3). This accounts for the fact that although the bracelets appear deceptively solid and heavy, they are made of only sheet silver. On the outside, they are decorated with a quadruple butterfly design made up of inlays of semiprecious stones set into depressions in the metal. The butterflies are seen from above, a characteristic way of representing some small creatures and insects in Egyptian art. On the inside, the bracelets are hollow.

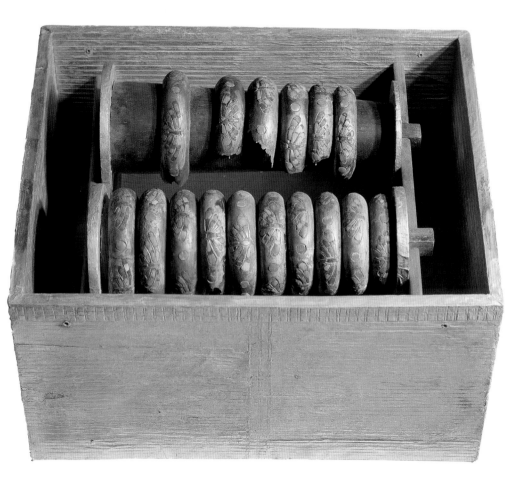

Armchair of Queen Hetepheres, from a cache at Giza

*c.*2530 BC. Restored, wood, gold, copper, h. 79.5 cm, 31 in. Egyptian Museum, Cairo

The remains of furniture, especially beds, are frequent in tombs of the Early Dynastic period. There are many examples of furniture represented in Old Kingdom tombs but finds are less common. The cache of Queen Hetepheres at Giza is a happy exception. It contained the remains of two armchairs (see also 207), a bed with its canopy, a palanquin, and several chests and boxes (see also 204). One of the armchairs has been restored. The space below the arms is filled by an openwork design of three tightly bound papyrus flowers, while its legs imitate the front and rear paws of a lion placed on drums protected by copper shoes. All parts of the chair were carved in wood and, apart from its back and seat, are covered with gold casing. The back is of plain wood, as is the seat which probably was provided with a cushion. The armchair's frame is mitred; the techniques employed in its manufacture include dowels, mortise and tenon and leather thongs. The gold casing is ribbed or patterned in places. The understated design of this piece is emphasized beautifully by its gold decoration. Together they make it one of the supreme examples of the taste for luxury during the Old Kingdom.

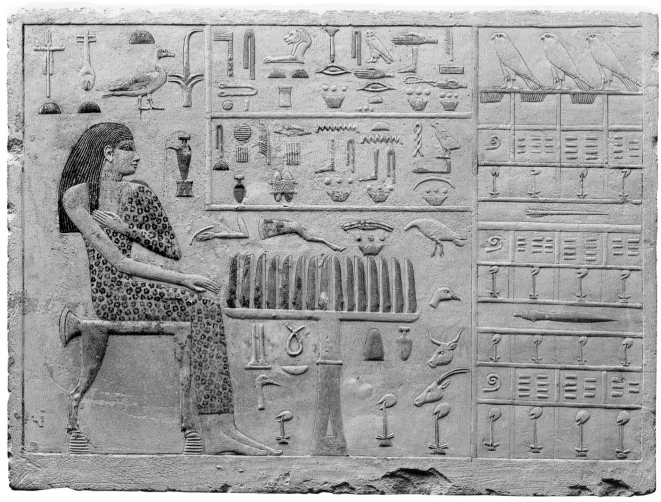

Princess Nefertiabet at table, from her tomb at Giza

*c.*2530 BC. Raised relief in limestone, h. 38 cm, 15 in. Louvre, Paris

Most of the monuments made for temples and tombs were of well-established patterns. The stability of ancient Egyptian society and the fact that all artists belonged to tightly controlled workshops ensured that any changes were only gradual. But occasionally a new type was introduced or a style changed as the result of political decisions or religious developments. The large stone tombs built by King Khufu around his pyramid as part of an overall plan for his pyramid complex contain several new monuments. Among these there are rectangular stone slabs which show the tomb owner seated at a table with lists of offerings among which linen and various types of grain feature very prominently. This motif is the essential element of any tomb decoration (see also 78) and an attempt may have been made here to combine the decoration of the stela and the tomb walls. We do not know who introduced these completely new types of funerary monuments, but it is unlikely that it was the decision of the artists. The authority of the King himself may have been required. These reliefs are known only from the reign of Khufu and perhaps one or two of his successors.

Soneb and his family, from their tomb at Giza

*c.*2520 BC. Limestone,
h. 33 cm, 13 in.
Egyptian Museum, Cairo

The group of the dwarf Soneb and his family illustrates the artists' inventiveness and skill in portraying unusual subjects. Most statues followed well-established patterns but sculptors were able to improvise when faced by new and unusual problems. In this case, the man in the family suffered from a severe physical deformity although this did not prevent him from becoming wealthy and influential at the royal court. He had a large head, a stocky body and short arms and legs. The sculptor came up with an ingenious variation of a family group statue. He placed the figures of the couple's two small children in front of (rather than next to) the seated dwarf, in the space where one would expect the legs of a seated person. Soneb is shown seated on top of the seat in a pose similar to that of scribes (see 70 and 290), with his hands clasped on his chest. His wife places her left hand on her husband's arm while she embraces him with her right arm. The ingenious composition restored the balance of the statue and at the same time provided a charming demonstration of family affection.

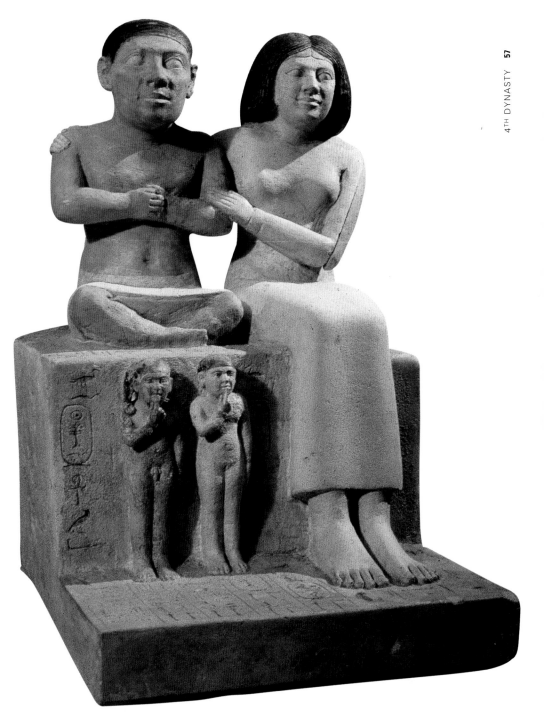

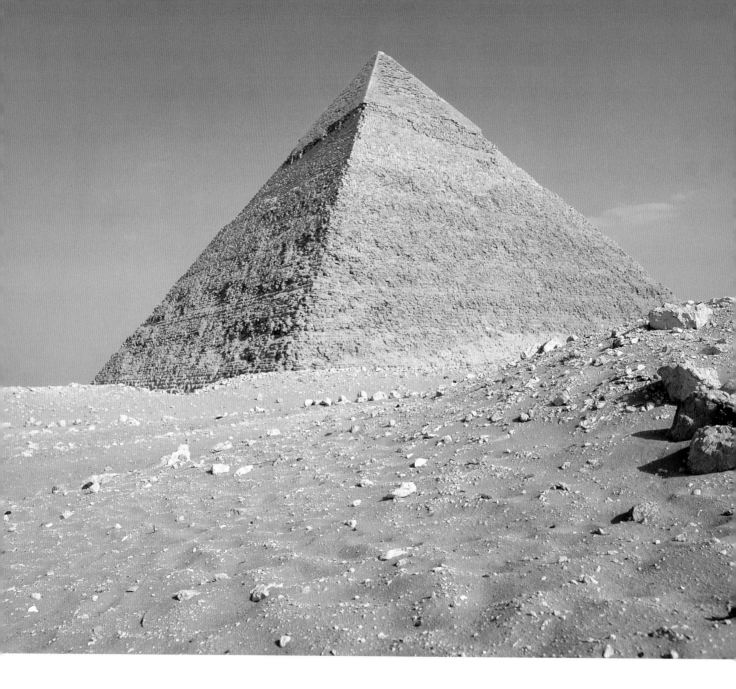

The pyramid of King Khephren at Giza

c.2500 BC. Limestone, with other
materials in the adjacent temples,
original h. 143.5 m, 471 ft

No geometrical form is more
closely connected in our
consciousness with Egypt than
the pyramid (see also 52–3). Its
simplicity, the square plan and four
inclined faces meeting at the
summit, is immensely pleasing
when reproduced on a huge scale.
But the form was arrived at
through a combination of practical
considerations and religious ideas
rather than through aesthetic
feelings. A pyramid was a much
safer structure to build than one
with vertical sides: with a sensibly
chosen incline of the pyramid's
sides its height was limited only
by the builders' ability to handle a
huge volume of material. The form
may have also been influenced by
the shape of the benben stone
which was sacred to the sun god
at Heliopolis (the north-eastern
part of modern Cairo). This was a
pyramid-shaped meteorite and its
shape may have been imitated
by royal pyramids when the
cult of the sun god was in the
ascendance in Egypt some time
after 2600 BC. The same religious
ideas affected the whole pyramid
complex by stressing its east–west
axis and so the regions of the
rising and setting sun.

King Khephren protected by a hawk, from his valley temple at Giza

*c.*2500 BC. Gneiss diorite,
h.168 cm, 66 in.
Egyptian Museum, Cairo

This statue is possibly the finest sculpture ever made in Egypt. It is aesthetically a masterpiece, but its original importance lay in the religious ideas which it conveyed and preserved. It demonstrates the ingenuity with which the Egyptian artist was able to express and combine different religious concepts. One of the forms in which the god Horus manifested himself was a hawk (see 89); another of his manifestations was the king himself who was therefore a living god Horus for his subjects (see also 36). The fierce bird of prey is perching on the back of the king's seat and facing the same way as the king, so that we may think we see the same deity in a kind of double vision, in two different manifestations. But the hawk's outstretched wings cradle the king's head on either side, a gesture which in Egyptian art was connected with the concept of divine protection. The statue can therefore also be seen as contrasting, and at the same time uniting, the humanity of the king and the divinity of the god.

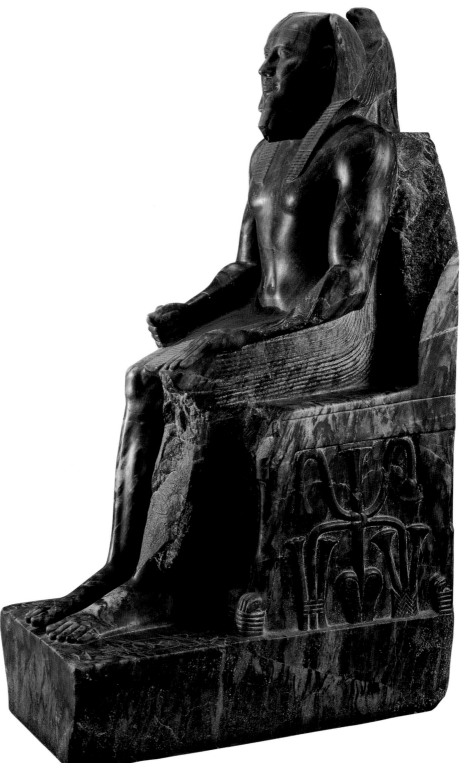

The Great Sphinx of
King Khephren at Giza

*c.*2500 BC. Carved in limestone rock,
h. 20 m, 66 ft

The Great Sphinx is the largest
stone statue ever made in Egypt.
A zoomorphic deity could be
represented either in a fully animal
form or with a human body and a
creature's head. The latter was the
preferred form in pharaonic art
but it was a purely artistic device;
there was no religious distinction
between the two. The concept of
a sphinx, a beast with the body of
a lion and a human head, is the
exact opposite of it. Only the head
distinguished statues of different
kings from one another (see 67),
and so when the pharaoh wished to
be shown as a manifestation of a
zoomorphic deity, it was necessary
to combine his head with the body
of the appropriate animal to achieve
this aim unambiguously. Statues of
lions are known from the beginning
of pharaonic history but sphinxes
did not appear before the reign
of Radjedef. It is, therefore,
remarkable to see the confidence
with which the Great Sphinx at Giza
was carved only a generation later.
The lion god may have been Ruty,
one of the guardians at the gates
of the underworld.

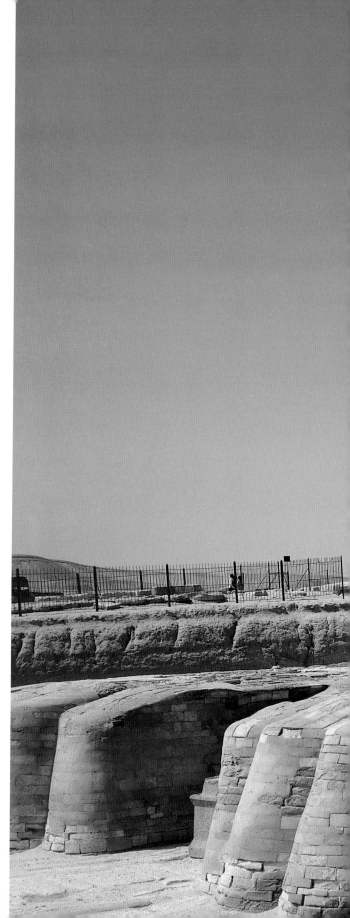

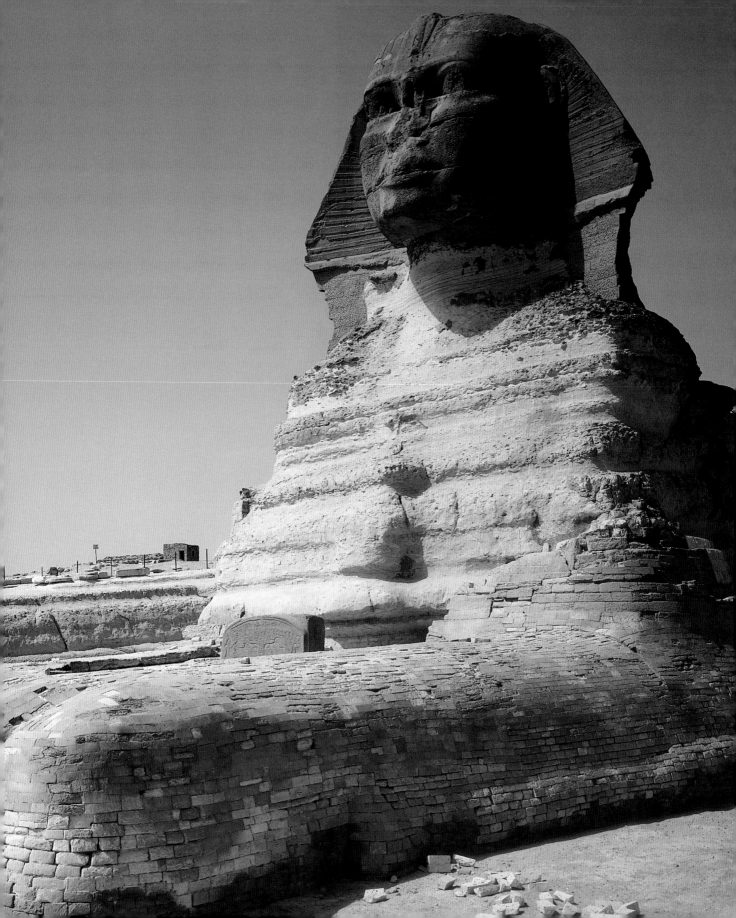

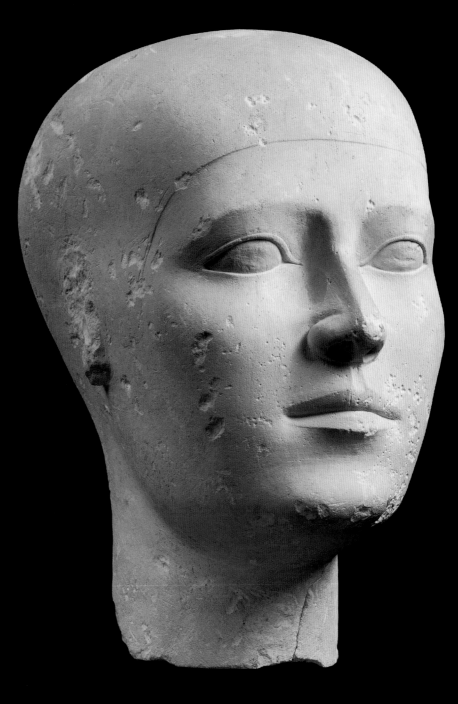

Female reserve head, from a tomb at Giza

*c.*2500 BC. Limestone, h. 27.7 cm, 10 in. Kunsthistorisches Museum, Ägyptisch-Orientalische Sammlung, Vienna

The beautifully carved life-size heads which are known from the 4th dynasty appear to break one of the cardinal conventions of Egyptian art, that of the need for completeness. Egyptian artists resorted to all kinds of ingenious solutions in order to show human figures in their entirety. But there were good reasons why the rules did not apply to these heads. Statues placed in tombs were meant to provide a secondary abode for the person's *ba* ('personality') in case the body perished. But efforts to preserve the body were not abandoned altogether and various methods, such as bandaging strengthened by plaster and, ultimately, mummification were tried. The head, or more precisely the face, is the most recognizable feature of a person and the purpose of such a head, placed next to the body, was to provide a substitute for the real thing. The ideas underlying their making were, therefore, different from those behind statues. These 'reserve' heads are admirable works of art. Most of them were made for the royal family by artists who seem to have tried to produce true portraits. But their carving remained confined to the reign of King Khufu and his immediate successors (see also 56).

Baker making cakes, probably from Saqqara

*c.*2460 BC. Limestone,
h. 19.7 cm, 7¾ in.
Louvre, Paris

A new type of sculpture appeared in tombs some time after 2500 BC. These are the so-called servant statuettes which show people engaged in various domestic activities, especially those connected with the preparation of food: grinding grain, straining beer, cleaning beer jars, kneading dough, shaping cakes, heating bread moulds on a fire, slaughtering an ox. These small statuettes perform the same tasks as people represented on tomb walls. Later, in a development similar to that observed in reliefs (see 78), the range of activities expands and may include craftsmen, musicians, women nursing babies and children at play. These statuettes, it seems, were at first made of stone but from about 2300 BC there is a marked increase in the number made of wood (see also 108). This small sculpture represents a kneeling man shaping cakes. The man's head is much too large yet his body is carved with competence. As in the case of many of these statuettes, the baker's facial expression is undeniably rustic and contrasts strongly with the faces of people in tomb statues proper. It is difficult to escape the suspicion that this was done on purpose, and if so, we must credit the sculptor who carved this piece with greater ability than we would otherwise be inclined to do.

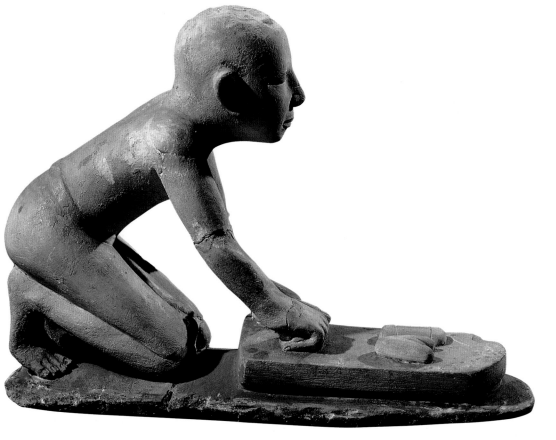

King Menkaure and his queen, from the valley temple of his pyramid at Giza

*c.*2460 BC. Greywacke,
h.139 cm, 54³⁄₄ in.
Museum of Fine Arts, Boston

Statues of a husband and wife are not unusual in Egyptian sculpture. The earliest known example in royal sculpture is that of King Radjedef where a queen is kneeling on the ground next to his legs and is very obviously a minor figure in the composition. But in Menkaure's statue, only two generations later, the king and his queen are treated as equals. The woman, possibly Menkaure's wife Khamerernebty, is only marginally smaller than the king, and was carved with the same care. The king enjoyed a unique position between the gods and humans, but a queen was not endowed with any divine characteristics. The apparent equality which this statue displays has prompted suggestions that the figure might be a goddess, perhaps Hathor (see 65). The queen is not identified by an inscription and there may have been special reasons, of which we are unaware, for portraying her as the king's equal. The king wears the characteristic royal headcloth, a ceremonial beard, and a short kilt (*shendjut*) The statue, originally painted, was soon imitated in non-royal sculptures.

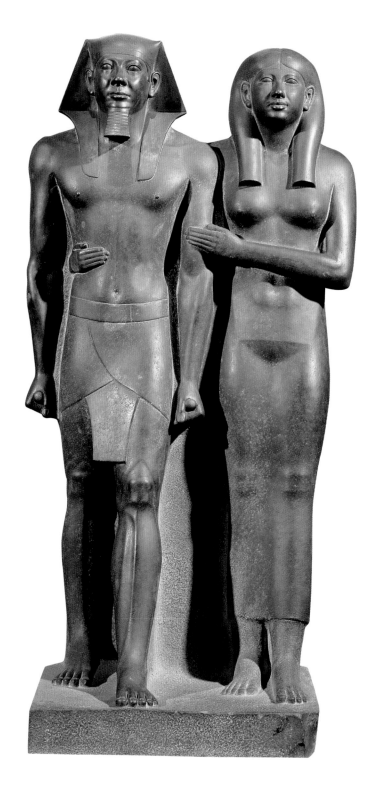

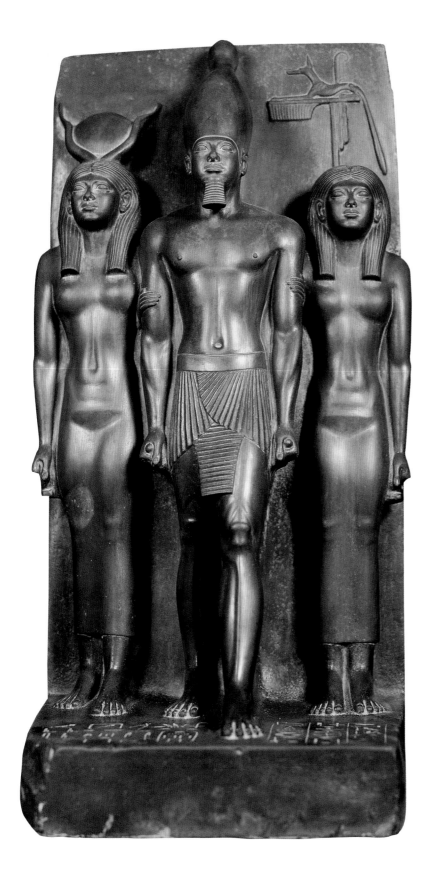

King Menkaure, the goddess Hathor and the personification of the Jackal district, from the valley temple of his pyramid at Giza

*c.*2460 BC. Greywacke,
h.92.5 cm, 36 in.
Egyptian Museum, Cairo

King Menkaure's triads (groups of three figures) are aesthetically very pleasing but they also carry a multi-level ideological message. The king who is the central figure in this triad is embraced by the goddess Hathor (see also 220) on his right and the personification of the Jackal district (present Asyut) on his left. The goddess Hathor was one of the main deities of the area round the temple in which this sculpture was found. Her connection with it was especially close because many of the offerings required in the funerary cult came from her farms, some in other parts of the country, and one or more of them in the Jackal district. The triad, therefore, represented an artistic record of the temple's entitlement to provisions from the district's estate. Like a legal document written on papyrus, it guaranteed offerings for the mortuary cult in Menkaure's pyramid in perpetuity. In this sense, it was strictly functional. At the same time, it established a permanent relationship between Menkaure and the goddess Hathor.

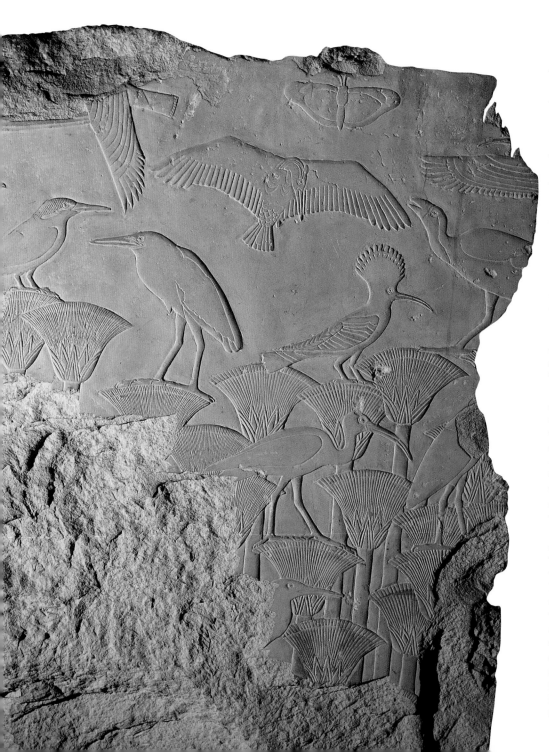

Birds in a papyrus thicket, from the pyramid temple of King Userkaf at Saqqara

*c.*2450 BC. Raised relief in limestone, 102 x 77.5 cm, 40 x 30½ in. Egyptian Museum, Cairo

Representations carved in relief are usually discussed in the same breath as drawings and paintings, as though they were two-dimensional, but this can be misleading. In this relief, the artist carved away the background of the representations, which were left projecting slightly above the surface surrounding them. Apart from delineating the representations more permanently and vastly increasing their durability, the third dimension also introduced greater contrast between light and shadow. This technique is called raised relief. When, as in this case, the difference between the two surfaces is only a few millimetres, we talk about low raised relief, or low relief (bas-relief) for short (see also 72–8, 80, 82, 84–5). When the representations project more we use the term high raised relief, also just high or bold relief (this terminology differs from that used by art historians elsewhere). As a very general rule of thumb, for most of the Old Kingdom the height of relief continued to increase, from very low during the reign of King Khufu to bold during that of Pepy II. Userkaf's relief has now lost almost all of the paint which completely covered it, so we can only try to visualize its original appearance in which green papyrus plants and bright multicoloured birds were set off against the grey background.

5TH DYNASTY

King Userkaf, from his sun temple at Abusir

*c.*2450 BC. Greywacke,
h. 45 cm, 17³₄ in.
Egyptian Museum, Cairo

Royal statues display characteristics which make it possible to assign even those which are not identified by name to a specific pharaoh. The similarities are, however, confined to the head, or more specifically, to the face of the king (see also 61). It is extremely difficult, and in many cases impossible, to identify an uninscribed headless statue. This head was found in Userkaf's sun temple and its identification was temporarily disputed, but it shares some of its features with the colossal head from Userkaf's pyramid temple about which there can be no doubt: the rounded face with chubby cheeks and marked nasolabial folds, the heavy eyebrows, the fleshy and slightly bulbous nose, and the straight lips. Such a uniformity of portrayal must have been ensured by centrally promulgated instructions, but how this was really done is not clear. And were the statues real portraits, reflecting accurately the king's physiognomy, or just an agreed way of representing him? We do not know for certain. It is unlikely that royal images would have been entirely unconnected with the king's appearance, but some discreet 'editing' may have taken place (see also 113 and 119).

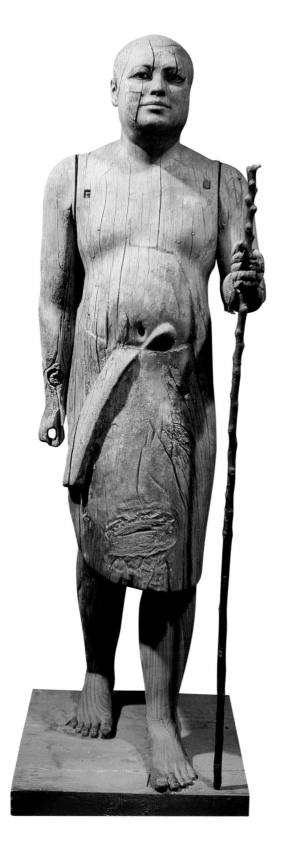

Kaaper as a corpulent middle-aged man, from his tomb at Saqqara

*c.*2450 BC. Wood, h. 110 cm, 43¼ in. Egyptian Museum, Cairo

Some large wooden statues were made in several parts. This statue is formed of at least six sections: the head and the trunk, the bent left arm in two parts, the right arm, and the legs (and probably also the base, now missing). There is no way of knowing whether it was intended to be a portrait of a real person; on the whole, this seems unlikely (see also 70). Examples can be quoted where statues display facial features similar to representations of the same person carved in relief, but it is possible that both the sculptor and the maker of the relief simply adopted the same facial type. Such exceptions are in any case confined to products of royal workshops and may be personal styles adopted by individual master sculptors. The corpulence of this statue was probably intended as a general indication of dignity and prosperity, rather than as representing an actual characteristic of a living person. This wooden statue was made by an extremely competent sculptor but probably not one whose clientele belonged to the highest ranks of Egyptian society. The man was identified by an inscription on the now lost base. We know that he was a priest called Kaaper, but the sculpture is now known by the name given to it by workmen who discovered it and whom it reminded of their village chief, 'Sheikh el-Balad'.

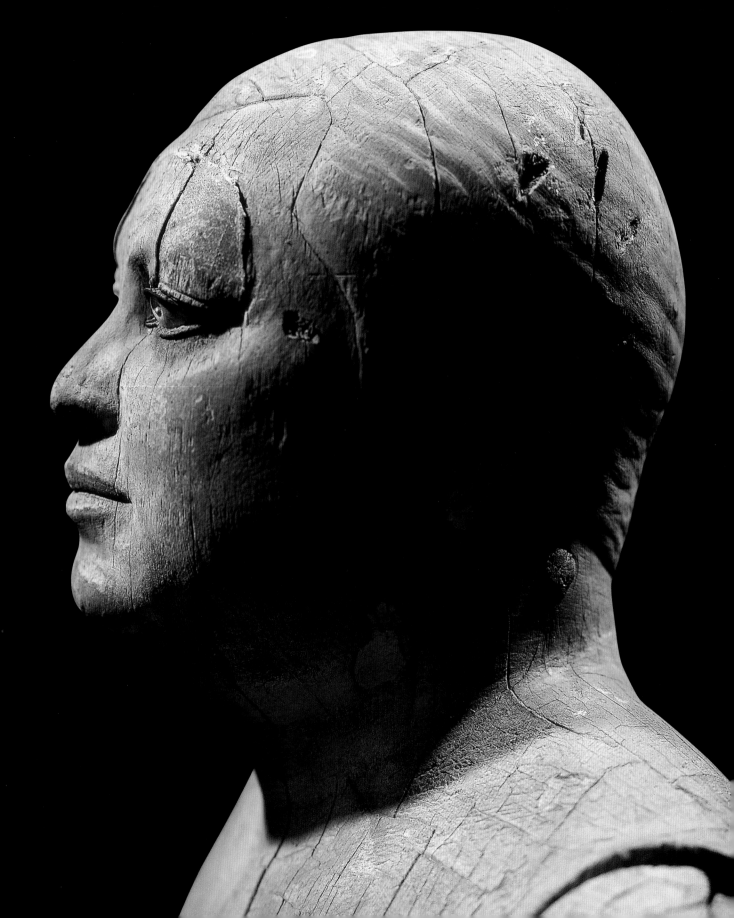

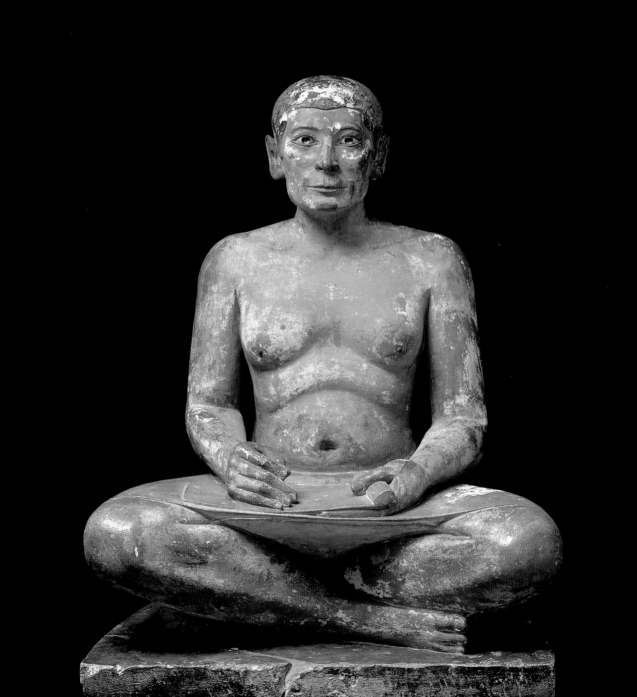

Kai as a scribe, from his tomb at Saqqara

*c.*2450 BC. Limestone and other
materials, h. 53.7 cm, 21 in.
Louvre, Paris

Several types of tomb statues were
known during the Old Kingdom.
The most popular were seated and
standing statues (see 47 and 68).
The third type, and one of which
there is no example among
sculptures of kings, was the scribe
statue. The man (there were no
female scribe statues) is seated on
the ground with his legs crossed
and holds a roll of papyrus on
which he is writing, or from which
he is reading. Different sculptural
types expressed different notions
of the man they portrayed. The
ability to read and write was a
precondition for an administrative
office, and even the highest
officials and royal princes were not
averse to being shown as scribes.
The face of 'The Louvre Scribe',
as this statue is known, conveys
intelligence and concentration,
which creates an impression of
individuality. His eyes are of
travertine (alabaster), rock crystal
and magnesite set in copper, and
his nipples are of wood. The
scribe's arms are, unusually, shown
as freed from the body. However
instinctively we may feel it, we
cannot be sure that this is a portrait
of a real person. While there is no
final evidence either way, it is likely
that this is just an outstanding
example of a sculptural type.

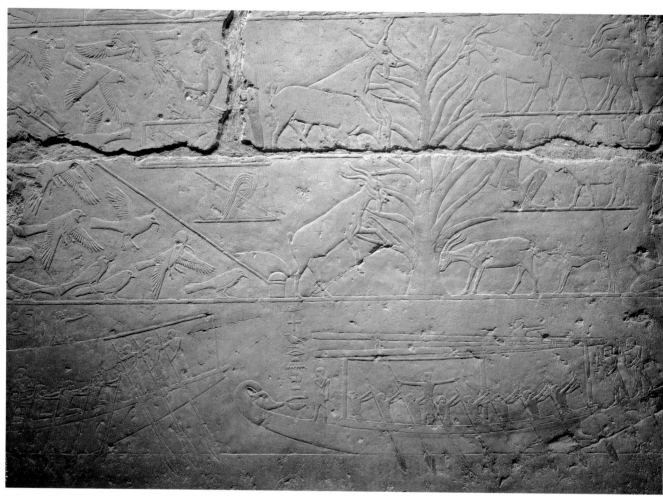

Browsing goats, and boats, from the tomb of the priest of the god Khnum, Akhtihotep, at Saqqara

c.2410 BC. Raised relief in limestone. Louvre, Paris

The depiction of a herd of goats browsing on the branches of a tree in the tomb chapel of Akhtihotep is one of the most successful attempts to overcome the straitjacket of registers (see 29). Rather than being rigid divisions of the wall into strips of uniform width, they have been reduced to mere base lines interrupted by the tree. The different levels at which the goats are placed produces an unbalanced composition, but this is exactly what the artist tried to achieve in order to capture the disorderly scramble of the animals after the tastiest branches. The animals are shown in what was regarded as their most characteristic view, almost always a profile. The only exceptions to this rule were some small creatures such as lizards, turtles, beetles and butterflies which were shown as if viewed from above (these do not appear on this relief). The horns of two of the goats are shown in front view, a method almost always used for cattle. The rules concerning the position of the animals' legs are the same as for people (left leg forward when facing right and vice versa). Below the scene with goats there are representations of boats with hedgehog prows (the hedgehog is, allegedly, very sensitive to the changes in wind).

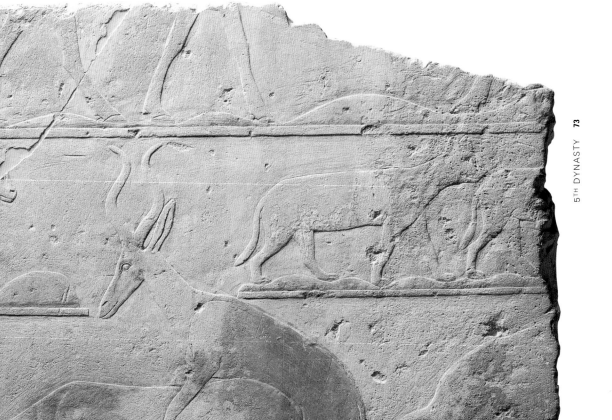

Desert animals, from the tomb of Pehenuka the vizier at Saqqara

*c.*2400 BC. Raised relief in limestone, 28.5 x 43 cm, 11¼ x 17 in. Brooklyn Museum of Art, New York

Scenes of a hunt in the semi-arid desert margins occur only sporadically in Old Kingdom tombs (see also 82). Artistically, they presented special problems. Many of the animals are small and so the registers are of a reduced height, or are divided into sub-registers. In order to indicate the uneven surface of the desert the artist often introduced a secondary undulating base line over the straight register line and placed many of the animals and vegetation on it. In the bottom register of the relief illustrated here, we can see copulating antelopes and another giving birth. There are conspicuous similarities between these scenes and the portrayal of Egyptian countryside in the so-called Room of the Seasons in the sun temple built by King Neuserre. There, the aim was to record the beneficial influence of the sun god. It is possible that similar ideas prompted the inclusion of these scenes in tombs. It is almost certain that such depictions of the desert and animals living there owed much to the decoration of sun temples.

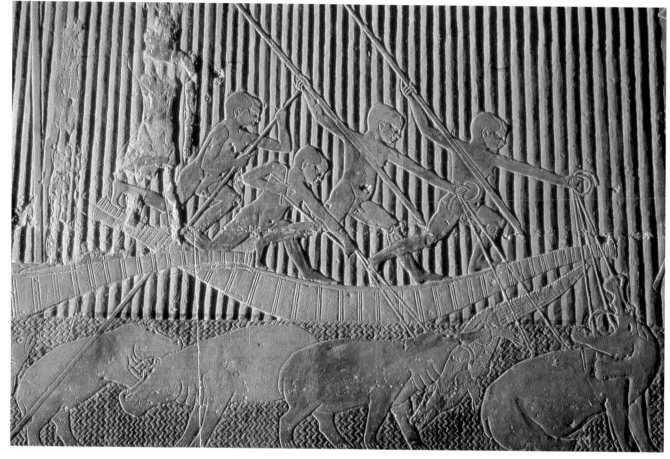

Hippopotamus hunt, in the tomb of the chief hairdresser Ty at Saqqara

*c.*2400 BC. Raised relief in limestone

In most tombs, the standard of the initial design of scenes was superior to that of the carving and colouring. Large blank areas were regarded as unsightly and avoided, and so could not be used to emphasize the importance of certain scenes. Other artistic means, some of them astonishingly 'modern', had therefore to be used to focus the viewer's attention on the main elements of the decoration. The hippopotamus hunt by men in a small papyrus boat in the tomb of Ty takes place in a dense marsh. It is shown against the background of tall and uniformly vertical papyrus stalks. The water is full of hippopotami: two of them are fighting while another is killing a crocodile. Although the scene of the hunt is relatively small, our attention is immediately directed towards the harpooned hippo by the hypothetical lines, originally probably actually sketched on the wall but removed in the subsequent processes of carving and painting. Our eye follows the direction in which the long harpoons held by two of the men are about to be launched. The taut ropes attached to barbs already lodged in the body of the hapless victim also focus our attention unerringly on the harpooned hippopotamus. The long punting pole held by the man in the stern of the boat meets the harpoons at a right angle and delimits the scene on the left.

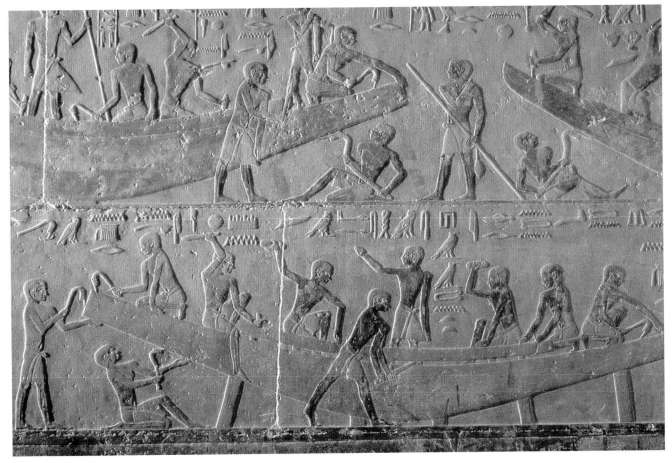

Boat builders,
in the tomb of the chief hairdresser
Ty at Saqqara

*c.*2400 BC. Raised relief in limestone

Representations on the walls of tombs and temples are almost always accompanied by hieroglyphic texts. These are written next to the scene and are oriented in the same way (i.e. if the people shown in the relief face right, the hieroglyphs also face right). The texts can perform several different tasks. Quite often they simply describe the activity depicted by the relief. In this scene, the inscription above the men working on the stern of the boat in the left half of the lower register says 'hewing wood with an adze'. This is self-evident and may have just been an attempt to fill an unsightly blank space. Elsewhere the inscription provides additional information which is not obvious from the picture. It may identify the represented person, for example the man standing in the boat in the left half of the upper register is 'the sole companion Ty' ('sole companion' was a court rank). In other cases the inscription records a conversation, so the men fitting the boat's gunwale in the right half of the lower register shout a warning to their comrades 'Make room! Your hands are under us!' The narrative content of the scenes is, therefore, complemented and elucidated further by texts.

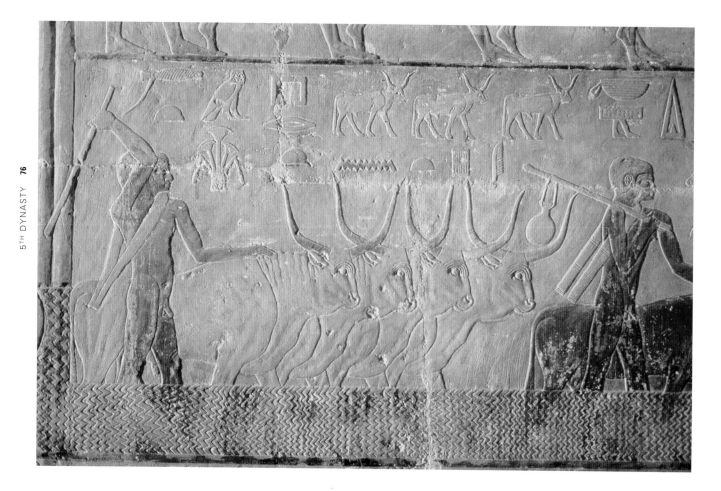

Herdsmen with cattle, in the tomb of the chief hairdresser Ty at Saqqara

c.2400 BC. Raised relief in limestone

The repertoire of 'daily life' scenes in Egyptian tombs was well established, but the lively subject and beautifully observed, often innovative details ensured that repetition was avoided. In the tomb of Ty, herdsmen and cattle are depicted crossing a canal. The cattle are represented on the same base line but with their bodies partly overlapping and the head of each clearly visible. Their long horns further strengthen the impression of a closely packed herd. The figures of herdsmen are discreetly in the foreground but their connection with the herd is emphasized: two of them guide the animal closest to them by a hand placed on its flank. The representation of the canal, with water indicated by ripples (a standard method in Egyptian art), combines two views (see also 36). It is seen as if in an aerial view, from above, but the legs of the herdsmen and cattle (especially near the left end of the scene) are shown as if we were watching them through a glass wall in a large aquarium. They are partly visible and resting on the register line which represents the canal's shallow bottom.

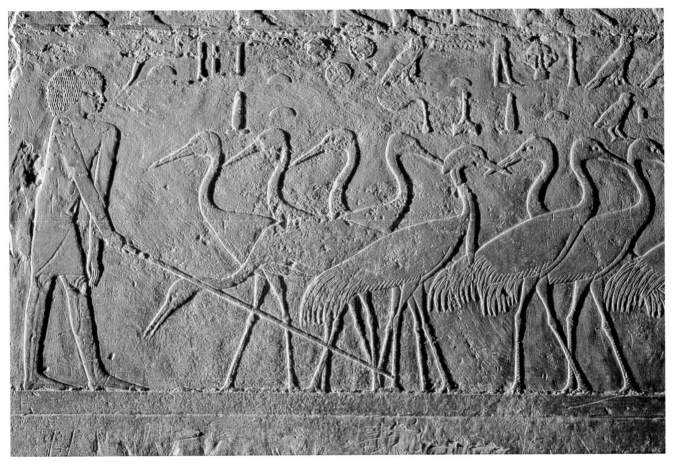

Man with cranes, in the tomb of the chief hairdresser Ty at Saqqara

*c.*2400 BC. Raised relief in limestone

One of the characteristics of tomb decoration is the large number of depictions of groups with overlapping figures. This is due to the subject-matter which is often very lively and so contrasts with temple scenes which tend to be more formally regimented. The Egyptian artist soon discovered the most expressive ways of portraying groups. Cattle, donkeys or sheep being brought by herdsmen were not allowed to stop or digress from their path, and so their heads, shown close together, point in the same direction. But in order to liven up the composition the artist often introduced a 'dissenting figure' which breaks up the uniformity, such as an animal turning its head and looking back, or trying to steal a quick nibble at a clump of grass, to pick up an ear of corn lying on the ground (85) or to drink from the canal which the herd is crossing. A completely different approach was used for a herd of cranes which are being brought for inspection in the tomb of Ty. The indecisive milling about of the birds which are difficult to control is suggested by the different directions in which they are facing. Although seemingly spontaneous, these were standard ways of representing such topics which were familiar to all well-trained artists.

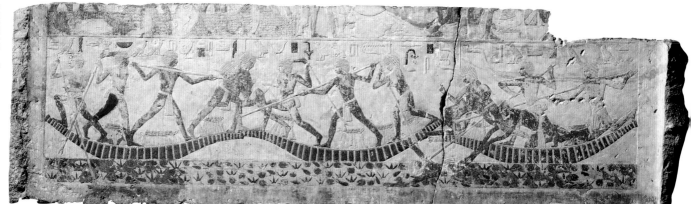

**Jousting boatmen,
almost certainly from
a tomb at Saqqara**

*c.*2400 BC. Raised relief in
limestone, w. 145 cm, 57 in.
Egyptian Museum, Cairo

Many of the topics shown on
the walls of Old Kingdom tomb
chapels are only very loosely
connected with the idea of tomb

provisioning. There is, as yet, no
clear agreement on why such
scenes were introduced (see
also 50–1). The most widely
accepted theory suggests that
representations of the tomb owner
seated at a table surrounded by
food offerings (see 56) were at
first expanded by scenes showing
such offerings being brought to
the tomb. The next step was to
show the 'preparatory' scenes

which preceded the presentation
of offerings: cattle being
slaughtered, fish and fowl caught,
bread baked and beer brewed. A
further expansion of the tomb
repertoire incorporated 'secondary'
scenes which were far removed
from the main theme but were
connected with the 'preparatory'
scenes. Men who went in small
papyrus canoes into the marshes
to catch birds indulged in rowdy

fights with other boatmen, perhaps
when competing to be first home
or to have the right of way in
narrow canals. Punting poles were
used without mercy in these
fights. These are among the
liveliest scenes in Old Kingdom
tombs with some of the least
orthodox and most interrelated
and overlapping depictions of
human figures.

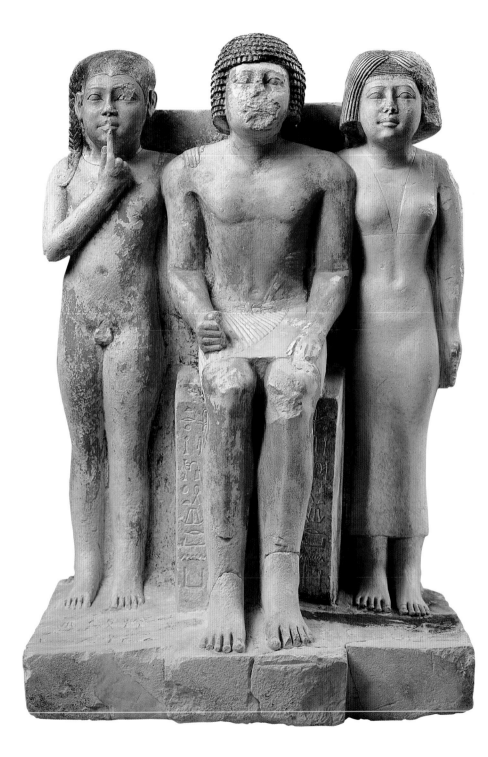

Nikare, the inspector of granary scribes, and family, from their tomb at Saqqara

*c.*2380 BC. Painted limestone, h. 57.5 cm, 22 in.
Brooklyn Museum of Art, New York

The architecture and decoration make it clear that an Old Kingdom tomb was intended for the burial of a man as the head of a family. Other members of the family may have shared the tomb chapel and the burial rooms. Sculptures placed in the tombs mirrored this arrangement. Statues of couples imitated royal prototypes but those showing whole families were developed specially for non-royal tombs. The man is the central figure, often seated. In the hierarchy of postures the seated figure is superior to the standing one. The wife may sit next to her husband or be standing, while children are usually shown on a smaller scale and are never seated. The sculptor who carved Nikare's family group succeeded in producing a beautifully balanced sculpture while making the hierarchy of the figures quite clear. The woman is the median figure of the composition. The man is nearly twice as large as his wife, but the fact that he is seated reduces the impression of unequal sizes. The son is naked, with a finger of his right hand in his mouth and with a juvenile sidelock of hair. All these are indications of youth and help to overcome the fact that, unusually, he is shown as tall as his mother.

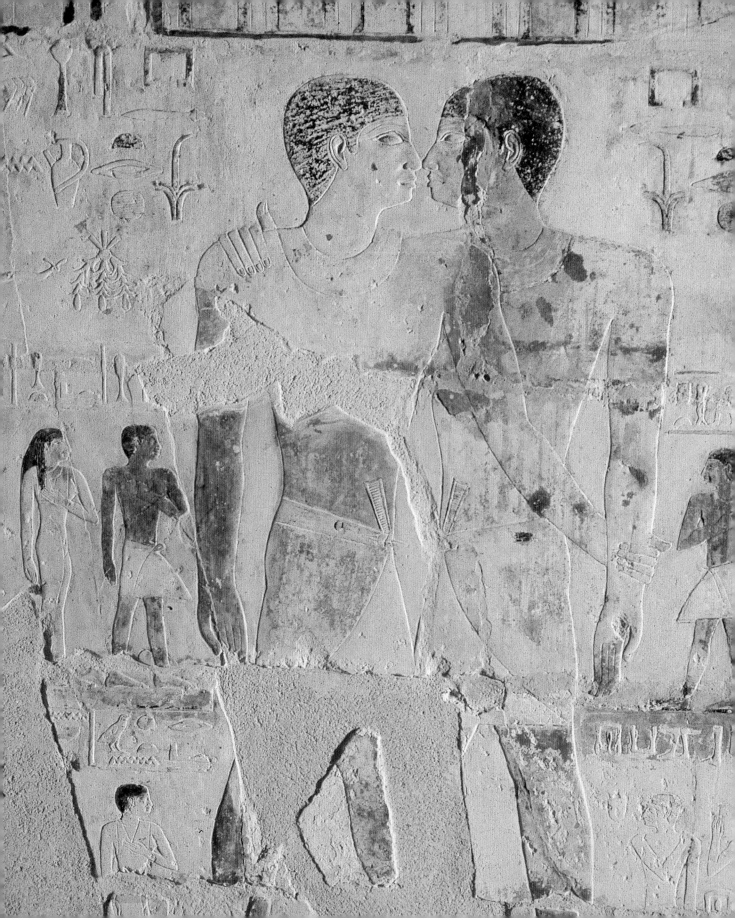

The chief manicurists, Niankh-khnum and Khnumhotep, in their tomb at Saqqara

*c.*2375 BC. Raised relief in limestone

The conventions of two-dimensional representation were honed to perfection in reliefs of the Old Kingdom. The human body was not viewed as an integrated entity but as an assemblage of elements in their most characteristic views. The links between them were less important although every effort was made to make them look 'natural'. This relief depicts two men, called Niankh-khnum and Khnumhotep. A representation of two men embracing is very unusual and their relationship may seem sexually ambiguous. In this particular case we know that both these men had wives and children. The general concept that lay behind this embrace was probably that of 'breathing life into somebody's nostrils', in the way a god might breathe life into a king. Niankh-khnum's (on the left) 'left' hand clasps Khnumhotep's forearm, but also the hand belonging to the arm shown behind his body (in reality, alongside) appears to be 'left'. One of the possible explanations is that in order to show the back of the hand (not the palm which was not, as a rule, depicted during the Old Kingdom), the hand attached to the 'right' arm had to be 'left'. Perhaps surprisingly, the result does not look at all unnatural.

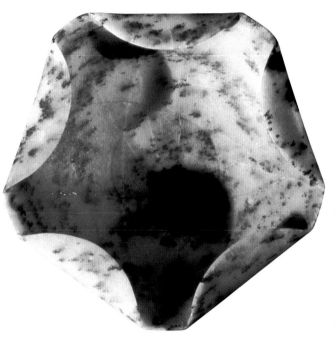

Pentagonal bowl, from a tomb at Giza

*c.*2350 BC. Diorite gneiss, w. 20 cm, 7 in. Phoebe Hearst Museum of Anthropology, Berkeley

The shapes of some of the stone vessels made for inclusion among funerary goods seem to challenge the material of which they were made, as if their makers tried to prove that nothing was impossible for them. With infinite patience and very simple tools (see 34), the vase-makers were able to produce almost any desired form. The manufacture of stone vessels reached its peak in quality as well as quantity during the Early Dynastic period (34, 38). But very fine stone vessels continued to be made during the Old Kingdom (see also 42) and the art never disappeared. Here, a stone vessel from a tomb at Giza was made in very hard gneiss but its shape, with parts of the rim turned in, reminds one forcibly of a much softer and more pliable material. The form may have been created in an imitation of a flower which is about to burst open. The other possibility is that this is an image of a star: in Egyptian arts, the typical star had five points around a small centrally placed circle, similar to the circumference of the vessel's base. But these attempts at interpretation may be just flights of fancy, and the form may have been arrived at entirely arbitrarily.

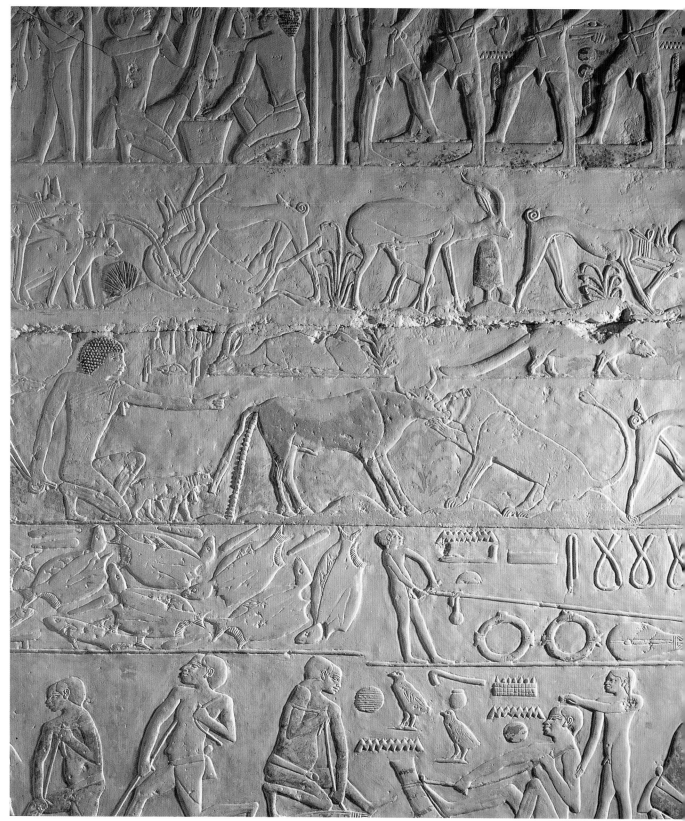

Hunting in the desert, and men making ropes and papyrus canoes, in the tomb of the vizier Ptahhotep at Saqqara

*c.*2320 BC. Raised relief in limestone

Although the number of 'fleeting moments' for each activity shown in tomb reliefs is large, it is quite easy to draw up a list of the standard episodes most often represented. There are, of course, variations in their presentation and selection. Originality was not seen as making a break with tradition and creating something entirely new. This was not even desirable: representations in tombs served a specific purpose (see 78) which might be jeopardized if one deviated significantly from what was believed to have been effective in the past. Rather, the uniqueness of the artist's creation was in a new and original combination of known elements. In the relief illustrated here, from the tomb of Ptahhotep at Saqqara, the artist depicted a hunt in the desert. In such scenes, the hunter is not shown killing animals but is a passive observer, accompanied by his hounds, or capturing animals alive with a lariat. Violence is perpetrated by animals, usually the hunter's dogs or large predators such as lions, on other creatures. Men engaged in various activities taking place in the marshes are depicted in the register below, including rope-making and papyrus canoe-making.

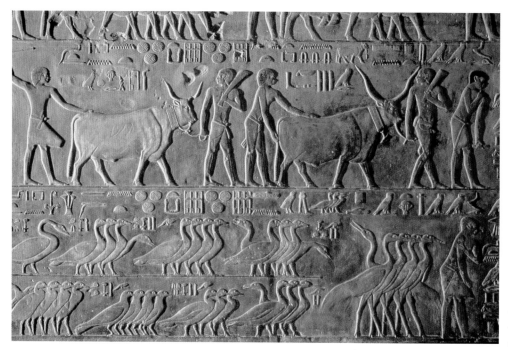

Inspection of animals, in the tomb of the vizier Ptahhotep at Saqqara

*c.*2320 BC. Raised relief in limestone

The Egyptians did not know the concept of perspective which has been employed in Western art since the Renaissance to indicate distance and space. All depicted figures shared the same base line, a rule which was modified only when the subjects were not large enough. In such cases, the register was divided further into two or more sub-registers (see the division of the bottom register with ducks and geese in this relief). The represented subjects were not shown as diminishing in size with the increasing distance and there was no attempt to view them from a higher plane (and so to place those further away slightly above those nearer the viewer). This would have involved a distortion of the elements of which each subject consisted and this was regarded as unacceptable. Instead, the Egyptian artist showed the more distant subject as of the same size and on the same plane (base line) but projecting forward, i.e. further to the right if the figures were facing right, and further to the left if facing left. This allowed the more important aspects of the represented subjects, such as faces of people and heads of animals, to be seen.

**Donkeys,
from the tomb of Metjetji at Saqqara**

c.2300 BC. Raised relief in limestone,
42 x 47 cm, 16 x 18½ in.
Royal Ontario Museum, Toronto

The design of tomb decoration
involved a series of multiple
choices. First, a wall was selected
and space, usually one or more
registers, reserved. Then the artist

chose the preferred episodes to
which the topic was reduced. So,
for example, the harvesting of
grain could include men reaping
with sickles, binding sheaves and
putting them into sacks, bringing
donkeys, loading the sacks
on them and taking the sacks
away. Other scenes might show
threshing the grain by driving cattle,
sheep or donkeys over it, sifting,
winnowing, measuring and storing

grain, and stacking straw. Each
scene was made unique by
variations in the arrangement of its
elements. Finally, individual figures
were made different by varying the
positions of their arms, legs, etc.
In this way, identical scenes were
consciously avoided. Here, on a
relief from the tomb of Metjetji,
donkeys which will transport the
grain are shown being brought to
the field. Note the animal bending

its head and so breaking the
monotony of the composition
(see also 77). This gives the
impression of spontaneity and
uniqueness but it is a frequently
occurring artistic device.

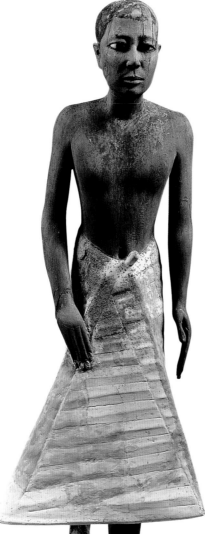

The chief of the department of tenant farmers, Metjetji, wearing a kilt with a triangular front, from his tomb at Saqqara

*c.*2300 BC. Wood with inlays, h. 61.4 cm, 24 in.
Brooklyn Museum of Art, New York

Wooden sculptures became more numerous in the later phase of the Old Kingdom, after about 2350 BC. Many of them display features which clearly distinguish them from earlier statues. The proportions of the sculptures change. These statues tend to be smaller in size, but slimmer, with attenuated arms, long hands and a narrow waist. The head is large and the usually inlaid eyes are hauntingly conspicuous. These are characteristics of a new artistic style which cannot be dismissed as merely works by less skilful sculptors or signs of a general decline in standards. These developments must be seen as influenced by the circumstances in which the sculptures were made. Changes were taking place in royal as well as non-royal tomb architecture and, probably, in the organization of the necropolis and its workshops. The provision of a tomb and its sculptures was now left entirely to the initiative of each individual. Perhaps because the links with the royal workshops were loosened, some of the artists working for non-royal clients were able to develop a new style, influenced by working mainly in wood and dictated by demand.

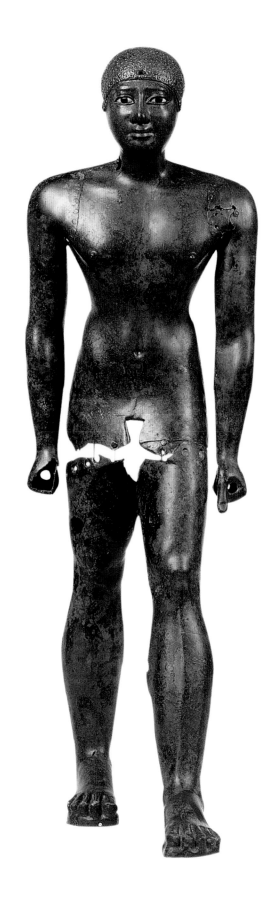

King Pepy I, from the temple at Hierakonpolis (Kom el-Ahmar)

*c.*2250 BC. Copper with inlays,
h. 65 cm, 25 in.
Egyptian Museum, Cairo

Egyptian annals mention the manufacture of a royal statue made of copper during the reign of King Khasekhemui of the 2nd dynasty, but this has not survived. Two dismantled and much oxidized copper statues of King Pepy I, some 400 years later, fared better because they were buried during one of the clearances of the temple at Hierakonpolis. On such occasions, items which were no longer required in the temple were not simply thrown away or destroyed, but buried within the temple precincts (see also 161, 214, 290). One of the statues has now been restored and provides important information on how such statues were made. The material and the techniques used in the making of statues in copper allowed the artist freedom which he did not have when working in stone. The modelling of the statue is very fine. It consists of a number of parts made of hammered copper sheets joined by rows of nails, presumably over a wooden core. The cobra on the king's forehead, his kilt and the staffs which he held in his hands were probably made of different materials. The eyes are inlaid in black and white stone set in plaster, and other details, such as toenails, were emphasized in gold leaf.

A lion,
from the temple at Hierakonpolis
(Kom el-Ahmar)

*c.*2250 BC. Terracotta,
h. 42.5 cm, 16¾ in.
Ashmolean Museum, Oxford

This statue of a lion was found
in the temple of Horus at
Hierakonpolis. Made of red
terracotta with a polished slip (the
red colour indicates a male of the
species), he was made in the best
tradition of Predynastic animal
pottery. The lion sits on an oval
base with a raised ledge, a detail
which one would not find in stone
or wooden statues. He is heavily
maned but the mane is so neatly
square cut on his chest that it
creates the impression of a bib. His
tail is curled alongside his right hind
paw. There is some evidence that
terracotta sculptures continued to
be made during the Old Kingdom
and perhaps even later. But this is a
very fine piece and not the product
of somebody who had to resort to
terracotta because he was unable
to work in any other material.
Fragments of another lion were
also found and the pair may have
guarded one of the entrances to
the temple. The early 6th dynasty,
perhaps the reign of Pepy I from
which other monuments were
found in the temple, can be with all
caution suggested as the date of
this sculpture.

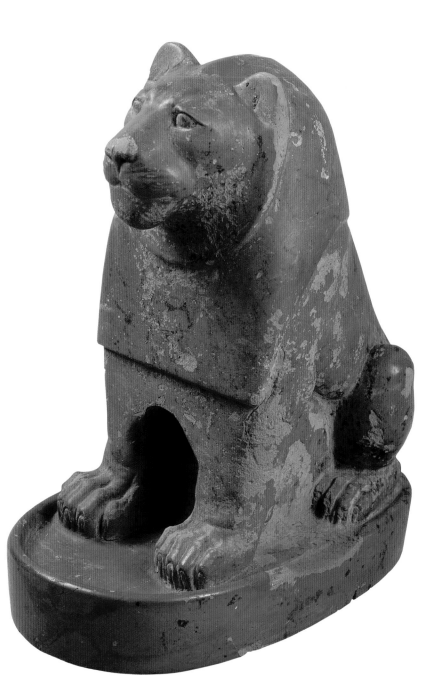

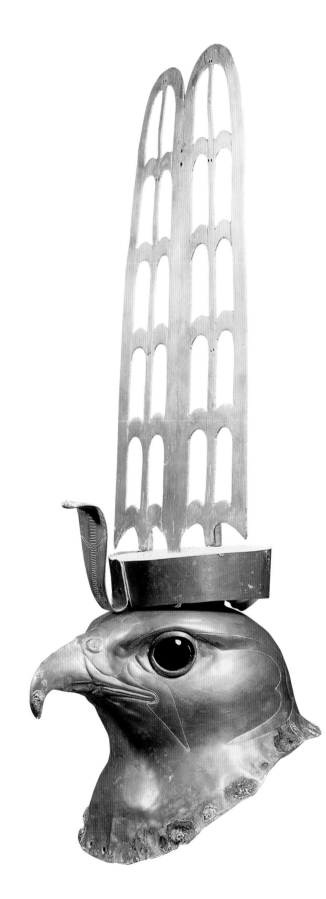

**Head of a hawk,
from the temple at Hierakonpolis
(Kom el-Ahmar)**

*c.*2250 BC. Gold inset with obsidian
eyes, h. 37.5 cm, 14¾ in.
Egyptian Museum, Cairo

No royal statues made of gold have
survived from the Old Kingdom,
and this image of the Horus hawk
is unique among deities. But it is
likely that such statues did exist
and their disappearance is due to
the value of the metal and its 're-
cycling'. Gold was linked to the king
(one of his names identifies him as
'Horus of Gold') and the gods, and
Egypt had plentiful supplies from
mines in the Eastern Desert and
Nubia. This statue was, no doubt,
a royal gift and may have served
as the temple's main cult image.
It was in the form of the archaic
image of the Horus hawk in which
the bird is crouching close to the
ground rather than perching in an
upright position. Its head is made
of a sheet of beaten gold, the body
of copper, and the eyes are formed
by a rod of obsidian inserted into
the head. The metal was attached
to a wooden core (see also 87).
There was a small figure of a king,
also of copper, accompanying the
hawk, though this may have been
added later.

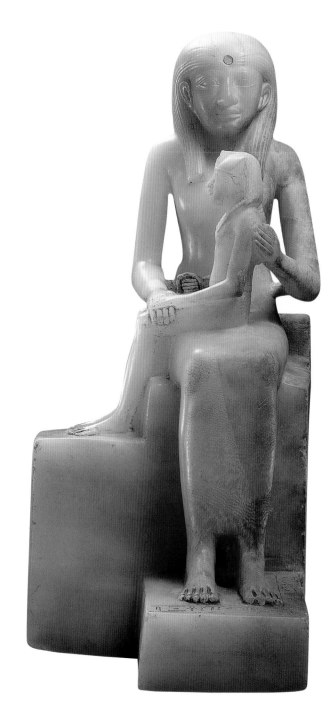

King Pepy II on the lap of his mother, probably from Saqqara

*c.*2230 BC. Travertine (alabaster),
h. 39 cm, 15in.
Brooklyn Museum of Art, New York

While in non-royal statues the
sculptor deviated little from the
shape of the original block of stone,
royal statues were more complex.
Here, the statue of the young king
Pepy II seated on the lap of his
mother Ankhnesmeryre II is, in fact,
conceived as though it consisted of
two sculptures combined with their
main axes crossing at right angles.
The king is shown as an adult, with
no concessions in his appearance
or posture made to the logic of the
sculpture which demands that he
be a child. His mother is shown
in the way the goddess Isis was
portrayed when nursing her son
Horus, and we know that the king
was regarded as a manifestation
of the god Horus (see 36 and 59).
The king might as well be seated
on a royal throne, and this is how
the sculpture might have been
understood: in Egyptian, the
hieroglyph for the name of Isis
could also be read as 'throne'. The
carving of an image with open
spaces between the queen's body
and her arms, and between the
seat and her legs, presented
difficulties which were usually
avoided in non-royal sculptures
(see, however, 70).

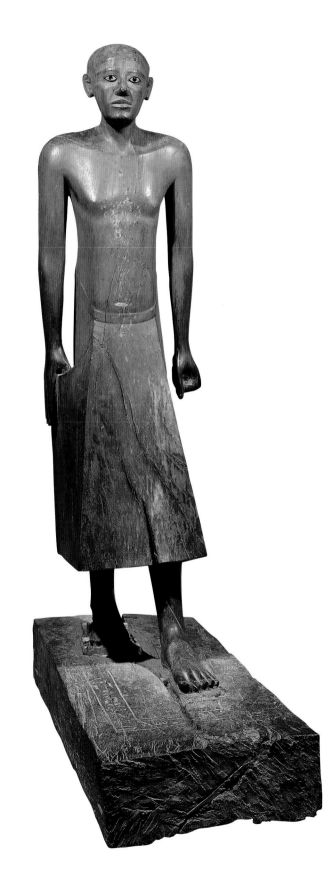

Chancellor Nakht,
from his tomb at Asyut

*c.*2050 BC. Wood with stone inlays,
h including the base 178.5 cm, 70¼ in.
Louvre, Paris

Around 2124 BC the Old Kingdom
disintegrated and split into two
independent states. The northern
area, centred on Heracleopolis
(Ihnasiya el-Medina), was the
true successor of the earlier
monarchy but the strict controls
in administrative and artistic
spheres which had previously
been exercised from the capital
at Memphis were significantly
loosened. Workshops attached to
temples and cemeteries in Middle
Egypt began to develop their own
artistic styles. Asyut, some 210 km
(130 miles) south of Memphis
and close to the southern limit of
the Heracleopolitan kingdom,
was one of the most important
centres of artistic production.
Asyut workshops excelled in the
production of items made of wood,
especially coffins and statues.
Statues made at Asyut continued
and further developed the new
sculptural style which had first
appeared in the Memphite
area towards the end of the Old
Kingdom (see 86). Nakht's statue
is life-size and displays the
characteristic lean and tall figure,
achieved mostly by lengthening
the lower part of the body, from
the chest down. The arms are
correspondingly long and the hands
are large. The eyes are inlaid in
stone set in dark wood. The statue
was polished and, apparently,
painted all over in red.

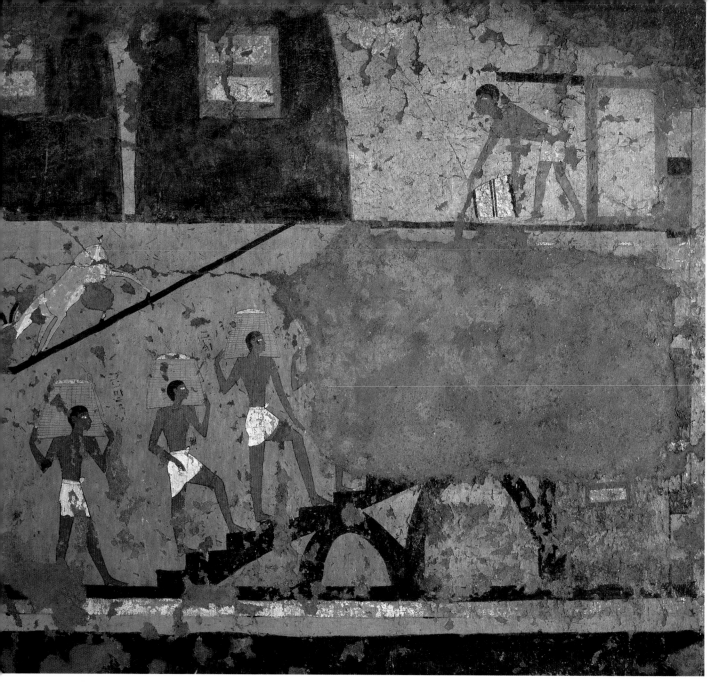

Men bringing grain to a granary, from the tomb of General Iti at Gebelein

*c.*2050 BC. Wall painting on
plaster, h 127 cm, 50 in.
Museo Egizio, Turin

One of the results of the political
disunity which followed the end of
the Old Kingdom was increased
artistic independence of work-
shops in the south of the country,
which was dominated by the kings
of Thebes. Links to traditional
art centres in the old capital
at Memphis were completely
severed and southern artists had
to go their own way and develop
their own styles. Gebelein was an
important town some 30 km (19
miles) south of Thebes. Several
tombs of local officials from the
period between the Old Kingdom
and the reunification of the country
by King Nebhepetre Mentuhotep II
in about 2040 BC have been
found. The most spectacular
among them belongs to General
Iti. It has a portico with sixteen
brick-built pillars and a rock-cut
central chapel flanked by ten
storerooms. The pillars and walls
of the portico were decorated with
a series of painted scenes. The
bearers carrying baskets of grain
who ascend a staircase in order to
fill up the granaries have tall, slim
almost 'matchstick' bodies. This
mirrors the same tendency in the
depiction of human figures in the
Heracleopolitan kingdom in the
north (91).

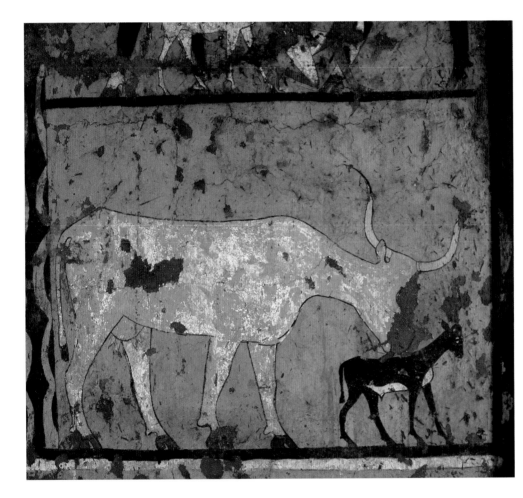

A cow and a calf,
from the tomb of General Iti at Gebelein

*c.*2050 BC. Wall painting on plaster,
h. 54 cm, 21¼ in.
Museo Egizio, Turin

Several features of the wall
paintings in the tomb of Iti at
Gebelein may be regarded as
characteristic of regional art during
the First Intermediate period.
These are changed proportions
in representations of the human
body, modifications in the repertoire
of scenes and a different use
of colour. The tones tend to be
brighter and are used in a different
way from earlier tombs. One of
Iti's paintings shows a cow which
has just given birth to a calf and is
licking it and cleaning it up. The
outlines of the mother cow are,
unusually, edged in a fine black line
(these are not the remains of the
original sketch). The dado (the
ornamental part of the wall below
the painted scenes), which also
functions as a base line for the
representations, consists of bands
of dark brown, white and yellow,
with the bottom of the wall painted
dark brown. The painted decoration
of later Middle Kingdom tombs
derived their inspiration from these
provincial paintings rather than from
their much more distinguished
Old Kingdom predecessors.

King Nebhepetre Mentuhotep II, from his funerary temple at Deir el-Bahri

*c.*2040 BC. Sandstone,
h. 183 cm, 72 in.
Egyptian Museum, Cairo

When King Nebhepetre Mentuhotep II gained control of the whole of Egypt some time around 2040 BC, the city of Thebes was elevated to the centre of the country's politics, religion and arts. The king built his combined tomb and funerary temple at Deir el-Bahri, on the west bank of the Nile opposite the city (see 139). The temple's terraced design was unlike anything Egypt had seen before although elements of it can be traced to the tombs of Mentuhotep's predecessors and perhaps also to the temples of the rulers of the Old Kingdom in the north. The king is wrapped in a royal festival cloak but wears a curved divine beard, has his arms crossed on his chest and his hands once held the now lost insignia. This is the posture of Osiris, the ruler of the netherworld, with whom the dead king had already become identified in the texts written inside Old Kingdom pyramids (see 162, 223, 255, 265). It probably also explains the dark face and complexion of the statue. Even in the best royal statues of the Old Kingdom the legs were heavy but here they are positively massive. Also the face is imbued with a certain laboured heaviness. The statue betrays the artist's limited experience in creating according to the traditional canon of proportions of royal statues and on this scale.

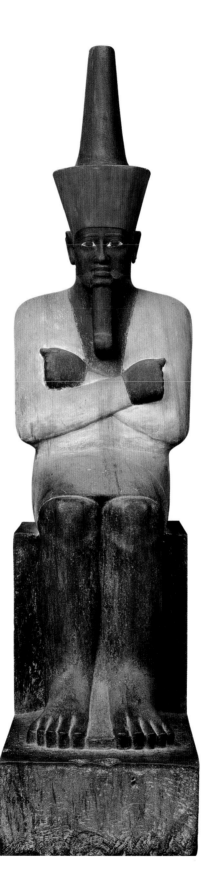

Queen Nofru and Henuti, her hairdresser, from Nofru's tomb at Deir el-Bahri

*c.*2040 BC. Sunk relief in limestone, h. 19 cm, 7$\frac{1}{2}$ in.
Brooklyn Museum of Art, New York

Queen Nofru was buried in the vicinity of the tomb and funerary temple of her husband, King Nebhepetre Mentuhotep II, at Deir el-Bahri. The decoration of her rock-cut tomb combines bold raised and sunk relief. Unlike raised relief which was employed for scenes viewed in diffused light, for example inside temples and tombs, sunk relief was originally introduced in areas exposed to direct sunlight, such as exterior doors and walls. It relies on the strong contrast between a brightly illuminated surface and the shadows cast into the carved-out areas by the outlines of representations. The technique can be seen as the opposite of cutting raised relief: representations and inscriptions were below the surface surrounding them but could be further modelled by varying the depth of carving inside their outlines. A variation of sunk relief, with so little of the original surface removed from inside the representations that it resembles incised outlines, was used in provincial tombs during the period following the collapse of the Old Kingdom. During the reign of Mentuhotep II the original reasons for the introduction of sunk relief were no longer paramount (see also 96–7). Thus it could be used inside the tomb of Queen Nofru in areas not exposed to direct sunlight. The scene shown here was originally described as 'doing up hair of the King's wife', but a part of the text is now lost.

Princess Kawit and her maid, and a milking scene, on Kawit's sarcophagus from Deir el-Bahri

*c.*2040 BC. Sunk relief in limestone, h. of whole 119 cm, 47 in, l. 262 cm, 103 in. Egyptian Museum, Cairo

Six tombs and chapels of royal ladies of King Nebhepetre Mentuhotep II were incorporated into his funerary temple at Deir el-Bahri during one of its enlargements. The sarcophagus of Princess Kawit bears on its exterior scenes cut in sunk relief (see 95) but with quite bold modelling inside the figures. The representations may seem a little rigid but the relief was carved with supreme confidence and meticulous attention to detail. In one of the scenes, Kawit is shown seated holding a lotus flower in one hand while dipping the fingers of the other in a vase of ointment held up to her by a maid. Before them is Kawit's jewellery, shown above and next to a jewellery casket (as was usual with the contents of boxes) in which it was kept. The women have the elongated figures and long hands characteristic of the First Intermediate period. Their eyes are extended by cosmetic lines which reach almost as far as their wigs. The other scene shows a cow being milked, with two calves (one is tied to one of her front legs, the other is not shown in this illustration). Elsewhere on the sarcophagus the princess is shown drinking milk. Deir el-Bahri was the place of worship of the goddess Hathor who appeared there in the form of a cow, which these scenes may refer to.

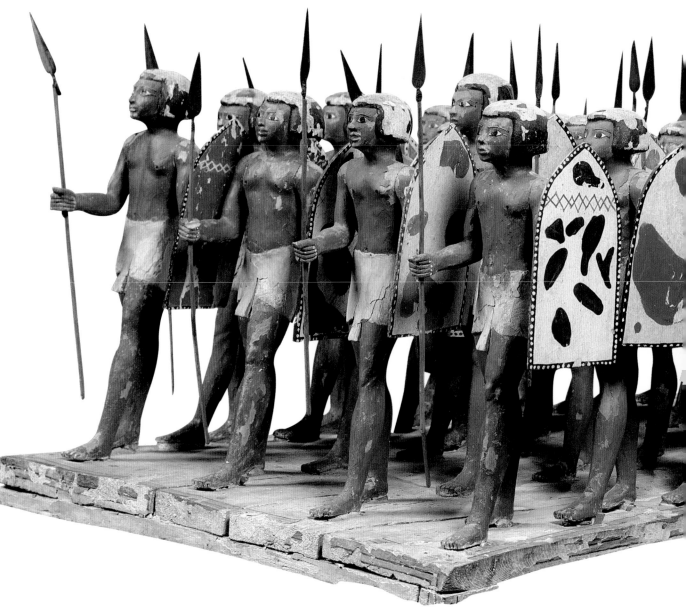

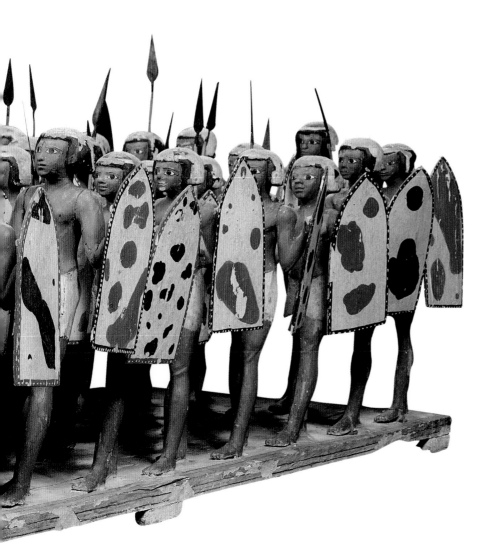

**Local militia, model
from the tomb of the overseer
of priests, Mesehti, at Asyut**

*c.*2000 BC. Wood covered with plaster
and painted, 168.5 x 62.5 cm,
66 x 24 in. Egyptian Museum, Cairo

The rules concerning the form
of tombs and funerary goods
prepared for them were based
on contemporary ideas about
requirements in life after death and
were not left to the imagination of
artists and craftsmen or the wishes
of the tomb owner. The same idea
could be expressed in different
ways. The times which followed
the break-up of the centralized Old
Kingdom were uncertain and armed
conflict flared up occasionally.
In several tombs of local
administrators at Asyut this was
reflected in the appearance of
armed men carved in relief on the
tomb walls. It was not an attempt
at recording contemporary
events but a precaution against
emergencies in the afterlife in
which such soldiers might be
needed. Although the tomb of
Mesehti dates to the period shortly
after the reunification of the
country under King Nebhepetre
Mentuhotep II, the need for
such scenes was still felt. Now,
however, it was expressed by two
large wooden models of units of
local militia and Nubian mercenary
bowmen, each 40 men strong,
which were put in the tomb. The
Egyptian soldiers are represented
as a well-drilled unit but their maker
tried to make them individual by
introducing slight differences, for
example in the pattern of their
oxhide shields.

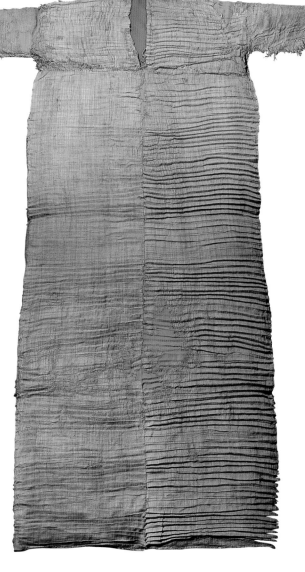

V-necked pleated dress, from a tomb at Asyut

*c.*2000 BC. Linen cloth,
h. 139 cm, 54³⁄₄ in.
Louvre, Paris

Flax was the main, but not the only, source of material for the textile industry. It seems that only women were engaged in spinning, weaving and tailoring. Textile workshops are occasionally represented in tombs and can also be found in wooden models. Egyptian garments were mostly made of undyed white fabric although a variety of ways of decorating textiles was known, from dyeing, embroidering and painting to the sewing on of sequins and beads. The preference for unadorned white was intentional and pleating usually was the only sign of distinction. This pleated sleeved garment was made of several pieces of linen sewn together. Textile experts still argue whether the pleating was produced manually, impressed on special boards while the garment was wet (in which case it had to be laboriously renewed every time it was washed), or introduced earlier during the weaving process, which would have produced permanent pleating. The illustrated dress probably belonged to a woman and has been worn as it shows signs of staining in the region of the armpits. It was, therefore, not specially made for the burial although many garments almost certainly were. Clothing and rolls of linen made up a major part of funerary goods in many tombs.

Fishing boats, model from the tomb of chancellor Meketre at Deir el-Bahri

*c.*1990 BC. Wood covered with plaster and painted, 90 x 62 cm, 88⅛ x 60¾ in. Egyptian Museum, Cairo

Servant statuettes, sculptures showing people performing various domestic tasks, appeared around 2500 BC. At first these were single figures made of stone, but wooden figures gradually became common. In the period which followed the end of the Old Kingdom and in the early Middle Kingdom such statuettes, by then exclusively made of wood and called models by Egyptologists, became very popular (see also 108). Models show whole groups of people engaged in related activities. This was, no doubt, connected with the decrease in the number of decorated tombs. The largest and most accomplished collection of such models was found in the tomb of Meketre, the chancellor of King Sankhkare Mentuhotep III of the 11th dynasty. Scenes showing life on Meketre's estate which might have been shown on tomb walls were transformed into three-dimensional sculptures instead (see also 102–3). Meketre had quite a collections of boats, ranging from canoes with men netting fish (illustrated) to luxury sailing boats carrying him, his son and his musicians.

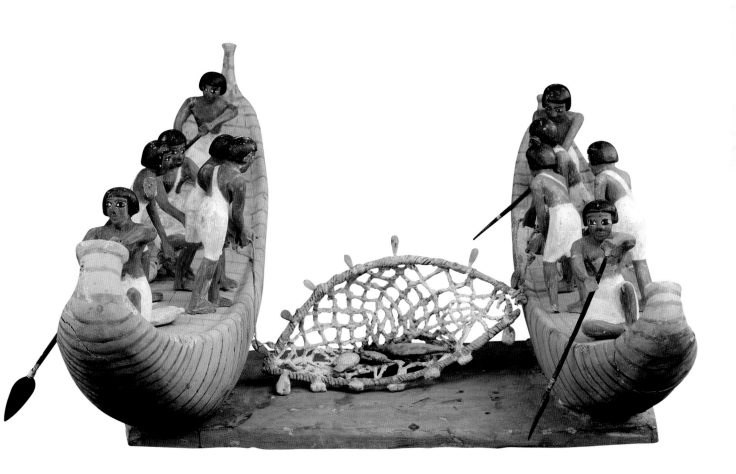

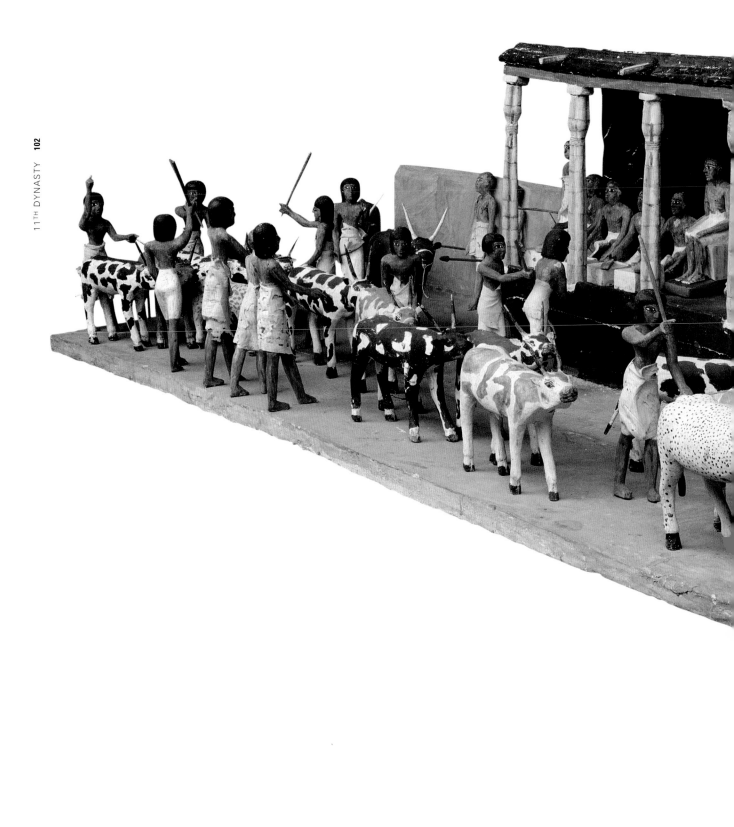

Inspection of cattle, model from the tomb of chancellor Meketre at Deir el-Bahri

*c.*1990 BC. Wood covered with plaster and painted, 72 x 173 cm, 70½ x 169⅜ in. Egyptian Museum, Cairo

Chancellor Meketre's models (see also 101) include the usual episodes connected with the preparation of food, such as brewers and bakers, a slaughterhouse and a granary. Carpenters' and weavers' workshops are also present. There are several houses and a stable with cattle. The spectacular representation of an inspection and counting of cattle (illustrated) is the star of the show. As a depiction of life on the estate of an Egyptian noble these models are the most accurate known. Because they are three-dimensional there is very little which artistic conventions make ambiguous, and because they were made of easily carved wood their makers were able to depict various activities with life-like accuracy. As a record of Egyptian country life these models may be naïve but they are completely realistic. Only a few details pay tribute to the conventions of more formal contemporary sculptures, such as the slim and elongated figures and the advanced left foot (though this is not always present). There are few works of Egyptian art which are closer to our modern way of seeing and representing reality and which feel less 'ancient'. If it was not for the ancient Egyptian reality which they depict, these models might have, almost, been made by contemporary artists yesterday.

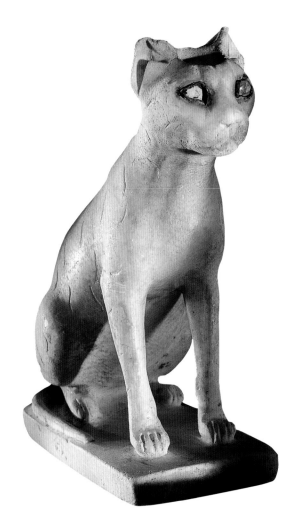

Vase in the shape of a cat, location of discovery not known

*c.*1950 BC. Travertine (alabaster), rock crystal, copper, h. 11.4 cm, 5½ in. Metropolitan Museum of Art, New York

The Egyptian cat from which many of our domestic cats descend became fully domesticated around 2000 BC. The reasons for the initial contacts between cats and people were economic (the cat's ability to destroy vermin and so to protect barns and silos), protective (it can kill snakes) and sentimental (the cat made an ideal household pet with which dogs and baboons of the Old Kingdom just could not compete). This vase is the earliest three-dimensional representation of the cat which is larger than a small amuletic figurine. If one did not know, it could pass easily for a sculpture and, in fact, the initial effort required in its carving was not different from the making of a statue. But it was further complicated by hollowing the figure in order to produce a vase with very thin walls. Sculpturally, the carving is more audacious than what we normally see in sculpture proper, with large areas of undercutting between the front and hind paws and the animal's belly. The cat's eyes were inlaid in rock crystal set in a copper frame, with the pupils painted in black, but only the left eye has been preserved in full. The vase may have been used for the storage of cosmetics or medicines.

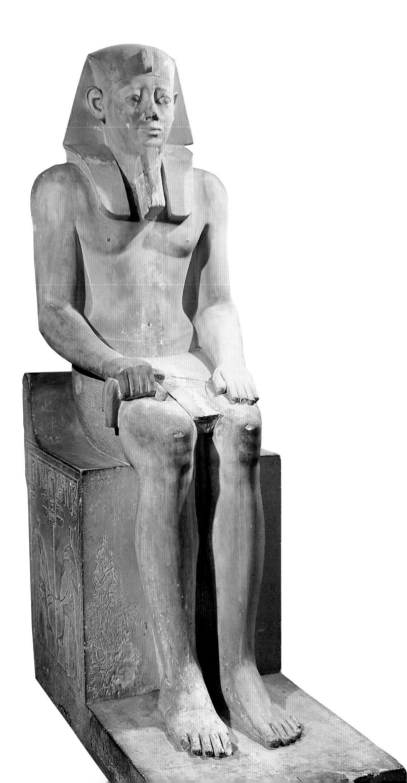

King Senwosret I, from his pyramid temple at El-Lisht

*c.*1930 BC. Limestone,
h. 200 cm, 78³⁄₄ in.
Egyptian Museum, Cairo

Ten seated statues of Senwosret I were found in his pyramid temple at Itj-tawy (El-Lisht), the new state capital founded by his predecessor Amenemhet I. The type is the traditional official royal portrait established in the Old Kingdom (see 59): the king is wearing a royal headdress with a uraeus (cobra) and a ceremonial straight beard. His short kilt is his only other garment; he is bare-chested and barefoot. His left hand is lying flat on his left thigh while in his right hand he clutches a folded handkerchief. Although the sculptor diligently indicated the musculature of the body, arms and powerful legs, the modelling lacks the conviction of a naturalistic sculpture. But the main difference between these statues and those of the Old Kingdom is in the king's face. Instead of the self-confident and commanding presence of the rulers of the Old Kingdom, the statues of Senwosret display bland features which idealize but obliterate all personality of the king. Hardly any royal statues have survived from the 6th dynasty and so we cannot be sure whether sculptors of Senwosret I imitated idealizing tendencies of their Old Kingdom predecessors or whether they, unsuccessfully from our viewpoint, created their own types.

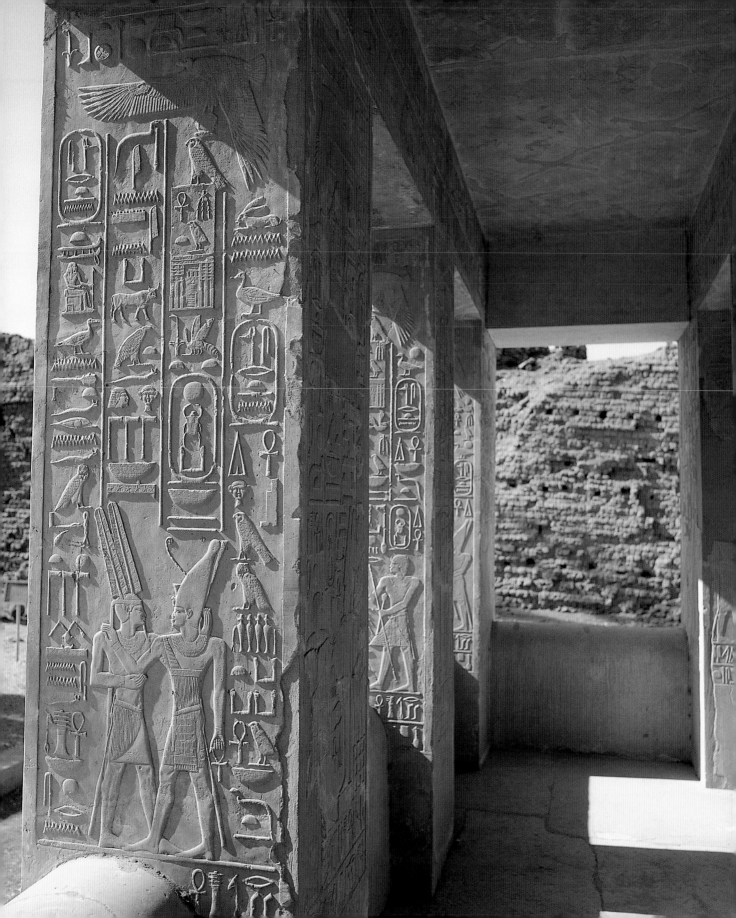

Hieroglyphs,
in the reconstructed festival kiosk
of King Senwosret I at Karnak

*c.*1930 BC. Raised relief in limestone

Perhaps no other script in the
world has been more successful at
retaining the link with the images
from which it originally derived than
Egyptian hieroglyphs. They are
recognizable pictures of people,
animals, heavenly bodies, buildings,
tools, etc., and are subject to the
same conventions as other two-
dimensional representations.
But the hieroglyphic script is not
picture writing because most signs
perform functions similar to those
of the letters of our alphabet and
diacritics. The 'picture' need not
be in any way associated with the
sign's meaning or function, but
when such a connection exists,
the hieroglyphs can convey extra
meaning which is lost in our writing
system. When we write the word
'man', we cannot be sure whether
we refer to a young or old man,
slim or fat, with a beard or without.
In Egyptian script all these nuances
could be conveyed by modifications
made to the appropriate hieroglyph.
But this facility, while available, was
used only occasionally and most of
the hieroglyphs were standardized.
Their forms reflected at least to
some extent contemporary reality
and changed their appearance with
the represented object (e.g. tools
and boats). The hieroglyphs on
the walls of the festival kiosk of
Senwosret I are renowned for their
elegance and attention to detail.

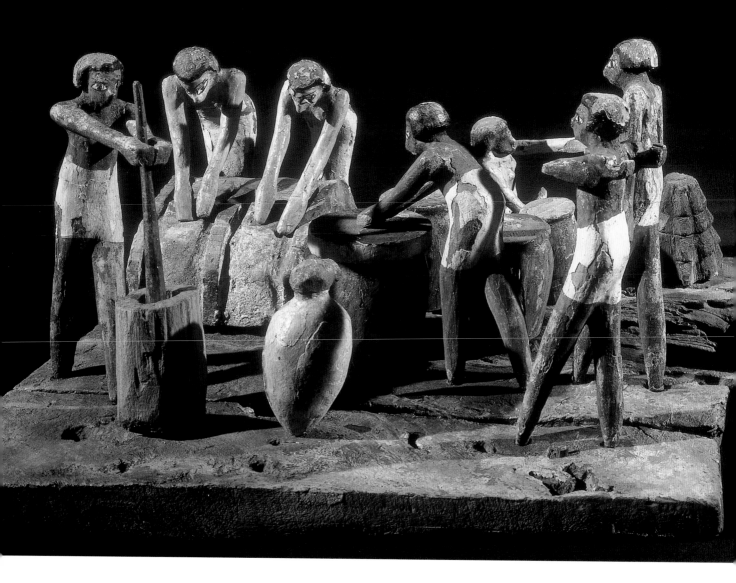

Baking and brewing, model from a tomb at Asyut

*c.*1900 BC. Wood, l. 41 cm, 16 in.
Museo Egizio, Turin

Egyptian burial places and their decoration expanded or contracted according to prevailing conditions, and ranged from tombs with multi-room chapels to coffins in small undecorated burial chambers. The two most important elements to which all tombs could be reduced were a coffin with the body of the deceased person and a stela with the name of the deceased and the so-called offering text requesting offerings to be made at the tomb. People engaged in the preparation of food and drink were depicted in publicly accessible tomb chapels. When, however, the tombs did not have decorated chapels, the role of these scenes was taken over by wooden models (see also 101) placed in the burial chamber, often piled up on top of the coffin. Because models are truly three-dimensional and carved with a certain primitive realism which is little affected by the conventions of Egyptian official art, they can be more informative than reliefs or paintings. But unlike reliefs, they are never inscribed. Models showing groups of people engaged in the baking of bread and the brewing of beer are among the most frequent. Here we can see two men grinding grain on large querns for baking bread. A man is dehusking grain by pounding it with a pestle in a mortar in the first stage of brewing beer, while another is rinsing chaff out of the mixture of ground sprouted grain (malt) and cooked grain in order to obtain wort, necessary for fermentation in beer-making.

Dagger of Princess Iti,
from her tomb at Dahshur

*c.*1890 BC. Gold, bronze, lapis lazuli, felspar, carnelian, l. of whole 25.8 cm, 10 in. Egyptian Museum, Cairo

The intact burial of Iti, probably a daughter of King Amenemhet II, was discovered at Dahshur. Among the objects found on the body of the princess was a magnificent dagger. Until the middle of the second millennium BC the dagger was the only thrusting weapon for close combat in the Egyptian armoury (the sword was not known). However, Iti's dagger was almost certainly ceremonial, probably a sign of royal status, and was not intended to be used in anger. Its blade is of bronze, the hilt of gold. The large pommel consists of a crescent-shaped piece of lapis lazuli attached to a gold base. The hilt is decorated with 36 rosettes set in gold. The four petals of the flowers are inlaid with lapis lazuli and felspar, with carnelian inlays between the rosettes. The guard of the dagger is made of gold and the blade is attached to it with three gold rivets. Although the form of the dagger is purely Egyptian, serious arguments have been advanced in favour of a theory according to which it is a foreign import, perhaps from Crete or Byblos on the Lebanese coast. The last word about this weapon has not yet been said.

Collar of Princess Khnumet, from her tomb at Dahshur

*c.*1890 BC. Gold, carnelian, lapis lazuli, turquoise, w. 35 cm, 13¾ in.
Egyptian Museum, Cairo

Jewellery made in the early second millennium BC seems to have been more attractive than at any other period of Egyptian history, but this may simply mean that it is closest to our own ideals of elegance (see also 124 and 125). We are fortunate in having some personal ornaments of several royal ladies of the 12th dynasty who were buried at Dahshur. The broad collar was a typically Egyptian item of jewellery worn by men as well as women. The gold openwork collar found on the body of Princess Khnumet is astonishingly delicate, and its combination of inlays in semi-precious stones gives it an understated grace. This was, no doubt, a gift from the king and references to royalty are conspicuous. The first four of its five rows of pendants are in the form of alternating hieroglyphic signs for life (*ankh*), stability (*djed*) and dominion (*was*), the three concepts closely linked to kings and deities. The pendants increase in size downwards and are inlaid in blue-green turquoise and red carnelian. The fifth row consists of large gold drop beads. The terminals with which the collar was fastened around the neck imitate Horus-hawk heads and are inlaid with blue lapis lazuli, carnelian and green jasper.

Fish pendant,
from a tomb at El-Haraga

*c.*1880 BC. Gold, l. 4 cm, 1½ in.
Royal Museum of Scotland, Edinburgh

Several gold pendants in the form
of the fish *Synodontis batensoda*
were found accompanying a child's
burial at El-Haraga. They may have
belonged to a necklace, been
attached to a garment or, most
probably, were hair ornaments.
It is not possible to establish with
certainty whether the choice of
this particular fish was for purely
aesthetic reasons or whether the
attraction was its very unusual
characteristic: it swims upside
down when feeding. The pendants
may have been amulets intended
to protect the wearer from
drowning. As is often the case with
subjects taken from the animal
world, there is little to suggest that
the pendants were made by an
ancient Egyptian artist. Although
certain poses and ways of seeing
animals, birds or fish became
standard, they were never as rigid
as depictions of human beings
governed by the conventions of
Egyptian two- or three-dimensional
representation (see also 72). This
representation of *Synodontis
batensoda* is so naturalistic and
displays such convincing details
that if the circumstances of the
discovery were not known, it
could be claimed by several other
cultures and might even easily pass
as a product of a modern artist.

Head of a queen, from a sphinx, location of discovery not known

*c.*1880 BC. Dark green
stone, h. 38.9 cm, 15 in.
Brooklyn Museum of Art, New York

Sphinxes, creatures with a human
head and the body of a lion, were
usually set up along approaches
to temple gates (see 61 and 234).
Their guardian role derived from
statues of lions which had been
used in the same way from very
early in pharaonic history (see 88).
The head was usually that of a
king but sphinxes of royal women,
either queens or princesses, were
made during the Middle Kingdom,
after 2000 BC. This was one of
several periods when royal women
enjoyed unusual importance
because of the emphasis placed
on descent from a particular
queen. Egypt was, on the whole,
a monogamous society although
cases where a man had several
wives are known. The king had
more than one queen and there
was a clear hierarchy in their
positions at the court. The eyes of
this queen are extended by lines
of cosmetic paint, and a similar
treatment probably accounts for
her heavy eyebrows. The queen's
own hair shows beneath her
massive wig and a small uraeus
(cobra) on her forehead indicates
her royal status. Her eyes have
lost their original inlays.

King Senwosret III, location of discovery not known

*c.*1860 BC. Obsidian, h. 12 cm, 4³⁄₄ in. Museu Calouste Gulbenkian, Lisbon

Among Egyptian royal sculptures those of Senwosret III and his successor Amenemhet III reign supreme. It is as if the sculptor copied the best statues of the Old Kingdom but took away their unquestioning supreme self-confidence and replaced it by an awareness that painful decisions have to be made and that success is not always guaranteed. This, at least, is how we should like to interpret these sculptures in their historical context. Their naturalism is not in doubt but to see them as an expression of the spirit of the period is a very modern approach and probably not justified when dealing with Egyptian sculptures. Even the best among them were not made to convey inner feelings of the person whom they represented. But if our modern interpretations are mere wishful thinking, what accounts for these extraordinary faces? The likeliest explanation is that they belong to a new sculptural style which deliberately distanced itself from the idealizing statues of the beginning of the 12th dynasty. The head in the Gulbenkian Museum displays the characteristics of this style in extreme. The sunken eyes, high cheekbones in a deeply furrowed face and slightly down-turned lips suggest that this is a realistic representation of King Senwosret III.

Birds in an acacia tree, in the tomb of the overseer of the Eastern Desert, Khnumhotep II, at Beni Hasan

*c.*1880 BC. Wall painting on plaster

Tomb and temple arts were directly dependent on the prevailing political and economic situation in the country because they were made to order. After the sometimes charming but hesitant efforts during the First Intermediate period (92–3), painting reached a remarkably high standard during the 12th dynasty. The reasons for it were historical. The families of local princes in Middle and northern Upper Egypt were, probably in return for their acceptance of the Theban overlord, able to retain a considerable degree of self-government and they had large rock-cut tombs made as their burial places. The main centres of artistic excellence were Qaw el-Kebir, Asyut, Meir, Deir el-Bersha and Beni Hasan. The decoration on tomb walls may have been carved in relief or just painted. The birds painted in the tomb of Khnumhotep II at Beni Hasan are only a very small detail of a scene showing the tomb owner netting fowl in a clap net. The theme is traditional and it is unlikely that Khnumhotep ever indulged in this activity. It is equally improbable that he ever attempted to spear fish in the marshes or hunt wild fowl with a throwstick, as suggested by the scenes flanking the netting of fowl. But the details of this fictitious event are completely naturalistic and accurately observed.

Three daughters of Djehutihotep II, the chief of the Hare district (El-Ashmunein), from his tomb at Deir el-Bersha

*c.*1870 BC. Raised relief in limestone, h. 80 cm, 31 in. Egyptian Museum, Cairo

The tomb of Djehutihotep II at Deir el-Bersha is one of the most accomplished in Middle Egypt during the 12th dynasty. The three daughters preceded a large figure of Djehutihotep. It is interesting how the artist solved the difficulty of representing their dress held by two straps in the obligatory front view of the upper part of the body, as well as their rather ample bosom indicated by one breast shown in side view. The impression is that the dress left the breasts exposed but this is unlikely. It is more probable that this simply combines side and front views. The faces of the three daughters are rather severe but their figures are remarkably slim. They conform to a fixed grid of proportions of the human body which became established during the Middle Kingdom. If the height of the whole figure, from the soles of the feet to the point where the wig touches the forehead (here the horizontal fillet of the lotus diadem), is divided into eighteen equal parts, the top of the sixth section from the bottom intersects the leg at the knee or just above it, the eleventh at the waist, the twelfth at the elbow and the sixteenth at the shoulders. This canon of proportions was in use, with only minor modifications, until the Late period.

Procession of attendants, from the tomb of Djehutihotep II, the chief of the Hare district (El-Ashmunein), at Deir el- Bersha

*c.*1870 BC. Raised relief in limestone, h. 33 cm, 13 in. British Museum, London

Because of the arrangement of scenes in registers and the consequent need to place figures on a base line, people are often arranged in 'processions' with little or no overlap (see also 173, 312–13). But this must be understood as not more than a way of representing groups of people and should not be regarded as a peculiarly Egyptian penchant for walking in a line. Such 'processions' approach the focal point of the scene, usually a large figure of the tomb owner or a deity in a temple. A large figure also provides a chronological benchmark so that if several stages of the same activity or several episodes of the same topic are shown in the same register, it is the scene closest to the large figure which is chronologically the most recent or where the activity is shown in its most advanced stage. Something similar applies to the chronological sequence of the registers themselves. The bottom register is the most recent one while the top register usually shows the early stages of the activity shown (see 162). This approach was at its most consistent during the Old Kingdom. When Djehutihotep's tomb at Deir el-Bersha was decorated other considerations already eroded the initially strict 'chronological logic' of wall decoration.

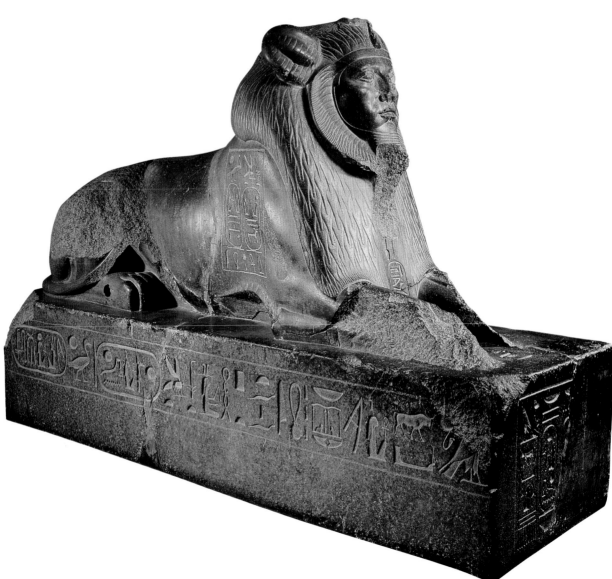

Sphinx of King Amenemhet III, from Tanis (San el-Hagar)

*c.*1850 BC. Granite, h. 150 cm, 59 in. Egyptian Museum, Cairo

Royal statues which were 'usurped' by other kings can help us understand the degree of importance the Egyptians placed on the likeness of the represented person. The naturalistically depicted face of this sphinx, with its high cheekbones, fleshy nose and full nearly straight lips, is that of statues of King Amenemhet III, although there are no inscriptions present which would inform us of the identity of the original owner. The sphinx is unusual in having a lion's mane instead of the *nemes* headdress (see also 88). Some 550 years later Ramesses II inscribed his names on the base of the sphinx and so made it his own, 'usurped' it, without making any alterations to the facial features of Amenemhet III. It was clearly thought that the change of the name was enough and that the face, which is quite unlike that of Ramesses II on his own statues, was less important. Later Kings Merneptah and Psusennes I had their names carved on the shoulders and chest of the sphinx (the former probably over another name added to the sphinx sometime during the Second Intermediate period) but did not try to obliterate the names of Ramesses II (unless perhaps they were made invisible by other means such as covering them up with plaster, of which traces do not survive). Their actions might, therefore, be regarded as 'participation' rather than 'usurpation'.

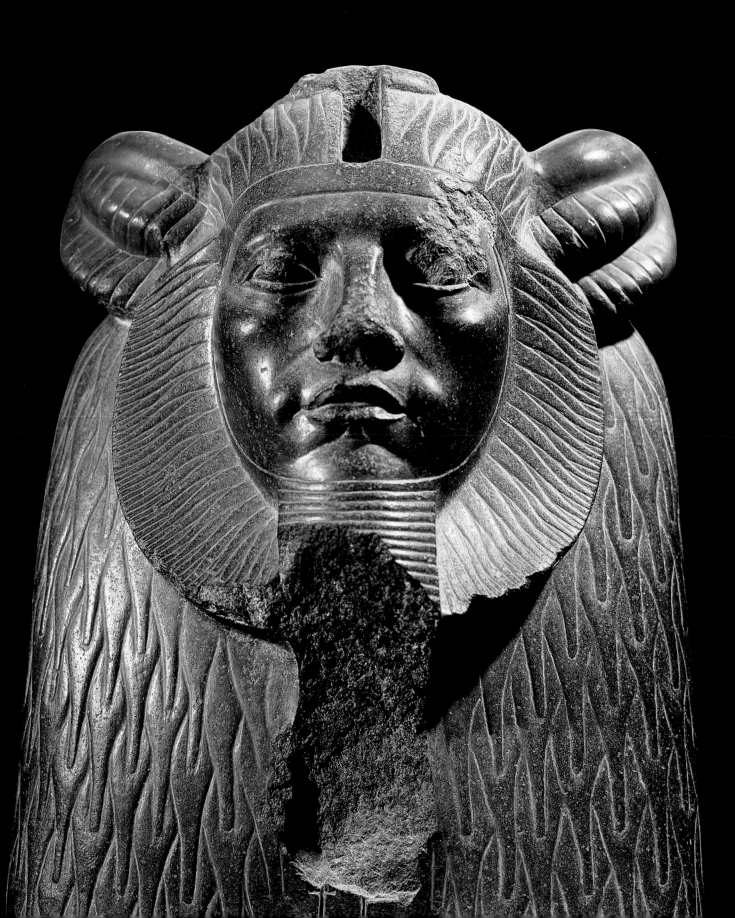

Amenemhet III, from Karnak

*c.*1850 BC. Granite, h. 73.5 cm, 29 in.
Egyptian Museum, Cairo

The best among Egyptian
sculptures, almost exclusively
those representing kings, can be
distinguished by their facial types.
But this remains fixed and does
not vary according to the statue's
setting. This is a powerful
argument against attempts to read
feelings and sentiments into facial
expressions of Egyptian statues.
Postures and gestures were,
therefore, immensely important.
A person seated was always of a
higher rank than a person standing.
The arms and hands convey the
situation quite unambiguously.
We know that this sculpture of
Amenemhet III was found in the
temple of Amun at Karnak, but even
without this information we would
recognize it as a temple statue. The
arms hanging down along the body
and the hands placed flat on the kilt
are a gesture of respect: the king
stands in the presence of his god.
In another gesture of high respect,
usually called 'adoration' (although
'supplication' may sometimes
be more appropriate), both arms
are held in such a way that they
resemble a large letter W, with the
palms of the hands open towards
the object of 'adoration' (see also
162, 255, 265). If the arms were
kept closer together with the palms
towards the person's face it would
be a gesture of mourning. One
arm stretched forward almost
horizontally, with the palm of the
hand open, is the gesture used
when addressing somebody.

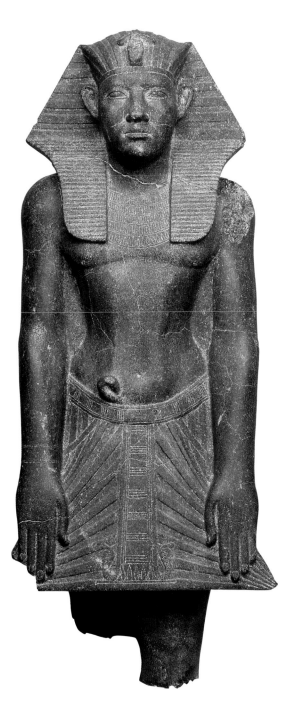

The roads of Mehen, on the coffin of General Sepi from Deir el-Bersha

*c.*1850 BC. Painting on gesso on wood,
70 x 65 cm, 27½ x 25 in.
Egyptian Museum, Cairo

During the First Intermediate period
there was a marked increase in the
attention paid to coffins. For many
people this was the only significant
funerary item, and coffins became,
in effect, miniature tombs
containing all that was needed
in the next life. Spectacularly
decorated coffins continued to be
made during the 12th dynasty. They
were painted on the outside as well
as the inside, usually on a thin layer
of gypsum plaster (gesso) applied
to the wood. Two features of these
coffins were regarded as essential
for the person's well-being in the
afterlife: painted 'friezes' (rows)
of various objects and inscribed
religious spells known as the Coffin
Texts. On the interior head-end of
the coffin of General Sepi, at the
top, the hieroglyphs record his
name and rank. Underneath, there
is a 'frieze' of objects, and further
down some of the spells
concerning the mythical Roads
of Mehen, with their illustration.
These were nine elliptical roads
which the deceased had to
negotiate in order to approach the
sun god Re. On Sepi's coffin the
god is shown seated on a throne
turning his head to face the viewer.
A full-face representation was very
unusual but these small scenes
accompanying religious spells often
break artistic conventions, as if they
did not apply in the other world
which they depict (see also 247).

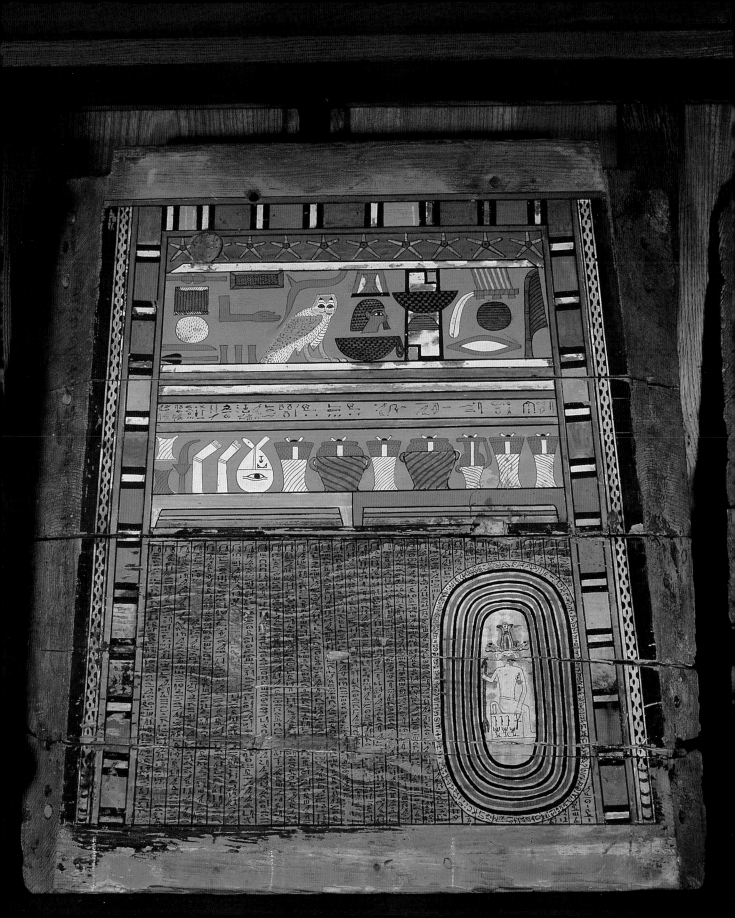

Vessel for cosmetics, location of discovery not known

*c.*1850 BC. Obsidian and gold, h. 4.9 cm, 1⁷₈ in. Cleveland Museum of Art

Many of the vases which were intended to hold cosmetics were of unusual and fanciful forms (see 104, 158, 217). Nevertheless, despite the ingenuity and skills of their makers none surpasses in elegance the simple cylindrical beakers known from the treasures of jewellery and various items of personal adornment which belonged to several royal ladies of the 12th dynasty. They are made of obsidian, a jet-black volcanic glass imported from Ethiopia which was particularly popular during the Middle Kingdom. The dark colour of the obsidian is set off beautifully against the glistening yellow of the burnished gold which covers the vessel's rim and forms a circle around the base. The gold was applied in the form of strips, two of which were compressed around the rim and one around the base. The beakers were provided with lids made of the same materials but the lid has been lost in the case of this vessel.

Mirror of Princess Sithathoriunet, from the 'Treasure of El-Lahun' found in her tomb

*c.*1850 BC. Gold, electrum, silver, obsidian, faience, carnelian, rock crystal, etc., h. 28 cm, 11¾ in. Egyptian Museum, Cairo

A complete set of jewellery and other items of an Egyptian lady of a high rank was found in the tomb of Princess Sithathoriunet near the pyramid of King Senwosret II at El-Lahun, at the edge of the Faiyum oasis. Sithathoriunet was a daughter of Senwosret II but must have died considerably later because she owned a pectoral bearing the name of Amenemhet III. The 'El-Lahun Treasure' contained a mirror which is an item of exceptional elegance. Egyptian mirrors are polished metal discs with a decorative handle. The metal is in most cases copper or bronze; Sithathoriunet's mirror is made of silver. Its form is not unusual but the craftsmanship is exquisite. The handle is of obsidian inlaid with gold and its shape is that of the papyrus plant in flower with the head of the goddess Hathor superimposed over it. Hathor was a goddess particularly closely connected with women. She could appear in bovine form and so her head on the handle of the mirror displays the large ears of a cow. The head is a miniature masterpiece in its own right, made in two halves, of gold, with inlaid brows and eyes.

Pectorals of Princess Mereret, from her tomb at Dahshur

*c.*1820 BC. Gold, amethyst, carnelian, turquoise, lapis lazuli, h. 6.1 and 7.9 cm, 2 and 3 in. Egyptian Museum, Cairo

The pectoral (a necklace with a large pendant falling down on the breast) in the form of a small shrine with supporting poles and a corniced roof first appeared during the Middle Kingdom and remained popular through the rest of Egyptian history (see 294). More than most other items of jewellery, these pectorals conveyed messages concerning religion, kingship and life after death. These two openwork examples were found in a cache of jewellery near the plundered tomb of Princess Mereret, a daughter of King Senwosret III (see also 125). Although designed differently, both carry a similar message about the king's supremacy over foreign lands. The first shows two griffins, mythical creatures with the body of a lion and the head of a hawk, trampling on foreign enemies. The griffins symbolize the king himself and flank the name of Senwosret III written in a cartouche. A vulture spreads its wings above the whole scene. The second pectoral also has a symmetrical scene which uses the symbolic scene of a king ritually slaying captive enemies with a mace. The two cartouches are those of Amenemhet III. The jewellery must have been given to the princess by her father and brother. The pectorals were made in openwork cloisonné (set in metal 'cages') technique which employed semiprecious stones as inlays.

Girdle and anklet of Princess Mereret, from her tomb at Dahshur

*c.*1820 BC. Gold and amethyst,
l. 60 and 34 cm, 23³⁄₄ and 13¹⁄₂ in.
Egyptian Museum, Cairo

By the time of the Middle Kingdom the range of jewellery worn by high-ranking ladies included all the types known from ancient Egypt. Diadems and earrings adorned the heads (face jewellery decorating the eyebrows, nose or tongue was not known). Collars, necklaces and pectorals were worn round the neck, and bracelets and rings on the arms and hands. Decorative girdles round the waist and anklets completed the personal adornment. The jewellery of Princess Mereret found at Dahshur (see also 124) included a girdle and an anklet. Women's ornamental girdles were often formed by imitations of cowrie shells or acacia seeds in gold. The beads which make up Mereret's girdle maintain the basic shape of acacia seeds but adopt the form of double heads of a big cat, the lioness or leopard. There is, no doubt, a meaning behind this but the symbolism of the big cat was so extensive that it is difficult to explain it with certainty. It may be a reference to one of the goddesses who manifested themselves in the form of a lioness. The heads are double-sided and hollow, each side cast separately. The beads contained small pieces of metal which may have been introduced intentionally because they rattled when Mereret moved. The gold pieces in the anklet represent feline claws.

Crocodile,
location of discovery not known

*c.*1820 BC. Bronze and electrum,
present l. 22.4 cm, 8³⁄₄ in.
Staatliche Sammlung Ägyptischer
Kunst, Munich

The crocodile was a much-feared
animal regarded as a manifestation
of several deities, especially the
god Sobek in the Faiyum oasis.
This statuette was hollow-cast
of bronze and covered with a
layer of a black copper oxide with
emplacements for electrum (an
alloy of gold and silver) inlays. The
crocodile is shown in its standard
'hieroglyphic' form. Although the
pattern of the rectangular scales
on its back is uniformly geometric,
the overall impression is
remarkably naturalistic. The animal
was originally placed on a now-lost
pedestal which may have been
inscribed. It is clear that this was
a costly temple item, perhaps
presented to the temple by the
king or a person of very high
standing, and that it cannot be
compared to the bronze statuettes
of animals, thousands of which
were given to temples by pilgrims
during the first millennium BC.
This is intriguing: until sometime
after 1400 BC fully zoomorphic
representations of deities were
characteristic of the religious
beliefs of ordinary people while the
official state religion of the temples
preferred mixed human-and-animal
forms and shunned animal cults
(see also 311).

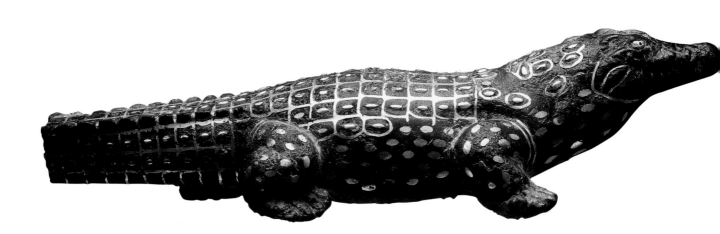

Hedgehog,
location of discovery not known

*c.*1800 BC. Faience, l. 9 cm, 3½ in.
Ägyptisches Museum, Berlin

Protection against everyday dangers that may threaten in the afterlife was probably the reason for the inclusion of faience statuettes of hedgehogs in tombs during the first half of the second millennium BC. The hedgehog's ability to destroy various noxious creatures, such as scorpions and insects, and even snakes, was valued. This statuette is made of Egyptian faience, a glazed material which consists mainly of crushed quartz or sand with some additional ingredients. Rudimentary faience technology was known in the Predynastic period but it was the first half of the second millennium BC that witnessed marked increase in the production of small objects in this medium. The making of a faience statuette involved modelling the form by hand with the help of a binding agent; hedgehog statuettes such as this one were shaped around a straw core. The bright blue colour is due to the presence of copper in the coating which produced the glaze. The tips of the spines were painted in black before glazing. This statuette of a hedgehog is completely naturalistic and quite unaffected by any special conventions of Egyptian art.

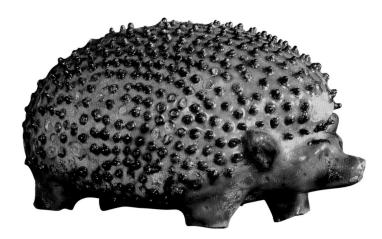

Hippopotamus, probably from a tomb at Dra Abu el-Naga

*c.*1800 BC. Faience, h.12 cm, 4³⁄₄ in.
Louvre, Paris

In the first half of the second millennium BC, faience statuettes of hippopotami were regularly included among grave goods. The hippopotamus can be standing, walking, lying down, turning its head or lifting it as if baying, or even sleeping. There are no indications that these were hunted animals and so the likeliest function of these little sculptures was apotropaic (protective). The hippopotamus was the only animal powerful enough to kill a crocodile and its presence in the tomb would have provided protection against these dangerous reptiles in the afterlife. The creation of these faience statuettes involved modelling of the soft core rather than carving. There is one decorative technique which these beasts have in common with their Predynastic counterparts. The plants and birds, and even insects, which surrounded the hippopotamus in its natural habitat, were drawn in black manganese paint on the body of the animal before glazing.

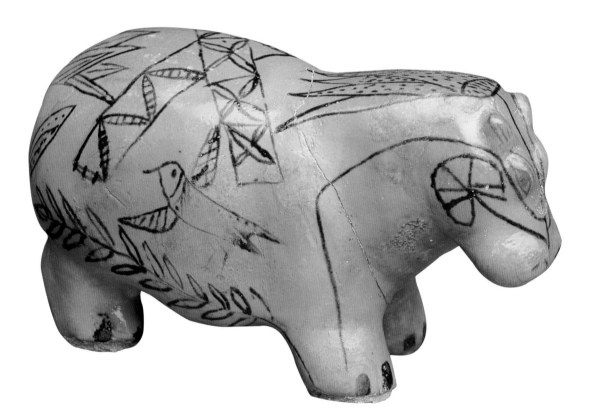

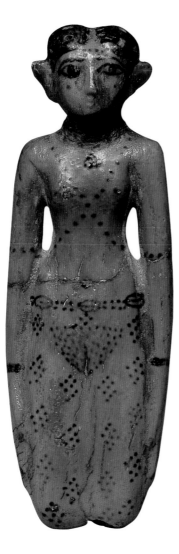

Companion of the dead, from a tomb in Western Thebes

*c.*1800 BC. Faience, h. 13.3 cm, 5¼ in.
Ägyptisches Museum, Berlin

Nude female figurines were sometimes included among tomb goods in the first half of the second millennium BC. These were not the usual tomb sculptures. Rather, the purpose of such a statuette was to act as a female companion and to ensure that the person was able to procreate, and possibly enjoy sex, in the afterlife. Tattoo marks, here forming a regular pattern of lozenges on the woman's hips and legs, occur often and the figure's sexuality is indicated in no uncertain way. The woman represented in this statuette wears a decorative girdle consisting of cowrie shell beads low on her hips. Artistically, these statuettes are interesting because their legs terminate at the knees. It has been suggested, probably only partly seriously and almost certainly mistakenly, that this was to prevent them from escaping. But these are not sculptures made according to the strict artistic rules, and a contradiction of the concept of completeness which elsewhere is so important in Egyptian art did not matter (see also 62). They were often made of faience and shaped in a mould; the absence of feet would have greatly simplified their manufacture.

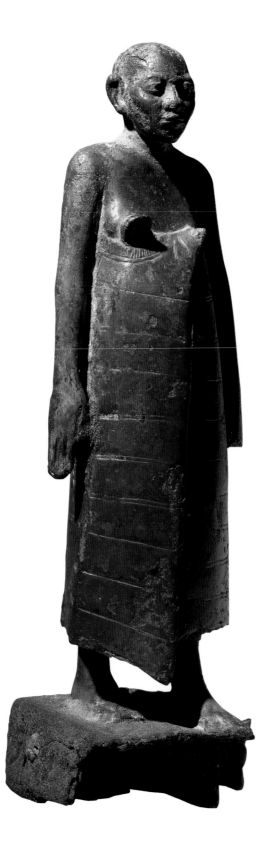

Corpulent man,
location of discovery not known

*c.*1750 BC. Bronze, h. 28.3 cm, 11¼ in.
Louvre, Paris

During the third millennium BC
only royal statues were made of
copper or bronze (see 87). Non-
royal statuettes in this expensive
material appeared in the second
millennium BC but for the first few
centuries remained rare. They were
mostly manufactured by the lost-
wax casting method in which
the 'wax' was moulded around a
central core (hollow casting). They
were quite small and only rarely
inscribed. The material of this
statuette is a copper alloy which
contains some 5 per cent tin and
1 per cent arsenic. Its arms and
legs were made separately and
assembled with the body. The
statuette displays several typical
features of the end of the 12th or
the 13th dynasties, especially the
bald head with large eyes and ears
and the long arms and big hands.
In a process similar to that which
took place at the end of the Old
Kingdom and the First Intermediate
period the length of the lower part
of the statuette from the chest
down increased in length (see
86). There is, however, one
clear difference from the earlier
sculptures. The figure is far from
slim and the tendency towards
corpulent types was now quite
noticeable (see also 133).

Scimitar, from Shechem (El-Balata, near Nablus, on the west bank of the Jordan)

*c.*1750 BC. Bronze, electrum, niello, l. 45.2 cm, 17³⁄₄ in. Staatliche Sammlung Ägyptischer Kunst, Munich

This bronze scimitar (sickle sword) was found, together with a hoard of other weapons, at Shechem (El-Balata), east of Nablus. The scimitar was not originally an Egyptian weapon although it was used in Egypt from the middle of the second millennium BC. There was no corresponding slashing weapon known in Egypt before that except for the battleaxe with a long scalloped blade. The absence of the sword is usually explained by the relatively low standard of Egyptian metalworking. This scimitar has a central raised rib running the whole length of its blade which is inlaid with electrum on the background of a layer of black copper oxide. The main element of the decoration is a lotus flower, and its stalk is filled with double spirals, parallel lines and small interlaced four-petalled flowers. The lotus flower is undeniably Egyptian but the scimitar was almost certainly manufactured outside Egypt, possibly in Byblos in modern Lebanon. It may have been made to Egyptian order but exactly how the transmission of the artistic motif took place is not clear.

The ka ('life energy') of King Awibre Hor, from his tomb at Dahshur

*c.*1750 BC. Wood, originally gilded, h. 170 cm, 66 in. Egyptian Museum, Cairo

The *ka* was the force animating and bringing to life the visible form (the body or a statue) which a person's *ba* ('personality' or similar) adopted. It was, therefore, immaterial and formless. The texts concerning offerings brought to tombs specifically state that they are intended 'for the *ka*', in other words to sustain the life energy. This statue was found in a wooden shrine in the tomb of King Awibre Hor. The two arms on the head of the statue are a hieroglyph which reads *ka* and identifies it as a representation of the king's life energy. The figure originally held a long staff in the left hand and a sceptre in the right hand. That this is not a statue of the king himself is clearly indicated by the tripartite wig, often worn by deities, and the curved divine beard. The main function of Egyptian temple and tomb arts was to express ideas and abstract concepts. Here, the artist portrayed something which, by definition, did not lend itself to being represented.

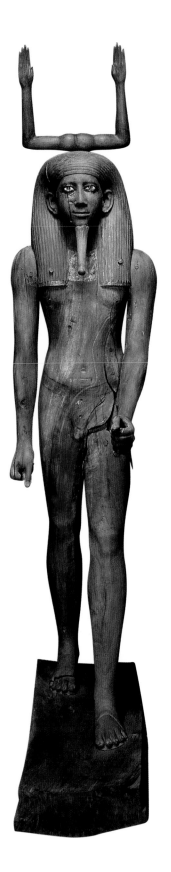

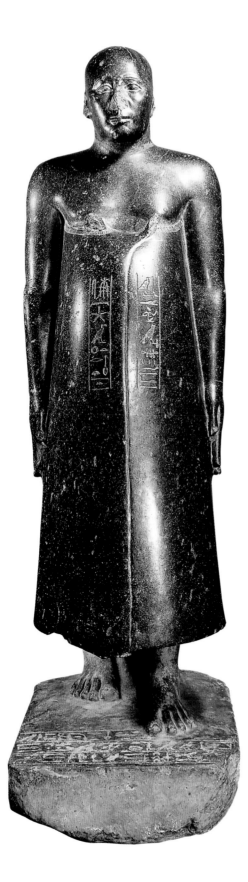

The herald in Thebes, Sobekemsauf, from the temple at Armant

*c.*1710 BC. Granodiorite,
h. 150 cm, 59 in.
Ägyptisch-Orientalische Sammlung,
Kunsthistorisches Museum, Vienna
(the base on loan from National
Museum, Dublin)

The high achievers of the 12th
dynasty were succeeded by kings
who, in restricted circumstances,
tried to maintain the tradition of
the Middle Kingdom for another
century and a half, until about
1648 BC. There was no spectacular
collapse but rather a gentle
decline. The arts mirrored political
events. Decorated tombs all but
disappeared and monumental
temple building fizzled out. But
occasionally, especially in the
sculpture in the round, a piece of
startling quality appears, which
shows that some workshops were
still able to produce excellent
results. The statue of Sobekemsauf
shows a hugely obese bald man. If
inexpertly handled, this could have
been a caricature, but the sculptor
has succeeded in endowing
this faintly absurd figure with
tremendous physical presence
and understated authority. The
implication is clear: this is not a
man to cross. In the case of such
an outstandingly naturalistic statue,
we should like to know whether
this is how Sobekemsauf really
looked. Would a thinner man
have accepted the statue as his
likeness? Unfortunately, the answer
is yes. For most Egyptians this was
not obesity but a mark of well-being
and status and so a very desirable
state of affairs.

Bull and an acrobat, from Tell el-Daba

*c.*1530 BC. Fresco on plaster,
l. 40 cm, 14³⁄₄ in.
Supreme Council of Antiquities,
Tell el-Daba

The influence of Egyptian art on the cultures of neighbouring countries has never been in doubt. There has, however, been a tendency to understate artistic ideas brought to Egypt from abroad and confine them to details of little importance, as if they somehow devalued Egyptian art. This is now changing rapidly as the intensity of various forms of artistic contacts throughout the ancient Near East and the Eastern Mediterranean is becoming apparent (see also 109, 131). Tell el-Daba, ancient Avaris, in the eastern Delta, became an important centre for migrants from Western Asia during the late Middle Kingdom. It was from there that the takeover of the country was launched by their leaders, the Hyksos. Even after the defeat of the Hyksos by King Ahmose around 1540 BC Tell el-Daba remained the focus for foreign contacts. This has been confirmed by an extraordinary discovery of fragments of frescoes in Minoan style which probably adorned a local palace (the Egyptian king had residences in various parts of the country). The frescoes were almost certainly made by itinerant Minoan artists and seem to be directly related to those in the palace at Knossos in Crete. The question of why the Egyptians employed Minoan artists for the decoration of a building at Tell el-Daba is not easily answered. The new ruling élite's demand for the exotic and luxurious probably was the main motive, encouraged by the fact that what was acceptable in the outlandish conditions at Tell el-Daba would not be easily received elsewhere.

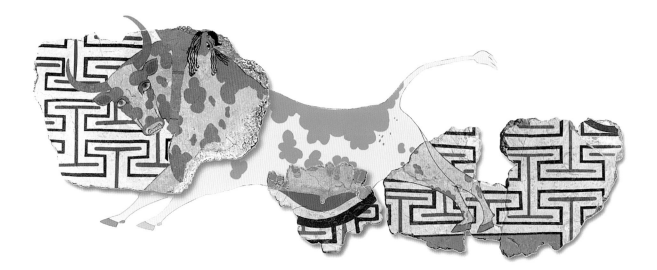

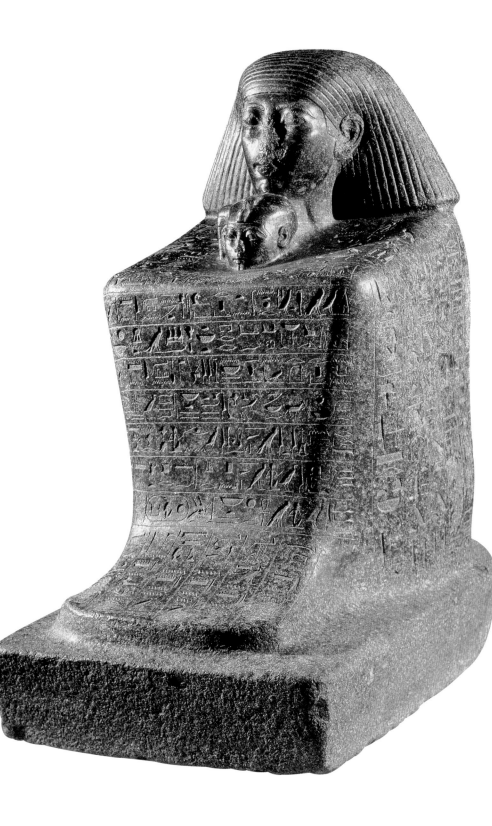

Senenmut and Princess Neferure, perhaps from the temple of Amun at Karnak

*c.*1475 BC. Granite, h. 100.5 cm, 39½ in. Ägyptisches Museum, Berlin

Through many finished works one can perceive the outlines of the original cube of stone which the sculptor began to reduce as the statue was fashioned. Before he embarked on carving the block into the desired shape, the sculptor sketched the front and side views of the statue on it, often with the help of a grid in order to maintain the required proportions. This procedure explains why the conventions of two-dimensional and three-dimensional representation are so closely linked. The obduracy of stone, especially hard stone, encouraged compactness and put a limit on elements freed from the mass of the sculpture. None of the sculptural types demonstrates this better than the so-called block statues. A block statue is basically a cube; only the head and feet, and occasionally details such as the child's head in the statue illustrated here, stand out. Nevertheless, there is a certain effect of naturalism: people seated on the ground with a cloak tightly drawn over the knees would have been common. A block statue provided a great deal of space for texts which very often covered it almost completely. This statue shows Senenmut, a very influential official during the reign of Queen Hatshepsut, with Neferure, the young daughter of Thutmose II and Hatshepsut.

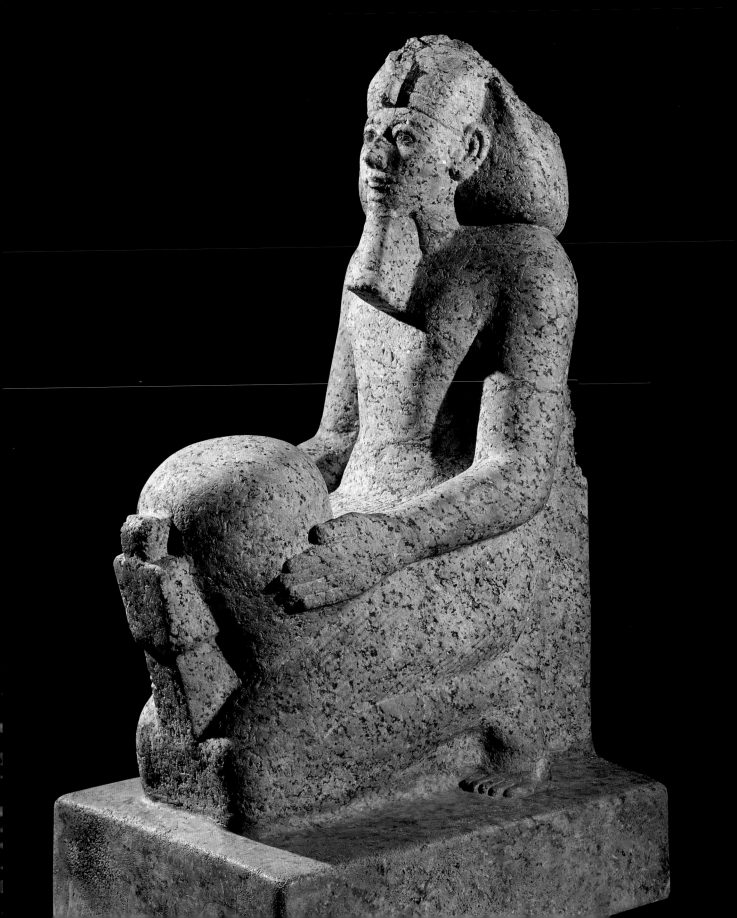

Queen Hatshepsut, from her funerary temple at Deir el-Bahri

*c.*1465 BC. Red granite, h. (without the restored base) 76 cm, 29 in. Ägyptisches Museum, Berlin

Egyptian artists were well used to depicting queens as royal consorts but it was a different matter when it became necessary to represent queens reigning in their own right. But the number of such occasions was minimal and Queen Hatshepsut was only the third or fourth woman on the Egyptian throne in the first 1,500 years of Egyptian history. She was crowned as a pharaoh because of the youth of her nephew (a son of her husband Thutmose II and another wife) Thutmose III. This kneeling statue made to represent her is one of several hundred made for her funerary temple at Deir el-Bahri. The queen is kneeling holding a vase with the symbol of stability (*djed*), and it seems likely that the sculpture was made for the occasion of the queen's jubilee festival. The god before whom the queen is meant to be kneeling is almost certainly Amun. There is little to suggest that this is a statue of a woman except the face which is ambiguous. The queen wears a male *khat* headdress, a ceremonial beard and a short kilt. She is bare-chested but the body might as well be that of a man. Such masculine sculptures are typical of the end of Hatshepsut's reign; statues of her early years may show her in a male attire, but with a charmingly delicate feminine face.

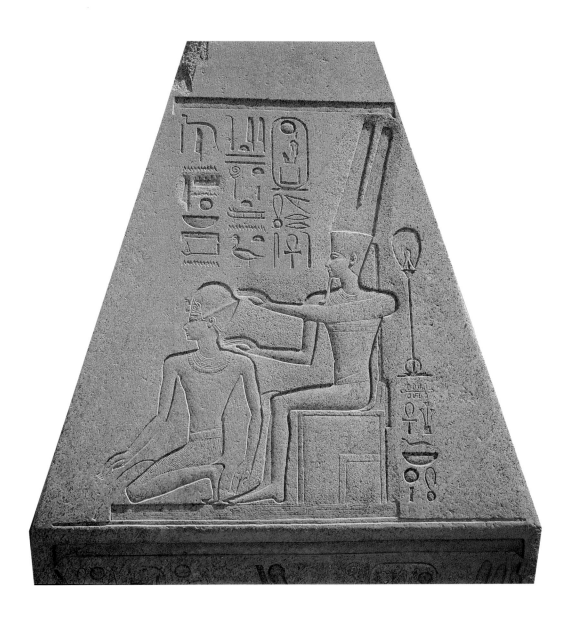

Queen Hatshepsut crowned by the god Amun-Re, on the broken-off summit of an obelisk in the temple of Amun at Karnak

*c.*1465 BC. Sunk relief in red granite, original h. of the whole obelisk c.30 m, 94 ft

Some reliefs display corrections and changes made either during their carving or at a later date. The reasons for an interference with the original design varied, from artistic to political and religious. Reliefs and inscriptions may have been altered even before their completion, usually because of the change of the overall design rather than the ineptitude of the sculptor or an accident during the carving. In such cases the surface of the wall was made good in plaster and the new scene or detail was carved again. Unfortunately, the plaster may have by now fallen off and we are faced with parts of both carvings. Another possibility was to cut away the earlier scene or inscription completely and carve into the new surface. Such corrections tend to betray themselves because of the greater depth of the carving. In the case of Queen Hatshepsut's obelisk at Karnak the reasons for the change were religious. The name of the god Amun-Re in the first column of text from the left was cut away under King Akhenaten when the names of the traditional gods were replaced by that of the Aten (the sun disc). Also the figure of Amun-Re was attacked. However, when Akhenaten's revolution was over, both were restored.

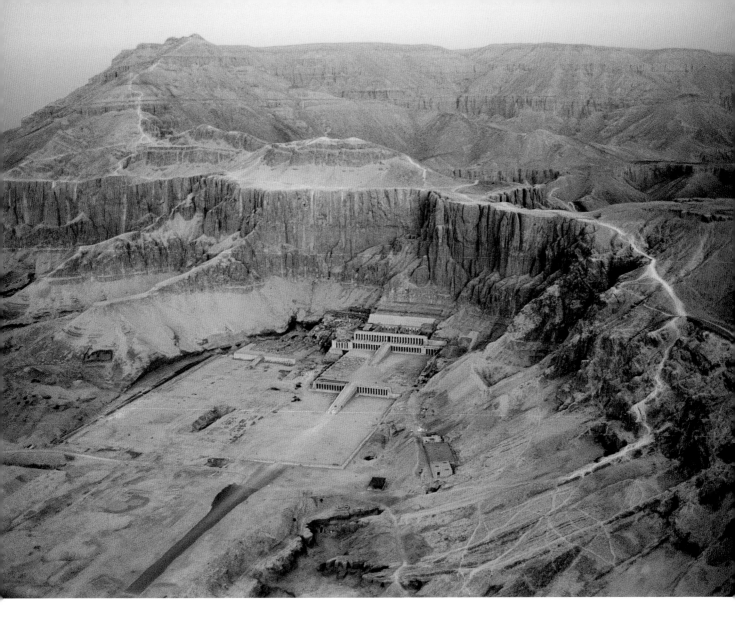

The funerary temple of Queen Hatshepsut at Deir el-Bahri

*c.*1460 BC. Limestone

Although modern settings of many Egyptian temples are very picturesque it is unlikely that landscape played an important part in the architect's plans. The temple was deliberately separated from its surroundings by enclosure walls and protected from any possible encroachment by the forces of evil and chaos from outside by a pylon, a massive front wall with an entrance gate (see 142). Queen Hatshepsut's temple at Deir el-Bahri (on the right in the illustration) is set in a bay in high cliffs and approached by a rising causeway. Its unusual terraced plan with pillared porticoes imitates the temple of King Nebhepetre Mentuhotep II of the 11th dynasty, and so nearly 600 years older, lying next to it (on the left). The main purpose of the temple was to perpetuate the queen's funerary cult and in this respect it may be compared to the temples built next to the royal pyramids of the Old Kingdom. There the king was buried inside the pyramid and the temple for his funerary cult (usually described as a pyramid temple or an upper temple) was immediately to the east of it. Rulers of the New Kingdom were interred in the necropolis on the Theban west bank, mostly in the Valley of the Kings, but their funerary temples were lined up in the plain along the Nile (see 167, 246, 250–1).

Headdress, from the tomb of the three wives of King Thutmose III in Wadi Qubbanet el-Qirud (the west bank at Thebes)

*c.*1460 BC. Gold, carnelian, turquoise, glass, faience, h. 36 cm, 14 in. Metropolitan Museum of Art, New York

This headdress, or wig cover, has been completely reconstructed using its original elements which were found in a tomb badly affected by water. The reconstruction has undergone some changes but is reliable. The form of the headdress can be compared to a headscarf which covers the sides and back of the woman's head and falls down on her shoulders. The piece which keeps the headdress together is an oval gold plate on the crown of the head with rings for the suspension of strands of rosettes. There were about 24 rosettes, increasing in size downwards, on two strings in each strand, with a diamond-shaped inlay element combined with the top rosette, and three lunettes combined with the rosette at the bottom. Each of the nearly 900 cloisonné rosettes was inlaid with semiprecious stones, glass or faience. It is likely that there were pendants attached to the crown plate hanging down onto the forehead. The headdress probably weighed nearly 2 kilograms (nearly 4$\frac{1}{4}$ pounds) when all elements and inlays were in place.

Probably young King Thutmose III, location of discovery not known

*c.*1455 BC. Siltstone, h. 45.7 cm, 18 in.
London, British Museum

The difficulties associated with the identification of this head epitomize problems often encountered when we try to assign unprovenanced and uninscribed sculptures to specific rulers. They also underline the importance of the context for works of art. The task of identification and interpretation is made significantly easier if we know the circumstances in which the item has been found. There is a general agreement that this head shows either Queen Hatshepsut or King Thutmose III. The differences between the faces of statues of these two rulers can be very small. They were an aunt and a nephew, and unless we believe that there was no connection whatsoever between the rulers' appearance and their statues, an unlikely proposition, some facial similarity is to be expected. The face of the illustrated sculpture appears youthful and feminine but it is different from Hatshepsut's early statues. The physiognomy of her sculptures underwent significant changes towards the end of her reign, almost as if it reflected her advancing years (see 136). The less usual material of this sculpture may have had some influence on its appearance, but unless this is a highly idealizing sculpture, it is more likely that the head shows young Thutmose III.

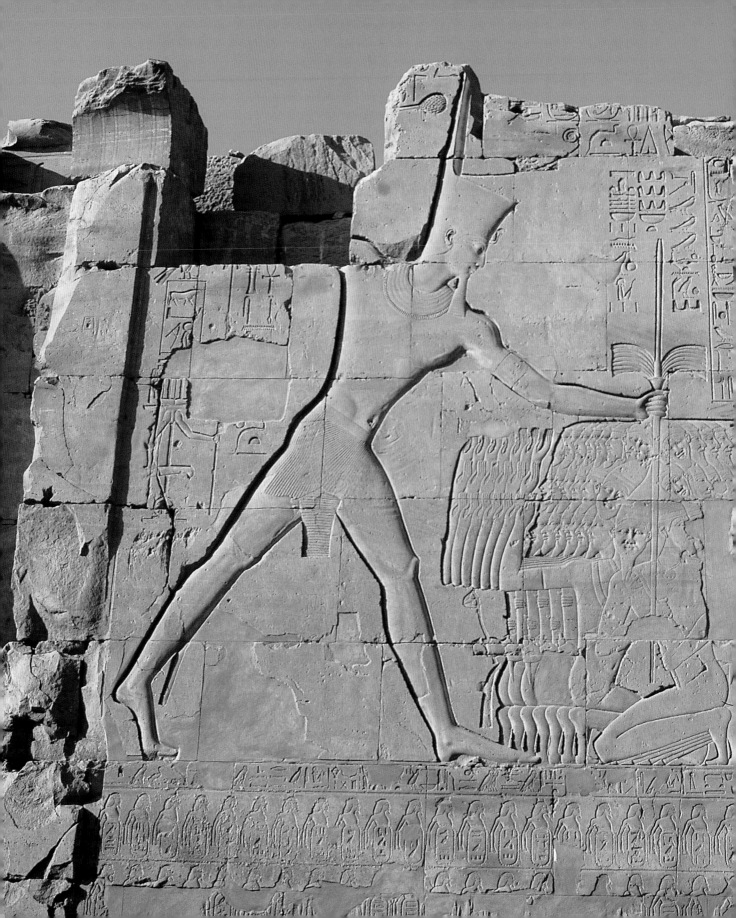

King Thutmose III massacring enemies, on the southern face of the 7th pylon of the temple of Amun at Karnak

*c.*1450 BC. Sunk relief in limestone

A pylon is the temple's front wall with an entrance gate (see 234, 320). It is of massive proportions because its role is to protect the temple from the forces of chaos which threaten to invade it from outside. Its decoration often consists of a huge scene in sunk relief which shows the king ritually killing foreign captives. One of the main tasks of the king was to maintain the order of the world and protect it against enemies and the forces of nature which put it at risk all the time. An artistic expression of this ideological concept is the colossal scene found on the 7th pylon of the temple of Amun at Karnak. The theme appeared early in the third millennium BC and was used, with variations, throughout the rest of Egyptian history (see 353). Although it looks very convincing, it was a symbol and not a reflection of a real event – perhaps with the exception of the Early Dynastic period, human sacrifice was not practised in ancient Egypt. The sunk relief used for the carving of the scene is the deepest ever found in Egypt. Artistically, it is interesting to see that the central figure in the bunch of captives whose skulls are about to be crushed by the king's mace is usually represented in a full face view, something which is only rarely encountered in Egyptian art (see 159).

Gold bowl of General Djehuty, from his tomb at Dra Abu el-Naga (the west bank at Thebes)

*c.*1450 BC. Gold, d. 18 cm, 7 in.
Louvre, Paris

From the very beginning of the pharaonic period metalworkers manufactured vessels for everyday as well as funerary purposes. Copper and bronze were most often used but also gold and even the more rare silver. This gold bowl is unusual because its inscription tells us that it was presented to General Djehuty by King Thutmose III. It was, therefore, made by one of the best goldsmiths of its time. The two main elements of the bowl's decoration are concentrically arranged lotus flowers and six fish (*Tilapia nilotica*). The bowl was beaten into shape from a sheet of gold, its decoration delicately hammered from outside in order to produce the equivalent of raised relief, and then finished with a chasing tool. One can see the attraction of such a design. When the bowl is filled with liquid any slight disturbance would appear to make the fish come to life. But *Tilapia nilotica* carries its eggs in its mouth and may seem to self-propagate, and the lotus bursts open above the surface of water in the morning and closes in the evening as if it were reborn every day. Both themes were linked to ideas about rebirth and fertility in the afterlife, and the bowl would have made an ideal funerary item.

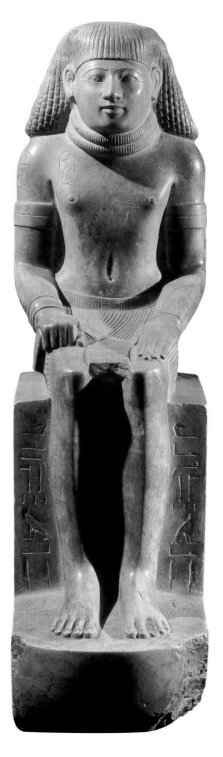

The overseer of priests, May, probably from the temple of the god Min at Akhmim

*c.*1430 BC. Limestone,
h. 73.5 cm, 28 in.
Ägyptisches Museum, Berlin

All Egyptian works of art destined for tombs and temples were made with a specific purpose in mind. In order to explain some of their characteristics it is necessary to understand how they functioned in the context of an Egyptian temple (see also 151). This seated statue of the overseer of priests, May, is dated to the reign of Thutmose III by the royal names written on it. But even without them we would assign it to the mid-18th dynasty by the type of wig which May wears and his face, which shares some of its characteristics with contemporary royal statues. The prominent nose, slightly slanting eyes, straight mouth, chubby cheeks and a faint, somewhat smug smile are all characteristics of statues of the mature Thutmose III. The sculptor made a good, albeit perhaps a little naïve, attempt at imitating royal sculptures. The statue, and so May himself in the afterlife, was entitled to a share of offerings presented to the temple by May's sovereign, Thutmose III. The cartouches written on the statue's right shoulder and the right breast were intended to prompt the memory of the priests when the occasion of the redistribution of offerings occurred in the temple.

Glass vessels, from graves at north Saqqara

*c.*1430 BC. Polychrome glass, h. 9.5 and 8 cm, 3³⁄₄ and 3¹⁄₄ in. Egyptian Museum, Cairo

Although small objects made of glass may have occasionally occurred earlier, manufacture on a larger scale did not begin until around 1500 BC. Some Egyptologists maintain that even then the Egyptians depended on Western Asia for raw materials from which glass objects were made. Throughout the New Kingdom glass remained a relatively rare material used for the making of luxury items such as vessels for oils used as cosmetics (see also 189). It was treated as an artificial semiprecious stone when used in inlays. Glass was not employed for the manufacture of mundane objects of everyday life such as bottles for the storage of ordinary commodities. Many polychrome glass vessels display this typical garland style decoration which was made by impressing heated glass rods of various colours to the body of the pre-heated vessel during its manufacture. The soft and pliable bands of different colours were then manipulated with a tool to produce a festoon pattern. The illustrated vessels were the most expensive items in the relatively modest graves in which they were found.

King Thutmose III suckled by Isis as a tree goddess, in his tomb in the Valley of the Kings (the west bank at Thebes)

*c.*1425 BC. Drawing on plaster

Tombs of 18th-dynasty kings were cut in rather poor limestone rock in the Valley of the Kings, opposite the city of Thebes. Their plan consists of a series of rooms strung like beads on a long string. The walls of the tomb of Thutmose III bear texts and representations taken from one of the 'afterlife books' called *Imi-duat* ('That which is in the underworld'). It seems that there was an attempt to retain the appearance of a text written on a papyrus. The texts are written in cursive hieroglyphs in red and black ink, and the representations are only sketched. This was the intended finished product, not a preliminary stage of the tomb's decoration. Sketched on a pillar in the oval-shaped sarcophagus room, Thutmose III is suckled by the goddess Isis as a tree goddess. The linking of a female breast and arm with a tree was achieved effortlessly; similar combinations had been known for some 1,500 years (see 27 and 28). They seem incongruous yet they express an ancient feeling of relationship to the natural world. The king was regarded as a manifestation of the god Horus and Isis was Horus's mother, often shown nursing him. Isis was closely connected with two other goddesses, Hathor and Nut, and so here she is also shown as a tree with human attributes.

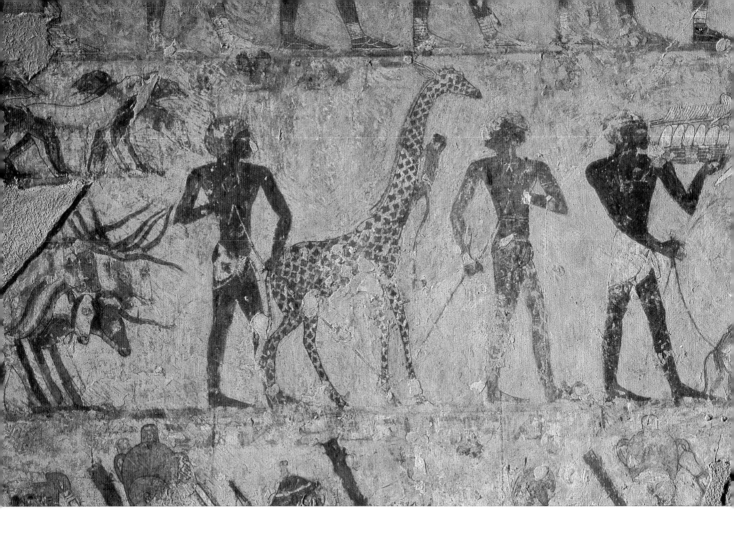

Nubians bringing tribute, and banquet scenes with female musicians and a servant girl, in the tomb of vizier Rekhmire at Sheikh Abd el-Qurna (the west bank at Thebes)

*c.*1425 BC. Wall painting on plaster

The rock-cut tomb of Rekhmire, the vizier (chief minister) of King Amenhotep II, was one of the largest and most spectacularly decorated at Thebes during the first half of the 18th dynasty. Its cruciform plan is simplicity itself: a large open court, a very wide but narrow outer hall (21 x 2.25 m, 69 x 7 ft), and a long and narrow corridor-shaped inner hall (26.5 x 1.95 m, 83 x 6 ft 5 in) with a stela and a niche for a statue of

Rekhmire and his wife at the back. This plan was repeated throughout the 18th dynasty and continued, with some modifications, into the Ramessid period. The decoration of Rekhmire's tomb is painted throughout on a grey-blue background. The inventiveness shown in the range of subjects probably surpasses the quality of the painting although some unusual artistic experiments are present. The decoration pays homage to Rekhmire's position as a vizier, the highest administrative office in Egypt. The collection of taxes, inspection of workshops and the receiving of tribute sent from foreign countries are prominent although they need not be taken as records of specific

events. The illustrated scene is a detail of the tribute from Nubia, the area in the south below the first Nile cataract, which included a giraffe with a humorous detail of a small monkey climbing its neck. The depiction of a banquet includes a group of female musicians and also contains a very unusual detail. Some representational freedom and even experimentation was acceptable in the depiction of minor figures in reliefs and paintings in tombs. This was, in fact, often dictated by the fact that these people were engaged in physical activities which demanded less orthodox artistic solutions and sometimes, as here, had erotic implications. The pose of the serving girl

pouring a drink to a guest in the banquet scene is perfectly still, but her representation is very unusual. Her back is turned on the viewer and her buttocks are depicted. The position of the girl's left arm strengthens the pose. The rest of the body is standard: her head is seen in profile and her legs change to the expected position somewhere in the region of the knees (thus her right foot is attached to the left leg and *vice versa*). The 'three-dimensional' effect which the artist achieved by such simple means is remarkable.

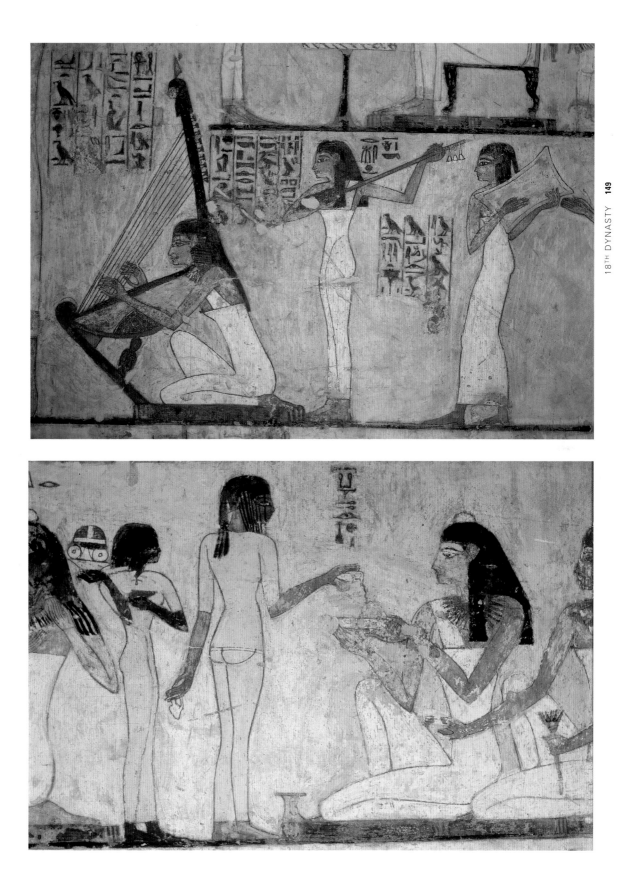

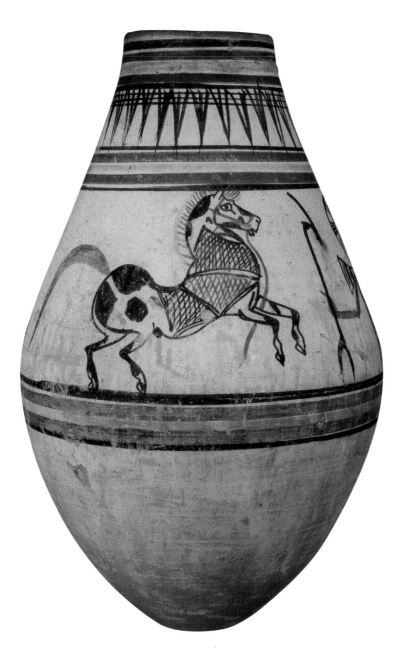

**Jar with prancing horses,
location of discovery not known**

*c.*1420 BC. Painted pottery,
h. 43 cm, 16 in.
Ägyptisches Museum, Berlin

Monochrome painted pottery was widespread during the Predynastic period (see 16 and 19–20), but painting on pots fell out of fashion and did not regain popularity until polychrome decoration appeared during the second half of the second millennium BC. Much of it remained limited to floral motifs and geometric patterns. Figurative motifs drew their inspiration mostly from the animal world; human figures rarely appear. The decoration of this jar is unusual. The horse and the chariot were introduced to Egypt from Western Asia some time after 1700 BC and their association was never broken. The horse was not used as a draught animal for transport of heavy loads and was rarely ridden. This establishes the probable context for the jar with two prancing horses as the royal palace or a house of a high official who used a chariot as a means of transport. The piebald animals are sketched in black on a light brown background, with the horses' mane and tail, as well as their harness, the loose rein and a part of the cover thrown over them in brownish red. A third colour, grey-blue, occurs in the horizontal bands above and below the horses. This jar is dated by the occurrence of a similar vessel represented on a wall of a tomb dated to the reign of King Amenhotep II.

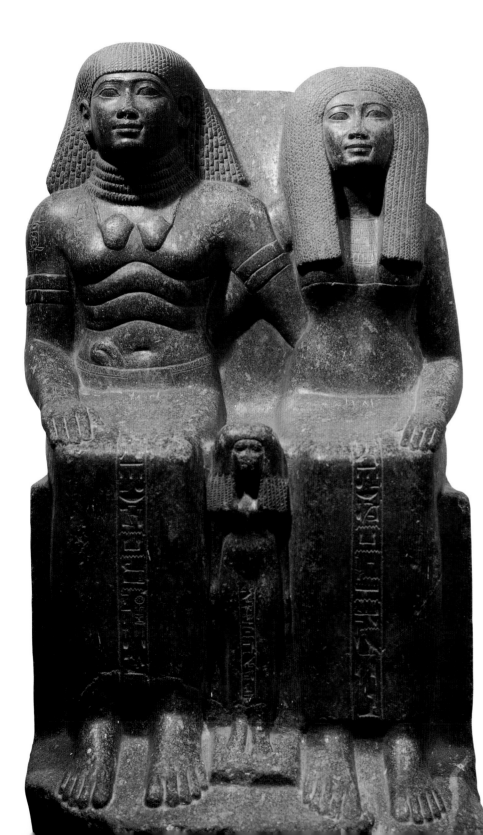

**The mayor of Thebes, Sennufer,
his wife Sentnay, and their
daughter Mutnofret,
from the temple of Amun at Karnak**

*c.*1410 BC. Granodiorite,
h. 120 cm, 47¼ in.
Egyptian Museum, Cairo

To distinguish between statues
which were set up in temples and
those which come from tombs is
by no means easy. Certain types of
non-royal statues were primarily
intended for temples, for example
block statues (see 135), while
others were typically tomb
sculptures, such as seated statues.
These were less suitable for
temples because the position was
not sufficiently humble for a person
who was in the presence of a god
(it is the god who should be seated
while the supplicant is standing).
It seems that seated statues
which have been found in temple
precincts come from publicly
accessible areas where the seated
position commanded respect while
the visitor to the temple was
standing. This statue was found to
the north of the hypostyle hall at
Karnak, within the temple precinct
but not in the temple proper.
Sennufer was an important person
at Thebes during the reign of
Amenhotep II and had a splendid
tomb made on the Theban west
bank (see 152–3). The inscriptions
appeal for offerings to the gods
Osiris and Amun-Re and the
goddess Hathor but are not
different from those one would find
in a tomb. In the course of time,
the texts inscribed down the
couple's garments were partly
effaced by many hands which
touched the statue.

Return from Abydos, in the tomb of Sennufer at Sheikh Abd el-Qurna (the west bank at Thebes)

*c.*1410 BC. Wall painting on plaster

Because of the stability of Egyptian religion, the recurrence of certain themes is characteristic of its art. In tombs, one of these is the representation of a symbolic pilgrimage to a religious shrine which everyone wished to accomplish after death. The theme of pilgrimage seems almost universal: journeys to Jerusalem and Mecca are modern examples. The topic was known during the Predynastic period of ancient Egypt (see 19–21) and is found in the decoration of Old Kingdom tombs. It was reinterpreted when Abydos, the centre of worship of the god Osiris, came to prominence at the beginning of the second millennium BC. Boat journeys to Abydos were often shown in tombs of the 18th dynasty. The purpose was to obtain divine approval of one's conduct in life and permission to enter the kingdom of the dead. The voyage is fictitious because it is supposedly taking place in the afterlife, though such a pilgrimage may have been undertaken in life. As so often in tomb art, two planes, one of a fictitious event and the other of a realistic setting, merge imperceptibly. The barge shown here is towing another boat carrying the mayor of Thebes, Sennufer, and his wife on a triumphantly successful return journey from Abydos.

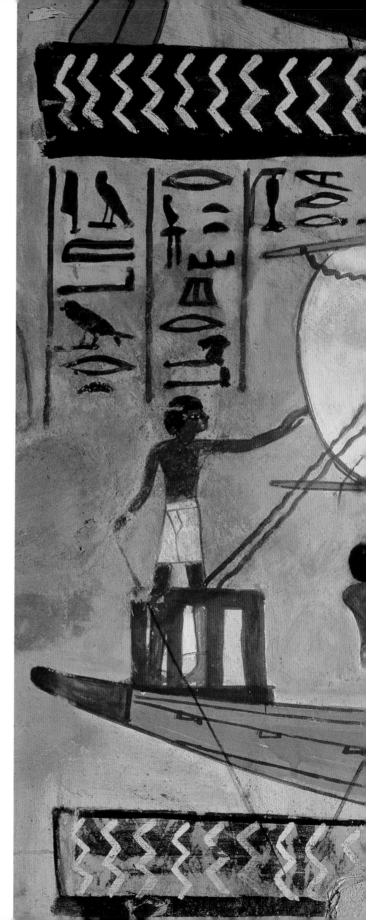

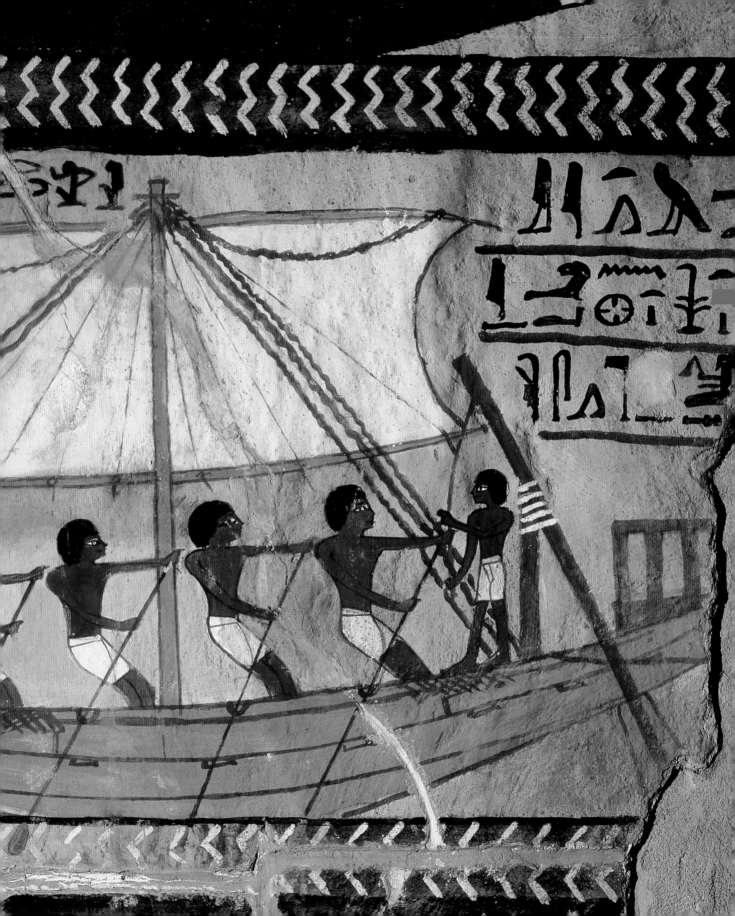

The woman Henuttaui, probably from a tomb in the Theban area

*c.*1400 BC. Wood, partly gilded, h. 29 cm, 11½ in. Museu Calouste Gulbenkian, Lisbon

The relationship between wealth and the arts is intriguing. In Egypt, the question of whether improved material conditions are correspondingly reflected in the quality of works of art is relatively easy to answer. There were no artists making their living by creating sculptures, reliefs, paintings or other works of art freely, on the off-chance that a customer would find them attractive and would wish to buy them. The artists' dependence on the palace, temple or necropolis workshops to which they belonged and the availability of work commissioned there was almost absolute. As Egypt's prosperity grew, so did the quality of works of art. The raised expectations of their customers also played a part. In the mid- and late 18th dynasty the image of female beauty was explored by Egyptian sculptors in countless variations. Wooden statuettes of women became very popular. The detailed and sensuous modelling of the female body seems to anticipate works of the Amarna period. These may be tomb sculptures but there is a clearly erotic element present in them which cannot be dismissed by the traditional references to fertility and child-bearing.

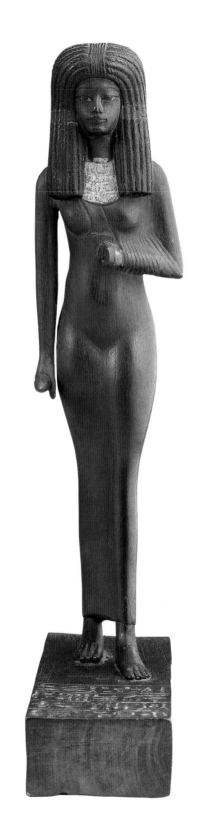

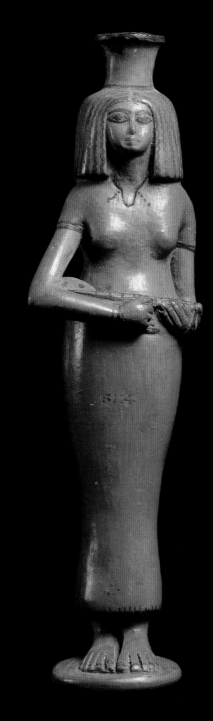

Woman playing the lute, from the Theban area

*c.*1400 BC. Pottery, h. 21.5 cm, 8½ in.
British Museum, London

Small troupes of female musicians
and dancers were all the rage at
banquets during the 18th dynasty.
They appear in wall paintings and
reliefs in a number of tombs,
especially at Thebes (see 149 and
159), but also at Memphis. The
theme of a female musician occurs
as a decorative element on various
luxury items. Here, a pottery vase
was made in the form of a woman
lutanist. The figure was hand-
modelled, or possibly moulded in
parts which were then joined, and
the details of the face, hands and
feet, as well as the wig, gown
and the lute were painted or
emphasized in black over red. If it
was not for the fact that the figure
has a spout on the crown of the
head and a discreet handle on the
back it would be easy to think that
this is a sculpture rather than a fully
functioning vase. The maker of this
object clearly felt that it was a vase
first and a sculpture second: the
base on which the figure stands
is round, thus deriving from the
bases of vessels, rather than being
the usual rectangular base of a
statuette (see also 88).

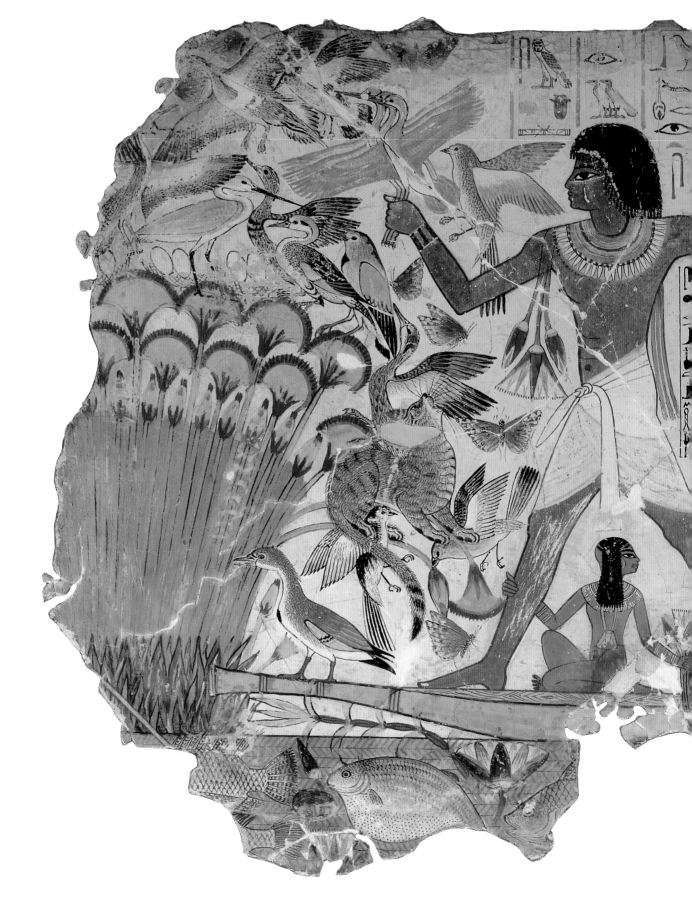

The reckoner of grain, Nebamun, and his cat hunting, from Nebamun's tomb on the west bank at Thebes

*c.*1390 BC. Wall painting on plaster, h. 81 cm, 31 in. British Museum, London

In Egyptian tombs fiction and reality combine without any obvious borderline, and it would be foolhardy to accept everything at face value. Taken literally, Nebamun's favourite pastime was hunting wild fowl. His wife, wearing her best gown, and his young daughter accompanied Nebamun on his hunting trips. Their family cat also took part in the hunt and may have retrieved birds brought down by Nebamun's throwstick. But there are several things here which do not ring quite true. The harpoon which is visible in the bottom left corner of the painting indicates that this is a fragment of two symmetrically arranged fishing and fowling scenes. These can be found in tombs more than a thousand years earlier and became a traditional element of decoration in an Egyptian noble's tomb. It is doubtful whether Nebamun ever wielded a throwstick. His wife is most inappropriately dressed for a hot and humid marsh. And only those who have never had any dealings with a cat would suggest that it would willingly retrieve. This is a traditional, but fictitious, theme of the tomb repertoire dressed up as contemporary reality.

Vase in the form of a young ibex, location of discovery not known

*c.*1390 BC. Terracotta,
h. 14.6 cm, 5³⁄₄ in.
Staatliche Sammlung Ägyptischer
Kunst, Munich

Some of the ideas which we admire so much in modern art can already be detected in the arts of ancient Egypt. One of them is the ease of interchange between a functional element which the artist turns into a decorative feature and the other way round; sometimes it is difficult to establish which came first. This recumbent young ibex, with its legs tucked under it, is in fact a perfectly functional vessel as the spout between the animal's ears shows. It is made of polished red terracotta. The oryx's characteristic curved horns were here reduced to one and connected with its back, and so provided the vessel with the perfect handle. The vessel probably served a specialized purpose and may have been a container for oils.

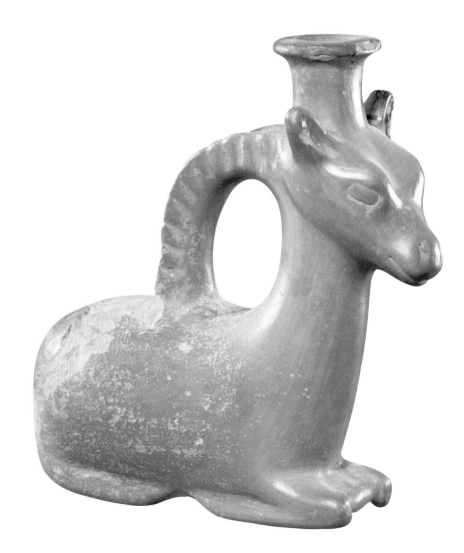

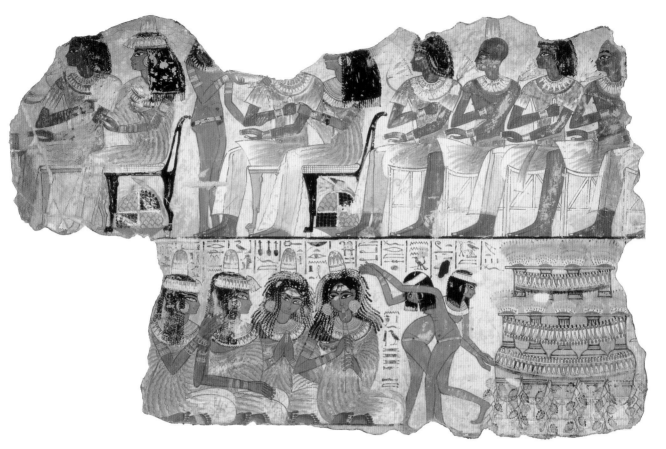

Female musicians and dancers in a banquet scene, from the tomb of the reckoner of grain, Nebamun, on the west bank at Thebes

*c.*1390 BC. Wall painting on plaster, 69 x 30 cm, 27 x 10½ in. British Museum, London

The subject of female musicians, singers and dancers can sometimes be presented in a rather static way but this certainly is not true of the musicians from the tomb of Nebamun. The artist has been astonishingly successful at conveying the excitement of the music and the movement of the dancers. Several things are unusual about this painting. The lady playing the double-reed flute and one of the singers are shown full-faced, an unusual thing in Egyptian two-dimensional representations. Their large haunting eyes which follow us wherever we may stand create a link between the viewer and the painting and produce a feeling of immediacy which is rarely felt in Egyptian art. A very clever touch is that the heads of these two ladies are slightly inclined, and this produces a sensation of movement as they react to the rhythm and tune of their play.

Their arms and hands are shown in front view, and the depiction of the clapping hands of the singer is extremely unusual. The artist apparently also experimented with shading parts of the feet in order to create a three-dimensional effect. This is a work of a true master painter.

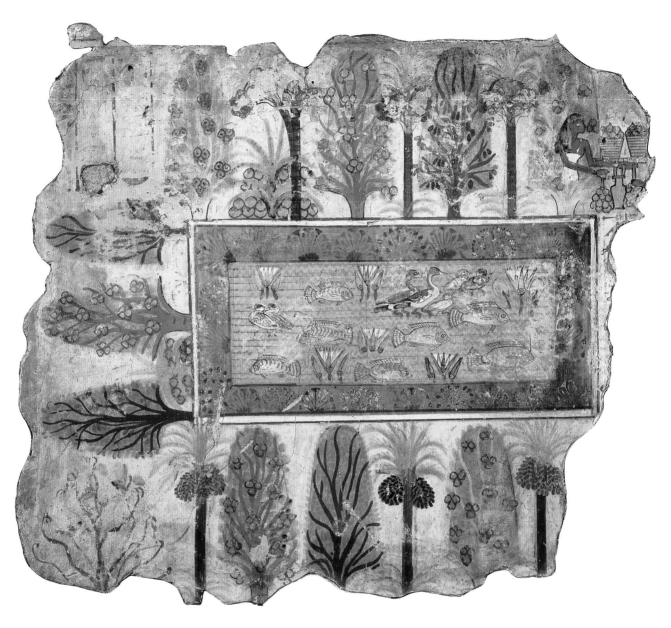

**Garden pond,
from the tomb of the reckoner
of grain, Nebamun, on the west
bank at Thebes**

*c.*1390 BC. Wall painting on plaster,
72 x 62 cm, 28 x 24 in.
British Museum, London

The estate of a wealthy Egyptian
invariably had a walled garden with
a pond. The garden in this painting
has dom and date palms,
sycamores, acacias, mandrake and
vines. Papyrus and other plants
grow around the lotus pond,
which is teeming with waterfowl.
Artistically, the depiction is a
variation of the typical Egyptian
'unfolded box'. The easiest way of
understanding it is if we imagine
that we are inside a large box
which has a depiction of the pond
on the bottom on which we are

standing, and representations of
plants and trees growing around
the pond on the interior vertical
sides. This is a three-dimensional
representation, so in order to turn
it into a two-dimensional picture
the vertical sides are allowed to
fall back. Here we have a modified
view of such an approach which
makes a concession to the usual
way in which we see reality but
defies the representation's logic:

the trees at the bottom of the
picture are not shown upside
down but in a 'normal' view. The
scene is a detail from a much
larger composition in which the
tomb owner and his wife were
probably enjoying the shade, cool
breeze and tranquillity of the place.
Many such gardens can be seen in
modern Egypt but none of them
has a tree goddess, visible in the
top right corner of the painting.

King Amenhotep III, from the temple of Amun at Luxor

*c.*1380 BC. Quartzite, h. 249 cm, 98 in.
Luxor Museum

A cache of statues which was found in the peristyle court of the temple of Amun at Luxor contained this over-life-size statue of King Amenhotep III. The sculpture is unusual for several reasons. The king is standing on a flat base placed on a stone imitation of a sled. The simple explanation is that this sculpture shows a statue being transported on a sled. A statue showing a statue may seem a strange concept but not impossible in Egyptian art where many of the representations of gods in reliefs and paintings are, in fact, depictions of their statues. But there is another intriguing way of explaining this piece. The cult of the sun god was already in ascendance in the reign of Amenhotep III. The sled can be seen as a large hieroglyph reading Atum, one of the names of the sun god. The king is also compared to the dazzling sun disc (the Aten) in the text on the back of the statue. Or are we just getting carried away by trying to see hidden meanings everywhere? The youthful face shows all the hallmarks of the statues of Amenhotep III at their most extreme, especially the long narrow eyes with highly stylized upper rims and cosmetic lines and the eyebrows indicated by bands modelled in raised relief.

Funerary scenes in the tomb of the priest of the god Amun, Pairy, at Sheikh Abd el-Qurna (the west bank at Thebes)

*c.*1380 BC. Wall painting on plaster

There were many different ways of selecting and showing funerary topics in Theban tombs of the New Kingdom, but some such scenes were almost always present. The artist responsible for the painted decoration in the tomb of Pairy assembled the most characteristic themes in a kind of synopsis on one wall. Near the top of the wall, Pairy and his wife Henutnefert, followed by bearers of offerings, are shown before Osiris-Onnophris, the ruler of the dead. Pairy's funeral and rites outside the tomb are shown in the two registers below. First, a sled carrying his mummified body in a rectangular coffin (but shown as if lying on top of it) under a canopy is dragged by oxen and men towards Pairy's tomb. Bearers of various goods to be deposited in the tomb, including a model boat, follow. Then the opening of the mouth ceremony is conducted on the mummies of the couple by a *setem* priest wearing a leopardskin. The rest of the register is divided into six compartments and shows different stages of the same ceremony performed on Pairy's statue. The purpose of the ceremony was to restore the senses to the mummified body and to endow his statue with them. A symbolic voyage to Abydos is shown in the bottom register (see also 152–3).

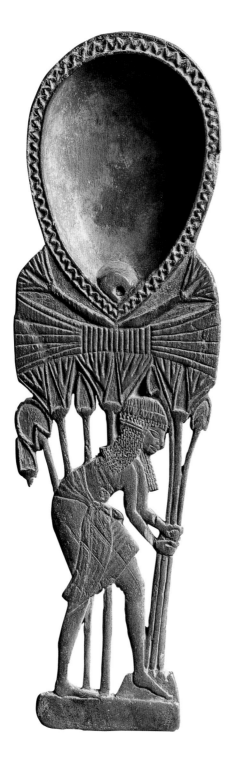

Cosmetic spoon in the form of a young woman plucking lotus flowers, from the Theban area

*c.*1380 BC. Wood, l. 18 cm, 7 in.
Louvre, Paris

Items connected with the personal adornment of women were often highly decorative and made with consummate skill. This object is a spoon which was used for dispensing cosmetics and similar materials. Its handle is formed by a miniature openwork scene the main element of which is a young woman plucking lotus flowers. The design is interesting: although the flowers appear to be taller than the woman and form a virtual thicket, we know that this would be botanically incorrect. The woman is probably standing in a shallow pond or canal and most of the stalks of the lotuses are under water, with only their top section with the flower showing above the surface. It is unlikely that the water would reach to her waist or even higher and so the artist probably sacrificed accuracy for the sake of good composition. In order to satisfy the functional demands of the object he simply lengthened the stalks. The bowl of the spoon was perceived as the loop of the *ankh* (life) sign and its horizontal bar rests on the lotus flowers. Other motifs found on the handles of similar decorative spoons include swimming girls, female musicians, servants carrying jars, and ornamental bouquets.

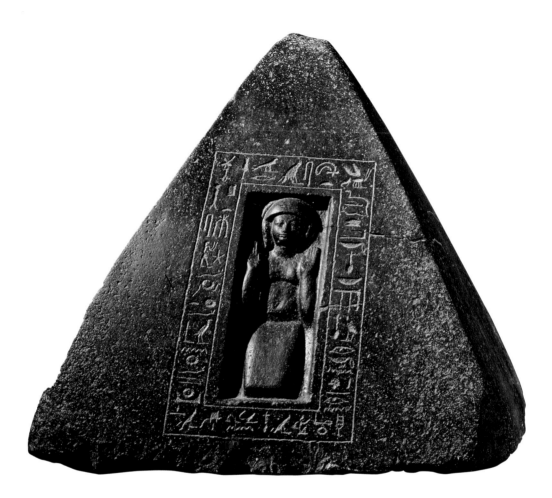

Pyramidion of the high priest of Ptah, Ptahmose, from Saqqara

c.1380 BC. Granite, h. 39 cm, 15 in.
Ägyptisches Museum, Berlin

In all spheres of life, certain things which had at first been the sole prerogative of the king or the highest echelons of Egyptian society were gradually being adopted by wider sections of the Egyptian population. Egyptologists still argue how this should be described, but there is no doubt that the former exclusive rights of the élite were trickling down the social scale. In the arts, the repertoire of scenes was affected profoundly. At first only the king could be shown in the presence of the gods, but from about 1500 BC this was extended to practically everybody. It was not a purely artistic development but rather a reflection of the change in ideas concerning the relationship to the gods. Initially only the king and the closest members of his family were buried in pyramidal tombs, but in the second millennium BC non-royal tombs with small pyramids became quite common. This is a pyramidion (monolithic capstone) from the summit of the tomb pyramid of the high priest of Memphis, Ptahmose. On two of its faces the tomb owner is shown kneeling in adoration of the rising and setting sun. The reason for the more widespread use of the pyramid was not purely architectural but was also linked to religion: it is not the sun as a physical entity Ptahmose is adoring but the sun god himself.

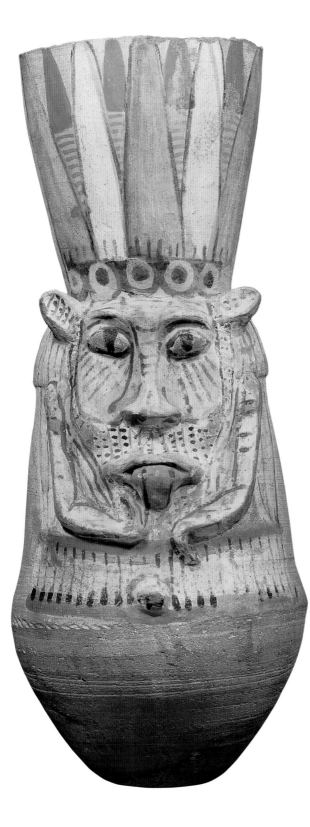

A Bes vase,
location of discovery not known

*c.*1375 BC. Painted pottery,
h. 50 cm, 19 in.
Ägyptisches Museum, Berlin

Vases decorated with a modelled
and brightly painted polychrome
image of the god Bes have been
found in settlements as well as
cemeteries. Egyptian religion
was far from homogeneous: the
official religion of the temples
was different from the beliefs of
ordinary people. Bes was one of
the most unusual members of the
Egyptian pantheon, a demigod
rather than a fully-fledged divinity.
He was at home in Egyptian
households and was linked to
family matters such as the well-
being and protection of pregnant
women, mothers and children, but
also to music, dancing and sexual
indulgence. Usually represented
as a dwarf with a grotesque mask-
like face (see also 335), he was
terrifying and harmless at the same
time. His characteristics usually
include lion's ears and mane, a
broad nose, a tongue lolling out of
his large mouth, short stunted arms
and bandy legs, and an exposed
penis. He often wears a crown of
feathers. A large Bes jar must have
been one of the most colourful
objects in the house. It is attractive
to think that it was a wine jar but
this is far from certain. More likely
it contained the household's supply
of water.

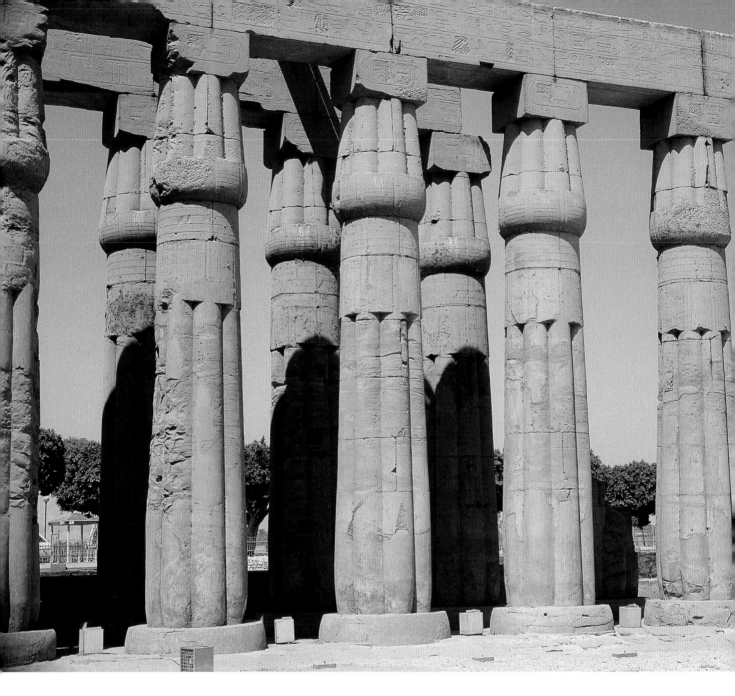

Columns with capitals in the form of closed papyrus umbels, in King Amenhotep III's part of the temple of Amun at Luxor

*c.*1360 BC. Sandstone

Egyptian architecture employed round columns or rectangular pillars when they wished to span distances which were too large for a single slab or an architrave. They were used in houses and temples as well as tombs. Columns could be monolithic, but very large columns were built up from a series of column drums or half-drums. Chronologically, wooden columns preceded columns made of stone. These origins are probably reflected in the forms of their capitals although symbolism which the columns later acquired may have influenced their form even more. The three most common types of column capitals imitate palm fronds, closed or open papyrus umbels (columns with closed papyrus capitals are shown on the illustration), and lotus flowers. A wide variety of column capitals is known from temples of the Ptolemaic and Roman periods. The shafts of columns may have been plain or decorated with scenes carved in relief or inscribed. Various types of stone were used for the making of columns, especially granite, sandstone and limestone. Columns were used to create covered walkways around the perimeter of a peristyle court or to hold up the roof of a hypostyle hall.

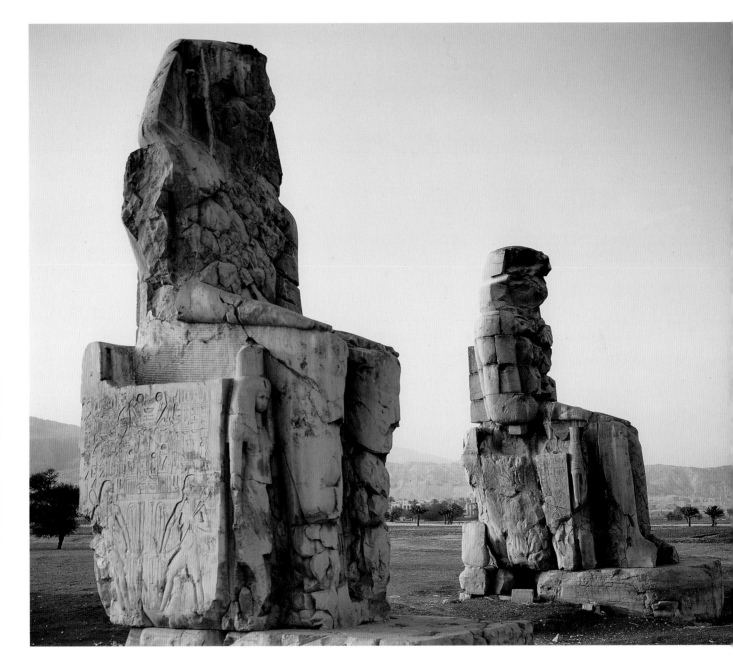

The Memnon Colossi, at the entrance to the funerary temple of King Amenhotep III at Kom el-Hetan (the west bank at Thebes)

*c.*1360 BC. Quartzite, original h. 21 m, 69 ft

Most statues of non-royal individuals were relatively small. Life size or colossal (over life-size) statues were in a minority. But royal statues which belonged to the overall design of a temple were often colossal because their size was dictated by the dimensions of the structure of which they were an integral part. The Memnon Colossi are, in fact, huge seated monolithic statues of Amenhotep III. They now loom in splendid isolation in the middle of the Theban west bank plain but originally they stood in front of the massive entrance pylon of Amenhotep's almost completely lost funerary temple. In Classical mythology, Memnon, the mythical king of Ethiopea, was the son of the goddess Eos (Dawn), and it was the northern colossus (on the right in the illustration) with which he was especially identified because of the sound the much eroded statue made at dawn when the air began to warm. The name of the man responsible for the transport of the huge stone blocks, from the quarries at Gebel Ahmar near Cairo (or, possibly, Gebel Tingar near Aswan) and the positioning of the Memnon Colossi is known. He was Amenhotep, son of Hapu, later deified for his achievements (see 170).

The chief of the women of the god Min, Tuy, perhaps from the Theban area

*c.*1370 BC. Wood, h. 33.2 cm, 13 in.
Louvre, Paris

There were several periods in Egyptian history during which women played a considerably more important role than at other times. In the royal family the reasons were almost always dynastic and connected with the succession, but this can hardly explain the increased attention given to works of art representing women in the second half of the fifteenth and the fourteenth centuries BC, leading towards the Amarna period. Erotically charged depictions of naked young girls participating in banquet scenes can be seen in tomb paintings. But sculptures of women where the juvenile-oriented erotic element is absent are a more telling indicator of the trend. Tuy, represented in the statue illustrated here, attained what was probably the highest position in temple administration open to a woman, and so it is likely that she was well into her mature years. Yet the sculpture shows a still very attractive woman, tall and slim, whose long garment emphasizes rather than conceals her body, especially her breasts, which are much more conspicuous than had previously been the custom. We do not know how faithfully the statue depicted the woman it purported to represent, but that is a different matter. It has been suggested that this is the mother of Teye, the chief queen of King Amenhotep III (see 169).

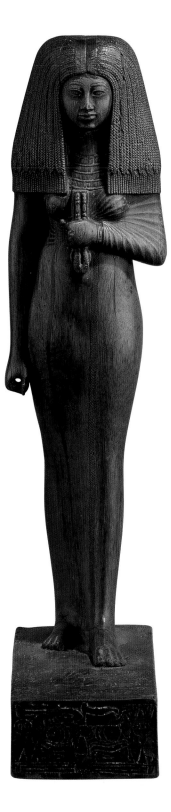

Queen Teye, location of discovery not known

*c.*1360 BC. Yew wood and other materials, h. 9.5 cm, 3³⁄₄ in.
Ägyptisches Museum, Berlin

Teye was the chief queen of Amenhotep III and the mother of King Akhenaten. This head comes from a statue which was probably displayed prominently during both reigns because its appearance was modified, presumably after the death of Teye's husband. This was not unusual and works of art were sometimes 'updated' when the situation of the represented person changed. The sculpture shows an undeniably mature woman, no longer in the first flush of youth. The queen's face is gaunt, the nasolabial furrows are pronounced and the corners of her mouth are turned down. All this gives her face a strikingly pessimistic outlook. Although the queen's eyes are slightly bulging they are overshadowed by her eyebrows to such an extent that they appear sunken. This is not the idealizing face which one would expect to find in a sculpture made some time towards the end of the reign of Amenhotep III. An explanation is not easily forthcoming. The soft material influenced the modelling but cannot be the reason for the apparent realism of the portrait. This may have been due to the tendencies which came in such a shocking way to the fore during the reign of her son, Akhenaten. At a later time, the queen's headdress, made of silver, was covered up by an imitation of a wig made of cloth.

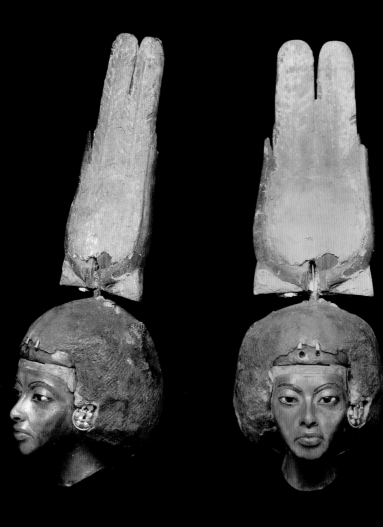

Amenhotep, son of Hapu, as an old man, from the temple of Amun at Karnak

*c.*1355 BC. Granodiorite,
h. 142 cm, 55 in.
Egyptian Museum, Cairo

Amenhotep, son of Hapu and Itu, was born in Athribis (Tell Atrib) in the central southern Delta and died, aged 80, in about 1355 BC. He was one of the few non-royal persons who achieved a posthumous semi-divine status. Amenhotep was one of the greatest directors of building projects Egypt ever knew. His most remarkable feats were achieved during the reign of King Amenhotep III and included extensions made to the temple of Amun at Karnak and the setting up of huge colossal statues, the so-called Memnon Colossi, outside the pylon of his royal master's funerary temple on the Theban west bank (167). The inscriptions on the statue tell us that it was given to Amenhotep by the king himself in order to be set up in the temple of Amun at Karnak. Egyptian statues sometimes seem to show the same individual in different stages of their life although it is not possible to say that one can discern signs of ageing on the same face and body (the identification is made by the statues' inscriptions). It is usually assumed this statue shows Amenhotep as an old man, wearing an archaic type of a wig.

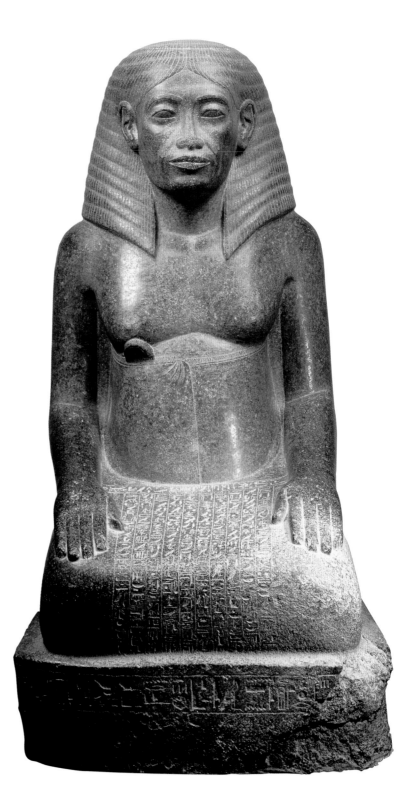

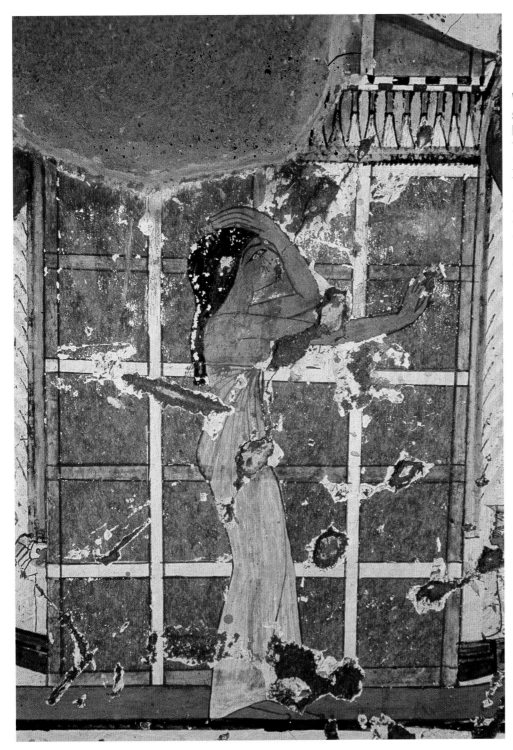

Widow mourning, in the tomb of sculptors Ipuky and Nebamun at Khokha (the west bank at Thebes)

*c.*1355 BC. Wall painting on plaster

The desire to show that all the procedures and rites required for a smooth transition from this world to the next had been carried out was the reason for including representations of funerals in tombs. In the tomb which was, unusually, shared by two men, Ipuky and Nebamun, the widow is depicted standing next to a bier with the coffin of her husband and lamenting his death. Her breast is bare and she is throwing dust over her head. The poignancy of the scene is enhanced by the fact that she is a lonely figure, standing apart from the other mourners. The two men were professional colleagues but they probably also were successively married to the same woman. Both were artists with the title 'chief sculptor of the Lord of the Two Lands', i.e. of the pharaoh. The term 'sculptor' is a somewhat free rendering of the Egyptian *tjay-medjat*, 'bearer of the chisel', that is to say an instrument used by the artists whose task was to carve reliefs in stone, not making statues. 'Engraver' might be a more felicitous term but even that might mislead. The colleagues of a 'bearer of the chisel' were a *zesh-kedut*, 'outline draughtsman', who sketched representations before they were carved, and a *zesh*, 'painter' or 'colourist', whose task was to paint the reliefs.

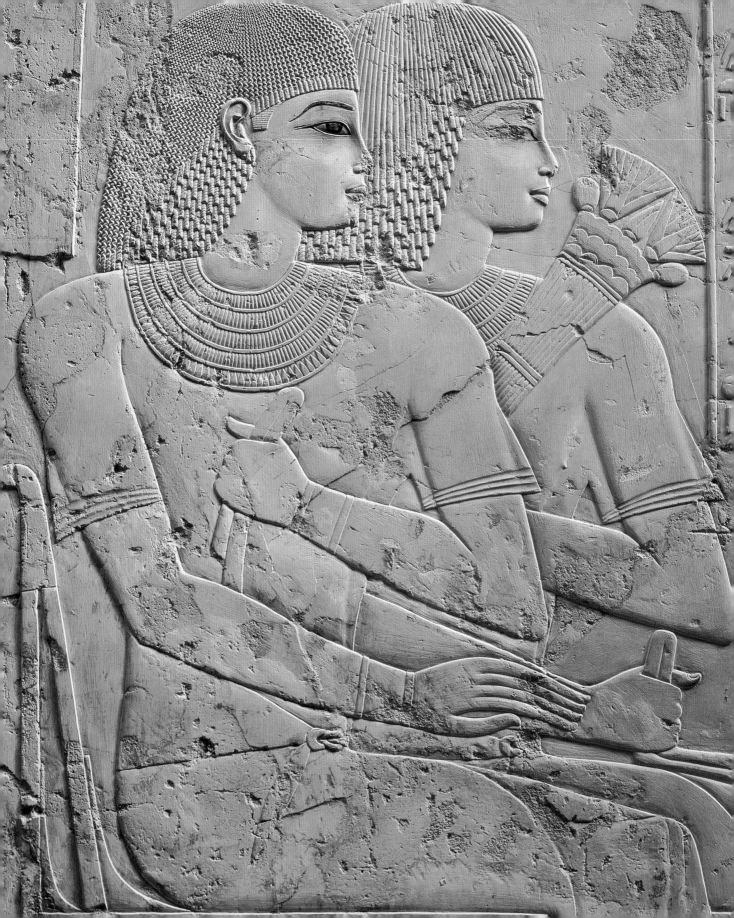

Seated guests and processions of offering bearers, in the tomb of vizier Ramose at Sheikh Abd el-Qurna (the west bank at Thebes)

*c.*1350 BC. Raised relief in limestone

The high mark of painted as well as carved decoration in tombs made on the Theban west bank during the 18th dynasty was reached in the reign of Amenhotep III. The confidence and complete lack of hesitation with which the sculptors carved the low raised relief in the tomb of vizier Ramose are astonishing, and the meticulous attention to detail is spell-binding. The internal modelling of the bodies was done with deliberate economy and the greatest attention was paid to the faces. The eyes and eyebrows were painted in black but the decoration of the tomb was not completed and the reliefs were left bare, with almost no colour applied to them. There was not enough time for the carving of some of the scenes, and so some of them were only painted or left as mere preparatory sketches. Although the two seated figures in the illustration are men, they are shown in a way more associated with married couples, including a large bouquet held by one of them. The offering bearers bring fowl, dishes with separate compartments for different kinds of fruit, flowers, cuts of meat, tall conical cakes of incense and other things.

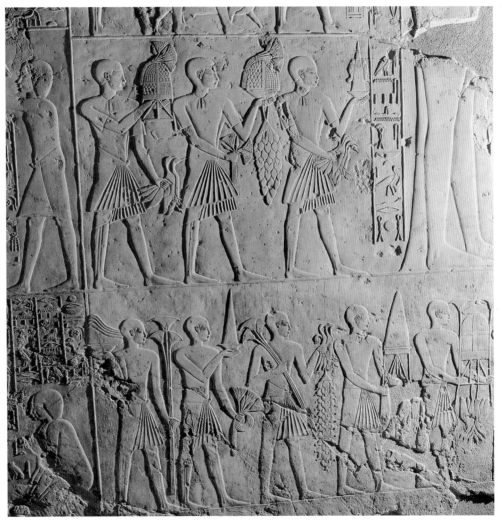

King Akhenaten,
from the temple of the Aten at Karnak

*c.*1350 BC. Sandstone,
original h. c. 4 m, 13 ft.
Egyptian Museum, Cairo

The conventional method of
figurative representation,
established at the very beginning
of the Egyptian history, was
drastically altered early in the
reign of King Akhenaten. The most
extreme cases are depictions of
the king himself, most dramatically
apparent in the colossal statues
made for the temples of the Aten
at Karnak. They were attached to
pillars lining large open courts, an
architectural technique well known
from earlier temples. The king is
shown having a strikingly long face
in which the nose predominates,
hollow narrow eyes, high
cheekbones, sensuous lips with
pouches at their corners and a
narrow pointed chin. The prominent
breasts and stomach rounded to
the point of being swollen
complete the figure. This may be
a cruelly unflattering portrait of a
possibly seriously ill young man.
More probably it exaggerates the
king's appearance in order to get
as far away as possible from the
earlier representational tradition
and to stress his uniqueness.
Some of the statues seem to
show the king nude but sexless
and support the idea that they
were more than realistic portraits
of an unusual person.

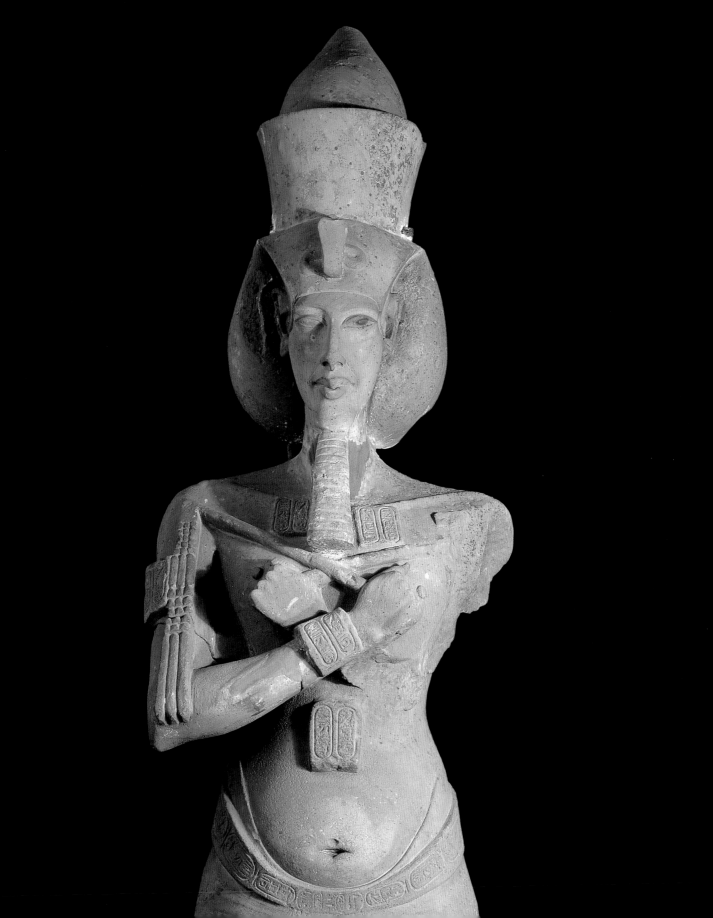

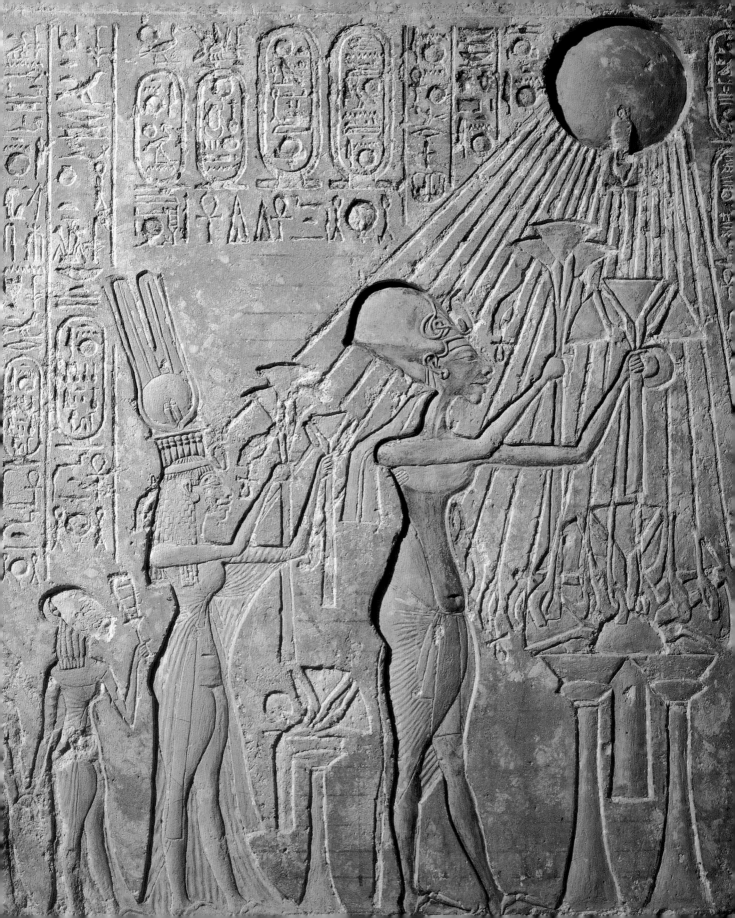

Akhenaten, Nefertiti and two daughters offering to the Aten, from El-Amarna

*c.*1345 BC. Sunk relief in limestone,
h. 53 cm, 20 in.
Egyptian Museum, Cairo

The sun disc, the Aten, was the only deity at the centre of the new religion of King Akhenaten. The simplicity of its form caused some difficulties for the artists whose task was to create the new religion's images but they solved the problem brilliantly. The sun disc was shown with a multitude of rays radiating from it and these terminated in human hands, some holding the traditional symbols of life (*ankh*) and dominion (*was*). The king and his family were included in the main religious icon of the Amarna period, shown offering to the Aten and receiving its blessing through the rays extended towards them. These linked the deity and its main proponents just as effectively as the earlier representations which showed a king being embraced by a god. The illustrated relief was found as a loose slab of stone in the royal tomb at El-Amarna and may have served as a pattern to be imitated in the tomb's decoration. In the central part of the scene are the remains of a grid. This was perhaps used to copy the representations or parts of them onto the walls, or even conceivably to transfer the scene onto this slab from elsewhere. The figures display the exaggerated features characteristic of the early phase of Amarna art.

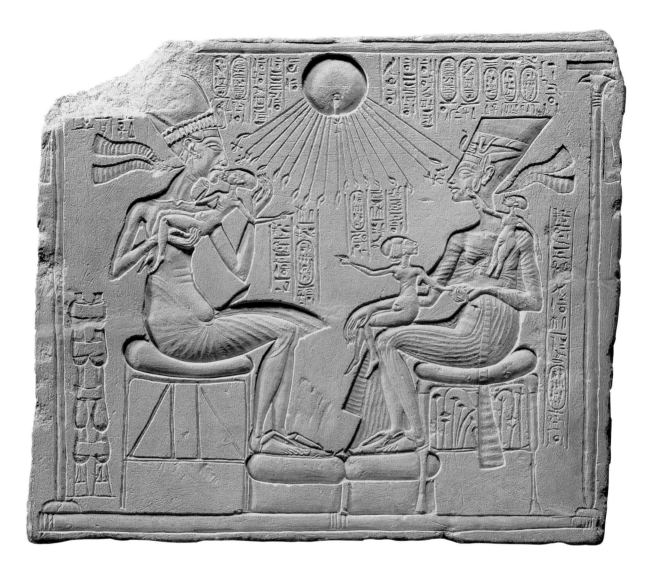

King Akhenaten and Queen Nefertiti with daughters, location of discovery not recorded but almost certainly El-Amarna

*c.*1345 BC. Sunk relief in limestone, 32.5 x 39 cm, 12³⁄₄ x 15 in Ägyptisches Museum, Berlin

The changes in style and subject-matter which took place in the reign of Akhenaten can be hardly

demonstrated in a more forceful way than on this relief. Akhenaten is portrayed with all the cruel lack of flattery of the early years of his reign: gaunt features, sharp and prominent chin, long neck, slim arms, hands with unnaturally long fingers, round stomach and spindly legs. There are echoes of the king in the face of Queen Nefertiti though not as extreme as in some other representations (see 179).

The princesses have the unusually long skulls which were the shared characteristic of Akhenaten's children. The king and queen are shown in an informal family setting, seated on comfortable chairs and playing with their three daughters. Akhenaten is kissing Merytaten, the eldest. Princess Meketaten is sitting on Nefertiti's knees while the third, Ankhesenpaten (later

Ankhesenamun, the wife of Tutankhamun) has climbed onto Nefertiti's shoulder and is playing with the uraeus pendant of her crown. In spite of all the subsequent bad publicity for Akhenaten's reign, his art suggests that his was a more humane and gentle world. No other Egyptian king had been shown in this way before and no other would be again.

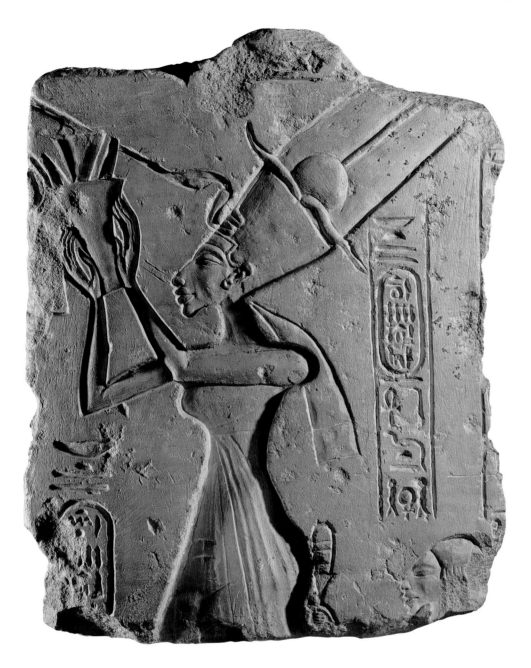

Queen Nefertiti and a daughter offering to the Aten, from El-Amarna

*c.*1345 BC. Sunk relief in limestone, h. 34 cm, 13 in Ashmolean Museum, Oxford

Can the almost grotesque face of Queen Nefertiti on this relief broken from a column also belong to the person represented in the famous bust (190–1), claimed by some to be the Mona Lisa of ancient Egypt? There can be no doubt about it and a more careful examination of the two faces shows, perhaps surprisingly, that they display undeniable similarities. This is true of their profile where the front of the crown continues as a straight line of the forehead and then, after only a very slight bulge and dip, as the nose. On the relief, the queen's nose is very long and the nostrils are emphasized; the lips are so huge that the upper one almost touches the nose; the hatchet chin is sharp and haggard. The queen's sexuality is noticeably emphasized. On Nefertiti's bust, the nose is still relatively large but not excessively so; the lips are small and set well apart from the nose; the chin is still quite sharp but delicate. Nowadays, one would congratulate the plastic surgeon but in Amarna art the new look was achieved by the artist. If one disregards the crown and the body from the neck down, the face of the queen on the relief is uncannily similar to the early representations of Akhenaten and the artist probably deliberately set out to achieve such an impression. The relief belongs to the early phase of Amarna art, the bust to its later stage.

Nefertiti, location of discovery not known but probably from El-Amarna

*c.*1345 BC. Quartzite, h. 29.5 cm, 11 in.
Louvre, Paris

The identity of the woman whom
this sculpture portrays is not
confirmed by an inscription. She
wears a pleated garment which
leaves her right shoulder bare and
reveals the outline of her prominent
collar bone, and is tied in a knot
under her right breast. The garment
conceals little and the sculpture
shows, no doubt, Nefertiti, King
Akhenaten's wife, because the
body is not that of a juvenile
princess. It is shown with what
has been, rather oddly, described
as 'erotic distortions', that is to say
with prominent breasts, narrow
waist, strong thighs, conspicuously
large behind and a prominent pubic
mound. These, of course, may
not have been distortions at all.
Sculptors showed an increased
interest in the portrayal of a draped
female body well before the
beginning of Akhenaten's reign
(see 154, 168) but there is no
way of knowing how close their
creations were to reality. This is
probably a fragment of a pair or
group statue because the right arm
of this woman seems to have been
placed around another person's
shoulder; other solutions are
possible but less likely.

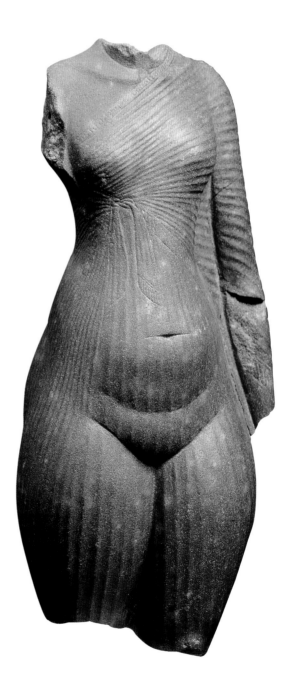

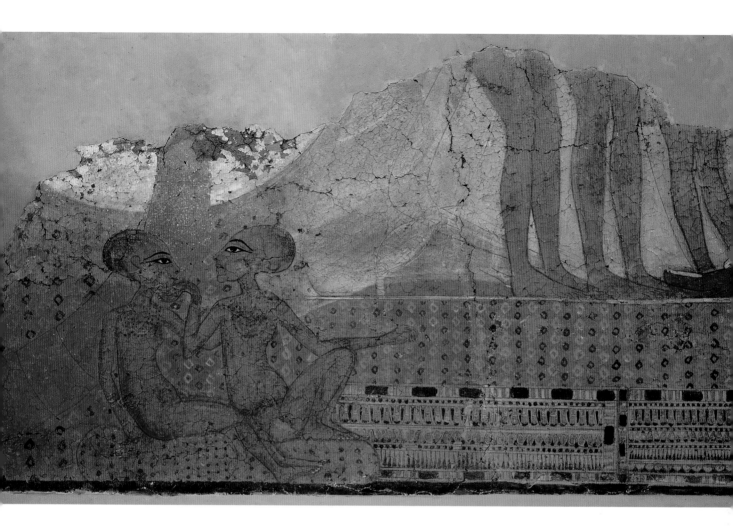

The daughters of King Akhenaten and Nefertiti, from El-Amarna

*c.*1345 BC. Wall painting on plaster,
40 x 165 cm, 15³⁄₄ x 65 in.
Ashmolean Museum, Oxford

El-Amarna, the site of the new
capital founded by King Akhenaten,
has produced substantial remains
of wall paintings. After its
abandonment the city was not
rebuilt and so, contrary to what
happened at most other town
sites, its buildings and the
paintings in them escaped
complete destruction. This
fragment comes from a painting in
the king's private residence which
depicted the Amarna royal family
'at home' (compare 178). The size
of the whole scene can be gauged
from the king's big toe near the
right margin of this fragment. The
king was seated on a chair while
Nefertiti was reclining on a cushion
opposite him. We know enough
about the royal family to identify
their daughters even without texts.
The three older princesses are
shown standing between the king
and the queen, and the varying
knee-height shows that Merytaten,
the eldest (later she may have
become, at least in name, the
queen of her own father and then
the wife of King Smenkhkare), is in
the centre, Meketaten on her right
(on the left from the point of the
viewer) and Ankhesenpaten (who
later married King Tutankhamun) on
the left. The two daughters seated
on a cushion next to Nefertiti are
Nefernefruaten-tasherit (on the
right) and the baby Nefernefrure.
The sixth and youngest daughter,
Setepenre, may have been shown
on Nefertiti's lap.

Decorated blocks from buildings at El-Amarna but found reused at El-Ashmunein

*c.*1345 BC. Sunk relief in limestone, 54.7 x 23.5 cm, 211$_2$ x 91$_4$ in, and 53 x 21 cm, 20 7$_8$ x 8 1$_4$ in. Metropolitan Museum of Art, New York

The task which faced the architects and builders of King Akhenaten was truly daunting. The new deity, the Aten (the sun disc) had to be provided with places of worship which would replace the old temples of the abandoned faith. The challenge was architectural (a new type of a temple, open to the sun and so suitable for a new deity and new forms of worship, had to be designed), decorative (a completely new temple scene repertoire was required) and constructional (new temples were needed quickly because none had existed before). The earliest temple for the Aten was begun at Karnak, but when the new capital was founded at El-Amarna, in Middle Egypt, the building activities moved there. The new religion had really only one iconic image showing the worship of the Aten (see 176, 179) but this occurred in countless subtle variations. The new temple repertoire incorporated scenes showing the royal family and various activities in and around the royal palace. These may have been formal scenes, such as audiences involving a great deal of bowing and prostrating on the ground by officials and courtiers paying homage to the king and queen, with attendants, soldiers and

onlookers also present. Chariot outings were depicted often, and also royal river boats. Many situations were less formal, such as groups of musicians, preparation of food, craftsmen at work, herdsmen feeding animals or men fishing. Trees, plants, animals and fish were often depicted. There was hardly anything comparable in the decoration of the earlier temples, and the depiction of the contemporary world in Akhenaten's reliefs was much more detailed and all-embracing than the formal and selective repertoire of tomb scenes. In order to speed up the quarrying and facilitate the transport of the stone blocks used in the construction of the new temples for the Aten, Akhenaten's builders chose a smaller size, about 52 x 26 x 24 cm (201$_2$ x 101$_4$ x 91$_2$ in), which we call talatat (a term used for blocks of similar size in Islamic architecture, from Arabic *talata*, 'three', i.e. three handspans long). This is the reason for the extreme fragmentation of scenes and the 'modern' appearance of these reliefs. The technique of sunk relief was preferred over the previously used raised relief. It was better suited for spaces open to sunlight and was easier to carve. But the stone which was used was not always ideal for the carving of fine relief and the consequently exaggerated effect influenced the appearance of the scenes at least to some extent. The reliefs were, as usual, painted. The stone for Akhenaten's temples at Karnak was sandstone extracted at Gebel el-Silsila, while the stone used at El-Amarna was limestone.

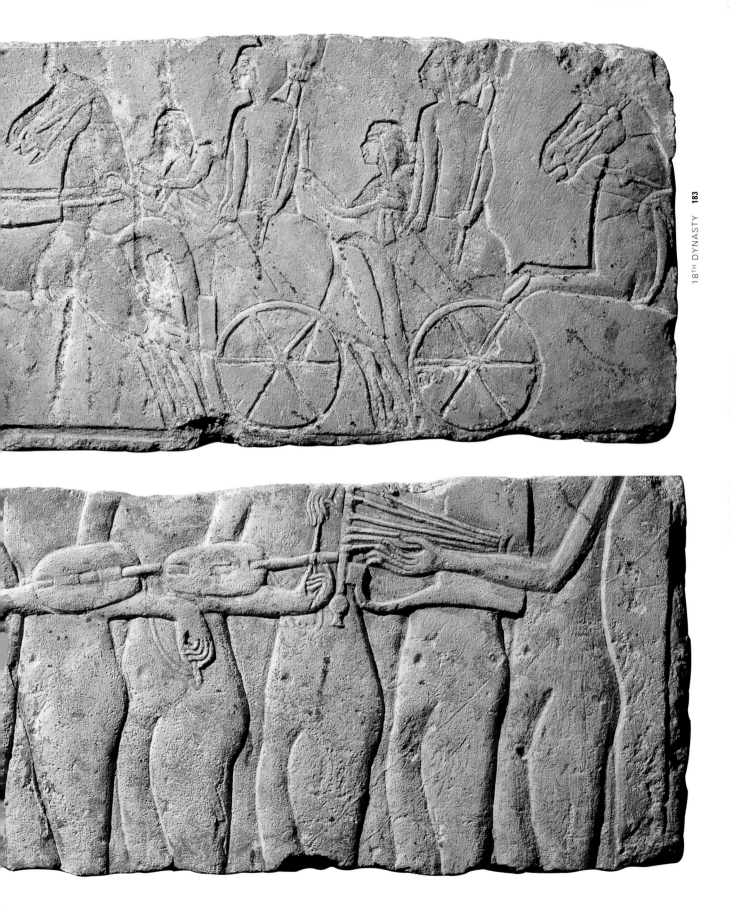

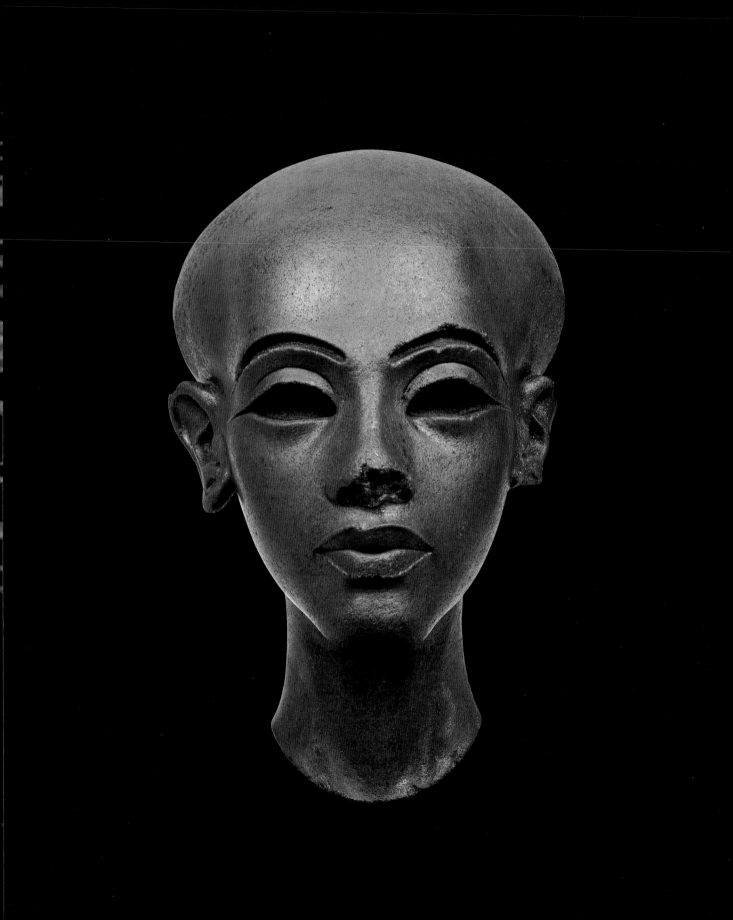

A daughter of King Akhenaten and Nefertiti, from El-Amarna

*c.*1345 BC. Quartzite, h. 21.4 cm, 8 in.
Ägyptisches Museum, Berlin

Most of the sculptures made at El-Amarna are of Akhenaten, Nefertiti and their daughters; very few were made even for the highest officials of the realm. The 'cult of personality' of the royal family which pervaded the Amarna period had much to do with it, but even more important may have been the fact that sculptors were too busy fulfilling royal orders to spare time for anything else. Amarna artists produced a number of composite sculptures where parts of a statue were made separately, probably even of different materials, and joined together. This is very much in line with the other Amarna characteristic, the fondness for inlays. Many of these were of glass and may have been the result of the great expansion of the glass-making industry. The shape of the skull and the presence of a tenon show unmistakably that the head in this illustration comes from a large statue of one of the daughters of Akhenaten and Nefertiti. The back of the skull is unusually long and is prominently depicted in statues as well as on reliefs and paintings of all the six daughters (see also 176, 178, 181). Neither Akhenaten nor Nefertiti were portrayed in the same way. It seems that this was a genuine family characteristic perceived as specially significant and deliberately exaggerated by Amarna artists.

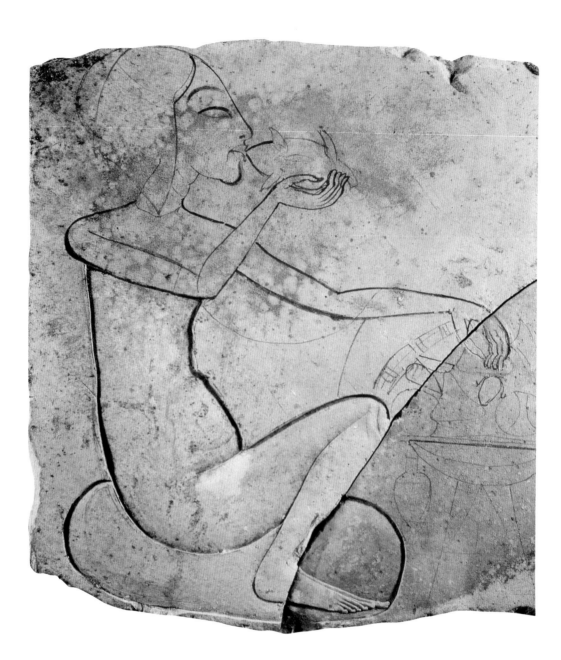

A young princess eating a duck, from El-Amarna

*c.*1345 BC. Drawing in black on limestone, h. 23.5 cm, 9¼ in. Egyptian Museum, Cairo

Much of the charm of this sketch lies in the seemingly incongruous combination of a beautiful young girl about to bite into a whole roasted duckling. The subject could have been handled disastrously but the artist succeeded in depicting it with elegance and wit: the princess might as well be kissing the little bird rather than taking a healthy bite (the Egyptians did not use cutlery). This was undoubtedly a trial piece on which an artist was proving his ability to handle a difficult topic, either for himself or for examination by others. The subject might have been considered for inclusion in a larger scene of the royal family relaxing in the privacy of one of their palaces (see 181). The beautifully fluent sketch shows the characteristically elongated skull of an Amarna princess with very high eyebrows, sensuous lips, a prominent chin and elegant but unusually long fingers. The body is still that of a child. Its lower half began to be carved in sunk relief and the original sketch was about to disappear but the work was left unfinished and the plaque thrown away.

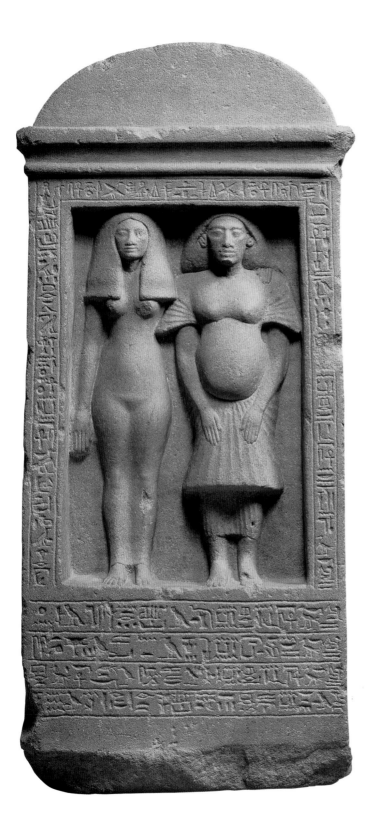

The chief sculptor, Bak, and his wife Tahere, location of discovery not known

*c.*1345 BC. Quartzite, h.67 cm, 26 in. Ägyptisches Museum, Berlin.

Self-portraits of Egyptian artists are very rare, and this may be the earliest such sculpture in the round. It is really a stela (gravestone) which was set up in the tomb of the 'chief sculptor of the Lord of the Two Lands [= the king]', Bak. It is likely that it was carved by Bak himself or under his direct supervision. He and his wife Tahere lived during the artistically stirring reign of Akhenaten. These statues replace the representations which had previously been carved in relief on tomb stelae; the monotheistic worship of the Aten (the sun disc) during Akhenaten's reign precluded representations of traditional deities, such as Osiris. Bak shows some of the physical characteristics of his royal master, such as the pendant breasts and the exaggerated (or uncompromisingly realistic) stomach. He came from a distinguished family of sculptors; his father Men fashioned the colossal statues of Amenhotep III known as the Memnon Colossi (167). Bak, however, adopted the radically new artistic style demanded by Akhenaten and is described as 'apprentice to His Majesty' on the stela. He may have been in charge of the carving of Akhenaten's colossal statues at Karnak (175).

A calf gambolling in the marsh, perhaps from El-Amarna

*c.*1340 BC. Tile with polychrome glaze, h. 10.8 cm, 4¼ in. Louvre, Paris

Aquatic and marsh motifs with plants, birds and animals decorated palaces, houses and cult buildings in Akhenaten's new capital at El-Amarna. The scenes were sometimes painted but often made up of glazed tiles which covered the lower parts of walls and floors. Tiles, glazed inlays of all kinds including hieroglyphs, and also three-dimensional elements made of faience, such as imitations of grapes, played an important role in Amarna architecture, and their popularity continued into the Ramessid period. It seems that this tile with cattle in the marsh was used in a similar way. The theme had already occurred in the palace of King Amenhotep III at El-Malqata, on the west bank at Thebes, and a wild cattle hunt is the subject of a large-size relief in the funerary temple of Ramesses III at Medinet Habu (251). While multi-coloured decoration was often created by combining faience paste of different colours, somewhat like creating a scene from inlays of different colours, many tiles had plants and animals painted on them before they were glazed, or the two techniques may have been combined.

Glass vessel in the form of a fish, from El-Amarna

*c.*1340 BC. Polychrome glass, l. 14.5 cm, 5¾ in. British Museum, London

The evidence for glass-making at Amarna is unusually extensive. Although Egyptian glass technology was still relatively young, glass-makers were not content with the standard range of vessels but attempted more ambitious forms, such as this fish. It may have served as a container for cosmetics. The method of manufacture and decoration was not much different from other glass vessels. It was modelled in blue glass around the central core of probably mainly organic materials and the garland decoration was created by applying softened rods of white and yellow glass and then partly displacing them from their original position. Egyptian representations of animals, birds and fish tend to be painstakingly naturalistic but here the effect of the fish's scales was created by entirely geometric means. The spiral form eyes are quite unusual. The fish is *Tilapia nilotica*, which used to be linked to the idea of regeneration in the afterlife. Its presence at El-Amarna, the capital of Akhenaten's religious revolution which had swept away the traditional Egyptian religious beliefs, is curious. The failure to provide an adequate concept of the afterlife was the Achilles heel of Akhenaten's religion, and one wonders whether the fish was meant to be more than just an attractive decorative motif.

Nefertiti, from El-Amarna

*c.*1340 BC. Painted limestone,
h. 50 cm, 19 in.
Ägyptisches Museum, Berlin

Artists of King Akhenaten created
some of the most unusual and
disturbing portraits of a human
being, mostly of the king himself.
Paradoxically, the same period also
produced what is often regarded as
the perfect female face. The bust
of Nefertiti, Akhenaten's chief
queen, was found in a sculptor's
studio at El-Amarna and probably
served as a model for statues of
Nefertiti which were commissioned
from there. It belongs to the
later phase of Amarna art which
abandoned many of the extremes
of the early style. Much of the
attraction of the piece stems from
its perfect, almost geometrical,
regularity which is so appealing to
our modern eyes: long straight lines
predominate, most conspicuously
those connecting the front of the
crown and the Queen's forehead
on profile, and the side of the
crown and her cheeks on front
view. This may be a face 'designed'
by the artist which bears only as
much relationship to the Queen's
appearance as her representations
in reliefs from the early phase of
the Amarna art. The 'modern'
appearance of the queen is due to
a large extent to the absence of
a wig. The inlay of the left eye is
missing. It may have never been
set in place because the right
profile was regarded as the more
important. The reason for this was
that the predominant orientation of
figures in Egyptian art was facing
to the right, so that side of the face
was more carefully finished.

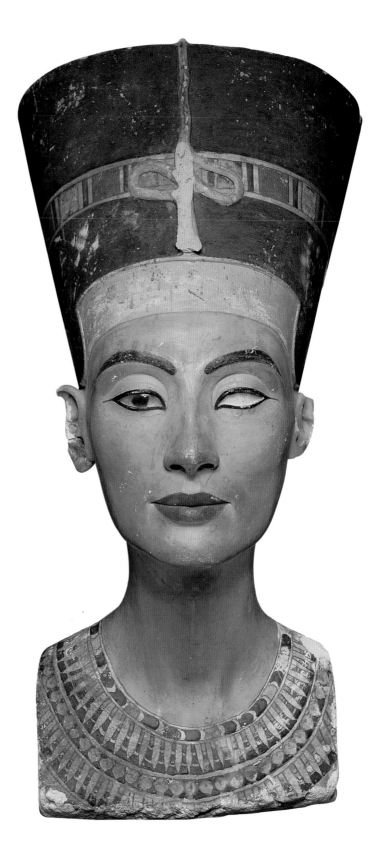

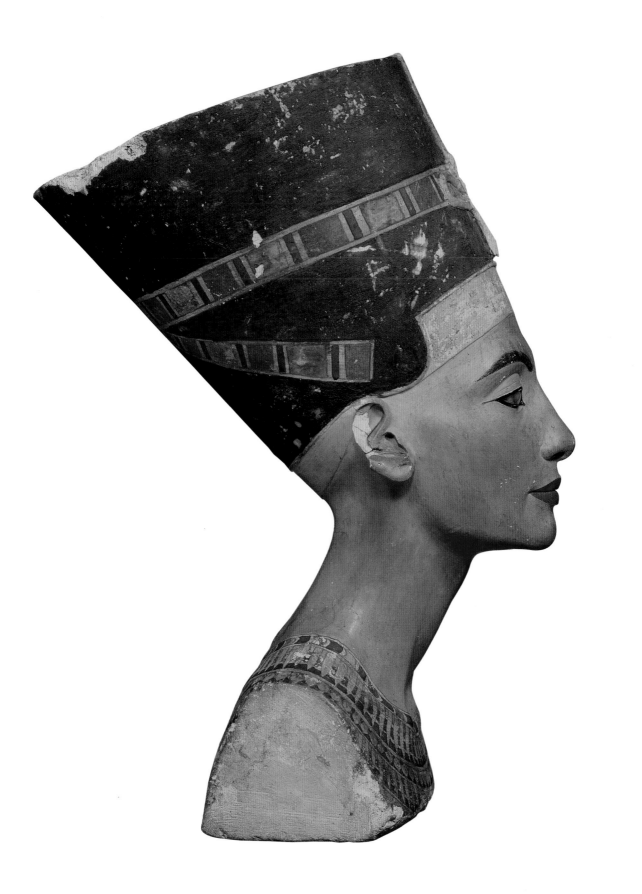

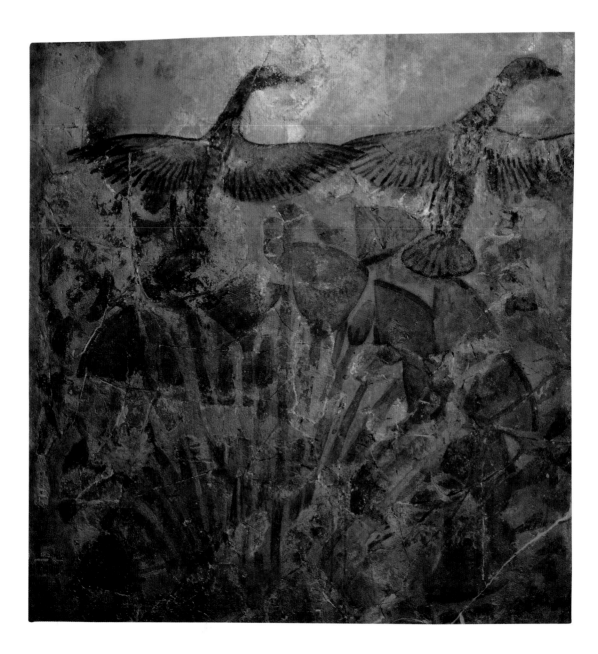

Ducks flying out of a thicket, from the pavement of a building at El-Amarna

*c.*1340 BC. Painting on plaster,
h. 93 cm, 36⅝ in.
British Museum, London

Akhetaten (modern El-Amarna), King Akhenaten's new capital of Egypt, contained a number of buildings for which there are no known parallels. This is partly due to the poor preservation of other Egyptian cities but also to the new religion introduced by Akhenaten which required structures of a new type. In the southern part of the city there was the precinct called Maru-aten. We know that it was connected with a queen, perhaps Akhenaten's daughter Merytaten, but its precise purpose is not certain. A pillared building contained a series of T-shaped water basins and the walls and pavement surrounding them were decorated with paintings of marsh scenes and other floral designs. They showed lotus flowers and other water plants, but also ducks and cattle. Representations of aquatic life and birds were often used in the decoration of private areas of palaces. The absence of other motifs in the decoration of this building certainly is not due to lack of imagination on the part of the artists but is a remarkable display of restraint and focus, something which is not always associated with Egyptian works of art. The representations alternate between detailed rendering and what in the 1920s the excavator rather pedantically described as 'an almost slovenly impressionism'.

Akhenaten and Nefertiti, location of discovery not known, perhaps El-Amarna

*c.*1340 BC. Limestone,
h. 22.2 cm, 8³⁄₄ in.
Louvre, Paris

One of the consequences of King Akhenaten's reforms was that the Egyptian religion, which had previously been so intensely visual in its presentations, found itself short of religious icons. The new creed's main deity, the Aten, was an impersonal sun disc with human arms. Contrary to earlier practices, Akhenaten and Nefertiti appear to have been treated as deities in their own right although in view of the general thrust of Akhenaten's reforms which aimed at creating a one-god religion that probably is a modern understanding. This statuette seems to come from a house shrine where it replaced the gods and demigods of the earlier popular religion. It is competently made and exudes a good deal of naïve charm but was scarcely the work of a top sculptor. The two protagonists do not show the exaggerated features of the early phase of Amarna arts although they still display the 'Amarna figure' with a prominent stomach and heavy hips. Their facial features are similar but, in contrast to works of art of the early Amarna phase where the face of Nefertiti imitated that of her husband's, one suspects that here it is due to the limited ability of the sculptor. The mouths turned down at the corners give their faces a curiously pessimistic expression.

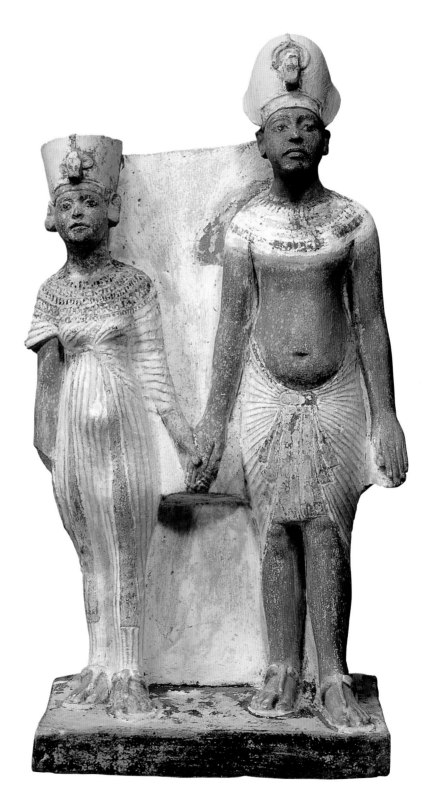

Young woman,
location of discovery not known

*c.*1336 BC. Limestone, h. 15.4 cm, 6 in.
Louvre, Paris

The face and hairstyle of this young
woman might give the impression
that she is our contemporary. This,
however, is the upper part of a full-
length sculpture made almost
certainly by artists trained at El-
Amarna. The woman is usually
thought to be one of the daughters
of Akhenaten, mainly because her
sidelock extended by a row of
tassels is similar to those seen
in representations of Amarna
princesses. But she is clearly older
and her bosom shows that she has
reached the age of puberty. None
of her features are exaggerated and
her skull is not of the abnormally
long form almost always associated
with Akhenaten's daughters (see
184). The naturalistic modelling
of her eyebrows which are
emphasized by painted lines, the
slight dip in the centre of the upper
lip where the philtrum touches it,
and the correspondingly shaped
lower lip point to the final phase of
Amarna art. So do the very faintly
downturned corners of the mouth.
Rather than representing an
Amarna princess, this may be a
statue of a young wife or daughter
of one of the important men at
the court of King Smenkhkare or
Tutankhamun.

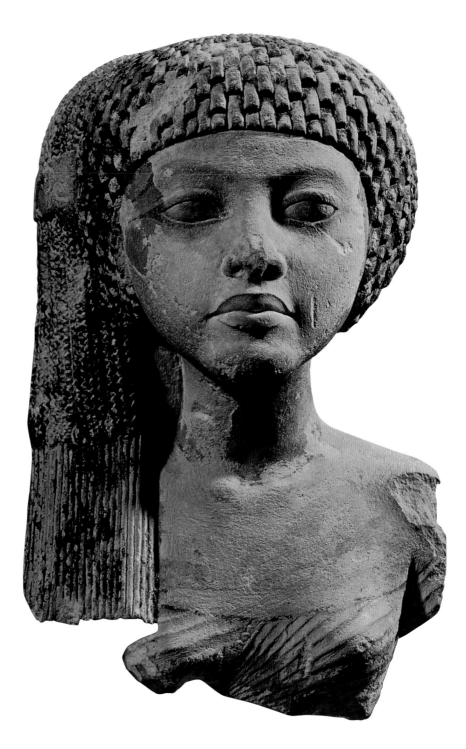

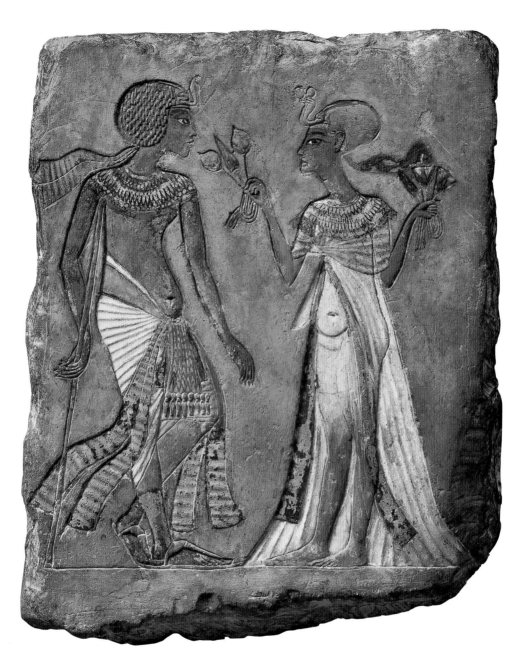

Royal couple, from El-Amarna

c.1336 BC. Sunk relief in limestone,
25 x 20 cm, 9 x 7 in.
Ägyptisches Museum, Berlin

Although this relief is almost fully
carved and painted, it is a trial
piece on which the sculptor
experimented. The subject – a
queen holding up a bouquet for
her husband to enjoy – is in the

purest tradition of the art of King
Akhenaten, and its style can be
detected in the king's young face
with the typical Amarna royal chin,
the round stomach over the rather
loose waist of the kilt, and the
unusually long fingers. The queen
has the abnormally long skull
characteristic of Akhenaten's
daughters. The ribbons of the
king's headgear are blown by the
'Amarna breeze', a new feature of

Akhenaten's art which attempted
to capture movement. The position
of the king's feet is audacious: the
left foot is brought around the
outside of the right foot, and the
stick on which the king leans may
well have been needed to keep
balance. The queen's diaphanous
gown does little to conceal her
round stomach and heavy thighs.
Artistically, there is no difficulty
in assigning this relief to the last

phase of the Amarna art. But
who are the couple? They are
too young to be Akhenaten and
Nefertiti but the king appears
to be too grown up for
Tutankhamun, who left Amarna
when he was about ten. This may,
therefore, be the enigmatic King
Smenkhkare, Tutankhamun's elder
brother or half-brother, and in that
case the queen is Akhenaten's
eldest daughter Merytaten.

Courtiers,
in the tomb of Haremhab at Saqqara

*c.*1330 BC. Sunk relief in limestone

El-Amarna, King Akhenaten's splendid new capital of Egypt, was abandoned after little more than fifteen years. King Tutankhamun and his court moved to the old traditional capital, Memphis, and the artists who had been involved in Akhenaten's artistic revolution followed. The country began to return to its former values in all walks of life, including the arts. Some of the artists who learnt the new 'Amarna style' under Akhenaten were now expected to 'unlearn' it under Tutankhamun. But this could not be achieved quickly and the splendid reliefs in the tombs built at Saqqara, the necropolis of Memphis, are full of echoes of the Amarna period. The courtiers watching General Haremhab's military parade were carved in sunk relief with a great deal of internal modelling. The Amarna artistic tradition can be seen in the depiction of the men's chests, almost feminine in appearance, their well rounded stomachs and the slim arms and hands with very long fingers which give the impression of an extra articulation. Their legs are concealed by their long billowing garments but there is more than a suspicion of the heavy thighs and spindly calves of the Amarna period.

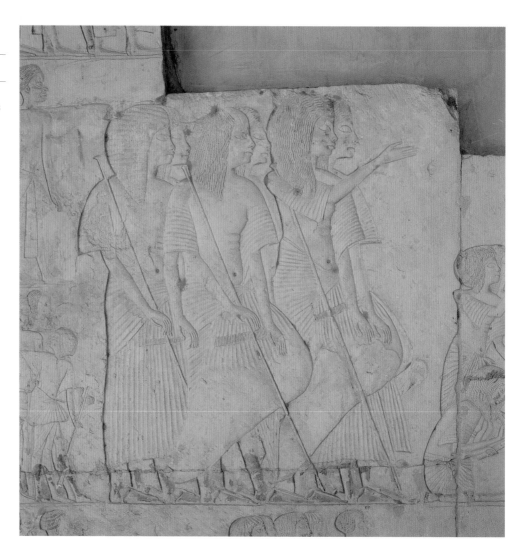

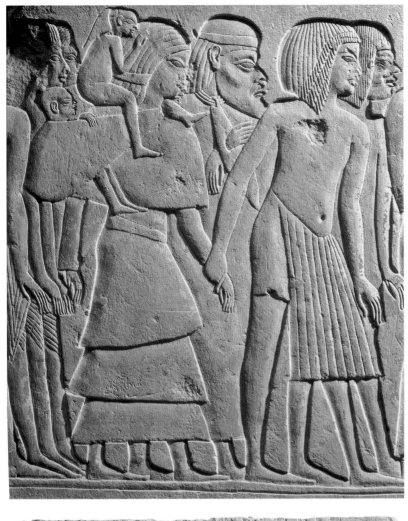

African and Syrian captives, from the tomb of Haremhab at Saqqara

*c.*1330 BC. Sunk relief in limestone. Syrians, still in the tomb. Africans, 62.5 x 85 cm, 24 x 33¹₂ in. Museo Civico, Bologna.

The tomb of General Haremhab was one of the first built at southern Saqqara, close to and probably visible from the city of Memphis, after King Tutankhamun's abandonment of El-Amarna. Haremhab wielded the military power in Egypt during the reign of young Tutankhamun. His tomb contains scenes of a triumphant parade of captives and booty brought from the Syro-Palestinian region in the north-east and Nubia and other countries in the south. But the veracity of these scenes is open to doubt. They may be artistic creations deemed appropriate for the tomb of Egypt's commander-in-chief, or may have been made 'in anticipation' of such events, or perhaps they broadly reflect real events without aspiring to historical accuracy. What is not in doubt is that in the scene of recording African prisoners the figures of Egyptian soldiers still belong to the Amarna period. The contrast between the tightly packed group of docile captives and the Egyptians, each of whom is shown very expressively in mid-action, also owes a great deal to the earlier artistic tradition. This is felt less strongly in the scene of a parade of Syrian captives and indicates that this may have been carved by an artist who was able to adapt more quickly to new stylistic requirements.

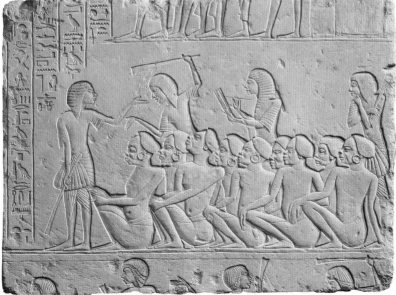

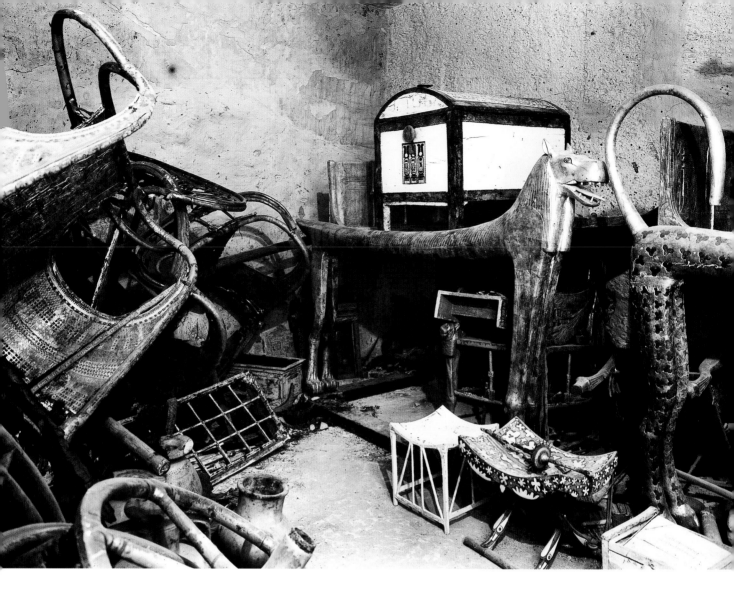

The 'Antechamber' of the tomb of King Tutankhamun with objects in situ, in the Valley of the Kings (the west bank at Thebes)

1327 BC. All objects are now in the Egyptian Museum, Cairo

The steps leading down to the tomb of King Tutankhamun were discovered on 4 November 1922 by Howard Carter during the excavations financed by Lord Carnarvon. Tutankhamun is the only Egyptian pharaoh of the third and second millennia BC whose tomb has been found substantially intact. The number and quality of objects found inside the tomb provide a tantalizing glimpse of the wealth which accompanied Egyptian kings to the afterlife. Nevertheless, direct comparisons with other rulers cannot be made because of the unusual circumstances surrounding Tutankhamun's life and death. The young king lived through the last phase of the religious revolution instigated by his father Akhenaten. His tomb and the composition of his funerary equipment must have been seriously affected by the religious, political and artistic upheavals which followed the end of his father's 'heretic' reign.

The tomb is quite unlike the other traditional royal tombs in the Valley of the Kings in its size (it consists of only four small rooms), plan (comparisons can be drawn with his father's tomb at El-Amarna) and decoration (only the burial chamber is decorated).

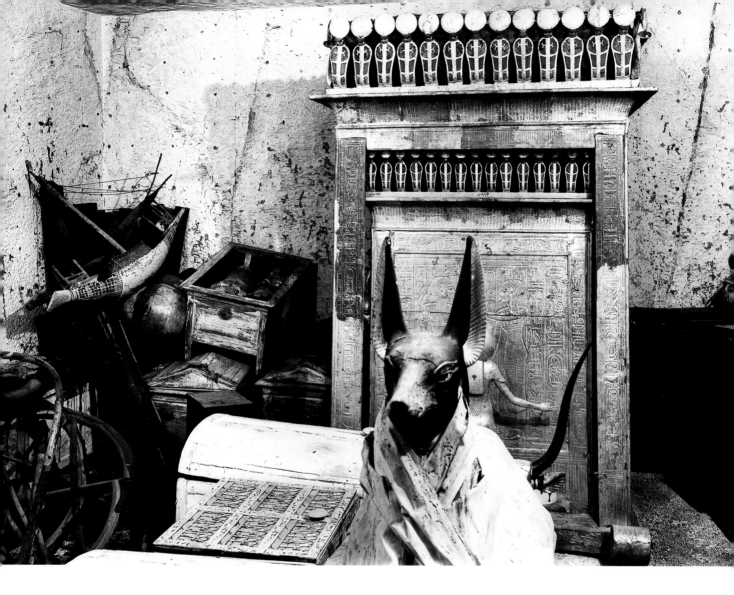

The 'Treasury' of the tomb of King Tutankhamun with objects in situ, in the Valley of the Kings (the west bank at Thebes)

1327 BC. All objects are now in the Egyptian Museum, Cairo

The discovery of a tomb which has escaped the attention of tomb robbers is very exceptional. The wealth of beautiful objects found in the tomb of Tutankhamun is overpowering. But the tomb's greatest contribution lies not so much in the formal aspects of its works of art, but rather in the sphere of technology and craftsman's skills which were required in order to produce them. It is one thing to see a representation of a piece of jewellery or an item of furniture on a tomb or temple wall, but it is something entirely different to be able to examine the object itself. The contents of the tomb were assembled from a number of sources. Some of the furniture was clearly made for a child and used by Tutankhamun in his lifetime; these items were brought from the royal palace. Other objects, such as some of the jewellery, were specially made in royal workshops, or supplied from royal storerooms (some of these are 'recycled' items originally intended for other members of the royal family). Objects of everyday use such as food and textiles came from royal estates. Items of specifically funerary nature, such as the sarcophagus and coffins, were, because of the king's sudden death, hastily made in necropolis workshops.

Tutankhamun's gold coffin, from his tomb in the Valley of the Kings (the west bank at Thebes)

1327 BC. Gold, bronze, obsidian, quartz, turquoise, carnelian, lapis lazuli, glass, l. of whole 187.5 cm, 73¼ in. Egyptian Museum, Cairo

King Tutankhamun's mummified body, with a gold mask covering his head and shoulders, was buried in three anthropoid (human-shaped) coffins which fitted into each other like a set of Russian dolls. These were placed in a rectangular stone sarcophagus. The lids of the coffins show the king as a mummy wrapped in bandages but his head and his crossed arms are shown as in life, with the crook and flail, the insignia of the god Osiris, in his hands. This is the third (innermost) coffin, made entirely of gold sheet about 0.3 cm (⅛ in) thick inlaid with glass and semiprecious stones and weighing just over 110 kg (243 lb). The king wears a headdress with its stripes indicated in relief, a ceremonial beard, a broad collar and two necklaces. The two protective goddesses of Egyptian kings, Nekhbet and Wadjit, are on the king's forehead. The goddesses are also present as two birds with outstretched wings, one vulture-headed, the other serpent-headed, over the king's abdomen and partly over his arms. The goddesses Isis and Nephthys 'protecting' the king with their outstretched wings are chased into the metal over the king's legs. Tutankhamun is shown as if wrapped in a feather cloak, a reference to the sky goddess Nut, indicated by chevrons.

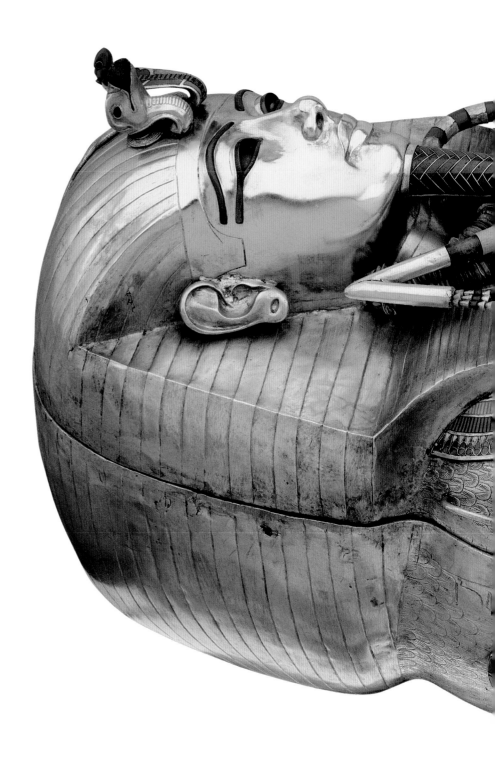

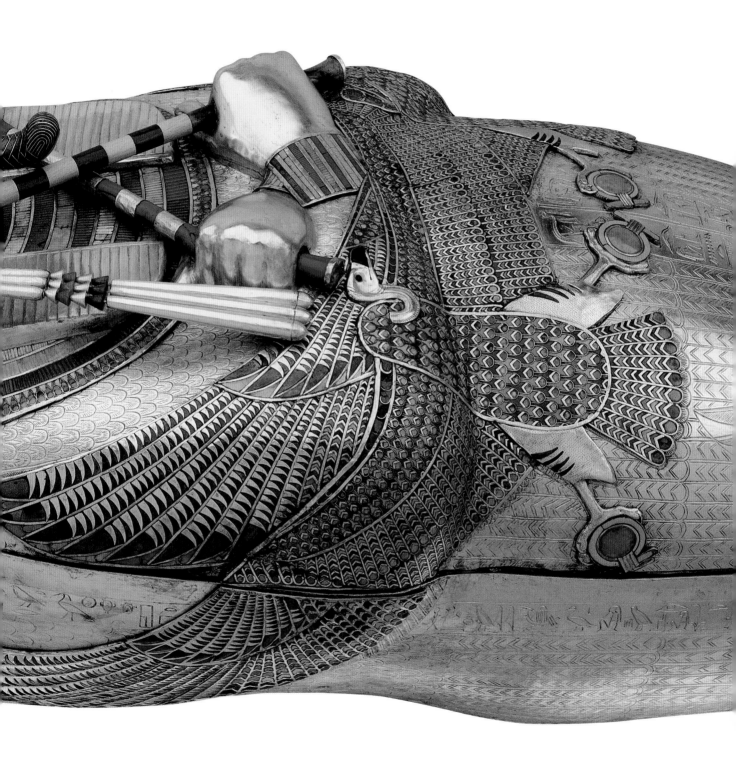

Tutankhamun's gold mask, from his tomb in the Valley of the Kings (the west bank at Thebes)

1327 BC. Gold, glass, lapis lazuli, obsidian, carnelian, quartz, felspar, faience, h. 54 cm, 21¼ in. Egyptian Museum, Cairo

The gold mask which covered the head and shoulders of Tutankhamun's mummy has become an instantly recognizable image of ancient Egypt. It represents the king wearing a striped royal headdress with the head of a vulture and a cobra (the two protective goddesses Nekhbet and Wadjit), a beard, and a broad collar. The mask retains the likeness of the person's most important characteristic, the face. Tutankhamun's mask was made of two sheets of gold which were hammered into shape, chased, inlaid and burnished. The yellow of gold and the blue of lapis lazuli, faience or glass dominate the colour scheme of the mask. The king's eyes are inlaid with quartz and obsidian, with spots of red painted in their corners. The eyes are extended by inlaid cosmetic lines. The king's ears were pierced. The headdress is rolled up into a pigtail at the back; its stripes are inlaid in blue glass. The shoulders and the back of the mask are inscribed with a text taken from the Book of the Dead, a collection of religious spells which were thought to be useful to a deceased person in the afterlife. The face of the king, especially in profile, bears a striking resemblance to his representations in reliefs.

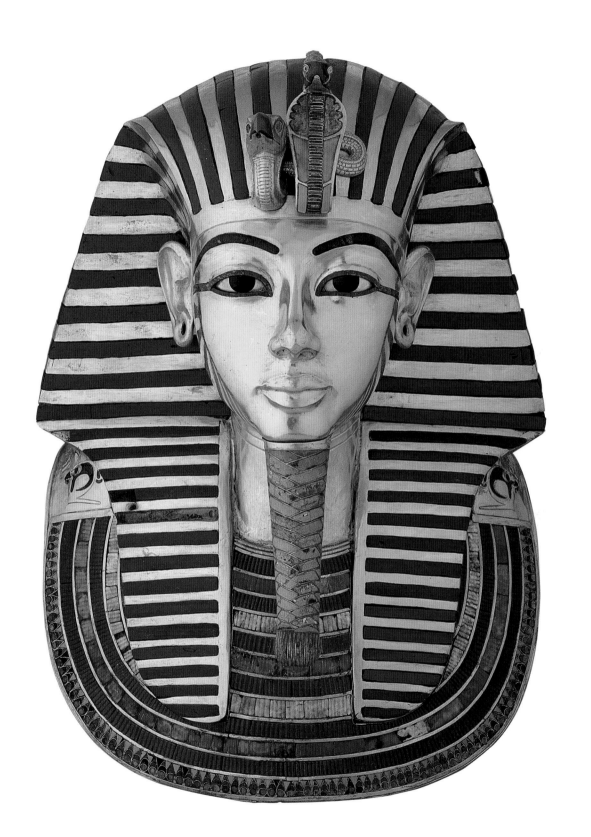

Painted box, from the tomb of Tutankhamun in the Valley of the Kings (the west bank at Thebes)

1327 BC. Wood overlaid with gesso and painted, h. 44.5 cm, 17¼ in, l. 61 cm, 24 in. Egyptian Museum, Cairo

Egyptian furniture did not include wardrobes. Instead, clothes were stored in chests and boxes. One of Tutankhamun's boxes is decorated with exquisite scenes painted on all its sides as well as the lid. Although the box is quite large the complexity and detail of the scenes makes them miniatures when compared with tomb paintings. On the long sides of the box the king is shown in his chariot charging the Syrians and Nubians, i.e. the two potential enemies in the north and the south. On the lid the king is again in his chariot, this time in two scenes of hunting wild animals. On the two short sides he is, in the guise of a sphinx, trampling over fallen enemies. These are the traditional themes reaffirming the pharaoh's domination over external enemies and the forces of nature, but they are presented in a way which became standard in the New Kingdom. The chariot was only introduced to Egypt in the period preceding the rise of the New Kingdom. The confused mêlée of fallen enemies is similar to the depictions of battle scenes on temple walls. There is, however, little doubt that Tutankhamun was personally never involved in wars against the Syrians or Nubians.

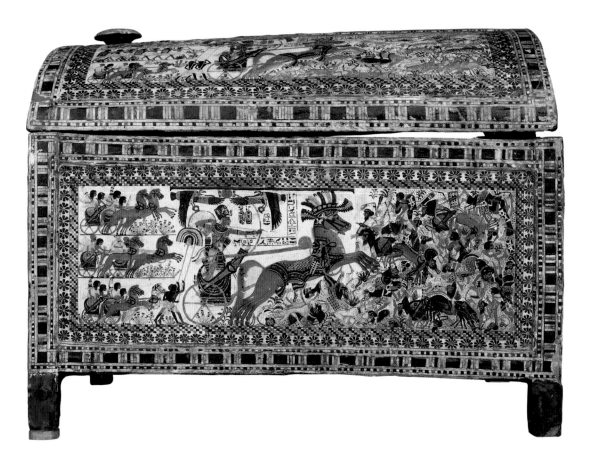

The goddess Selket, from the tomb of Tutankhamun in the Valley of the Kings (the west bank at Thebes)

1327 BC. Gilded wood, h. 90 cm, 35 in.
Egyptian Museum, Cairo

Tutankhamun's internal organs, which were removed during the mummification of his body, were stored in a chest made of travertine (alabaster). Egyptologists use the term 'canopic chest', which derives, inaccurately, from the name of Kanopos, the steersman of Menelaos of the *Odyssey*. The chest was enclosed in a wooden shrine with a wooden canopy over it. Four goddesses were regarded as guardians of the internal organs: Isis, Nephthys, Neith and Selket. The goddess Selket could manifest herself in the form of a scorpion and was often represented as a woman with a scorpion on her head. This was an artistic variant which avoided the awkward discrepancy in size between a human figure, or a large animal, and a small arachnid. Next to each of the four sides of the shrine was a figure of one of the guardian goddesses. They stood with their backs towards the spectator and stretched their arms as if to form a protective ring around the shrine. But the head of each goddess is slightly turned sideways rather than facing straight so that they show their part-profile. This is rarely encountered in Egyptian sculpture but it satisfied the contradictory demands made on these statues.

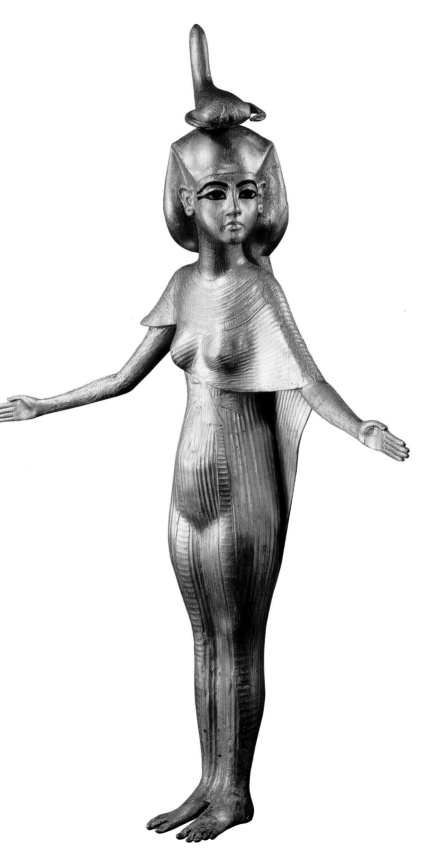

Duck-head chair, from the tomb of Tutankhamun in the Valley of the Kings (the west bank at Thebes)

1327 BC. Wood, gold foil, semiprecious stones, faience, glass, ivory, h. 102 cm, 40 in. Egyptian Museum, Cairo

Among the 'thrones' and chairs found in the tomb of Tutankhamun, the construction of the duck-head chair (sometimes called a 'ceremonial throne' or 'ecclesiastical throne') is the most interesting. The concept may seem curious: a chair which partly imitates a folding stool, but is rigid and does not function as such. The form, however, can be easily understood as a folding stool which has been permanently fixed in an unfolded position with an added slightly sloping back. The chair is made of wood partly covered with gold foil and inlays. Its solid wooden seat which curves in two directions substitutes for the leather of the folding stool and its inlays imitate an animal skin. Its legs are in the form of ducks' heads inlaid with ivory. Apart from the goddess Nekhbet as a vulture spreading her wings at the top of the chair's back, and so over the shoulders of the person sitting on the chair, the inlaid decoration is entirely geometrical. It has been suggested that its panelling effect derives from architectural decoration. The hieroglyphic inscriptions which record the names of the king refer to him as Tutankhaten and so the chair was made early in his reign when he still resided at El-Amarna.

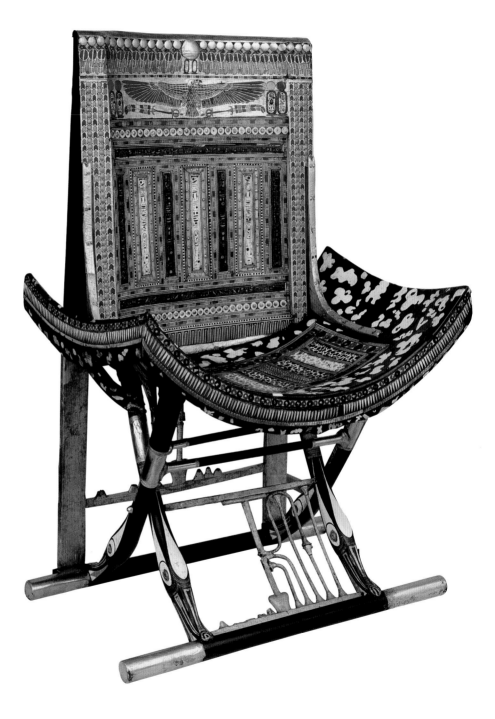

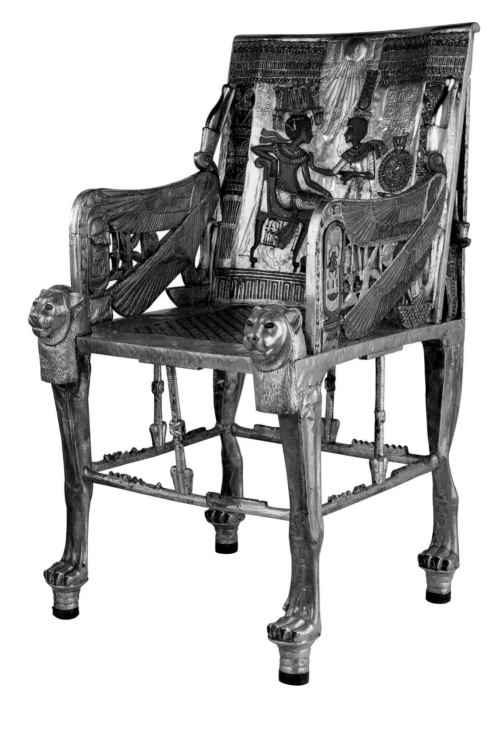

Armchair with Tutankhamun and his Queen Ankhesenamun, from his tomb in the Valley of the Kings (the west bank at Thebes)

1327 BC. Wood, sheet gold, silver, semiprecious and other stones, faience, glass, bronze, h. 104 cm, 41 in. Egyptian Museum, Cairo

This armchair, often called a 'golden throne', is the most lavishly decorated among the chairs found in Tutankhamun's tomb. Its present appearance is, however, somewhat misleading. The rectangular spaces between the seat and the struts connecting the legs is now empty and this gives the armchair a degree of lightness which counterbalances the heaviness of its back and the panels under its arms. Originally, however, these spaces were filled with an openwork design which was removed in antiquity. The armchair must have been constructed in the king's early years because the scene on its back is unmistakably in the style of Amarna art. It is inlaid onto a background of gold sheet and shows the king being anointed with scented oil by his wife Ankhesenamun. The Aten, a sun disc with rays which terminate in human hands (see 176), shines triumphantly above the young couple. Changes were made to their names: when the armchair was made the king was still called Tutankhaten and his wife was Ankhesenpaten. The alterations were carried out very superficially because on the less conspicuous reverse and arms of the armchair the names were left intact.

Lion head, from a couch in the tomb of Tutankhamun in the Valley of the Kings (the west bank at Thebes)

1327 BC. Gilded wood,
rock crystal, glass, bronze,
l. of whole 180 cm, 70 in.
Egyptian Museum, Cairo

Among the most curious objects found in Tutankhamun's tomb were three couches with animal heads, stylized bodies and tails. The animals are two lionesses, two cows and two composite deities resembling the hippopotamus. The body of each of the animals represents one of the couch's long sides. It looks as though two identical animals were yoked together and carried a bed between them, and this is how the couch was, in fact, constructed. The body of the lioness, identified with the goddess Mehyt in the couch's inscription, is carved of solid timber covered with gesso and overlaid with gold. Inlays of bright blue glass were used for the nose and tear drops, darker glass for the eye frames. The extraordinarily life-like eyes are of translucent crystal with colour details painted behind it: the irises are brown, the pupils black, and the corners of the eyes are red. The bed has a footboard decorated with pairs of large hieroglyphic signs for 'stability' and 'protection'. It is clear that these couches were not used for sleeping and so they are usually described as ritual items. Nevertheless, completely satisfactory explanation of their purpose has not yet been offered.

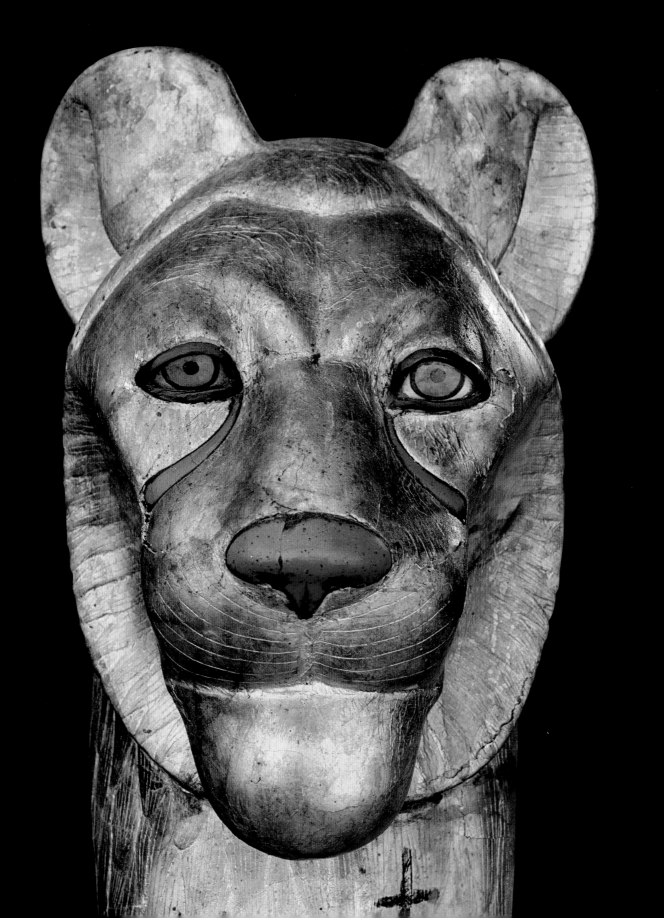

Chariot, from the tomb of Tutankhamun in the Valley of the Kings (the west bank at Thebes)

1327 BC. Wood, leather, gold, glass, semiprecious stones, axle l. 216 cm, 85 in. Egyptian Museum, Cairo.

The horse-drawn chariot was primarily a vehicle for conducting war, and secondarily a means of transport. Chariots were light, made chiefly of wood and leather. They provided little or no protection for the charioteer and the chariot warrior, and were not suitable for fighting among well-organized units of infantry. Instead they were used as fast mobile platforms which brought warriors armed with bows sufficiently close to the enemy's massed ranks to discharge their arrows. The chariot was introduced, together with the horse, from Western Asia some time during the seventeenth century BC. War scenes of the New Kingdom almost always show the king standing in his chariot, his bow drawn, charging the enemy. Six dismantled chariots were found in Tutankhamun's tomb. Three or four of these are ceremonial vehicles made of wood overlaid with gold sheet over gesso. The 'union of the Two Lands' (i.e. of the two parts of Egypt), with subjugated foreigners tied by the stalks of the symbolic plants, is the most conspicuous element of the decoration on the body of the chariot illustrated.

Gaming box, from the tomb of Tutankhamun in the Valley of the Kings (the west bank at Thebes)

1327 BC. Gold, wood and ivory, l. 44.4 cm, 17½ in. Egyptian Museum, Cairo

The game of *senet* was played on a board of thirty squares but did not resemble a battle between two armies in the way modern chess or draughts do. The aim was to reach the final square, and the pieces' moves were determined by a chance throw. It was a favourite pastime but also had religious and funerary connotations, presumably because the similarity to every person's path through life, with its 'good squares' and 'bad squares', and the final destination, was too obvious to miss. Tutankhamun's game set combines two boards, one for the *senet* game on its top surface and another for a game played on twenty squares on the bottom surface, with a long drawer for pieces at one end. The box is made of wood veneered with ebony and its boards are inlaid in ivory. The legs of the stand terminate in lion's paws with ivory claws on ribbed drums covered with gold sheet, and are set on a sled similar to those of shrines.

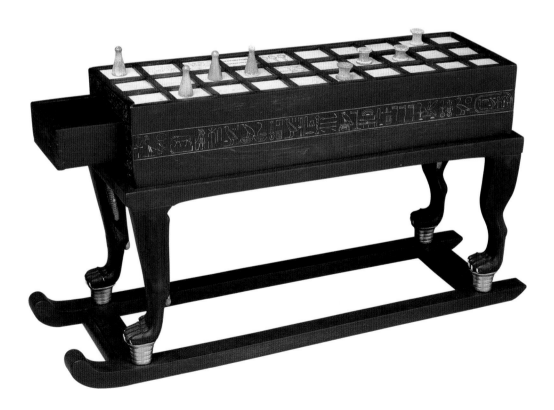

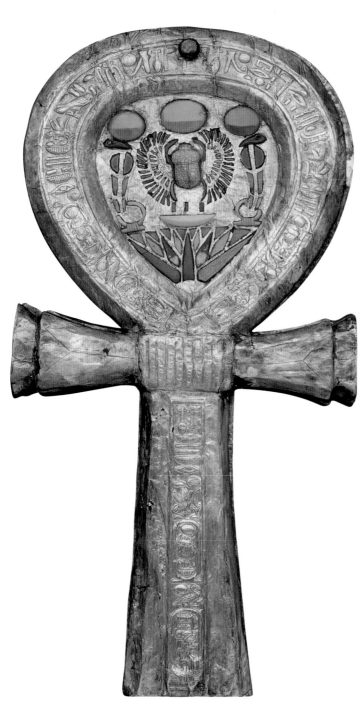

**Mirror case, from the tomb of
Tutankhamun in the Valley of the Kings
(the west bank at Thebes)**

1327 BC. Gilded wood, silver,
carnelian, glass, h. 27 cm, 10 in.
Egyptian Museum, Cairo

One of the Egyptian words for
a mirror was *ankh*. Although
hieroglyphs represent real people,
objects, etc., most of them convey
sounds and so their appearance
is not connected with the word
which they record. The hieroglyph
pronounced *ankh* probably shows a
sandal strap but its resemblance to
a mirror was the reason why *ankh*
was adopted as another word
for a mirror. The standard meaning
of *ankh* was 'life' or 'to live'
and this allowed further attractive
references to a mirror, for example
because it seems to come to
life when one looks into it.
Tutankhamun's mirror case is made
of wood overlaid with gold sheet;
its interior is covered in a similar
way with silver. In the centre of
the lid is a small scene, inlaid in
semiprecious stones and glass,
in which a winged scarab beetle
emerges out of a small basket
placed on top of a lotus flower and
greets the sun. This, in fact, is one
of Tutankhamun's names, Neb-
kheperu-re: the basket (*neb*) + the
beetle (*kheperu*) + the sun disc (*re*).
The name is protected by two uraei
(cobras). The mirror, unfortunately,
was not present when the case
was found.

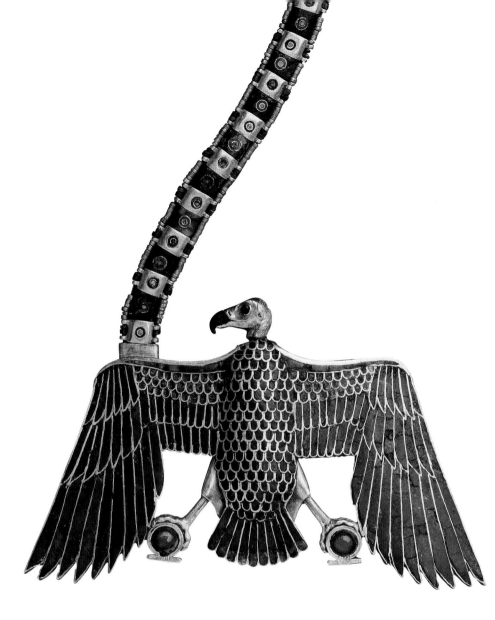

Vulture pectoral, from the tomb of Tutankhamun in the Valley of the Kings (the west bank at Thebes)

1327 BC. Gold, glass, obsidian, felspar, lapis lazuli, carnelian, w. without strap 11 cm, 4 in. Egyptian Museum, Cairo

The variety of forms of jewellery found in Tutankhamun's tomb is astonishing. These pieces appealed to the Egyptian appreciation of beautiful things and their fascination with rare and precious materials, in the same way as they attract us. But many of them had deeper implications. Some were worn as amulets in order to protect their owner against mishaps and disasters in lifetime or in the afterlife. Others conveyed religious concepts or ideas about the role of the king through visual symbolism. This pectoral was found suspended from Tutankhamun's neck. It shows a vulture with drooping wings, a reference to the goddess Nekhbet who was one of the protective deities of Egyptian kings. The vulture's body, tail and wings are inlaid with glass. The head and talons have very finely chased details. The straps are attached to the bird's wings. They consist of alternating rectangular plaques of gold and lapis lazuli with inlaid concentric circles, and are bordered by gold beads for lapis lazuli plaques and blue glass for gold plaques.

King Haremhab kneeling before the god Atum, from the temple of Amun at Luxor

*c.*1320 BC. Diorite, h. 190.7 cm, 75 in.
Luxor Museum

The design of this statue discovered in a cache in the court of King Amenhotep III at Luxor (see also 161) is often seen in two-dimensional representations but only rarely in large sculptures in the round. The reasons are the difficulties associated with the carving of such a subject and the less favourable chances of preservation. Artistically, there are several interesting features worth noting in this statue. The figure of the kneeling King Haremhab offering two bowls of wine was carved separately and inserted into the base of the statue of the god Atun. This was, no doubt, done in order to facilitate the carving of the statue. The figures of both Atum and Haremhab display back pillars which were characteristic of Egyptian statues and distinguished them from sculptures made anywhere else in the world. The back pillar of Atum is round at the top while that of Haremhab is squared; both carry an inscription. The origin of the back pillar is probably to be sought in the rear wall of the stone imitation of a shrine in which the early statues stood. Other advantages, such as additional support and a convenient place for inscribing texts, ensured that most Egyptian statues had such a pillar at their back.

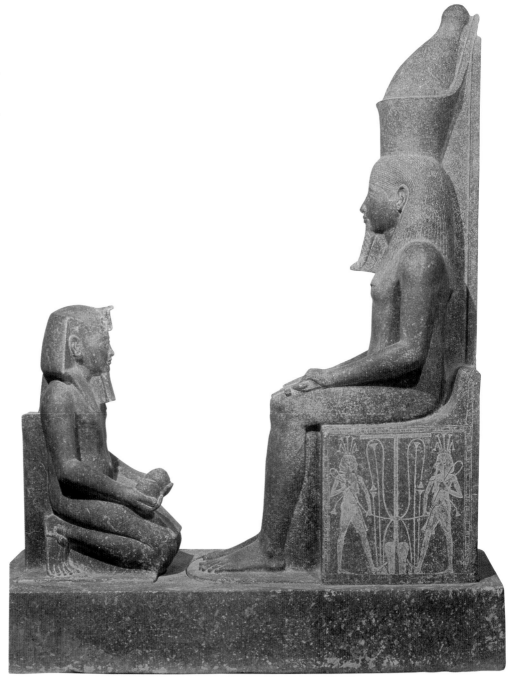

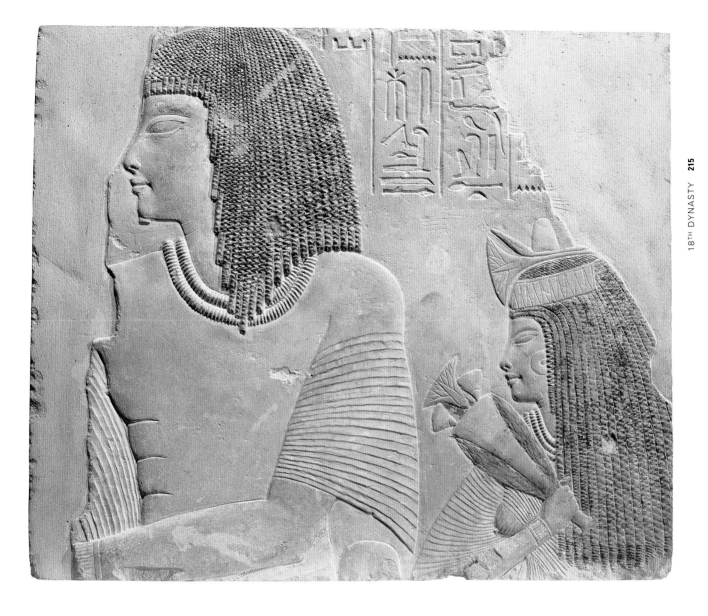

Amenmosi and his wife Depet, from the tomb of their son, General Amenemone, at Saqqara

*c.*1300 BC. Raised relief in limestone, h. 56 cm, 22 in. Louvre, Paris

Tombs which were built at Saqqara during the reign of Tutankhamun and his successors (see also 196–7) had a free-standing chapel with a small pyramid at its western end and a complex of subterranean burial chambers. The chapel may have consisted of an entrance pylon (front wall with a gate), one or more courts, some of them with pillars, and a tripartite offering room at the far (western) end. Most of the contemporary large tombs in the Theban area were rock-cut and so the similarity between the plans of Memphite and Theban tomb chapels is not immediately obvious. But there can be no doubt that there was a generally accepted idea of an 'ideal plan' and that Theban as well as Memphite tombs were an expression of it in two entirely different settings. The decoration at Saqqara was either in raised or sunk relief, sometimes both techniques being used. Although traces of the Amarna style never disappeared completely, they receded rapidly after the beginning of the 19th dynasty. The tomb chapel of General Amenemone was decorated at the very end of the 18th dynasty when the Amarna influences were still strong but had already mellowed. The result is one of the most attractive types of relief decoration ever produced in Egypt.

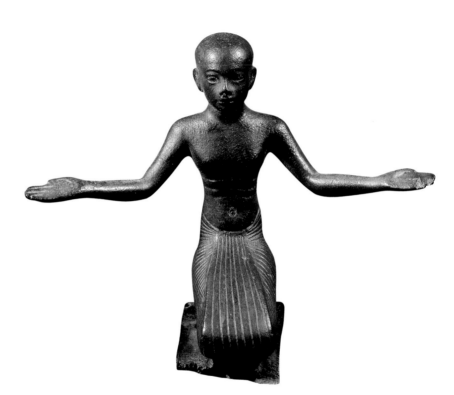

A kneeling man, location of discovery not known

*c.*1300 BC. Bronze, h. 8 cm, 3 in. Louvre, Paris

While during the second millennium BC some bronze statuettes of people appear to have been made for tombs, others were destined for temples. Their task was to ensure the donor's eternal presence at the side of the god. The bases were often made separately, possibly even in other materials, and because of this inscriptions identifying the person have been lost. Hardly any have been discovered in circumstances which would show us how they were displayed in temples. Because of their small size special arrangements must have been made to accommodate them.

Many of these statuettes show a person offering or in an attitude which suggests that they are trying to communicate with the god. This small sculpture shows a man kneeling on the ground with his arms stretched out, the palms of his hands upwards. It is likely that this gesture immediately precedes or follows the 'adoration' when both arms are half raised with palms open towards the god.

The person's pleated kilt slightly sagging at the waist suggests the influence of the arts of the Amarna period.

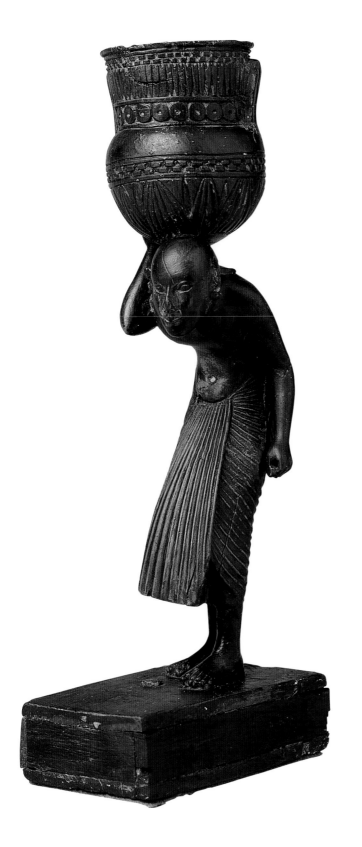

Container for cosmetics in the form of a servant carrying a jar, location of discovery not known

*c.*1300 BC. Wood, originally painted, h 21.5 cm, 8½ in. Liverpool Museum

At first sight, this object appears to be a statuette of a domestic carrying a large jar on his shoulders, supporting it with his right hand and bending under its weight. The pose is interesting and reminds one of servant statuettes of the Old Kingdom (see 63) and similar figurines in bronze from the Late and Ptolemaic periods. In fact, the jar functioned as a container for cosmetics and the figure of the man was an extra element added to increase the item's appeal. The jar had a lid, now missing. The left hand of the man is drilled, as if he had held a now lost object. But it is also possible – and this may upset aesthetic purists – that this had a practical application: it may have been for the insertion of a small spatula or stick with which the cosmetic was applied. Small traces of paint survive on the figure and there seems little doubt that originally it was painted in bright colours, another feature which may affront the artistic sensitivity conditioned by Western art appreciation. The nineteenth-century art connoisseur who stripped the figure of its gesso covering and its paint and replaced it with modern dark varnish held the same view.

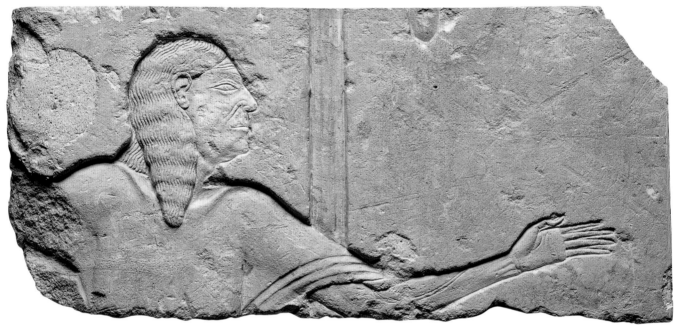

Old courtier, from a tomb at Saqqara

*c.*1290 BC. Sunk relief in
limestone, h. 14.4 cm, 5 in.
Brooklyn Museum of Art, New York

The tendency towards more
realistic portraiture and attention
to anatomical details were
characteristic features of Amarna
art and can still be seen in reliefs
carved at Saqqara in the post-
Amarna period. This fragment
probably comes from a tomb made
at the very beginning of the 19th
dynasty, some forty years after
the end of Akhenaten's political,
religious and artistic revolution. It
is a remarkably unflattering portrait
of old age. The man is standing in
a pavilion. His forehead is heavily
wrinkled and there are deep
furrows running from his nostrils
to the corners of his mouth; he
has a pronounced double chin.
His collar bones are conspicuous.
There is a general impression of
the flabbiness of an old body. Even
his long wig seems untidy and old-
fashioned. We perhaps read this
into the representation because of
the other characteristics, but it is
the sign of a true work of art that it
should stimulate our imagination in
this way. His unnaturally long arm
is stretched out, the lined palm
showing, in a gesture which in
Egyptian art usually suggests that
the person is addressing other
people. Probably intentionally, the
man's fingers are more like claws,
quite unlike the refined and
delicately shaped fingers which
we know from Amarna reliefs.
This is an exceptionally powerful
representation which transcends
the usual standard of Saqqara
reliefs.

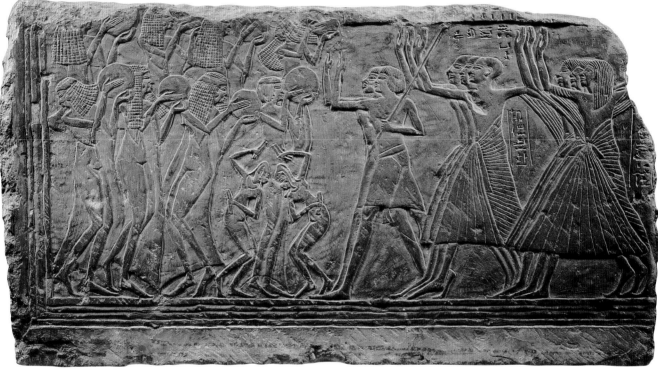

The arrival of a funerary cortege, from a tomb at Saqqara

*c.*1290 BC. Raised relief in limestone, w. 105 cm, 41 in. Egyptian Museum, Cairo

Depictions of funerals were frequently included in Theban as well as Memphite tombs during the New Kingdom. In the relief illustrated here women with tambourines and two girl dancers welcome a funerary procession. The artist very successfully conveys the highly emotional atmosphere of the occasion. The women musicians are stationary but one can almost see their bodies rhythmically sway and hear the sound of their tambourines. This is contrasted with the van of the procession approaching at a military quick march (see, especially, the feet of the men in the first row of three: the front foot is not yet fully placed on the ground and the back foot is shown with a raised heel). The artist resorted to several unusual methods of depicting overlapping bodies. Above the front row of female musicians there is another row of tambourine players who are shown in a way which suggests that the artist experimented with an alternative depiction of space, differing from most Egyptian two-dimensional representations. Only the upper parts of the women's bodies are visible above the heads of their companions in the first row and there is no base line for them.

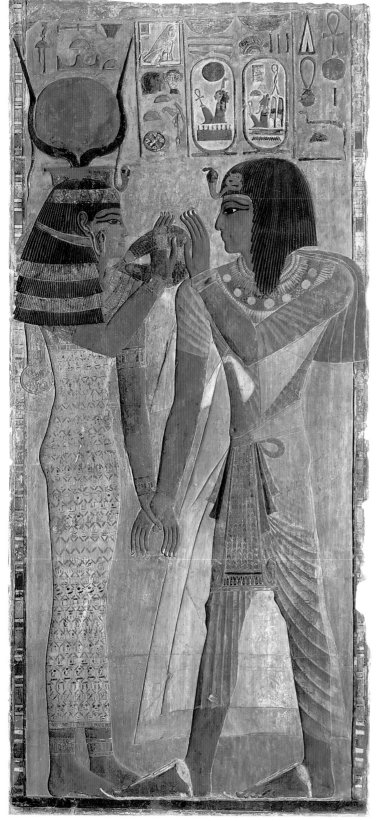

King Sety I and the goddess Hathor, from the king's tomb in the Valley of the Kings (the west bank at Thebes), and a view of the tomb's sarcophagus room

*c.*1280 BC. Raised relief in limestone, h. of detached relief 226.5 cm, 89 in. Louvre, Paris

Only a little over forty years separated the reigns of Sety I and Akhenaten. In the north, at Memphis, the influences of Amarna art still showed in tomb decoration (see 218–19). In the south, at Thebes, orthodoxy returned with a vengeance, especially in royal tombs. The scene on the left, originally on the side of a door in the tomb of Sety I, demonstrates it perfectly. It is impeccably designed and exquisitely carved in low relief, which was a hallmark of the reign of Sety I, but it has none of the vivacity and apparent spontaneity of Amarna art. It shows the king being welcomed and offered a necklace by the goddess Hathor. Hathor appears here as the patroness of the Theban necropolis. The necklace which she holds symbolizes the protection which the king was going to receive from the goddess by touching it. In addition to the scenes showing the king in the company of various gods, the decoration of the royal tombs also depicts various funerary rites and texts and representations of the so-called 'books of the afterlife' (texts concerning the underworld which were useful in the king's afterlife) and collections of other religious spells.

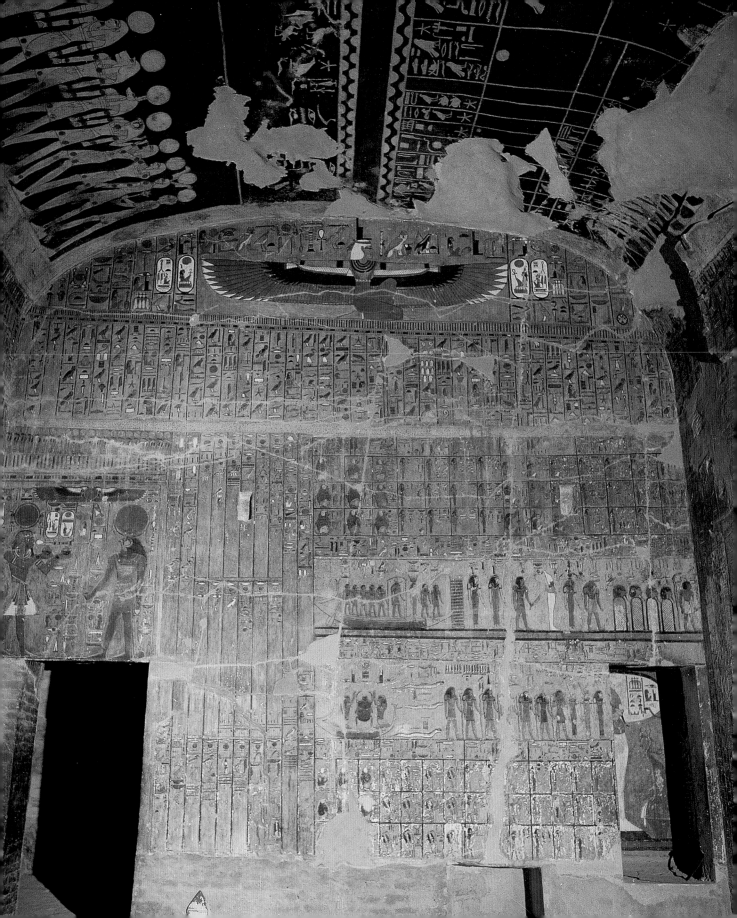

The burial chamber of the workman Pashed at Deir el-Medina (the west bank at Thebes)

*c.*1280 BC. Wall painting on plaster

During the New Kingdom, the majority of Egyptian pharaohs were buried in the Valley of the Kings (this is a modern term), on the west bank of the Nile opposite the city of Thebes. Their tombs were made by workmen and artists who lived in a close-knit community in the village of Deir el-Medina (also a modern name). These men used their expertise and spare time for making their own family tombs. The tombs are rock-cut but their outer part may be brick-built with a small pyramid above it. Sometimes the chapels, but especially the burial chambers, are decorated with painting. This illustration is a view into the burial chamber of one of them, Pashed. Two figures of the necropolis god Anubis, represented as a jackal, flank the entrance corridor. The rear wall of the simple burial chamber shows the god Osiris-Onnophris, the ruler of the kingdom of the dead, seated in front of a mountain (a motif which occurs often at Thebes). The text is a spell for 'lighting a lamp for Osiris', and one wonders whether the working conditions inside royal tombs were the reason for the choice of this particular spell. Pashed himself is the small kneeling figure behind the god. Various deities are depicted on the vaulted ceiling of the burial chamber.

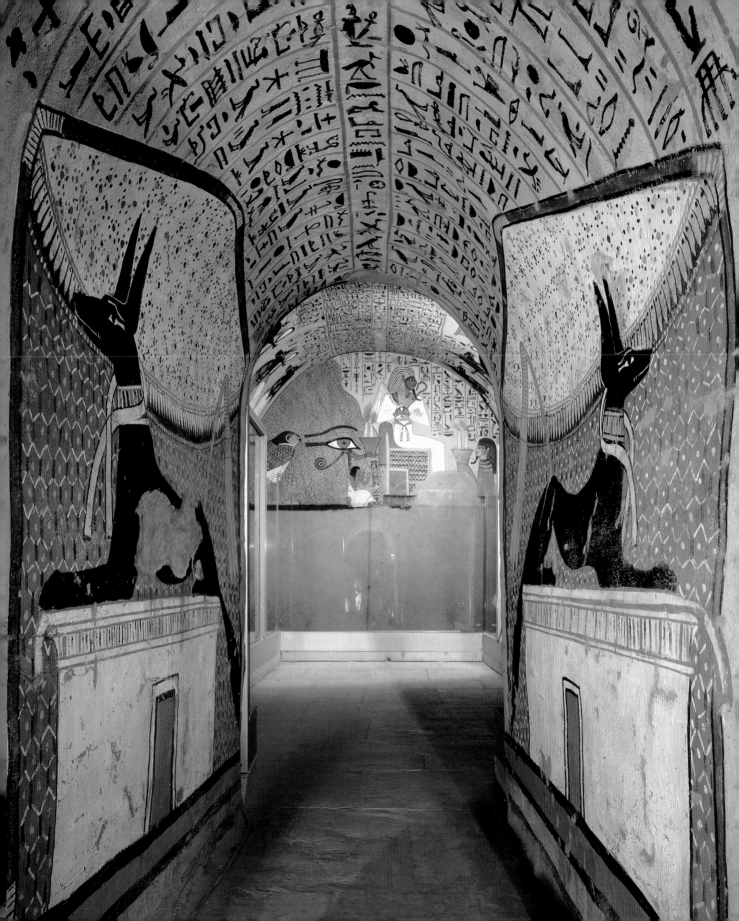

Woman acrobat dancer, location of discovery not known

*c.*1280 BC. Painting on a limestone fragment, w. 16.8 cm, 6 in. Museo Egizio, Turin

The word 'ostracon' (from Greek for 'potsherd') describes smooth flakes of limestone which were used for writing or drawing. Fragments of pottery may have served the same purpose but much less often. Ostraca were used for less formal occasions than papyri. The main reason why they were preferred in certain situations was not just that they were cheaper but because at Thebes, where most of them have been found, they were at hand and there was an inexhaustible supply of them. Artists used them for a variety of purposes: for rapid sketches while trying to work out a detail of a scene planned for a tomb wall or a stela, for making a quick record of an interesting topic seen elsewhere, or for informal drawings of all kinds which had nothing to do with work and were made for sheer amusement. This painting probably belongs to the last category. Female acrobats could have been seen represented on the walls of tombs as well as temples, but this sketch of a bare-breasted dancer also appears to be erotically charged and was probably appreciated as much for its titillating quality as for its artistic skill.

Ramesses II,
probably from Karnak

*c.*1270 BC. Granodiorite,
h. 194 cm, 76 in.
Museo Egizio, Turin

One of the reasons why King
Akhenaten embarked on his
'revolution from above' may have
been an attempt to revise the
position of the king in Egyptian
society and religion. But,
paradoxically, it was the ultra-
orthodoxy of King Ramesses II
which saw true modernization
of royal portraits. In the statue
illustrated here the king is wearing
the blue crown with a coiled cobra
and holds the crook (*heka*, the
symbol of royal authority), but he
is wearing a pleated garment with
a widening front panel and there
are sandals on his feet. This is a far
cry from the statues of the Old and
Middle Kingdoms showing a bare-
chested superman dressed only in
a short kilt. Because the reign of
Ramesses II was very long the
official royal image underwent
several modifications. The situation
was further complicated because
the immense scope of the king's
building activities meant that a
number of workshops in different
parts of the country were involved
in the making of his sculptures.
There is also ample evidence
showing that statues of earlier
kings, especially colossi (for
example those of King Amenhotep
III), were re-carved for Ramesses II.
The illustrated statue shares a
number of characteristics with the
sculptures of his father, King Sety I.
This suggests that it dates to the
early years of Ramesses II.

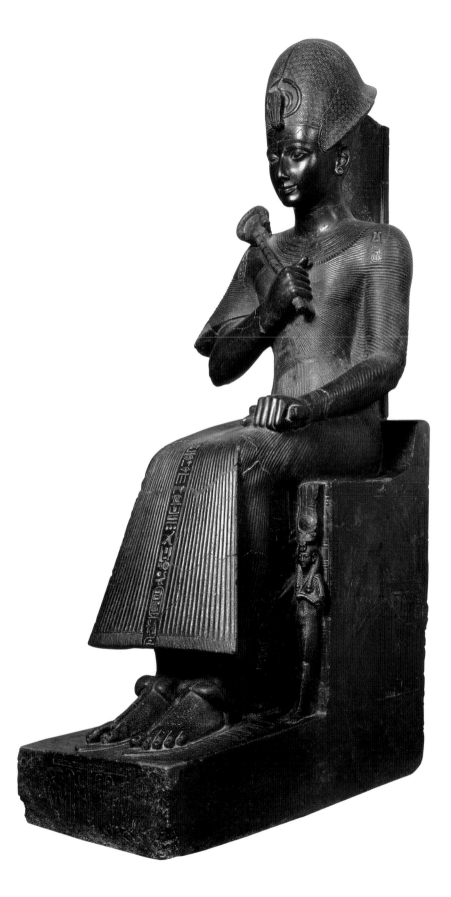

Ring with horses,
location of discovery not known

*c.*1270 BC. Gold, carnelian,
d. 2.2 cm, ⁷⁄₈ in.
Louvre, Paris

The passion for horses which was
such a feature of male society in
Egypt during the 18th and 19th
dynasties manifests itself in the
design of this unusual ring to be
worn on a finger. Presumably
intended for a man, perhaps the
pharaoh himself, the ring is made
of gold and was once lavishly
decorated with semiprecious
stones, but only one inlay of red
carnelian is now left. The central
scene on its bezel is surrounded by
lotus flowers and mandrake fruits,
all once inlaid in cloisons (cells) of
gold, and bordered by a row of
small gold pearls on both sides.
Two spirited horses with finely
chased details of the heads, manes
and covers thrown over their backs,
still remain of a miniature sculpture
in gold on the ring's bezel. A
substantial part of it seems to be
missing and its precise original
form is difficult to establish. The
ring is usually assigned to the reign
of Ramesses II although this dating
is rather tentative.

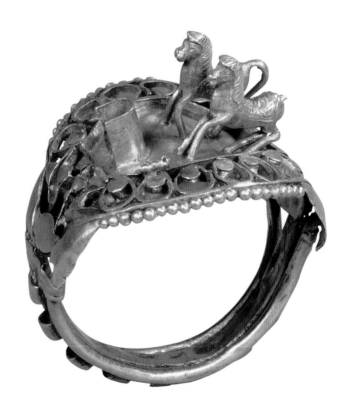

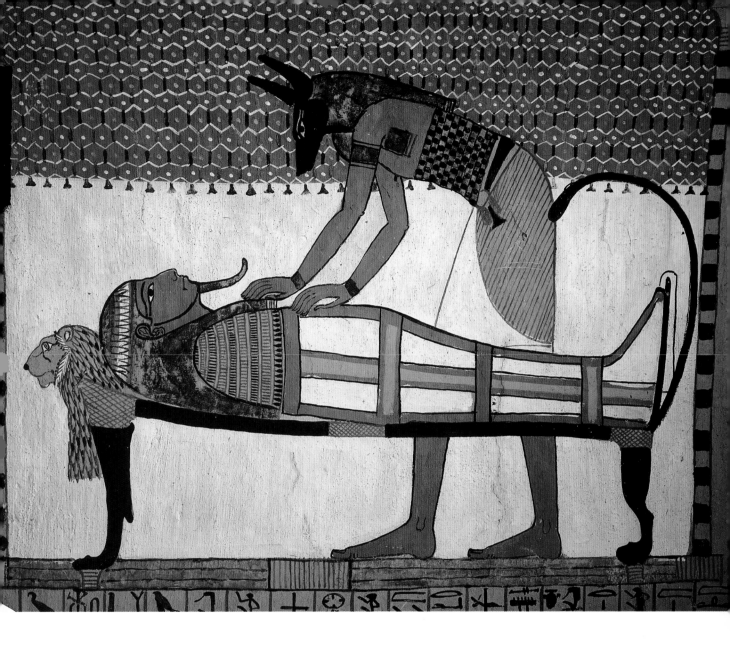

Mummification scene, in the burial chamber of the workman Sennedjem at Deir el-Medina (the west bank at Thebes)

*c.*1260 BC. Wall painting on plaster

The lives of the men who made royal tombs in the Valley of the Kings are known to us in intimate detail from papyri and ostraca found during the excavation of their village at Deir el-Medina and in the Valley itself. Artistically, this is of enormous importance because we can link the names of these artists with the royal tombs in which they worked, even though their signatures do not appear in them. For the first time in Egyptian history it is possible to follow in astonishing detail the individual styles of artists known to us by name. Such studies have already been undertaken but, as so often happens in Egyptology, have not yet been published in detail. Furthermore, it may even be possible to connect the decoration of the royal tombs with that in the tombs of the artists themselves and their colleagues. Here, in a scene in the burial chamber of one of these workmen, Sennedjem, the necropolis god Anubis is shown as an embalmer preparing the man's mummy on a lion-headed embalming bed. The text is spell 1 of the so-called Book of the Dead.

Trees and plants, in the burial chamber of the workman Sennedjem at Deir el-Medina (the west bank at Thebes)

*c.*1260 BC. Wall painting on plaster

Although many of the scenes painted in workmen's tombs at Deir el-Medina are, in fact, illustrations which belong to the texts of the so-called Book of the Dead and are set in the afterlife, their details are contemporary. Here, below the feet of Sennedjem and his wife toiling in the fields of the netherworld, there is a sub-scene with trees (sycamores, date and dom palms) and plants (mandrake, poppy and cornflower) growing on the banks of a canal. We probably should not read too much into the inclusion of the mandrake and poppy. They are the same trees and plants which the Egyptians saw around them in their lifetime and this, in a rather touching way, demonstrates that what the Egyptians hoped to find in the afterlife was very much what they knew during their lifetime. Egyptian artists were very observant and details of the fauna and flora are almost always accurate.

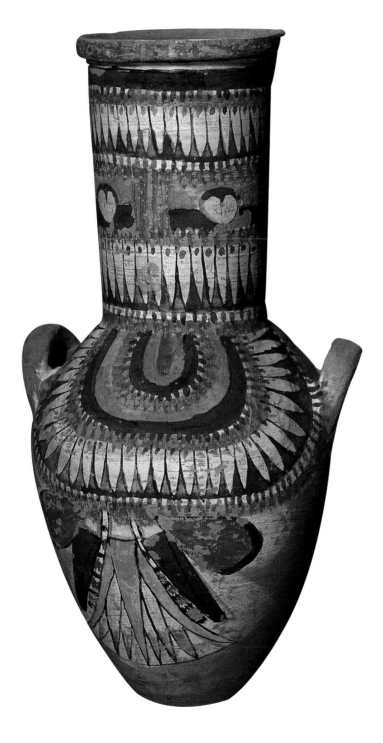

**Jar with floral decoration,
from the tomb of the workman
Sennedjem at Deir el-Medina
(the west bank at Thebes)**

*c.*1260 BC. Painted pottery,
h. 33 cm, 13 in.
Egyptian Museum, Cairo

A number of Ramessid tombs
contained attractive large decorated
jars which were almost certainly
specially made for inclusion among
funerary goods. The jars have tall
necks and handles and may have
been intended to contain wine.
The painted decoration on the pots
imitates the real floral garlands and
wreaths which we find draped
over vessels depicted in tombs.
It is difficult to establish with
certainty whether this was a purely
decorative arrangement or whether
there was a symbolic purpose (e.g.
in the choice of flowers) behind it.
As often in Egypt, the two fuse
easily: decoration acquires a
symbolic meaning and a symbol
can be presented in a highly
attractive way. On the jar illustrated
here, there are mandrake fruits on
its neck, and a large wreath with
a lotus flower and poppies is
suspended from it on its body. It
is possible, in fact, to see in this
arrangement an imitation of a collar
around a person's neck, and
it is unlikely that this would have
escaped the notice of the artist
decorating the jar. Lotuses are a
recurring motif in Ramessid tomb
paintings (see 254).

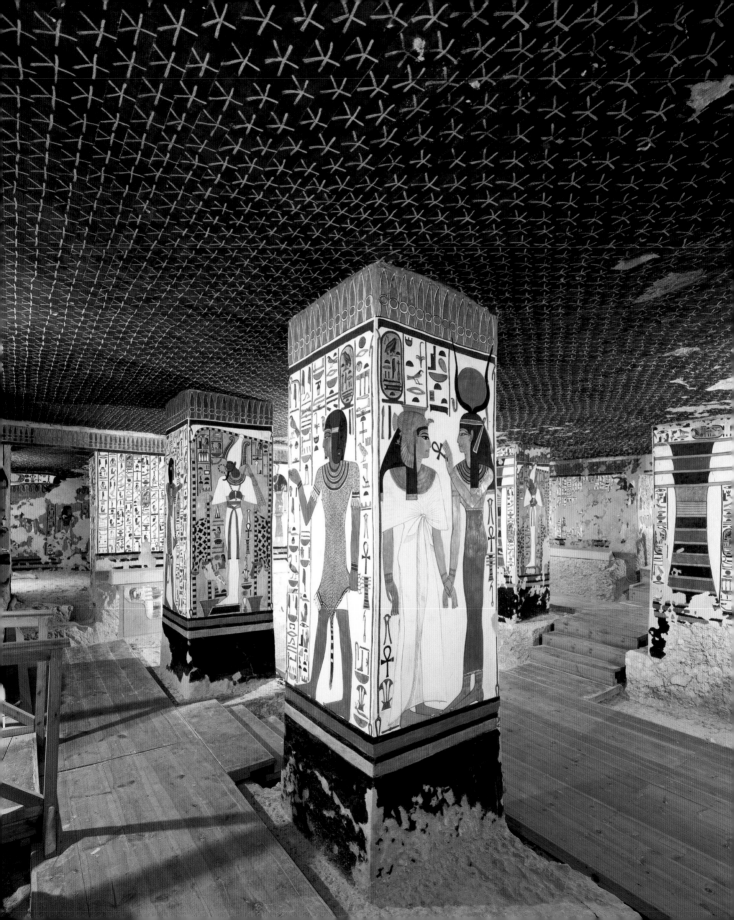

The sarcophagus room in the tomb of Nofretari, a queen of Ramesses II, in the Valley of the Queens (the west bank at Thebes)

*c.*1255 BC. Wall painting on plaster

Many members of the Ramessid royal families were buried in the Valley of the Queens, on the west bank of the Nile at Thebes. The orientation of scenes in tombs and temples is not accidental; often it indicates the route which a procession or visitors are expected to take. This can be seen in the sarcophagus room of Queen Nofretari. The ceiling is supported by four pillars decorated on all their sides, and it is the orientation of these scenes which virtually signposts the approach route. In the illustration the room is seen from its south-east corner. The funeral procession entered along the central axis from the south and was directed by the two figures of priests impersonating Horus Inmutef and Horus Nedjiotef to the sarcophagus space surrounded by the pillars. But there are two other routes, between the walls and pillars on either side of the room, and these are signposted by the figures of the queen on the pillars: the procession is prompted to follow in the direction in which she faces. The access to the central sarcophagus space from behind may be physically open but is barred iconographically by the figures of Osiris. To approach them from behind was not acceptable and so the only option left was to turn towards the room at the back, which may have originally contained the queen's statue.

A bull and seven celestial cows, in the tomb of Nofretari, a queen of Ramesses II, in the Valley of the Queens (the west bank at Thebes)

*c.*1255 BC. Wall painting on plaster

A large corpus of religious spells which were needed in order to negotiate successfully the dangers of the netherworld appeared after 1500 BC. It is called the Book of the Dead by Egyptologists and is the successor of the Coffin Texts (see 121). Many of the spells are accompanied by small illustrations which summarize their content (known as 'vignettes' to Egyptologists). The Book of the Dead is a modern name and these texts were no real book (books in the form of volumes, as they are usually understood, did not exist in ancient Egypt). They were mostly written on papyri but, accompanied by their illustrations, also on the walls of tombs. The change of the medium, replacing a sheet of papyrus by a tomb wall, was accomplished smoothly but had an interesting effect. The amount of space given to illustrations increased and it was the text which appeared to take a lesser role, providing an explanation of the scene. Here, in the tomb of Nofretari, the queen of Ramesses II, the bull and the seven cows, together with the 'four steering oars of heaven' (for the four cardinal points), form an illustration of spell 148 of the Book of the Dead, concerning provisioning in the afterlife.

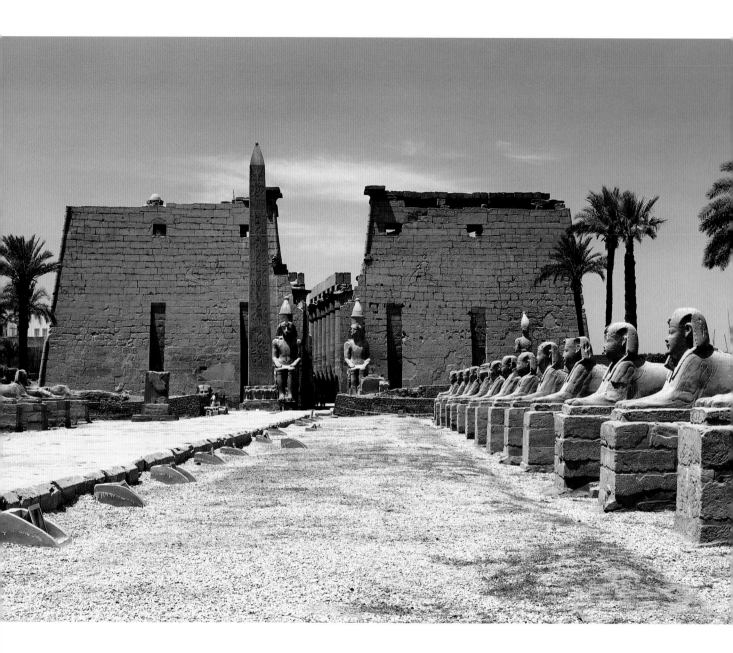

The pylon of the temple of Amun at Luxor and the alley of sphinxes

*c.*1250 BC (the pylon) and c.370 BC (the sphinxes). Sandstone

While temples for the royal funerary cult were essentially the work of one king, those of the gods were often extended, altered or decorated by a succession of rulers. The early part of the temple of Amun at Luxor was built by Amenhotep III and partly decorated under Haremhab, Tutankhamun and Sety I. A major enlargement was carried out about a hundred years later by Ramesses II, who added the large court and a pylon with obelisks and colossal statues that can be seen in the illustration. This was the usual method of extending a temple: by building in front of the existing structure.

Several other kings, including Merneptah and Sety II of the 19th dynasty and Sabacon and Taharqa of the 25th dynasty, contributed in a minor way. Some 900 years after Ramesses II, King Nectanebo I of the 30th dynasty constructed a magnificent alley of sphinxes which connected the temples at Karnak and Luxor. Under Alexander the Great the temple's sanctuary was reconstructed. This may have been the end of the pharaonic history of the temple but it continued to be used for religious purposes: the Emperor Hadrian erected a chapel for the god Sarapis and under Diocletian, after 300 AD, part of the temple became a sanctuary of the imperial cult. Finally, during the Fatimid caliphate, a mosque was built in the front part of the temple.

Ramesses II in the temple of Amun at Luxor

*c.*1250 BC. Granite, h. 12.7 m, 41 ft 8 in

Colossal monolithic seated or standing statues of kings, and much less frequently of queens, usually flanked gates and entrances to temples or stood in their open courts (the illustrated statue stands in an open court but also at the entrance to a columned approach to the temple's inner part). It was outside the temple's pylon that most of the colossi were placed. Although in almost all features colossal statues are similar to smaller sculptures, the sculptor was aware of the fact that colossi were going to be viewed in a different way and so he adjusted, in a subtle way, some of their characteristics. So, for instance, the head may be tilted a little forward so that the viewer standing in front of the statue is looking at the king's face rather than his throat. The disregard for the relative size of main and minor figures is characteristic of Egyptian art in general but is nowhere more obvious than in the case of queens or daughters in colossal statues. They may be carved as small statues in their own right, attached to the king's seat by their back (as Queen Nofretari in the illustrated colossus), or cut in relief on the king's seat or the slab of 'negative space' which connects the leg of the standing colossus to the back pillar.

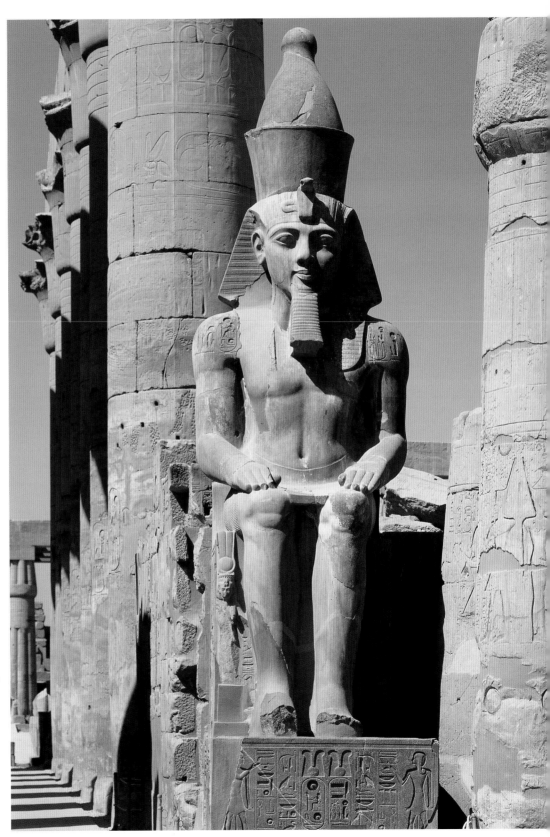

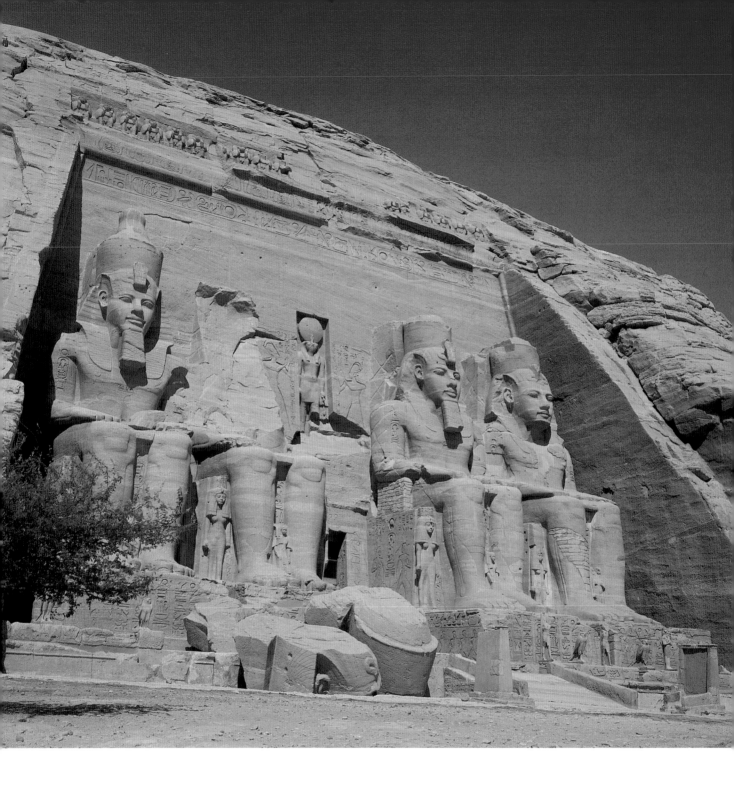

The 'great temple' of Ramesses II at Abu Simbel, after resiting

*c.*1250 BC. Cut in sandstone rock, h. of statues in the façade c. 21 m, 69 ft

Seven temples were created in Nubia, the area south of the first Nile cataract, during the reign of Ramesses II. The two rock-cut temples at Abu Simbel are the most unusual. The gods for whom the 'great temple' was made were the three state deities Amun-Re, Re-Harakhty and Ptah, and the deified king himself. It is interesting to see how the Egyptian architects maintained the traditional temple form in a rock-cut temple. In the 'great temple' at Abu Simbel the façade of the pylon was replaced by a similarly inclined face cut in the rock. Colossal seated statues of Ramesses II were carved in the same rock and left still partly attached to the façade. This is inset in the original rock face by vertical cuttings on either side, comparable to the narrow left and right sides of the pylon. While in a built pylon these define its mass in space, here they delimit the space from the mass of the rock. The design of a rock-cut temple is, therefore, in many respects a negative image of the traditional structure.

The first pillared hall in the 'great temple' of Ramesses II at Abu Simbel

*c.*1250 BC. Cut in sandstone rock

The plan of the interior of the 'great temple' of Ramesses II at Abu Simbel consists of two pillared halls which correspond to the pillared courts of free-standing temples, a vestibule and a sanctuary with a barque stand and the temple's cult statues. Because the temple is completely cut into the rock, its design had to be appropriately modified. The scenes depicting foreign wars which in free-standing temples were usually represented on exterior walls were brought inside the temple and are shown on the long sides of the first pillared hall (in the background, behind the pillars, in the illustration). The square pillars had addorsed (leaning against and attached by their back) statues of Ramesses II facing onto the central approach. These also occur in temples built in the standard way (see 246), but there they are made up of segments, in the same way as the pillars. Free-standing colossal statues were always monolithic (see 167). The statues attached to pillars are not weight-bearing and so are artistic rather than architectural elements.

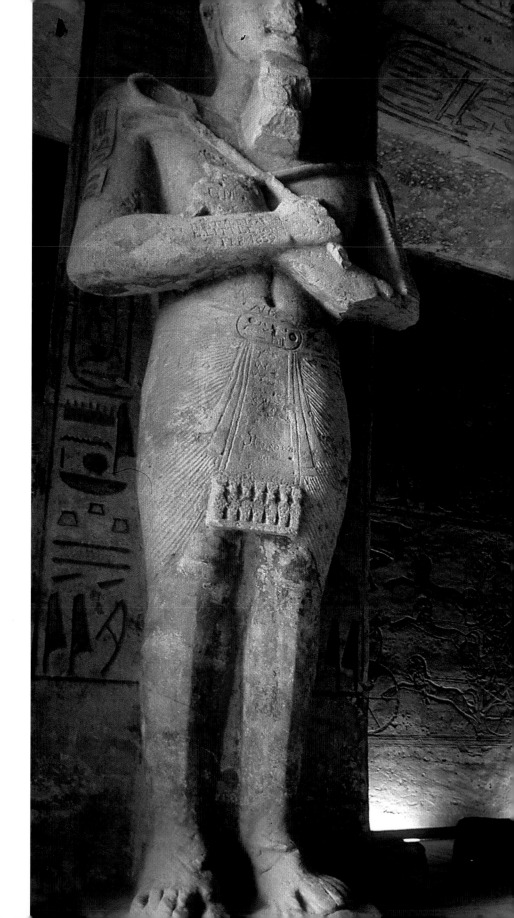

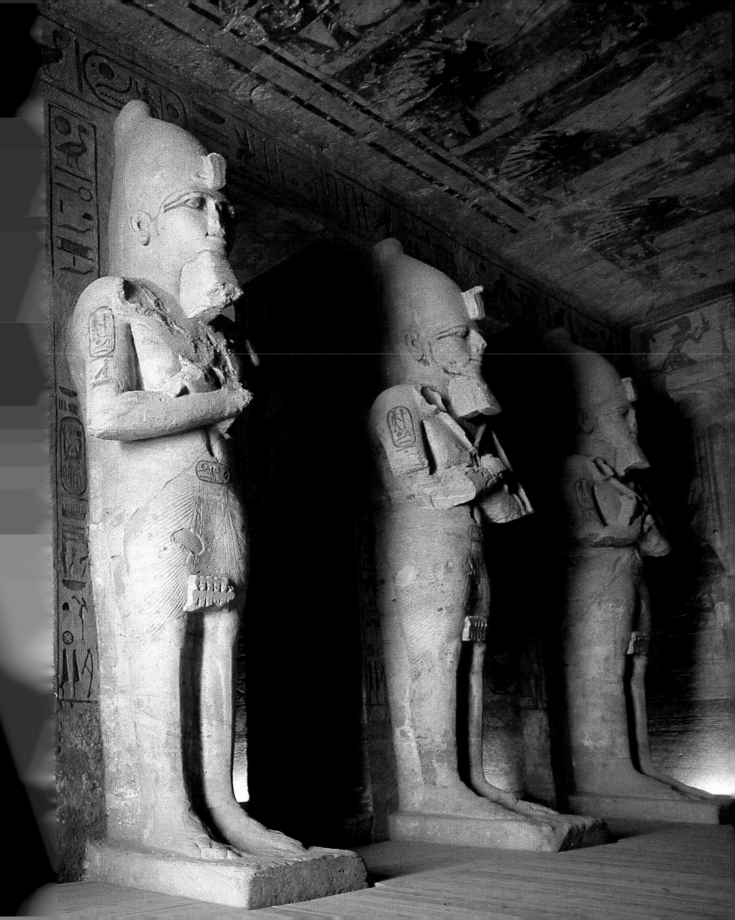

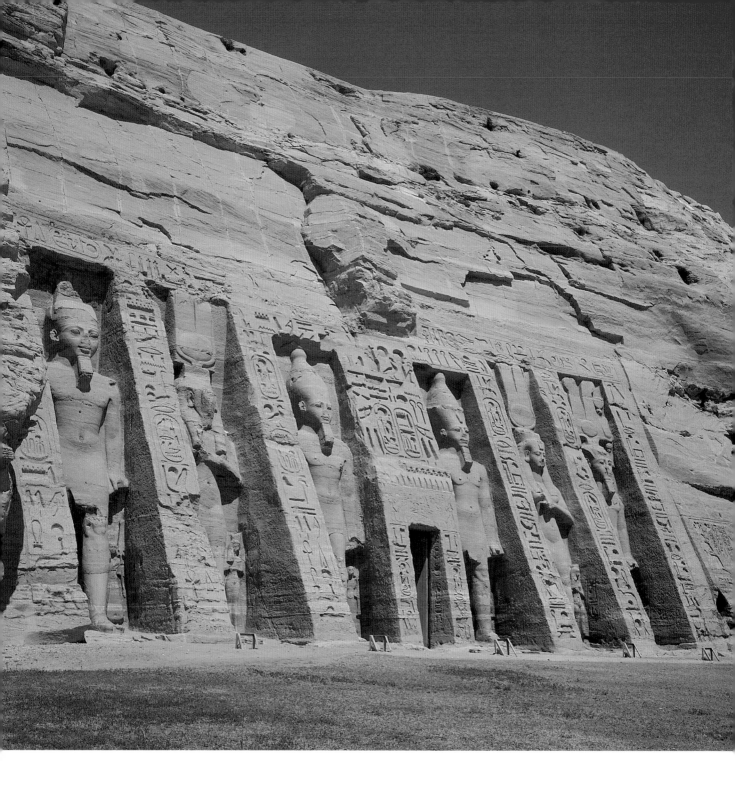

The 'small temple' of the goddess Hathor and Queen Nofretari, built by Ramesses II at Abu Simbel, after resiting

*c.*1250 BC. Cut in sandstone rock, h. of statues c.9.5 m, 31 ft

Many statues, especially those of deities, were displayed in Egyptian temples in wooden shrines. The sealing and unsealing of the doors of the shrine containing the temple's main cult image formed an important part of the daily ritual. Colossal royal statues in front of temple pylons (front façades and at the same time monumental gateways) were, of course, entirely free-standing. But the combined rock-cut façades and rock-cut colossi of the 'small temple' at Abu Simbel made during the reign of Ramesses II allude to such shrines. The temple was dedicated to the goddess Hathor and Ramesses II's Queen Nofretari. The symmetrically arranged standing rock-cut statues of Ramesses II and his queen Nofretari were, for purely practical reasons, inset into the temple's sloping façade, as if standing in shrines, but remained attached to the original rock. Such a combination of a sloping plane and a vertical line had been used previously, for example in placing masts for banners in front of traditionally built temple pylons. Abu Simbel is one of the few places where Ramesses II is shown as a god, and this may have been an added attraction of such an arrangement.

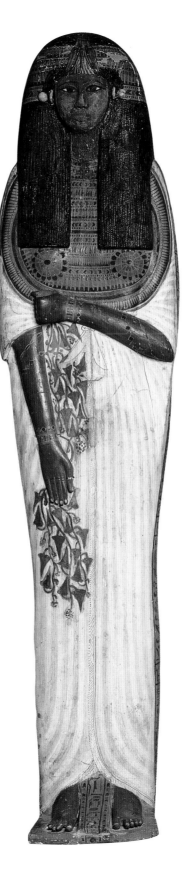

Lid of the inner coffin of the woman Esi, from the tomb of her father-in-law Sennedjem at Deir el-Medina (the west bank at Thebes)

*c.*1250 BC. Wood covered with linen and plaster and painted, l. 193.5 cm, 76 in. Egyptian Museum, Cairo

There is no agreement on the terminology of sarcophagi and coffins; here the term sarcophagus always implies 'made of stone', regardless of the shape, and the term coffin means 'made of wood' or, exceptionally, 'made of precious metal'. The earliest coffins were rectangular but in the second millennium BC anthropoid coffins, resembling a body swathed in mummy bandages, made their appearance. The Ramessid period (19th and 20th dynasties) witnessed a refinement of anthropoid coffins: rather than imitating a mummified body, some anthropoid coffins were made to resemble the persons themselves, as though they were very special sculptures. The coffin lid illustrated here shows a woman dressed in a pleated garment and wearing a massive wig with a lotus flower (the symbol of rebirth) on her forehead and a huge broad collar round her neck. She is holding a clump of flowering ivy, no doubt a symbol because other examples of it are known, but of uncertain significance. The lid is flat with some elements, such as the mask of the head, arms and feet, attached to it.

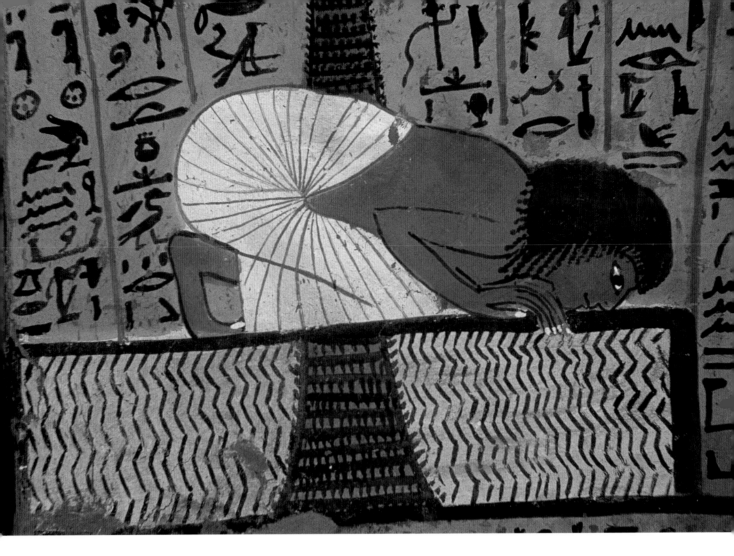

The workman Irynufer drinking from a pool, in his burial chamber at Deir el-Medina (the west bank at Thebes)

*c.*1250 BC. Wall painting on plaster

Painted scenes and texts which derive from the so-called Book of the Dead occur very frequently in tombs at Deir el-Medina. The depiction of Irynufer kneeling near a dom palm and drinking water from a pool is an illustration which belongs to a spell for 'drinking water in the necropolis' in the Book of the Dead. The design of the scene had to accommodate three different angles of view. The pool is seen from above and water is indicated as a series of zig-zag ripples. The tree is shown as if growing at the near side of the pool, closer to the viewer. Irynufer is kneeling on the bank on the far side of the pool – presumably so that his body does not obscure too much of the pool and the scene does not give the impression that he is actually kneeling in water. The tree similarly is not allowed to obscure him. The text surrounds the scene and leaves no doubt about their close connection. The hieroglyphic signs were simplified for writing on tomb walls, a characteristic feature of Deir el-Medina tombs.

Painted ceiling in tomb of the scribe of the treasury of the temple of Amun-Re, Neferronpet Kenro, at Khokha (the west bank at Thebes)

*c.*1250 BC. Wall painting on plaster

Egyptian art is usually perceived as being entirely figurative but this disregards the many occasions when the artist created a completely abstract geometric pattern. These occurred throughout the whole of Egyptian history, from the painted decoration on Predynastic pottery and the façades of tombs of the early dynasties through the carved decorative friezes near the top of walls in Old Kingdom tombs and the painted ceilings of Middle Kingdom tombs. Most of these were not arrived at randomly or by a predetermined geometrical construction but imitated natural materials, and the pattern was the result of their manufacture. Pottery decoration may have reflected the regularity of basketry. Parts of houses which were made of organic materials (e.g. wooden beams and rushes), as well as mat and textile hangings and other furnishings, provided an inspiration for works of art in other materials throughout Egyptian history.

Unfortunately, the connection is sometimes difficult to establish. Houses were situated in the Nile valley (unlike tombs, most of which were on desert margins) and were made of mud bricks (most temples and many tombs were built of stone), and so few have survived. A geometric design featured regularly on ceilings of Theban tombs during the New Kingdom.

Stonemason,
location of discovery not known

*c.*1250 BC. Drawing on a limestone
fragment, w. 15 cm, 5 in.
Fitzwilliam Museum, Cambridge

It is questionable whether we shall
ever be able to understand works
of Egyptian art fully, no matter how
much we may think we know about
the civilization which produced
them. They were informed by
the way the Egyptians lived,
their environment and how they
interpreted it, their religion and
views on what happened when
they died, the organization of
society of which they were a part,
and many other aspects. We may
try to get as close to their own
thinking as we can, but we can
never step in their sandals entirely.
It is, therefore, immensely
satisfying when we come across
something to which we seem to be
able to relate directly. This drawing
was probably made by one of the
Deir el-Medina artists working on
the royal tombs in the Valley of the
Kings (see 223). It is a quick sketch
representing a fellow workman,
a stonemason. The bald-headed
unshaven man is using a copper
chisel and a wooden mallet. He
is kneeling and one can almost
feel the hot, sticky and dusty
atmosphere inside the tomb from
looking at his half-open mouth
gasping for air. It is an astonishing
drawing, fluent and witty but not
a malicious caricature.

A Ramessid queen, almost certainly Merytamun, a daughter and wife of King Ramesses II, from the 'Chapel of the White Queen' on the west bank at Thebes

*c.*1240 BC. Limestone,
h. 75 cm, 28¹⁄₂ in.
Egyptian Museum, Cairo

The end of the inscription on the back pillar of this statue is lost and so are the main titles and name of this woman. But there is no doubt that she is a queen because of two iconographic characteristics: the special circlet of cobras, originally with two tall plumes and probably a small sun disc, on her head, and the two cobras (for the goddesses Nekhbet and Wadjit) on her forehead. This now anonymous statue was found at Thebes but a discovery at Akhmim (some 130 km, 80 miles north of Thebes) of a similar sculpture, on a colossal scale, helped to identify it as Merytamun, one of the daughters of King Ramesses II and Queen Nofretari. Merytamun herself became one of his father's queens after the death of her mother. She is shown wearing a tripartite wig, massive earrings and a broad collar with beads in the shape of hieroglyphic signs reading *nefer* ('beautiful'). In her left hand she holds a necklace consisting of strings of beads with a counterweight in the form of a goddess. The necklace identifies her as a priestess.

The second peristyle court, leading into the hypostyle, in the Ramesseum (the funerary temple of Ramesses II), on the west bank at Thebes

*c.*1225 BC. Sandstone

Egyptian temples can be divided into two basic types: those for the royal funerary cult and those for the worship of the gods. The purpose of the funerary temple was to ensure that the deceased king had all he needed in the afterlife. This was achieved by the mere existence of the temple and its statues, reliefs and inscriptions, but also by the rites performed in it and by the offerings placed on its altars. During the Old and Middle Kingdoms funerary temples were situated next to the royal pyramid in which the king was buried, and there were also much more modest structures for the royal cult in other parts of Egypt. During the New Kingdom the royal tombs, mostly in the Valley of the Kings, were separated from the funerary temples which were built in the plain along the Nile. Large memorial temples for the royal funerary cult were also erected in the main religious centres of Egypt such as Abydos and Memphis. In form, temples for the royal funerary cult did not differ much from those built for the gods. It can be said that there was a generally recognized plan of a temple which was adapted as each situation required: one or more pylons, open or peristyle courts followed by columned hypostyles and vestibules and finally the shrine itself, often with arrangements for the divine barque.

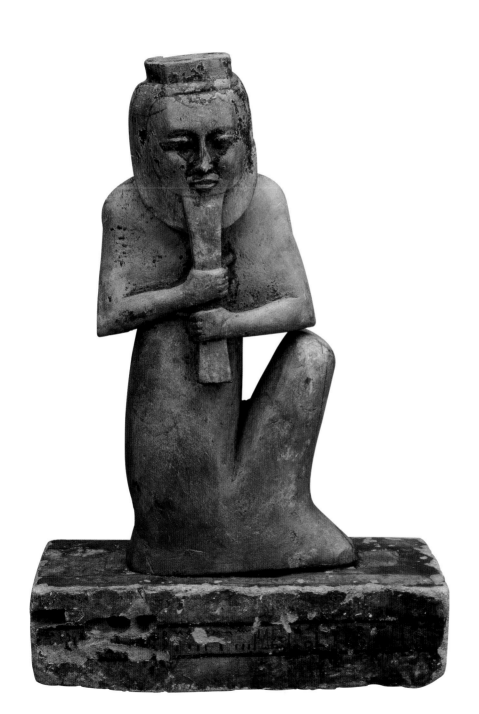

A bearded demon, perhaps from the tomb of King Ramesses II in the Valley of the Kings (the west bank at Thebes)

*c.*1225 BC. Wood, h. of figure 42.5 cm, 16¾ in. British Museum, London

Many of the so-called characteristics of Egyptian aesthetics which make it special and distinctive from the arts of other civilizations are sometimes presented as though they were generally valid and applied to all Egyptian works of art. This is a fallacy. We no longer believe that Egyptian religion was the same for everybody, and instead recognize that it was stratified and often contradictory. In the same way, we should begin to distinguish between different art categories. The principal ones are: the art of temples and tombs, works created by the same artists when they were not working on 'official' commissions, and 'everyday life' creations produced by men and women untrained in the conventions of temple and tomb. Representations and sculptures in tombs created by 'official' artists sometimes disregard the basic conventions of other 'official' artistic works. This is certainly true of the rule of frontality which would have us believe that in sculptures, figures always look straight ahead and do not turn their heads. The bearded demon, which may come from the tomb of Ramesses II, is a good example of an exception to this rule but there are others (see 121) which suggest that there is, in fact, a pattern underlying such occurrences.

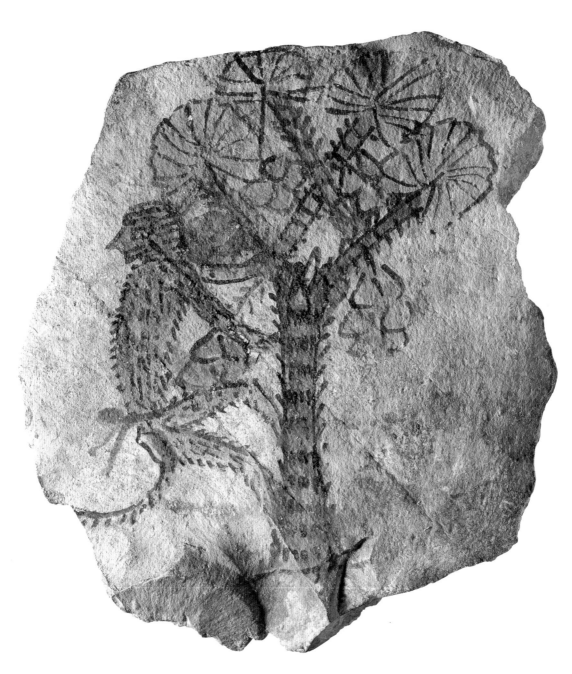

Monkey climbing a dom palm, location of discovery not known

*c.*1200 BC. Painting on a limestone fragment, h. 11 cm, 4 in. Fitzwilliam Museum, Cambridge

The reason why many of the quick sketches on ostraca were made is not always clear. But there can be little doubt about this one. It may have been made by one of the artists from Deir el-Medina. It is not a preliminary drawing for a tomb wall nor a record of a scene made for future reference, and it does not look like an illustration of a story. While in certain situations monkeys were used as symbols, the ribbon around the animal's waist suggests that this is a straightforward picture of a beloved household pet. It is entirely informal yet is a true work of art. Sketches like this one seem to challenge our definition of the term 'ancient Egyptian art' and make us wonder whether the Egyptians were right for not distinguishing between 'artists' and 'craftsmen'. One feels that when the artist finished this sketch, the craftsman got up and continued working on the beautiful but formal decoration of the royal tomb in the Valley of the Kings.

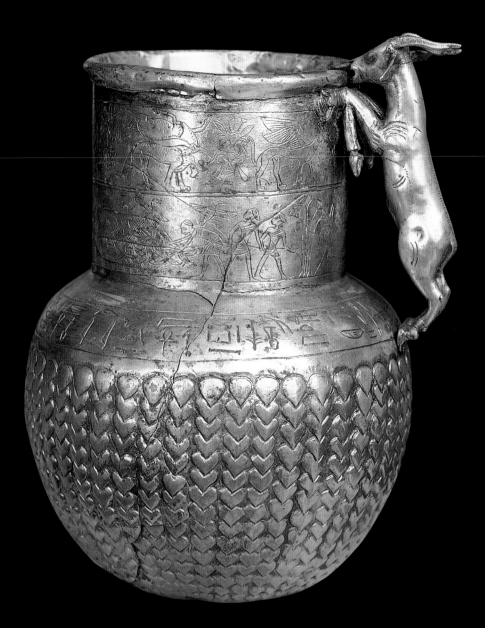

Silver goat jug, from Tell Basta

*c.*1190 BC. Gold and silver,
h. 16.5 cm, 6½ in.
Egyptian Museum, Cairo

The decoration of this jug was executed in several different techniques. Its body is made of a very thin (only about 1 millimetre) sheet of silver but the handle in the shape of a leaping goat touching the rim of the vessel with its muzzle, and the rim itself, are of gold. There is a band of incised text running around the shoulder of the jug which indicates that it was made for the royal butler called Atumemtaneb and suggests that this was a funerary rather than an everyday life item. The body of the jug is decorated with a pattern made up of partly overlapping incised droplets beaten into raised relief. The overlap of the droplets creates what one might compare to a linked series of heart-shaped forms, but this would be a modern interpretation; the Egyptians did not, in fact, know our 'heart' shape and their image of the heart was without the central indentation. The overall impression is that of vertically suspended cords. The neck of the jug carries two registers of incised scenes with desert animals, including a winged griffin (an animal with a feline body and the head of a bird of prey) and men in marsh scenes.

Naval battle, on the exterior of the funerary temple of Ramesses III at Medinet Habu

*c.*1160 BC. Deep sunk relief in sandstone

The exterior of the great funerary temple which Ramesses III had built for himself at Medinet Habu, on the Theban west bank, was decorated with scenes of his wars against the Libyans and a naval battle against a seaborne wave of migrants from the eastern Mediterranean. These were real historical events which took place early in the king's reign, but it would be mistaken to take the scenes for an accurate historical record. In the context of the temple these representations played a role similar to the traditional scenes of the king symbolically massacring enemies on the façade of pylons, and so any indication of less than complete success or a weakness on his part was inconceivable. Because of the very large size of these scenes, and in order to depict the chaotic conditions of a pitched battle as convincingly as possible, the artists used very large registers. The boats are arranged in rows but they are not placed on subdividing lines, the fighting men are superimposed over each other and the bodies of the dead are floating in the water in all kinds of contorted positions. The reliefs have now been completely denuded of any colours and it is strange to realize that these representations were once gleamingly bright and probably rather garishly colourful.

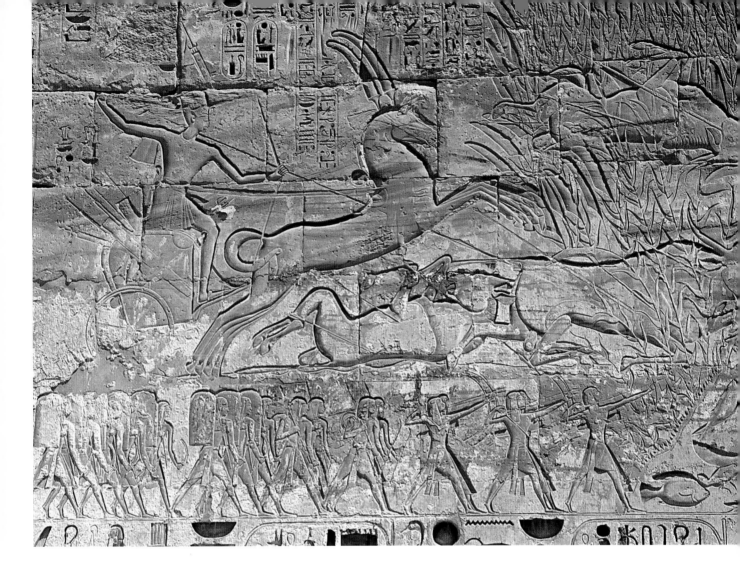

Ramesses III hunting wild bulls, on the exterior of the pylon of his funerary temple at Medinet Habu

*c.*1160 BC. Deep sunk relief in sandstone

The recasting as contemporary events of traditional themes in which Ramesses III suppresses the forces of chaos in his funerary temple at Medinet Habu is completed by reliefs on the west face of the pylon which show him hunting wild animals. Of course, we do not know for certain whether Ramesses III was a keen huntsman or whether this is just a product of the artist's creative licence, but the link is made quite clear by the inclusion of a narrow register of soldiers at the bottom of the hunting scenes in which they play no part. There are two large supra-imposed hunting scenes with the king driving a chariot in each, discharging his arrows into a mêlée of antelope, wild asses, oryxes and hartebeests, and spearing aurochs (wild bulls, *Bos primigenius*), (shown in the illustration). The artist's approach was similar to that employed in the scene of the naval battle (see 250). The animals are arranged as if in registers but are not placed on register lines. The similarity between the bodies of slain enemies strewn over the battlefield or floating in water and the bodies of animals is unmissable. Well-established conventions of hunting scenes, such as the undulating terrain (see 73) and the 'dissenting figures' among the animals (see 85), are present.

Foreign captives, from the funerary temple of Ramesses III at Medinet Habu

*c.*1160 BC. Polychrome faience,
h. 25.5 cm, 10 in.
Egyptian Museum, Cairo

The most common way of conveying the concept of the pharaoh's supremacy over neighbouring countries by artistic means was to show him humiliating his enemies. In Egyptian phraseology the king 'trampled on his enemies' or they were 'under the soles of his sandals'. Bound foreign captives can be found depicted in various techniques on the floors of ceremonial rooms in royal palaces, on stools on which the king rested his feet, on the dais of his throne and many other places connected with the king's official duties. The universality of the king's domination could be conveyed by the image of nine bows (three is the sign for many, three groups of three indicate infinitely many) placed under the pharaoh's feet. Egyptian artists also developed images of racial stereotypes distinguished by the skin colour, hairstyles, facial types and clothes. The tiles illustrated here come from the temple palace (one which was used on festival occasions but was not lived in permanently) of Ramesses III at Medinet Habu. They show five racial types, from left, a Libyan, a Negro, a Syrian, a bedouin, and a Hittite. The tiles were made in polychrome faience where several different colours of faience paste were employed in the manufacturing of one tile.

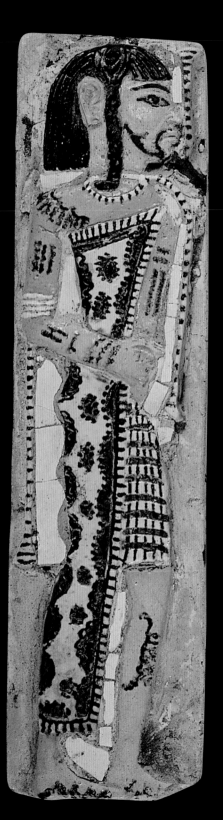
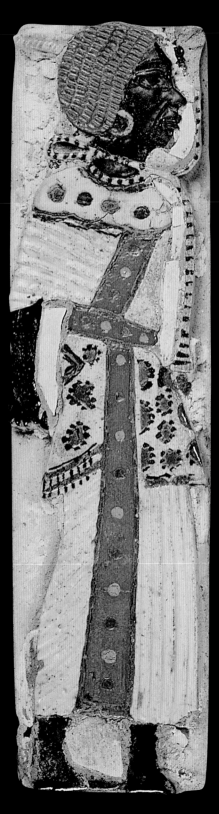

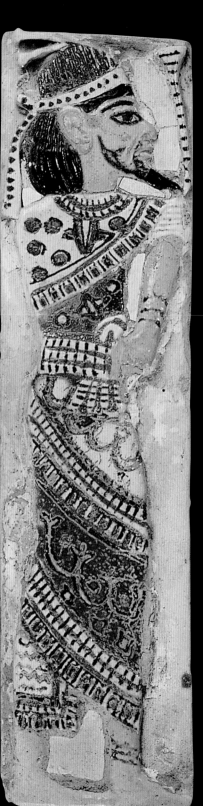
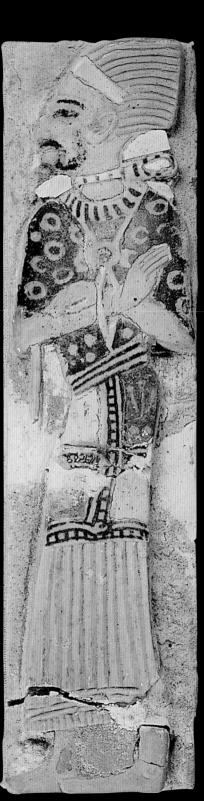
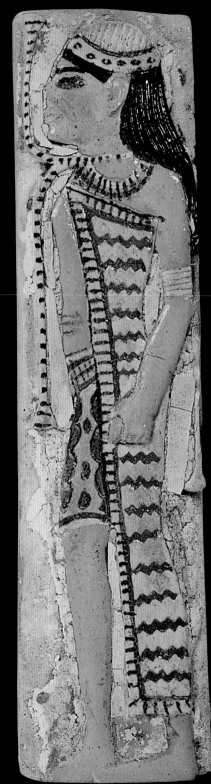

Birds brought as offerings for King Ramesses III, in his tomb in the Valley of the Kings (the west bank at Thebes)

*c.*1155 BC. Wall painting on plaster

Offering food and drink was an essential part of the ritual in temples and tombs, although it is necessary to remember that the amount of waste involved in it was very small. The god's or tomb-owner's spiritual *ka* (life energy or similar) was satisfied by the spiritual substance of the things offered. These could then be consumed by the temple or tomb personnel or be redistributed further, to other tombs or, in temples, to statues or used in other ways, and perhaps even go through another round of redistribution. Representations of offerings being brought to tombs occurred often because the mere existence of these images was enough to ensure their continuation. The represented offerings are standardized to such an extent that their connection with reality is rather tenuous, and it is impossible to read much into their selection. Prepared and processed food may be replaced by animals and birds shown alive, sometimes as unrealistically small in order not to interrupt the procession unduly. In royal tombs the offering bearers are often personifications of districts or geographical areas, as in the case illustrated here where the ducks suspended from a tray imitating an offering mat are carried by the personification of the area on the east bank of the Nile, opposite Memphis.

Tutita before the god Osiris, location of discovery not known

*c.*1150 BC. Painting on wood,
h. 30 cm, 11³⁄₄ in.
Louvre, Paris

From about 1500 BC the image of a person standing with the arms raised in adoration before the god Osiris became extensively used on the walls of tombs, on stelae and various items of funerary equipment. The meaning was clear and universally understood: Osiris was the ruler of the kingdom of the dead into which everybody wished to be accepted. The scene illustrated here is painted on a shabti box. Shabtis (later called ushebtis, see 315) were small statuettes which were meant to act as persons' deputies when they were called to perform manual tasks in the realm of Osiris. From about 1400 BC these figurines were placed in special shabti boxes in the form of a small shrine with a vaulted roof. These wooden boxes were painted with funerary scenes, often showing the tomb owner before a deity closely linked to the necropolis. The connection between the wall decoration in Ramessid tombs and contemporary shabti boxes is unmistakable. However, on some boxes, as on the illustrated example, the artist's approach became more impressionistic, indicating the outline of figures and objects but paying only limited attention to the detail. Shabti boxes stopped being used sometime during the seventh century BC.

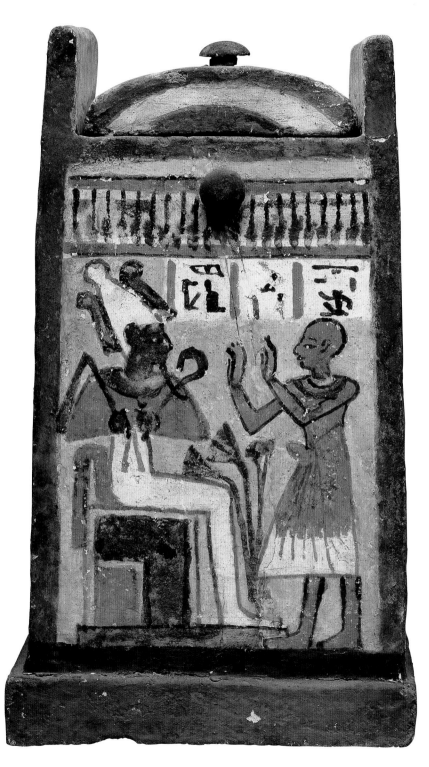

Animals behaving like people

*c.*1150 BC. Drawing on papyrus,
h. 15.5 cm, 6¹⁄₈ in.
British Museum, London

Sketches depicting single episodes from a topsy-turvy world where animals act in a way which completely contradicts their normal behaviour are known from ostraca, smooth flakes of limestone used as cheap writing material. They may be explained as casual doodles by artists which either illustrate folk stories or mock people who were known to the creator of the sketch and whose behaviour the sketches parody. But several papyri containing compilations of such scenes are an enigma, and the interpretation which may be offered for ostraca does not fit them. The episodes on this papyrus are unconnected and so do not illustrate a story. They do not appear to parody real people. It may be that this was an artist 'on his day off', simply amusing himself. Or could it be that this was intended to be a present, the equivalent of our book of comics? The drawings were made with the competence that can only be expected from a professional artist. The poses are those known from representations of people and the artistic conventions are those of standard two-dimensional representations (but note the absence of base lines for the ducks and the 'wrong' arrangement of the goats as well as the ducks).

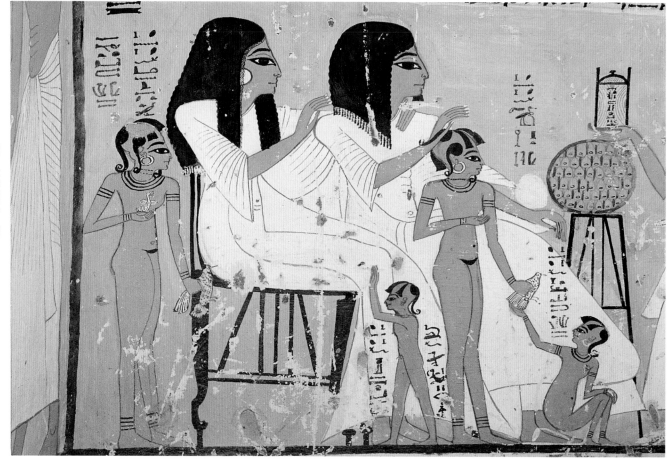

The foreman Inherkha and his wife with grandchildren, in the burial chamber of his tomb at Deir el-Medina (the west bank at Thebes)

*c.*1150 BC. Wall painting on plaster

Many of the representations in Deir el-Medina tombs derive from illustrations in the Book of the Dead (see 227–8, 242, 259), but they are at least to some extent counterbalanced by some of the most charming scenes of family life. Here, Inherkha and his wife are shown with their grandchildren: a boy and three girls. The representation is remarkable for the multiple overlapping of the represented figures. Inherkha and wife sit side by side on a chair, with his figure, unusually, behind hers. The grandchildren are shown as if in the foreground of the scene, partly obscuring the seated couple. The hand of the granddaughter holding a duck and represented behind the seated couple partly conceals the frame of the chair. This indicates that she is standing next to it, not behind it. Inherkha's long garment obscures the lower part of a stand with a tray of figs (seen from above) on it. These overlaps are further emphasized by some of the short texts giving the names and relationship of the family which are written over the representations. The effect of this arrangement is remarkably 'three-dimensional' even though all the figures share the same base line.

A cat slaying a serpent, in the burial chamber of the foreman Inherkha at Deir el-Medina (the west bank at Thebes)

*c.*1150 BC. Wall painting on plaster

The connection between the sun god Re and the cat was due to the cat's ability to kill snakes. It was in this capacity, as an apotropaic (protective) animal that the cat made its first appearance in Egyptian religion. This was also how it came to be associated with Re. At night, the sun god sailed in his barque through the underworld where he was threatened by many enemies, among which the giant snake Apopi was one of the most terrifying. Fortunately, the sun god's travelling companions included a large tomcat which was able to deal with this danger. The text concerning the slaying of the serpent before the sacred *ished* tree at Heliopolis (the main centre of worship of the sun god) appeared in the Coffin Texts and was then also incorporated into the Book of the Dead as spell 17 and provided with a vignette. Here, in the tomb of Inherkha, the mythical cat is shown cutting off the serpent's head. It is interesting that the artist no longer tried to portray a cat with any accuracy. Instead, although the posture is characteristic of the cat, he depicted a much more powerful mythical animal with long ears and the head resembling that of a lion.

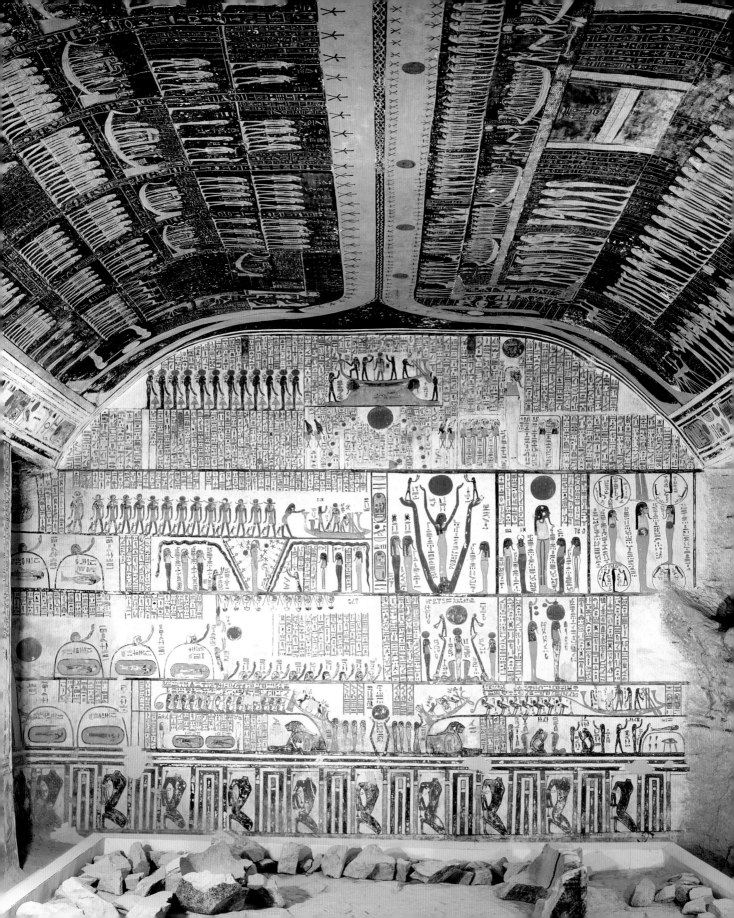

The Book of the Earth, in the sarcophagus room of the tomb of King Ramesses VI in the Valley of the Kings (the west bank at Thebes)

*c.*1140 BC. Wall painting on plaster

The Book of the Earth is one of the more unusual texts broadly known as 'books of the afterlife' which are found on the walls of royal tombs during the New Kingdom. Its main theme is the journey of the sun disc through the underworld, which is identified as the realm of the dead and the body of the earth god Aker. The purpose of the book, and others, is to demonstrate the successful cycle of rebirth and renewal undergone by the sun, and symbolically to participate in the process. The 'book', which consists of a large number of scenes accompanied by texts, occupies all the walls of the sarcophagus room in the tomb of Ramesses VI. The wall illustrated here is divided into four registers above a dado displaying decapitated enemies. The imagery is surreal and sometimes nightmarishly savage, the inhabitants of the underworld chillingly bizarre. The complexity of the representations can be seen in the large scene in the centre of the second register. A goddess called 'Annihilator' greets the sun disc with her outstretched arms. She stands on a head and arms emerging from the ground which also greet the sun. In this they are joined by the personifications of the East and West standing on the palms of the hands of the arms emerging from the ground.

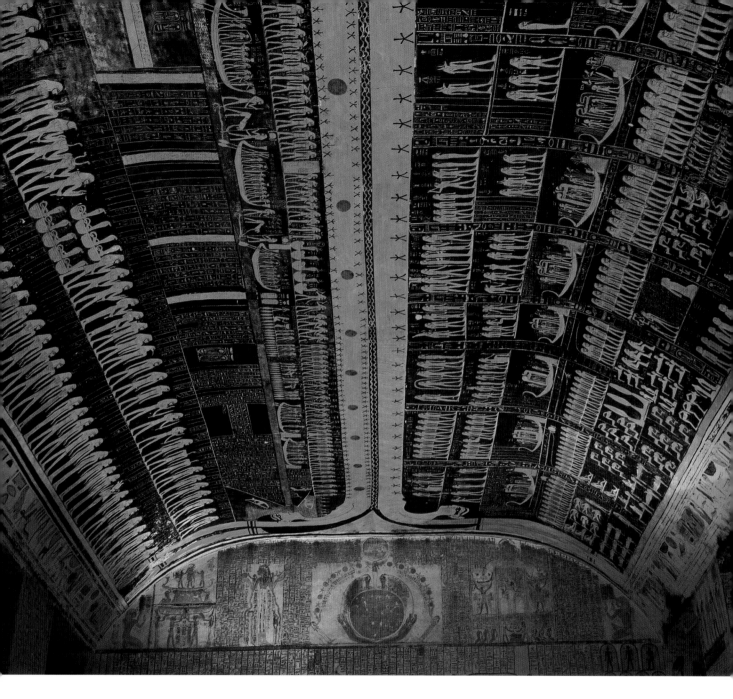

The Books of the Day and Night, on the ceiling of the sarcophagus room in the tomb of King Ramesses VI in the Valley of the Kings (the west bank at Thebes)

*c.*1140 BC. Wall painting on plaster

In addition to the 'books of the afterlife', royal tombs of the New Kingdom also contained two texts which are usually described as the 'books of the sky'. These refer to the journeys of the sun but are based on the idea that the sky goddess Nut gives birth to the sun in the form of a scarab beetle in the morning and swallows it in the evening. The representations and texts of both the 'books of the sky' can be found on the ceiling of the sarcophagus room of Ramesses VI and they provide a valuable insight into Egyptian cosmography (their understanding of the sky and the universe). Each book is delimited by a representation of the goddess Nut and divided into twelve hours. The daytime passage of the sun over the sky, represented by the body of the goddess in the Book of the Day (see above, left, and 263 upper), is indicated by repeated representations of the sun disc. Artistically, this was the usual way of indicating movement or action – by deconstructing it into its successive stages. The body of the goddess Nut in the Book of the Night is covered with five-pointed stars (see above, right, and 263 lower).

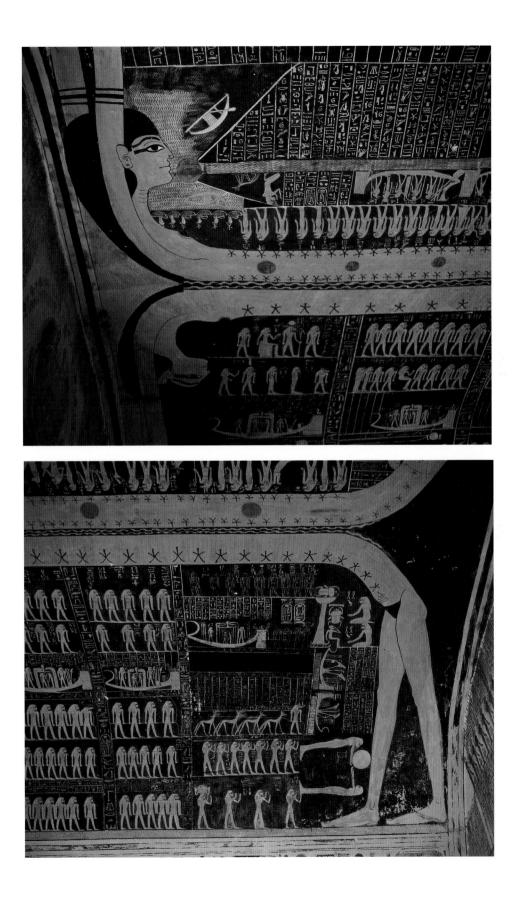

Part of the funerary canopy cover of the priestess of the god Min at Akhmim, Esiemkhebi, from the royal cache at Deir el-Bahri

*c.*1040 BC. Painted leather, l. of whole 272 cm, 107 in. Egyptian Museum, Cairo

Representations of funerals show coffins being brought in a funeral procession under a light wood-framed canopy with a leather cover. Such a cover was found rolled up and probably inadvertently dropped in the cache of coffins of Egyptian pharaohs of the New Kingdom and high priests of Amun and their families at Deir el-Bahri. It is the greatest piece of leatherwork known from ancient Egypt. The inscriptions on it mention Esiemkhebi, probably a daughter of the high priest of Amun Menkheperre. No other objects of Esiemkhebi are known. The cover is made of pieces of leather sewn together to form the roof and sides of what has been, not inappropriately, described as a funerary tent. The leather is painted: the roof is sky blue and sewn on it are regular rows of starry rosettes with a central band of six vultures with spread wings and inscriptions. This was the standard decoration on the ceilings of temples. The sides consist of a red and green chequered mosaic pattern assembled like a patch-work quilt. A band of rectangles near their top, illustrated here, contains alternating square panels with lotus and papyrus plants, winged scarabs, and kneeling antelopes. The representations were cut out and pieces of coloured leather inserted underneath.

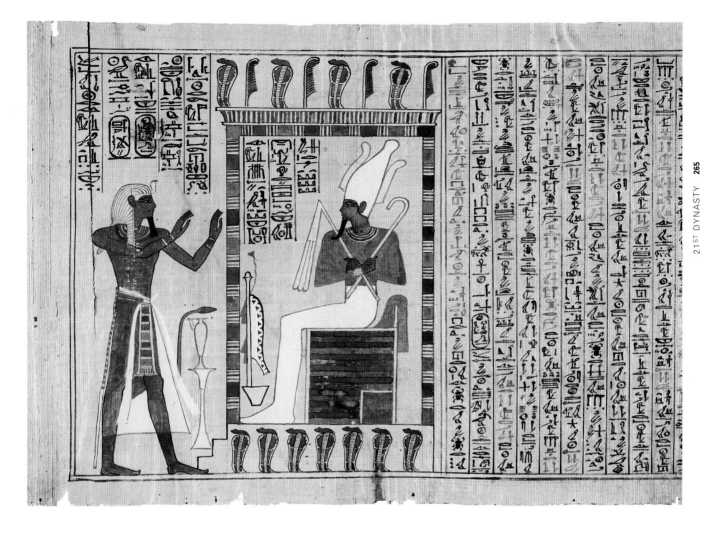

**Detail from the Book of the
Dead of 'King' Pinudjem I,
from the royal cache at
Deir el-Bahri**

*c.*1032 BC. Papyrus, h. 37 cm,
14$\frac{1}{2}$ in, l. of whole 450 cm, 177 in.
Egyptian Museum, Cairo

The end of the New Kingdom
brought about an almost complete
disappearance of decorated tombs.

This is usually thought to be the
result of less favourable political
and material conditions in the
country, but while this is not in
doubt, it seems too simplistic.
Certainly, some revaluation of
the funerary customs took place,
and expense and effort were
consciously directed towards
different goals. This papyrus with
a copy of selected spells from
the large religious corpus known

as the Book of the Dead was
found with the mummy of
Pinudjem I in the famous royal
cache of coffins at Deir el-Bahri.
Pinudjem I was a high priest of
Amun who adopted royal titles
and had himself represented as
a pharaoh. The papyrus is long,
but not the largest known. It starts
with Pinudjem I standing with his
arms raised in adoration before the
god Osiris, the ruler of the realm

of the dead. Such papyri took over
from the texts and representations
in New Kingdom tombs.

Pseudo-canopic jars of Henuttaui, the songstress of the god Amun, location of discovery not known

*c.*1000 BC. Painted wood, h. 39 cm (jackal) and 36.5 cm (hawk), 15 and 14 in. Staatliche Sammlung Ägyptischer Kunst, Munich

It is not always easy to establish whether an artistic development is solely due to a change in the underlying religious ideas or whether the artists themselves contributed to it. Sometimes the two cannot be disentangled satisfactorily. During mummification, the internal organs (the liver, lungs, stomach and intestines) were removed and stored in the so-called canopic jars (see 205). These eventually acquired lids in the form of the four 'sons of the god Horus' with whom the organs were identified: the human-headed Imset, baboon-headed Hapy, jackal-headed Duamutef, and hawk-headed Kebehsenuf. During the Third Intermediate period it was, for some reason, customary to return the internal organs into the mummified body. But canopic jars continued to be made, as solid 'dummmy' jars with no internal cavities. The usual explanation of this is that canopic jars were by now so firmly established as elements of the burial that they could not be given up easily. But this may be quite wrong. Perhaps these are no longer just jars but sculptural manifestations of Imset, Hapy, Duamutef and Kebehsenuf as jars.

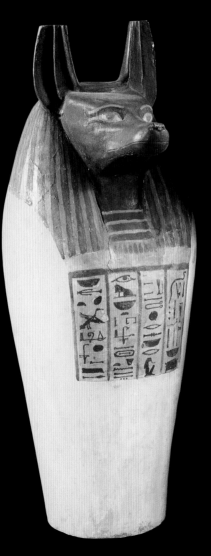

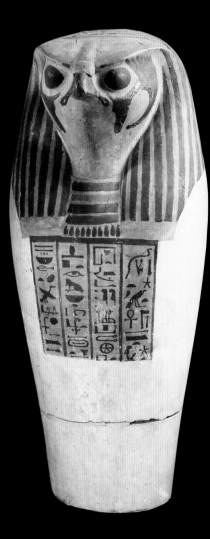

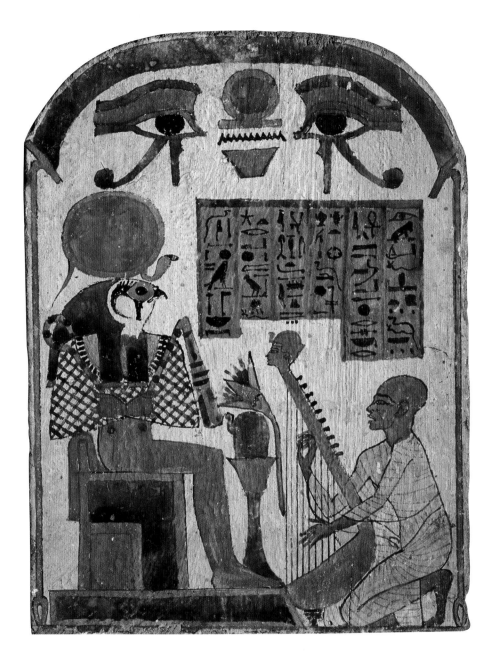

The singer Djekhensefankh playing the harp, probably from Thebes

*c.*1000 BC. Painting on plastered wood, h. 29 cm, 11 in. Louvre, Paris

After the body of the deceased person, which was deposited in a sealed underground burial chamber, the publicly accessible stela (gravestone) was the most important thing in tombs. Stelae varied greatly in form. Some stelae, especially those from the third millennium BC, resemble solid doors and so are called false doors by Egyptologists. Others are rectangular or round-topped. The stela was the focus of the funerary cult; it recorded, and often also showed, the deceased person, and was inscribed with an offering wish which guaranteed a supply of provisions needed in the afterlife. Real offerings were brought to the stela and ritual ceremonies took place in front of it. Artistically, the range of scenes depicted on tomb stelae was limited: mostly they showed the deceased person seated at a table with offerings, sometimes with members of his family and relatives, and from the middle of the second millennium BC before deities. The depictions of the deceased person did not aspire to be portraits; the identification was secured by the text. On his wooden stela, Djekhensefankh is shown playing the harp and singing before the god Re-Harakhty.

Vessels from the royal tombs at Tanis (San el-Hagar)

(a) bowl with the names of King Psusennes I and Queen Henuttaui, gold, d. 9 cm, 3¼ in.

(b) libation vase of King Amenemope, gold, h. 20 cm, 7 in.

(c) shallow dish of Wendebauended, gold, d. 15.5 cm, 6 in.

(d) footed bowl of the priest of the god Khons, Wendebauended, with the names of King Psusennes I and Queen Mutnodjmet, gold and electrum, h. 5.5 cm, 2 in.

*c.*991-984 BC. Egyptian Museum, Cairo

Although the funerary equipment discovered in the intact royal tombs of the 21st and 22nd dynasties at Tanis, in the north-eastern Delta, equals in most respects that found in the tomb of Tutankhamun in the Valley of the Kings (see 198–213), it is less well known. Vessels made of gold, which were almost completely absent in Tutankhamun's tomb, were numerous at Tanis, this being either a reflection of the advances made in Egyptian metal-working or of depredations suffered by Tutankhamun's tomb. Among the vessels illustrated here, the bowl has flower-petal fluting around its body, which was hammered from the inside, a motif known in Egypt at least since the beginning of the second millennium BC. It may have been adopted from abroad and is found in other countries of the ancient Near East. The form of the libation vase is even older and the vessel is often shown in the hands of priests making libations. The vase was made in five parts. The shallow dish of Wendebauended has a fluted body with a centre-piece inlaid with colour paste. The footed bowl imitates a flower, perhaps the white lotus, with its six rounded petals made alternately of gold and electrum.

Shallow dish of the priest of the god Khons, Wendebauended, from Tanis (San el-Hagar)

*c.*991 BC. Silver and gold,
d. 18 2 cm, 7⅛ in.
Egyptian Museum, Cairo

Wendebauended, who held important priestly as well as military offices under King Psusennes I, was buried in the tomb of his royal master at Tanis. His funerary goods include four exquisite metal vessels (see also 269c and d). One of them is a shallow dish (patera) made of silver with a centrepiece in the form of a twelve-petal rosette, originally inlaid. The rosette is surrounded by a ring of gold sheet with a scene which is engraved and beaten into raised relief. It shows two pairs of girls swimming in a pool among lotus flowers and fish, catching ducks. Apart from a wig, each girl is wearing only a collar round the neck and a belt round the waist, with two straps crossed over the torso. Aquatic themes were popular on vessels intended to hold water (see 144). The text which runs around the perimeter of the dish states that it was a gift from Psusennes I.

Head of the coffin of King Psusennes I, from his tomb at Tanis (San el-Hagar)

*c.*991 BC. Silver and gold,
l. of whole 185 cm, 72 in.
Egyptian Museum, Cairo

King Psusennes I was buried in
two stone sarcophagi (the outer
rectangular, the second anthropoid)
and a silver anthropoid coffin.
The decoration is almost entirely
engraved but there is a band of
gold across the forehead which
represents the border of the royal
headcloth. The cobra (uraeus) is set
high on the headcloth, well above
the gold band, as on the king's
funerary mask (see 274–5). For
reasons which are difficult to
ascribe to anything else but
'fashion' (i.e. a decision about
the style of royal representations
promulgated at the beginning of
each reign) the form and position
of the cobra remained constant in
representations of the same king
but changed from one reign to
another. Because of this, they are
important dating criteria. The king's
eyes are inlaid but the strap of the
beard is indicated merely in relief.
The body of the coffin is covered
with a feather pattern and there
are two columns of text running
down the front in which the king
addresses the goddess Nut.

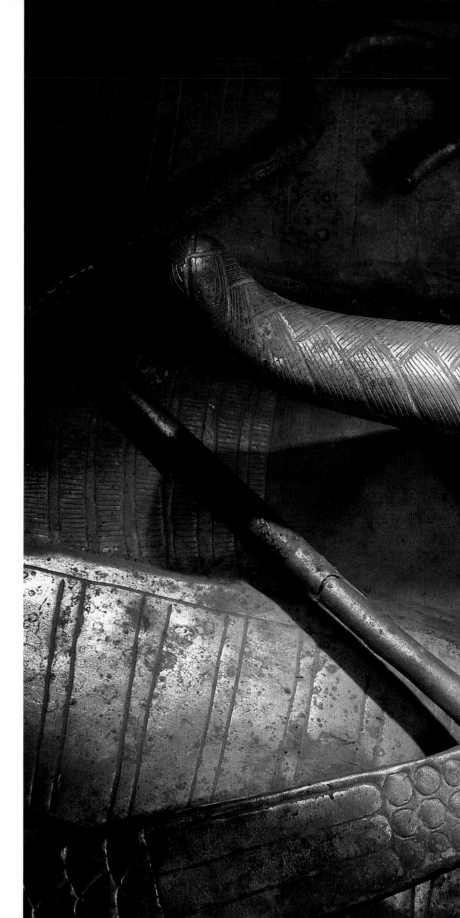

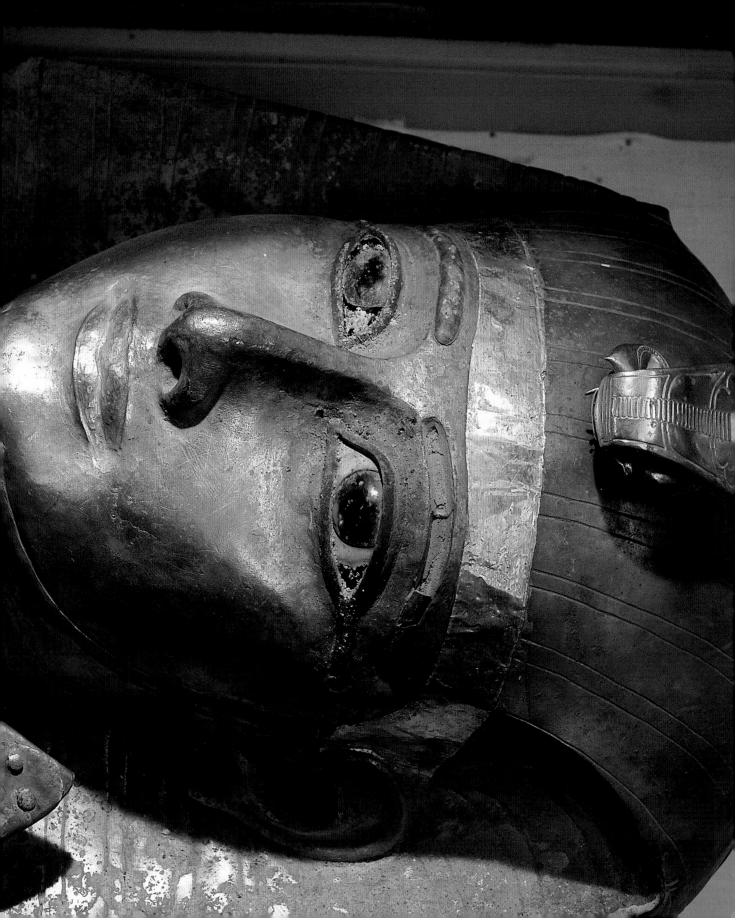

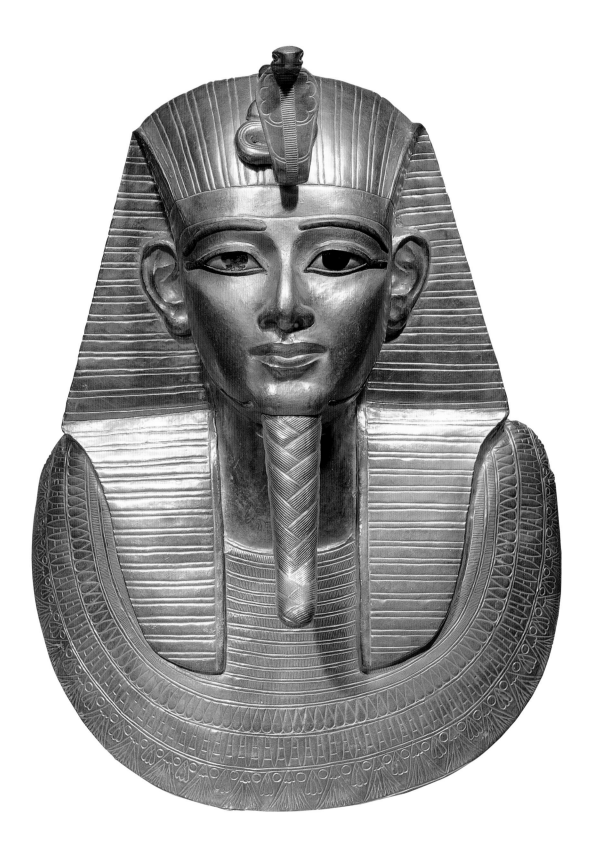

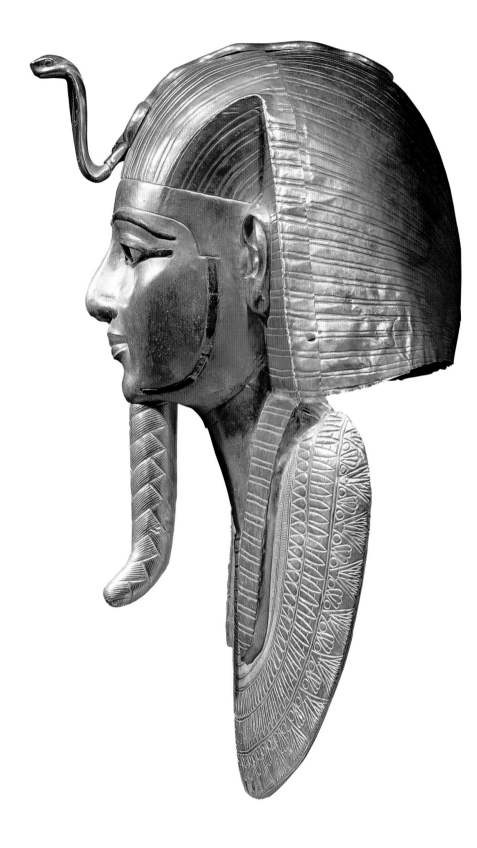

The gold mask of King Psusennes I, from his tomb at Tanis (San el-Hagar)

*c.*991 BC. Gold, lapis lazuli,
glass, h. 48 cm, 18 in.
Egyptian Museum, Cairo

Among the several funerary masks
found in the royal tombs at Tanis,
that of King Psusennes I is the
closest to the more than three
hundred years earlier mask of King
Tutankhamun (203). It is more
straightforward in its design: the
inlays are confined to the eyes,
eyebrows and the straps of the
ceremonial beard, and the mask
relies almost entirely on its very
fine incised decoration. There are
no inscriptions. The mask was
made in two pieces from a gold
sheet less than one millimetre
thick; details such as the royal
cobra and the beard were made
separately and attached. The
handsome face of the king conveys
the image of idealized eternal
youthfulness but probably bears
only marginal resemblance to
the appearance of the king. The
uniform striation of the royal
headcloth and the beard and the
regular strands of the broad collar
frame the face and set off and
emphasize its clean-cut features.
This is a beautifully focused and
controlled work of art which
through its simplicity might be
thought to surpass even the mask
of Tutankhamun.

Collar of King Psusennes I, from his tomb at Tanis (San el- Hagar)

991 BC. Gold and lapis lazuli,
d. 30 cm, 11¾ in.
Egyptian Museum, Cairo

The intact tombs of kings of the 21st and 22nd dynasties discovered at Tanis contained spectacular jewellery, in some very original forms. Here, a traditional collar consists of seven rows of gold rings strung tightly together so that they form thick flexible gold cables. During the New Kingdom such collars with varying numbers of rings in rows were presented by the pharaoh as a reward for exceptional achievements, often military. They can be seen worn by men in sculptures (151) as well as in reliefs and wall paintings. When this collar was put on, the rows of gold rings were visible round the neck at the front. A gold clasp acted as a counterweight at the back. On the front of it there are a winged scarab beetle, the names of Psusennes I, and small representations of the god Amun-Re and the goddess Mut, incised and partly inlaid. Attached to the clasp are gold chains with tassels and floral pendants.

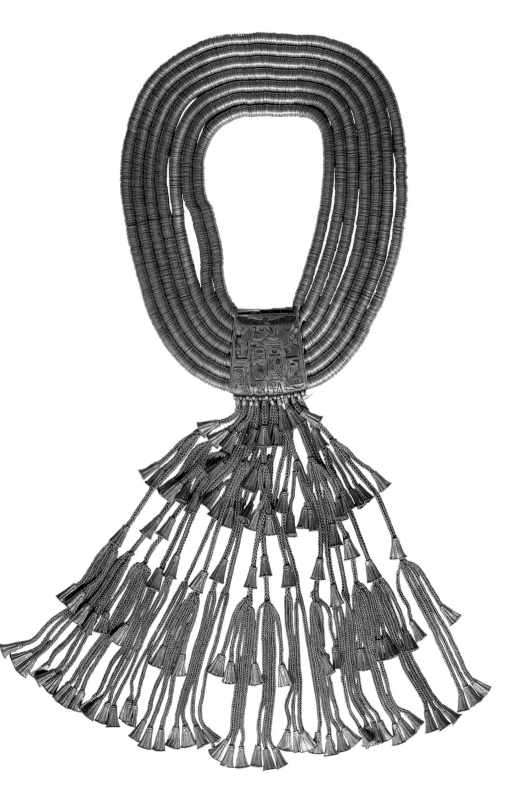

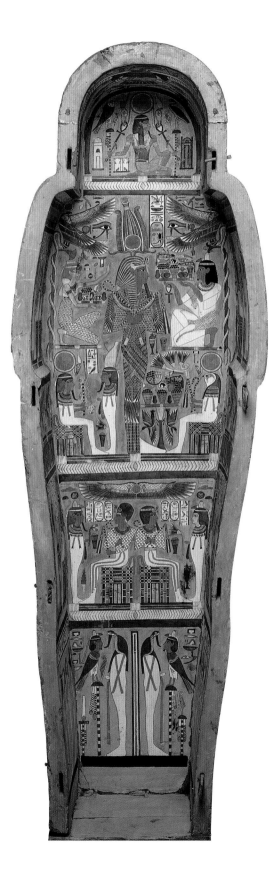

The coffin of Bekenmut, the god's father (priest) of Amun, from the west bank at Thebes but exact location of discovery not known

c.950 BC. Painted wood,
l. 208 cm, 81 in.
Cleveland Museum of Art

Egyptian coffins were often decorated not only on their exterior, but also inside. The coffin was like a miniature tomb and the environment created by its decoration was comparable to that of a decorated tomb. It is not accidental that some of the most spectacular coffins were made early in the first millennium BC when decorated tombs all but ceased to be made. Bekenmut was a priest of a relatively modest rank in the temple of Amun at Karnak. The decoration inside the lower half of his coffin, the floorboard on which the mummy lay, is divided into four registers. The large figure in the second register is King Thutmose III, of the 18th dynasty, more than 400 years earlier. He was worshipped as a 'local saint' in the Theban area during the period which followed the end of the New Kingdom. The man kneeling with offerings before the king is probably Bekenmut himself. The three deities below are different forms of the sun god. In the third register, there are two seated figures of another king of the 18th dynasty, Amenhotep I. The mummiform figures before him are Bekenmut and his wife. The two human-headed birds in the bottom register are representations of Bekenmut's *ba* ('personality').

Openwork vase,
location of discovery not known

*c.*900 BC. Blue frit, h. 17 cm, 6 in.
Brooklyn Museum of Art, New York

This vase is one of the most
ambitious and elaborate which
Egyptian craftsmen and artists
attempted in blue frit (also known
as 'Egyptian blue'). The substance
used to manufacture blue frit was
a naturally occurring pigment which
was crushed, mixed with water and
fired at low temperatures so that it
did not turn into glass. The vase
consists of two unobtrusively
attached shells, one an interior
plain container, the other an
exterior openwork design
surrounding it like a cage. The
openwork design is in the form of
a lotus flower at the bottom and
the neck and mouth. The ovoid
body consists of the Hathor head
flanked by cobras, vultures with
outstretched wings placed on
hieroglyphic signs for 'gold', and a
figure of the god Bes. These were
moulded in several parts and joined
before firing. Although the symbols
are difficult to interpret as a group,
the selection suggests a domestic
rather than ritual use.

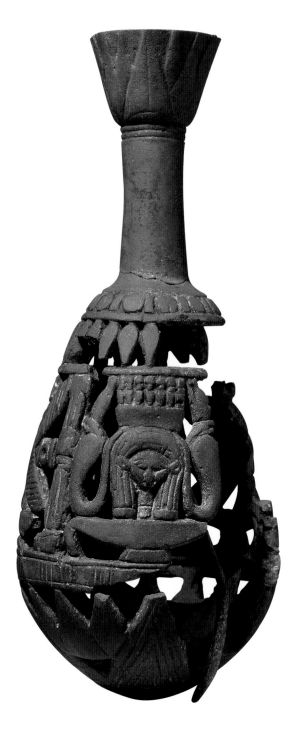

A king offering an image of truth and justice, location of discovery not known

*c.*900 BC. Silver and gold,
h. 19.5 cm, 7 in.
Louvre, Paris

The Egyptian word *maet* means 'truth', 'justice' or 'order'. The word was written with the hieroglyph of an ostrich feather, and the goddess Maet, who was a personification of the 'order', carried an ostrich feather on her head. This statuette shows a king offering a figure of the goddess Maet. The recipient must be a god and the act confirms that the order in the world has been successfully preserved. The king has his left foot advanced, a posture which is characteristic of male sculptures. We can work out why it is almost always the left foot. We have to be aware of three things: 1. In Egyptian arts, as well as in writing, the main direction was to proceed from right to left, with people facing right. 2. Whenever possible, an effort was made to show all the important elements. 3. Two-dimensional representations were placed on a base line. In the first stage of his work, the sculptor made several preliminary sketches of the statue on the block of stone which he was going to carve. In his main sketch the figure was facing right, and in order not to obscure the toes it was the left foot which had to be shown further to the right, i.e. 'forward'. The sculptor followed the sketch and the 'left foot forward' principle was automatically introduced into the sculpture.

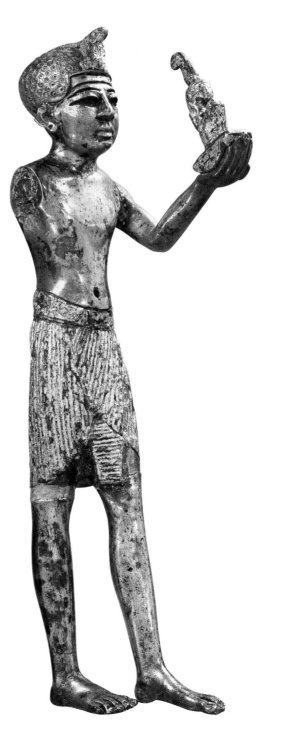

Bracelet found on the mummy of King Shoshenq II, from his tomb at Tanis (San el-Hagar)

*c.*890 BC. Gold, lapis lazuli, carnelian, faience, d. 7 cm, 2¾ in. Egyptian Museum, Cairo

All types of jewellery worn by women were also worn by men, although not during all periods: diadems, earrings, collars, necklaces, pectorals, bracelets, rings, decorative girdles and anklets. This is one of seven bracelets found on the mummy of King Shoshenq II, and one of a pair nearly identical and symmetrically designed (one for each arm). The bracelet consists of two hinged segments and the main element of its inlaid decoration is a large *udjat* eye. In Egyptian mythology the god Horus had his eye torn to pieces by his wicked uncle Seth. Thoth, the god of cleverness and wisdom, succeeded in reassembling the eye so that it once again became 'the sound eye' (the word *udja* means 'sound', 'healthy'). The *udjat* eye was one of the most widespread and potent symbols. On Shoshenq's bracelets the eye is on a basket on which deities, especially small-size zoomorphic deities, are sometimes placed. The basket is a hieroglyph which reads *neb* (or *nebet*, if feminine) and means 'master', 'lord' and also 'possessor' (and the feminine equivalents). A deity may be described as the 'lord' of a certain area or the 'possessor' of a certain quality. While the *udjat* eye was not regarded as a deity in its own right, it was accorded such a treatment.

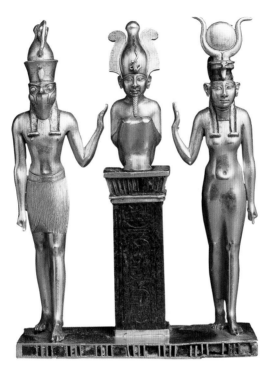

The triad of Osiris, location of discovery not known

*c.*850 BC. Gold and lapis lazuli, h. 9 cm, 3½ in. Louvre, Paris

This small sculpture showing the god Osiris, his companion Isis and their son Horus was probably meant to be worn suspended from a chain around one's neck. The goldsmith's aim was to exploit the contrast between the colours of gold and lapis lazuli, a mineral imported from north-eastern Afghanistan. Osiris is usually shown seated on a rectangular seat, but here he is squatting on the ground with his knees drawn up, rather as a young sun god just reborn. The figure is placed on top of a shrine which normally houses a statue of a deity. In relief or painting the standard way of showing the invisible contents of such a shrine would have been to represent them on its roof. By importing this convention into three-dimensional sculpture the artist was able to incorporate a large piece of lapis lazuli into his composition. Slivers of the same material, now lost, were probably also used in the wigs of Isis and Horus. The names on the shrine are those of King Osorkon II.

The god's wife, Karomama, probably from the temple of Amun at Karnak

*c.*850 BC. Bronze, electrum, gold, silver, copper, h. 59 cm, 23¹⁄₄ in. Louvre, Paris

The number of bronze statuettes increased noticeably at the beginning of the first millennium BC and represented a major artistic development during this period. Many were votive objects made for the growing pilgrim trade, attractively designed but with little additional decoration. But there were also larger statues which, to some extent, replaced sculptures made of stone or wood. Theban workshops must have been among the best in the land and produced a series of bronze sculptures of 'god's wives' and 'divine adoratresses'. These were priestesses who were, at least nominally, at the head of the Theban priesthood of Amun. Many of these women were very closely related to the royal family. The statue illustrated here shows the god's wife Sitamun-mutemhet Karomama-merytmut. Her young face and her heavy wig are reminiscent of the statues of the first half of the 18th dynasty. The two tall plumes which originally formed her headgear are now lost. In her hands Karomama held two sistra, musical instruments comparable to rattles used by Egyptian priestesses. This enabled her statue to participate for ever in the rituals performed in the temple where it was set up. The rattles, which were probably made of gold, are now missing.

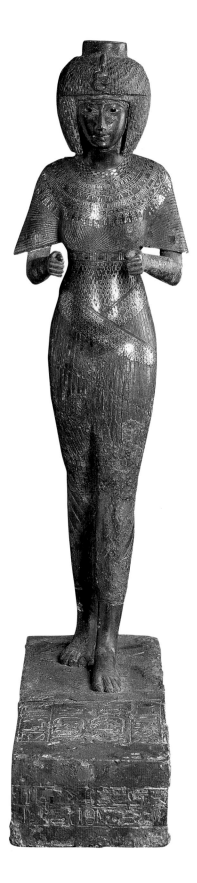

The mistress of the house, Tapert, before the god Atum, location of discovery not known

*c.*730 BC. Painting on plastered wood, h. 31 cm, 12¹⁄₄ in. Louvre, Paris

The dizzy heights of accomplishment reached by tomb painting at Thebes during the New Kingdom, in the second half of the second millennium BC, were not to be scaled again. It took another thousand years for painted decoration to reappear in tombs of the Ptolemaic and Roman periods, in a changed context and with a completely different subject-matter. Until then, painting continued to be used on various items of tomb equipment, especially wooden tomb stelae which became as common as stelae made of stone. Their repertoire was reduced to representations of the deceased person before the gods, usually the triad of Osiris, Isis and Nephthys, but also the hawk-headed sun-god Re-Harakhty and the four 'sons of Horus' connected with embalming, Hapy, Imset, Duamutef and Kebehsenuf. Deviations from this norm are unusual. The stela of Tapert is decorated on both sides. On one side, she is shown before the god Re-Harakhty, on the other (illustrated) before Atum, another form of the sun god. An interesting feature is the representation of the sky goddess Nut whose body is arched over the scene. The goddess Nut was believed to swallow the sun in the evening and to give birth to it in the morning (see also 262–3). Both acts are shown on the stela.

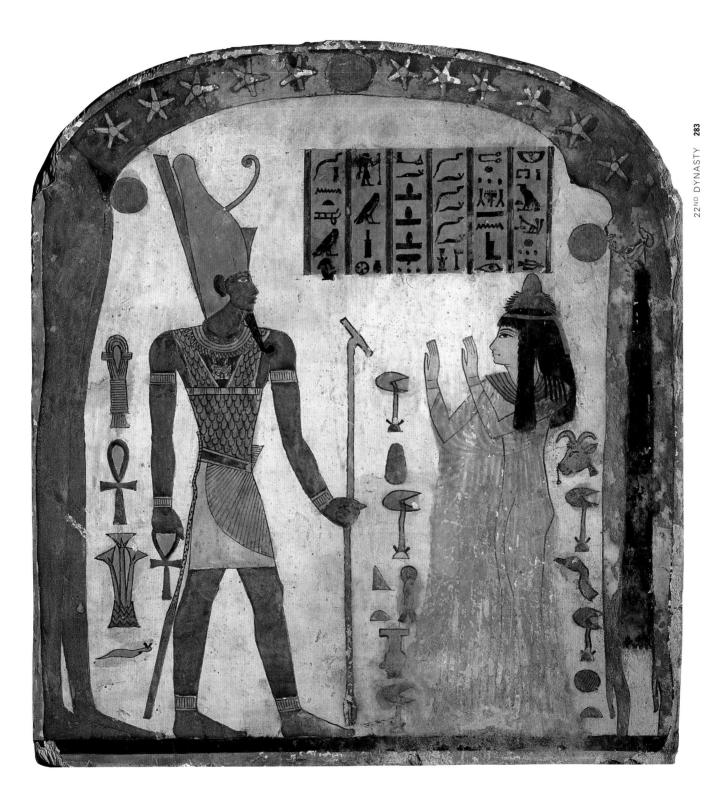

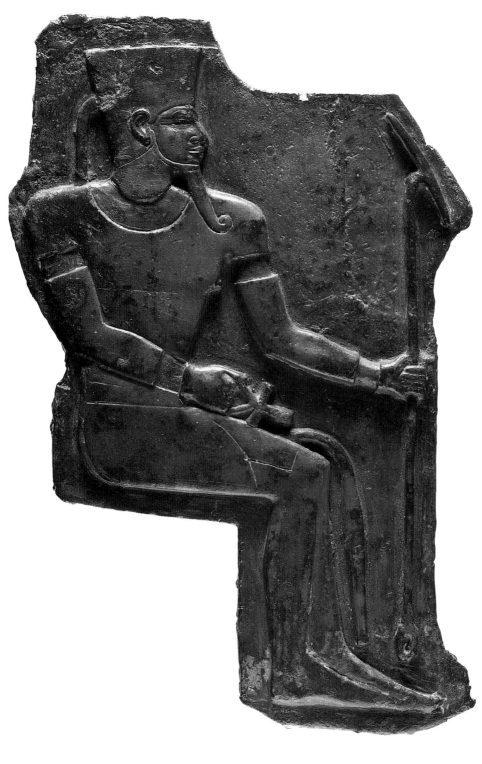

The god Amun, from Saqqara

*c.*710 BC. Raised relief in bronze, h. 17.9 cm, 7 in. Fitzwilliam Museum, Cambridge

Kings represented in statues, reliefs or paintings can be recognized by their facial characteristics which make them individuals. Representations of non-royal persons cannot be identified individually, but we can assign them to a specific historical period by various iconographic criteria, such as general facial appearance and other physical characteristics, types of wigs and clothing, etc. The identification and dating are, of course, enormously facilitated if the work has an inscription on it. The situation is much more difficult when we try to date representations of deities or animals where the type, once established, varied only a little. This bronze plaque probably formed part of the decoration of a wooden shrine or a similar item. It depicts the god Amun whose collar, armlets and bracelets were once inlaid in more precious material. The only dating criterion seems to be the god's face. It is full, with a prominent nose and lips, and reminiscent of the kings of the 25th (Nubian) dynasty. Their presence in the Memphite area is attested and if we accept the not entirely proven premise that during the 25th dynasty the faces of deities imitated those of the Nubian kings, the plaque can be assigned to their period.

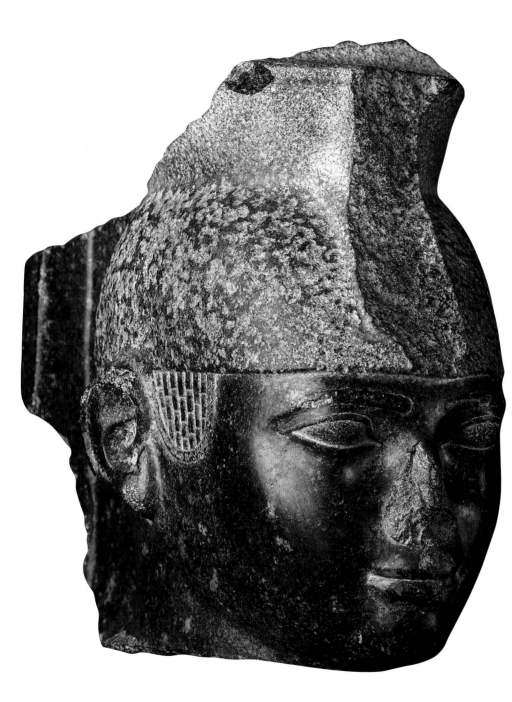

King Taharqa, probably from Thebes

*c.*670 BC. Granite, h. 36.5 cm, 14 in.
Egyptian Museum, Cairo

Admiration of things of the past characterized the whole 25th Nubian (or Kushite) dynasty of kings. This was not a retreat into the past – after all, the Kushites were newcomers from deep in the south, albeit brought up in the Egyptian tradition – but rather a conscious attempt to seek inspiration in previous great achievements. However, for reasons which are not easy to establish, the greatest innovation which appeared in Egyptian sculpture during the 25th dynasty was an interest in naturalistic representations. If one discounts the rather exceptional Amarna period, such a trend had not been seen in Egypt since the royal portraits of the 12th dynasty more than a thousand years earlier. The sculptures of the Nubian dynasty were made by Egyptian artists who, for the first time, were asked to portray pharaohs with non-Egyptian features. The degree of naturalism varied. Sometimes, as in the case of this statue of King Taharqa, a naturalistic rendering of the Kushite head in profile was combined with a good deal of the traditional Egyptian idealization of Taharqa's characteristically round face. The king wears a kind of cap with two uraei (serpents), now broken off, and tall plumes, also lost. His hair is showing from beneath the cap.

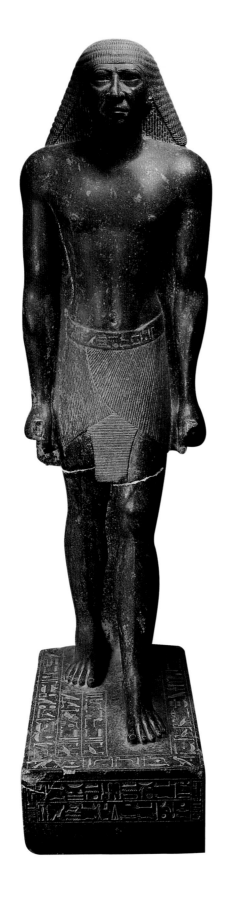

The mayor of Thebes, Montuemhet, from the temple of Amun at Karnak

*c.*670 BC. Granite, h. 137 cm, 53 in.
Egyptian Museum, Cairo

During much of pharaonic history the style of Egyptian sculpture in the round was set by royal statues; non-royal statues followed and imitated them. Discreet similarity in facial types between royal and the finest non-royal statues was probably due to the fact that they were made by the same sculptors. The mayor of Thebes and fourth prophet of the god Amun, Montuemhet, was a survivor. He lived through the Kushite occupation of the country during the 25th dynasty, the sack of Thebes by the Assyrians, and yet emerged as the most powerful man at Thebes at the beginning of the 26th dynasty. His standing statue shows a strong rather than a handsome man. It combines the naturalistic style of the Kushite royal statues with traditional elements which hark back to the past. Montuemhet's eyebrows, modelled in relief, are highly stylized but the rest of the face is contemporarily naturalistic, deeply lined, showing a powerful nose with slightly flaring nostrils and a wide mouth. A similarity with some statues of Kushite kings is there if one is prepared to see it. Montuemhet's wig is reminiscent of those of the New Kingdom and his bare chest and kilt imitate Old Kingdom statues.

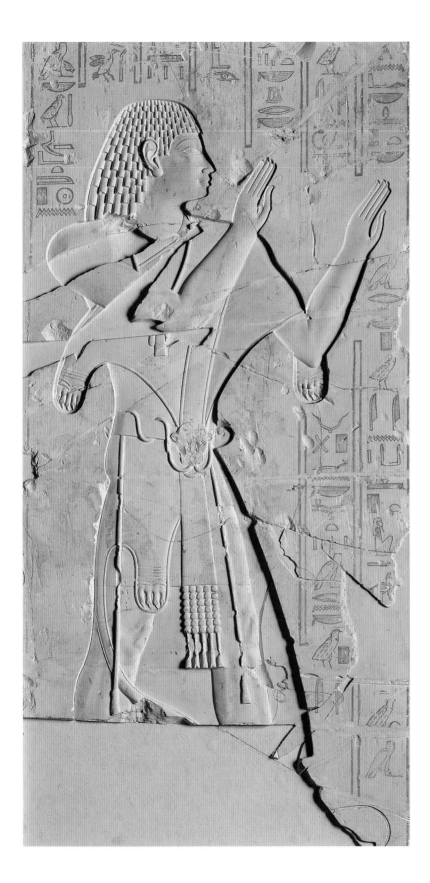

The mayor of Thebes, Montuemhet, from his tomb at Asasif (the west bank at Thebes)

*c.*650 BC. Deep sunk relief in limestone, h. 132 cm, 52 in. Cleveland Museum of Art

Statues of Montuemhet, mayor of Thebes, display all the hallmarks of the new naturalistic style introduced during the 25th Nubian dynasty (see 286). But when Montuemhet's tomb was being decorated, the style changed and the man who was by then twenty years or so older was shown as young and vigorous, the very essence of the idealizing representations characteristic of the 26th Saite dynasty. There is no noticeable similarity between the two faces. The relief illustrated here was on the thickness of a doorway to one of the small chapels in the tomb's first court. Montuemhet is depicted as a priest, wearing a leopardskin and with his arms (note that both hands are the same) raised in adoration towards the interior of the chapel which probably housed a statue. The representation is carved in deep sunk relief with a great deal of internal modelling. But the tomb was left unfinished and many reliefs were either left uncut or were never painted. Montuemhet holds a sad record for the largest number of fragments of reliefs which have been removed from one tomb. Some hundred of them are in various museums and collections.

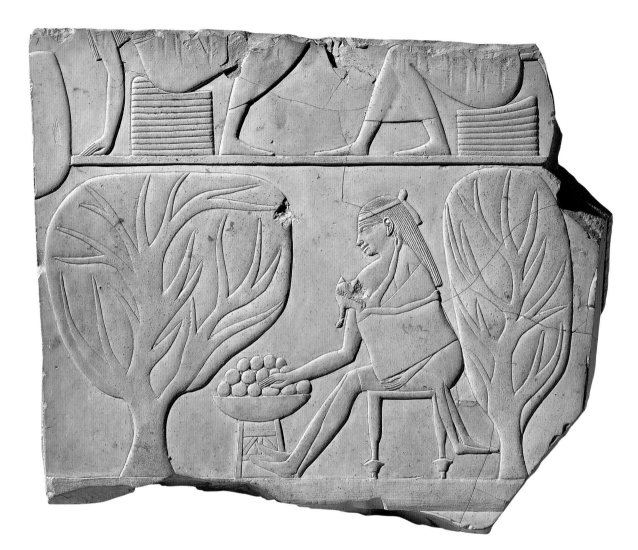

Woman with a child gathering figs, from the tomb of the mayor of Thebes, Montuemhet, at Asasif (the west bank at Thebes)

*c.*650 BC. Raised relief in limestone, 28.7 x 23.9 cm, 11 x 9 in. Brooklyn Museum of Art, New York

Scenes of no obvious religious or funerary significance occurred infrequently in tombs during the first millennium BC. The representation of a woman, with a baby in a shawl tied over her shoulders, seated under a sycamore tree and rearranging figs in a basket is, therefore, unusual. But even more surprising is the fact that the scene has a direct parallel in the tomb of a certain scribe Menna, at Sheikh Abd el-Qurna on the west bank at Thebes some 700 years earlier, during the 18th dynasty. It is, of course, impossible to prove that this is a direct copy of this tomb scene and that the motifs were not transmitted in a different way. There are significant differences between the two representations. Menna's tomb is painted while Montuemhet's tomb is decorated in high raised relief. The artist of the seventh century slightly rearranged the positions of the woman and the tree (the trees in Montuemhet's tomb look more like bushes) and introduced a decorative chair which appears totally unsuitable for an outdoor activity. The 26th-dynasty version of the scene is better designed but much more formal and far removed from the naturalism and immediacy of the 18th-dynasty painting.

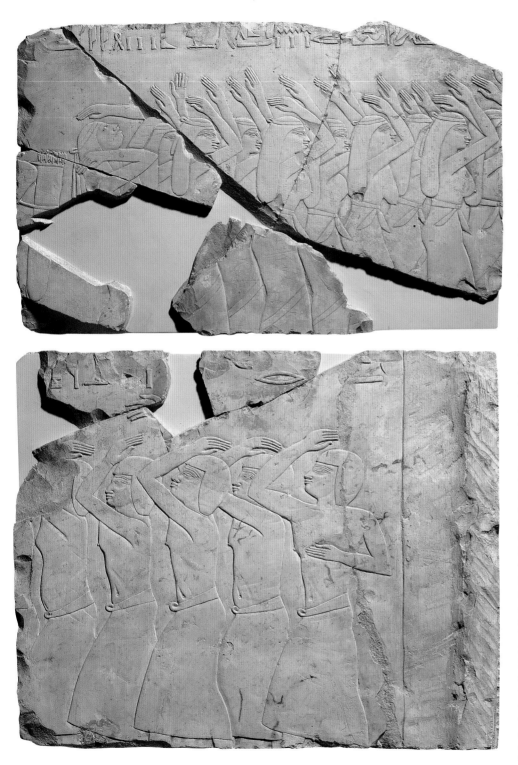

Mourners, from the tomb of the vizier Espekashuty at Deir el-Bahri

*c.*640 BC BC. Raised relief in limestone, 34.5 x 55.5 cm, 13 x 21 in. (women) and 13¹⁄₄ x 17 in. (men).
Brooklyn Museum of Art, New York

In Egyptian art, even the most profound emotions were conveyed by gestures rather than facial expressions. These are men and women mourning at the funeral of the vizier Espekashuty. Their arms are raised, probably in the act of throwing dust over their heads, and the women's breasts are bare, but their faces do not indicate any feelings. The representations of men are arranged in a somewhat unimaginative way and are distinguished only by slight variations in the way they hold their head and their hands. The four men on the left of the relief are shown with only one raised arm, the other was not carved presumably because it was felt that there was not enough room. The representations of women are much more accomplished and their overlapping bodies and arms well convey the impression of a crowd. These reliefs were cut in high raised relief in the fine limestone lining of the rather poor quality rock surfaces inside Espekashuty's tomb. They are often described as 'archaizing' and the models for them are sought in earlier periods, especially in the painted decoration of the tombs of the 18th dynasty. The decoration of Espekashuty's tomb, however, was left unfinished.

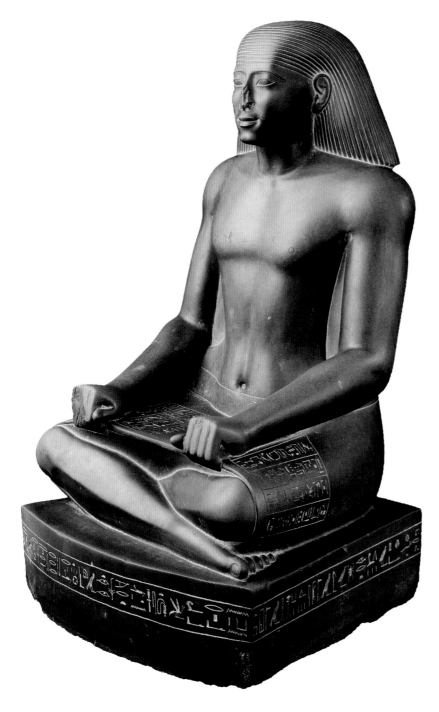

The vizier Espekashuty, from the temple of Amun at Karnak

*c.*640 BC. Greywacke, h. 80 cm, 31½ in. Egyptian Museum, Cairo

The scribe statue was introduced during the 4th dynasty and even the highest state officials still had themselves represented as ordinary scribes nearly 2,000 years later. Ordinary is perhaps not the best word to use: the statue was, because of its apparently humble attitude, very suitable for temples where this quality was required in the presence of the god. Yet at the same time it indicated that its owner was an educated man and a member of the bureaucratic élite. This statue was found in a cache which contained many other sculptures, but its original position must have been in a publicly accessible part of the temple, perhaps outside a pylon or in an open court. The text on the papyrus asks for an offering text to be recited on behalf of the statue's owner, the vizier Espekashuty. It is written in such a way that a person standing in front of the statue can read it, i.e. the scribe is not reading from the papyrus himself but is rather displaying it for the benefit of literate passers-by. Espekashuty has a slightly supercilious expression on his face. It is known as the 'Saite smile'; the 26th dynasty of which it is typical originated in the city of Sais in the Delta. His body shows a clear bipartite division (the chest and the rest) common in the first half of the 26th dynasty. There were several viziers called Espekashuty during the 26th dynasty and without any indication of the man's parentage the precise date of this statue is still disputed.

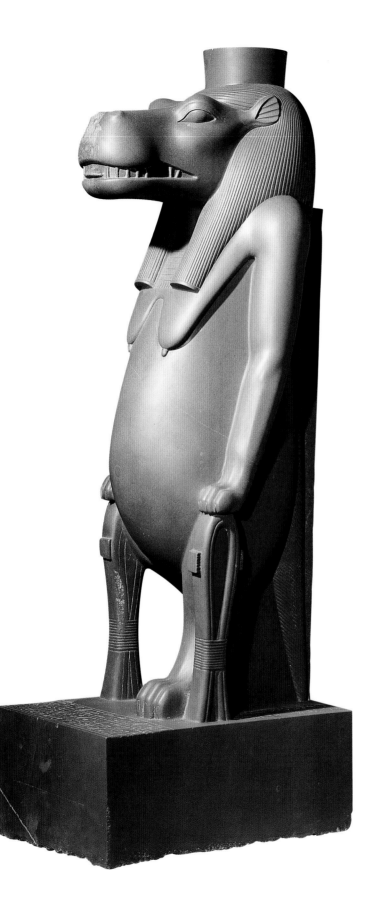

The goddess Tueris, from the temple of Amun at Karnak

*c.*620 BC. Greywacke, h. 96 cm, 37¾ in.
Egyptian Museum, Cairo

It seems strange that protective deities – perhaps more appropriately called protective demons – were themselves represented as rather terrifying creatures (see also 165). Originally, it may have been an attempt to befriend the hostile or to combat like by like. This is Tueris (in Egyptian: Taweret), who protected pregnant women and assisted at births. She has the body of a pregnant hippopotamus with pendant breasts but her paws are those of a lion and the tail belongs to a crocodile. This is a fully zoomorphic form, albeit composed of different animals, but Tueris is standing upright as if she were a human being. She wears a tripartite wig and on her head is the cylindrical modius, probably for the horns and sun disc, a standard headgear worn by goddesses. Her front paws rest on two hieroglyphic signs which read *sa*, 'protection'. Tueris was worshipped at Karnak and this sculpture, found in a closed shrine, was dedicated by Pabasa, the majordomo of Nitocris. Nitocris was a daughter of Psammetichus I who, in an act of political expediency, was made the religious figurehead at Karnak at the beginning of the 26th dynasty (see also 282).

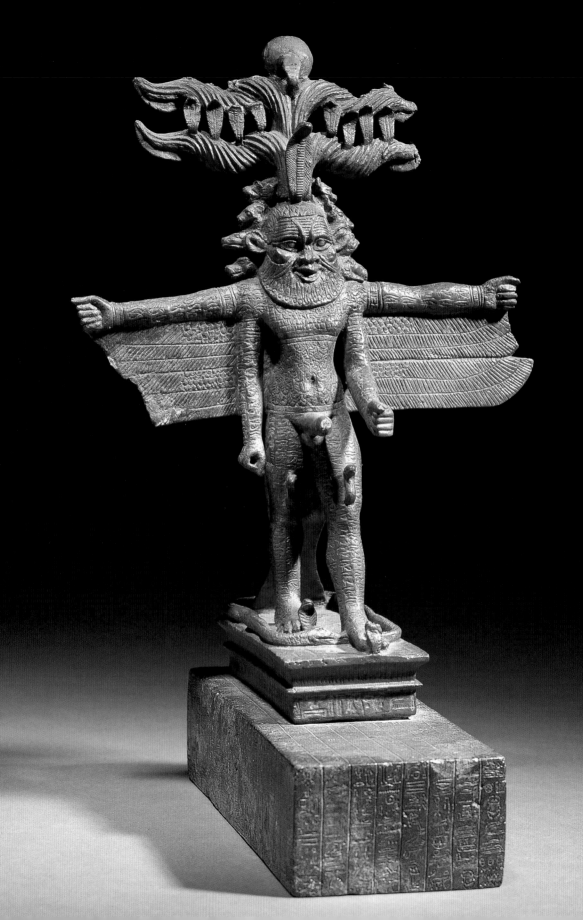

The god Harwer,
location of discovery not known

*c.*620 BC. Bronze with gold
inlays, h. 28.8 cm, 11 in.
Louvre, Paris

The inscription on the base of
this statuette mentions King
Psammetichus I, 'beloved of the
god Harwer'. Harwer, which means
'Horus the Great', was the name of
a local god worshipped at several
places in Egypt, but it seems that
the name of this extraordinary
creature should be understood
as 'Horus the Great (of Might)'.
This makes it a protective deity
belonging to the same category
as the demigod Bes whose facial
features he shares (see 335). It
may be a composite deity who
acquired characteristics of other
gods, a fairly common occurrence
in Egyptian religion called
syncretism. Artistically, this was
conveyed with astonishing ease
even though the individual
elements of this representation
seem so incongruous. The
face is that of Bes, with a crown
consisting of small animals, double
horns with cobras and a sun disc.
The god has two pairs of arms
and two pairs of wings. There are
serpents on his knees and his feet.
His body seems to be covered in
thick hair but this, on a closer look,
is made up of engraved *udjat* eyes
(see 280), symbols of a proper,
healthy and desirable state of
affairs. There is no doubt that the
terrifying creature is benign and
apotropaic, perhaps on the principle
that the best way of fighting fire is
with fire. The pedestal is covered
with magical texts.

Funerary pectoral of Panehesy, chief ointment-maker, location of discovery not known

*c.*600 BC. Faience with stone
inlays, h. 10.5 cm, 4 in.
Ägyptisches Museum, Berlin

Gold pectorals were popular items
of jewellery (see 124) but those
made of relatively cheap materials,
mostly faience, did not appear until
around 1500 BC. They were not
worn in the lifetime of the person
but were manufactured for purely
funerary purposes. They were
placed on the chest of the mummy
and conveyed an important idea
which preoccupied the mind of all
Egyptians: the wish to be reborn
after death. These pectorals are
in the form of a shrine with an
entrance gate and a concave
cornice. The scene is simple
but highly symbolic. Panehesy's
pectoral is typical: a barque with
a large scarab beetle is being
protected by two goddesses, Isis
on the left and Nephthys on the
right. The scarab symbolizes the
rising sun which has just been
reborn after a period of darkness
and expresses the deceased
person's wish to undergo a similar
transfiguration. The pectoral
combines the winged sun disc
which is often shown on the
cornices of doorways with the
allusion to the scarab's (dung
beetle's) tendency to roll a ball
of dung, in the same way the sun
might be imagined as being rolled
over the sky by a giant scarab.

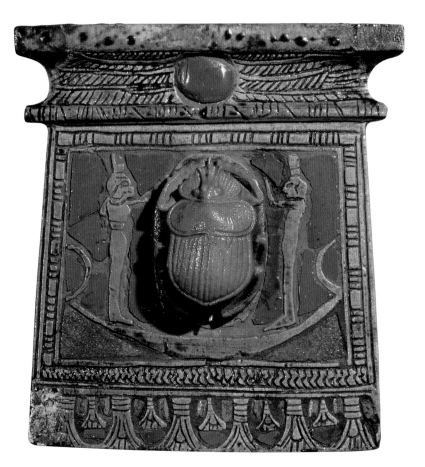

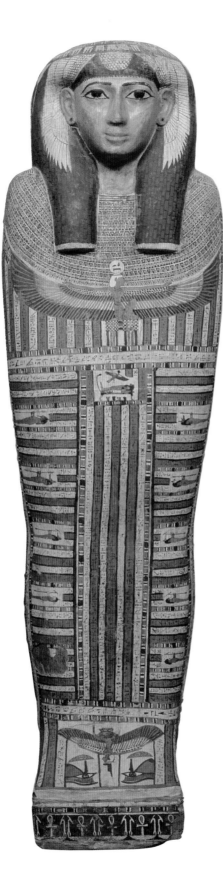

Coffin of woman Tashaenkheper, probably from Thebes

*c.*600 BC. Painted wood,
l. 175 cm, 68 in.
Museo Civico, Bologna

After the pyramids, the anthropoid or mummiform coffin is the other instantly recognizable symbol of ancient Egypt. It resembles a body swathed in bandages. An anthropoid coffin of the 26th dynasty, such as the coffin of Tashaenkheper, has a whole collection of miniature religious scenes painted on its outside as well as the inside. Some, especially those on the lid, were painted on the linen and plaster applied over the wood. The female face on the lid is completely conventional; there was no attempt to make it individual. Below the broad collar the goddess Nut is shown kneeling with outstretched arms. Further down, there is a small scene with a mummified body on a bier with its *ba* ('personality') as a bird hovering above it. On either side of the coffin there are standing deities separated by short texts, and the goddess Isis is represented on the feet of the coffin. Most of these coffins were made for people who did not have large tombs, so the decoration of the coffin took over the role of the carrier of scenes and texts regarded as essential for the deceased person in the afterlife.

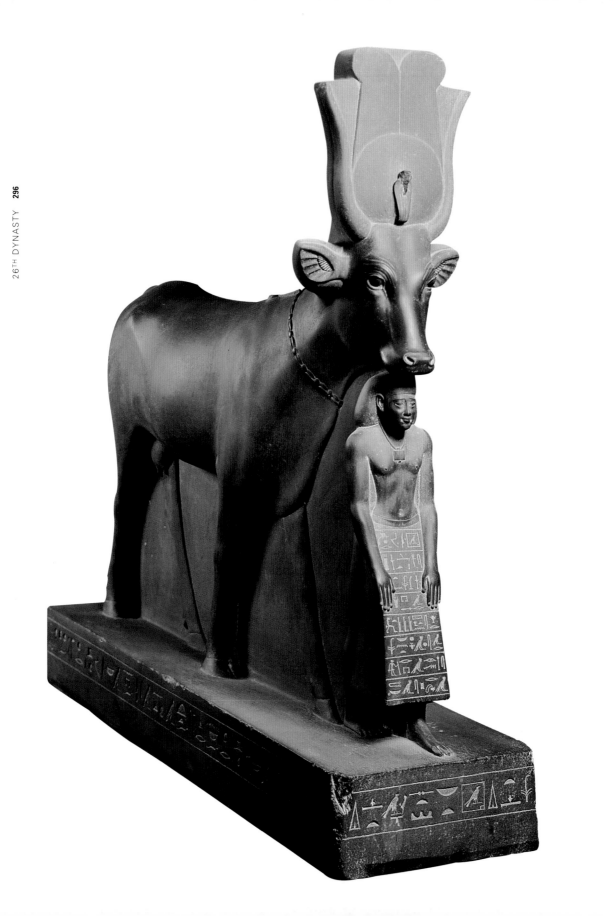

The chief steward Psametek protected by the goddess Hathor in the form of a cow, from Saqqara

c.550 BC. Greywacke, h. 96 cm, 37³⁄₄ in.
Egyptian Museum, Cairo

Two related concepts, of 'protection' and an 'action by proxy', were widespread in Egyptian society and often expressed in Egyptian art. In the first case, a person of a higher rank, or even a deity, 'protects', uses his or her power and influence, to save another person from misfortune. In the second case, the more powerful or influential person intercedes on behalf of a supplicant of a more lowly rank. One of the statues which Psametek had made for his tomb shows him together with a cow which is the visible image of the goddess Hathor. Hathor is described as the 'mistress of the western desert', i.e. the necropolis. The protection given by a zoomorphic manifestation of a deity can be shown, for example, by a bird of prey enveloping the person in its wings. When this is not possible, as in this case, the protection is indicated by placing the person under the animal's head which provides a kind of shelter. Artistically, it is worth noting that the sculpture of the Hathor cow shows all the four legs of the animal on either side of the sculpture. The two sides are separated by an indication of the 'negative space', a stone partition where one would logically expect free space, in which two of the legs on either side are carved in relief.

New Year's flask,
location of discovery not known

*c.*550 BC. Faience, h. 15 cm, 5 in.
Myers Museum of Egyptian and
Classical Art, Eton College, Windsor

Many features in Egyptian art
are symbolic references to ideas
which were immediately obvious
to the Egyptians. Unfortunately,
sometimes we lack the
required knowledge of Egyptian
environment, religion and culture,
so we either do not understand
them or we do not even recognize
them as symbols. The so-called
New Year's flasks were faience
vessels, round in shape but narrow.
They owe their name to short texts
written on them which mention the
Egyptian New Year. The illustrated
New Year's flask has a lotus-
shaped spout with two small
monkeys clinging to it and a
decoration imitating collars on its
shoulders. The purpose of these
flasks is not quite clear. The
Egyptian New Year began on 19
July when the heliacal (pre-dawn)
rising of Sirius coincided with the
arrival of the annual inundation.
The flasks, no doubt, contained
something connected with this
event. Was it a New Year's gift of
a precious unguent? Or just water
taken from the Nile when it began
to rise? Although the two monkeys
appear to be merely decorative, it
is much more likely that they are
discreet symbols connected with
the New Year. But we are at a loss
to explain exactly what they allude
to. All we can say is that monkeys
and baboons are linked to other
periodically occurring events, such
as royal jubilee festivals.

A king offering the udjat eye, from Saqqara

*c.*550 BC. Bronze with remains of gilding, h. 26 cm, 10¼ in. Egyptian Museum, Cairo

Many reliefs and paintings as well as sculptures show a king presenting ('offering') an item to a god or goddess. The deity may or may not be part of the composition. If, for example, the statue was set up in a temple then the representation of the god was, strictly speaking, unnecessary because it was already there in the form of the temple's cult image. We know from texts that real offerings of food and drink were offered on temples' altars, and in many cases the things which the king is holding in his hands are such offerings. A large variety appears in two-dimensional representations (bread, cakes, water, wine, beer, etc.) although only globular bowls of water or wine seem to be common in statues. Sometimes, however, the king is offering other things, for example a figure of the goddess Maet (see 279) or, as in the case illustrated here, the *udjat* eye. The explanation of such representations is different. It is unlikely that a figure of Maet or an object in the shape of the *udjat* eye were really presented to the temple. Instead, this is an artistic expression of an idea. The *udjat* eye is a symbol of normality, continuity and a healthy state of affairs. Offering such a symbol to a god is a statement that all is well and that the king is fulfilling his role by ensuring that the desired state of affairs continues.

Mask and bead shroud of the overseer of royal freight boats, Hekaemsaf, and a section of the bead shroud of the master of the horse, Pedeneit, both from Saqqara

*c.*530 BC. Gold, faience, semiprecious stones, l. of Hekaemsaf's shroud 145 cm, 57 in.
Egyptian Museum, Cairo

Workshops attached to cemeteries and the artisans and artists who worked in them depended on the patronage of the pharaoh and those wealthy enough to afford their services. The range and quality of tombs and funerary goods were, therefore, directly connected with the fortunes of the cities to which these cemeteries belonged. Throughout Egyptian history, Memphis was like a magnet attracting pharaohs, no matter from where they originally hailed. In the sixth century BC Kings Apries and Amasis, both natives of the city of Sais (Sa el-Hagar) in the north-west Delta, made Memphis their residence and administrative centre. This was immediately reflected in the appearance of tombs in which the most important people of their administration were buried. The small burial chamber, often decorated with good-quality reliefs, was built at the bottom of a huge shaft filled with sand. This was the only tomb ever devised which was almost completely safe from plunderers. There was no way to rob such a tomb except by emptying the shaft, and so a considerable number of them have survived intact until the arrival of archaeologists. The mummified bodies wrapped up in bandages were placed in wooden coffins inside stone sarcophagi. Masks were put over their heads and shrouds resembling a fine mesh consisting of thousands of faience beads, apparently without any textile backing, covered the bodies. Throughout Egyptian history, women's dresses with beads sown on them and cloaks made of beads were often shown being worn by goddesses. But these bead shrouds were placed over the mummies of men and may have been inspired by the similarity of their geometric pattern to that of the mummy bandages. The god Osiris is sometimes shown wearing a similarly patterned cloak (see 162). A broad collar, also made of beads, and the figures of the goddess Nut and the four deities of the internal organs, as well as a strip of text which includes the deceased's name, all made of sheets of beaten gold, were incorporated into Hekaemsaf's shroud. Pedeneit's shroud includes small rectangular plaques with the names of the god Osiris and Pedeneit himself.

Lid of the sarcophagus of the treasury overseer, Ptahhotep, from Giza

*c.*500 BC. Basalt, l. 204 cm, 80 in.
Ashmolean Museum, Oxford

A whole chain of large shaft tombs runs from Saqqara northwards as far as Giza. They are also known from the Theban area. These tombs began to be made around 600 BC and continued into the Ptolemaic period. The monument illustrated here comes from one such tomb at Giza where the shaft contained several burials. It is an interesting variation on the earlier anthropoid sarcophagus lids where the face was comparable to that of a statue. Here, however, the face is very stylized and looks more like a mask. That was probably the inspiration of this form, and the fact that the owner of the sarcophagus was one of the Egyptian 'collaborators' who served under the Persian kings of the 27th dynasty is almost certainly unconnected with the strangeness of the face. On wooden anthropoid coffins the face piece was often manufactured separately and attached to the lid as a fairly flat mask (the term sometimes used to describe such an item is 'coffin mask'). It seems that the face on this stone sarcophagus imitates such a flat mask on a wooden coffin. The five columns of texts inscribed on the lid contain a spell taken from the Book of the Dead.

A treasurer of the king of Lower Egypt, location of discovery not known

*c.*450 BC. Schist, h. 25.1 cm, 9 in.
Louvre, Paris

The tendency to create naturalistic sculptures, i.e. statues which need not be portraits but nevertheless represent people 'as they are', with characteristics which make them individual, occurred sporadically throughout Egyptian history. Some of the non-royal statues of the Old Kingdom belong to this category (68, 70), and so do the royal statues of the 12th dynasty (113, 120) and, in a special way, some of the sculptures of the Amarna period (175, 184). A return to a modified naturalistic approach took place during the 25th dynasty (285–6) and then again shortly before and especially during the Ptolemaic period (327, 342, 345–7, 349). In this sculpture, the man's eyes are very narrow, almost half-shut, and his face is broken into a number of sharply defined areas by deep lines and variations in the depth of the carving. This, for example, creates the heavy bags under his eyes. Also his throat displays several conspicuous folds. The overall impression of the face has been very aptly described as 'melancholic'. The established opinion, accepted here, is that it belongs to the 27th dynasty, and so attests to yet another resurgence of naturalistic sculpture, but more recently it has been argued with some conviction that it is about a hundred years later.

A priest of the god Amun, location of discovery not known

*c.*370 BC. Greywacke,
h. 51.2 cm, 20 in.
Brooklyn Museum of Art, New York

The 'Dattari Statue', after the collector Giovanni Dattari who first owned it, is a perfect example of the idealizing type of 30th-dynasty statuary. It has an inscribed back pillar and is meticulously finished and highly polished. It shows its subject in a deliberately archaizing way, with a wig and a short kilt being the only items of the man's dress. The antecedents of the massive wig can be traced as far back as the Old Kingdom, but the inspiration for it is more likely to have come from sculptures of the New Kingdom. Also the kilt is archaic and began as a kilt worn by kings during the Old Kingdom. The objects which the man holds in his hands are the so-called shortened staves. Staves and sceptres caused problems for sculptors because they could not be shown without using other materials than stone. Already during the Old Kingdom an elegant, if at first surprising and 'unnaturalistic' solution was found by showing only short sections of the staff and sceptre hardly visible beyond the man's fist, as if the rest of the objects was cut off (see 64). The face of the 'Dattari Statue' has chubby cheeks and its smile is characteristic of idealizing sculptures of this period. The upper part of the body shows a division into well-defined anatomical zones seen on many Late period statues.

Lion of King Nectanebo I, found in Rome but originally probably from Hermopolis Parva (Tell el-Baqliya) in the Delta

*c.*370 BC. Grey granite with red veining, l. 185 cm, 72 in. Museo Gregoriano Egizio, Vatican

After 30 BC Egypt lost its political independence and was reduced to a mere province of the Roman empire but, paradoxically, the impact of its religion and culture abroad had never been stronger. Since time immemorial it has been the custom of victors and occupiers to take home trophies of their foreign triumphs and this lion, one of a pair bearing the names of the pharaoh Nectanebo I, must have reached Rome in a similar way. It could be seen near the Pantheon in the twelfth century and was still there in the sixteenth. But then its fortunes waned and it was for some time used as a waterspout before its transfer to the Vatican Museum in the nineteenth century. The ethics of monuments abroad are complex, but there is no doubt that the Egyptian monuments of imperial Rome provided an enormous stimulus for the interest in ancient Egypt during the European Renaissance. Artistically, the lion is interesting because its front paws are crossed and its head is turned sideways. The combination of the axes of the body and the head at right angles is almost unknown in statues of people. It is, however, attested in animal sculpture from at least 1350 BC and in representations of underworld deities from even earlier (see 121).

A cat,
location of discovery not known

*c.*350 BC. Bronze, gold and
silver, h. 42 cm, 16¹₂ in.
British Museum, London

During the first millennium BC large
numbers of bronze statuettes of
cats were donated to temples of
the goddess Bastet. Bastet became
one of the best-loved deities
because of the popularity of the
cat, her animal form, and because
of her links to family happiness. By
donating a cat figure to a temple of
the goddess the devotee secured
himself a place at her side. Many of
these statuettes were hollow cast
and some were opportunistically
employed as cat coffins in cat
cemeteries. Unfortunately, animal
sculptures are difficult to date: the
chronologically diagnostic features
such as wigs and garments, which
are so helpful in the dating of
statues of people, are lacking in
the case of animals. The 'Gayer-
Anderson Cat' (the name derives
from the statuette's previous
owner, Major Robert G. Gayer-
Anderson) is one of the largest
of such sculptures. The incised
decoration is picked out in silver,
the eyes were inlaid. The seated
cat with its tail on the ground along
the right side of the body was the
animal's most frequent image. The
position of the tail has nothing to
do with the habits of cats but is an
artistic convention: in Egyptian art
the main direction was for people
and animals to face to the right and
there was an obligation to show all
the important elements.

A priest of the goddess Bastet holding a Horus-on-the-crocodiles stela, location of discovery not known

*c.*350 BC. Basalt, h. 67.7 cm, 26 in.
Louvre, Paris

Cases where one work of art, especially a statue, is represented in another work of art, such as a relief, painting or sculpture, are common. Statues may be shown being offered incense, dragged on a sled to a tomb, or being carried for presentation to a temple. This sculpture, known as the Tyszkiewicz Statue after the name of the collector who originally owned it, is a variation on this general theme. A man is shown holding a so-called Horus-on-the-crocodiles stela (also known as the 'cippus of Horus', from Latin for a boundary stela). These were small monuments of stone carved in very high relief with an image of the young god Horus surrounded by various dangerous animals, such as snakes, crocodiles and scorpions, and also gazelles (for wild animals in general). An episode in Egyptian mythology described how the young god Horus was stung by a scorpion and his life was only saved through magic worked by his mother Isis and Thoth, the god of wisdom and medicine. The function of cippi of Horus was to protect against such dangers. They were set up in houses but also in tombs for protection in the afterlife and, if small, were carried around as amulets. Water which had been poured over these stelae acquired healing qualities. This statue is completely covered by magical spells and small scenes which further develop the theme.

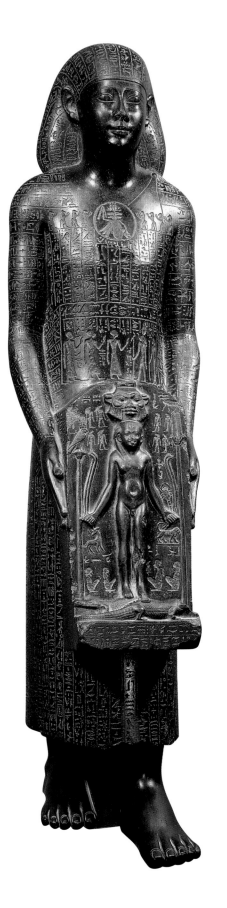

Aegis of a goddess,
location of discovery not known

*c.*350 BC. Bronze, h. 22.3 cm, 8³₄ in.
Roemer und Pelizaeus Museum,
Hildesheim

Because only the king and priests
were allowed into the inner part
of the Egyptian temple, ordinary
people had few opportunities to
see its main cult image, usually the
god's statue. It was only during
religious festivals that the shrine
containing the statue was placed in
a ceremonial barque, brought out
and carried along the festival route
lined by pilgrims who gathered
from afar. There were massive
figureheads, usually the head of the
deity above a large broad collar, at
the prow and stern of the divine
barque. This would have been the
first thing the pilgrims saw as the
procession approached. It would
also have left a lasting impression,
so much so that small replicas of
these figureheads in bronze were
among objects donated by pious
pilgrims to temples. Egyptologists
use the term *aegis* (from Latin for
'shield') for such an object. It is not
certain to which goddess this *aegis*
belongs, perhaps Mut, the female
companion of the god Amun. Her
eyes and eyebrows and also the
cobra on her forehead and her
necklaces were originally inlaid
with semiprecious stones.

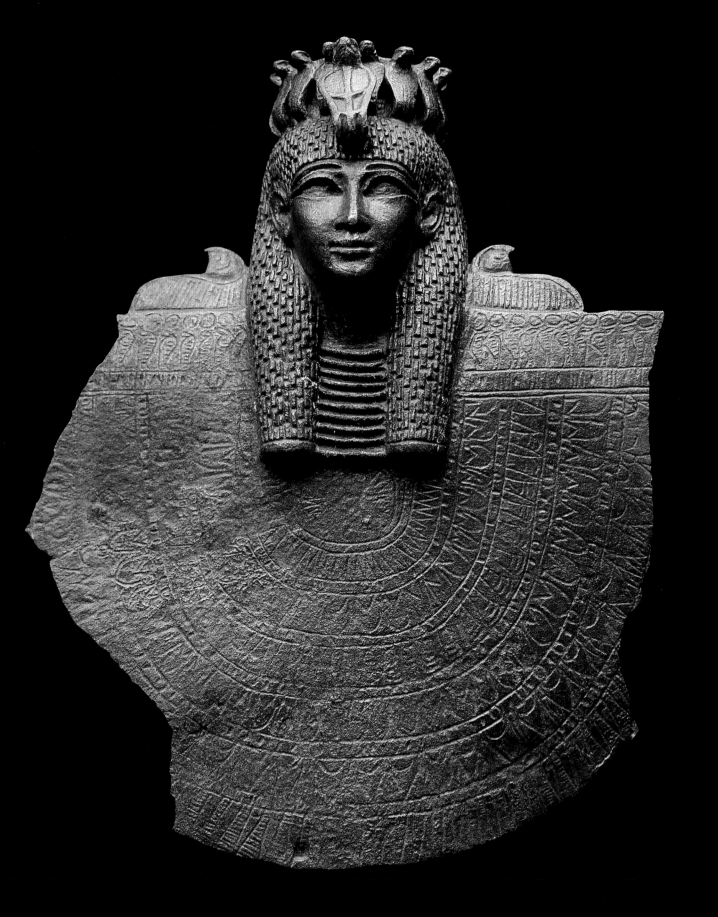

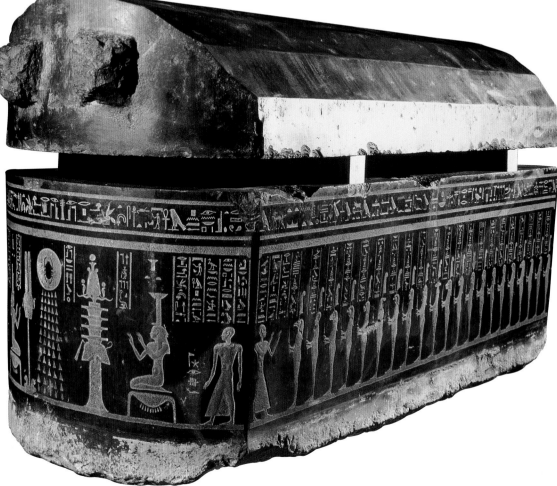

Sarcophagus of the overseer of servants, Ankh-hor, from Saqqara

*c.*350 BC. Granodiorite, l. 264 cm, 103 in. Ägyptisches Museum, Berlin

Some of the heaviest items of funerary equipment known are from the Late period, the last 400 years of pharaonic Egypt. These are massive sarcophagi, some anthropoid (see 302), others roughly rectangular. The profile of one or both sides of the lids of rectangular sarcophagi is often characteristically bevelled but this may have just been a way of dealing with imperfections in the slab of stone of which it was made. Ankh-hor, the owner of the sarcophagus illustrated here, boasted several traditional court titles which were, almost certainly, already devoid of any significance at the time when he lived. Surprisingly, his only other description was 'overseer of servants'. The head end of the sarcophagus is rounded. The decoration is carved in sunk relief. It uses traditional iconographic means. The sun disc with a scarab and shining rays is a symbol of rebirth in the afterlife. It is flanked by two pillar-shaped fetishes associated with the two main cult places of the god Osiris, the ruler of the dead: the cities of Abydos in Upper Egypt and Busiris in the Delta. Female mourners, the goddesses Isis and Nephthys, followed by Ankh-hor himself, are on either side of the scene. On the long sides of the sarcophagus, Ankh-hor is shown before the 42 judges whose task is to decide whether he is going to be admitted into the realm of Osiris.

Baboon,
location of discovery not known

*c.*350 BC. Bronze with gold and silver inlays, h. 6.5 cm, 2½ in. Museo Civico, Bologna

Egyptian religion was highly stratified and the beliefs of ordinary people were not the same as dogmas expressed by the architecture, sculptures and reliefs of large temples. One of the features of the 'religion of the poor' (an old-fashioned and convenient even though not quite accurate term) was a preference for animal forms of deities. Judging by the attention paid by kings to burial places of sacred animals, the 'official' religion did not fully accept animal cults until some time in the fourteenth century BC. However, in the first millennium BC festivals taking place in temples of animal deities were a happy meeting ground of people of all stations of Egyptian life. Bronze statuettes of animals, as in this case a small Hamadryas baboon, were donated by pious pilgrims. This sculpture of a conspicuously male baboon is completely naturalistic in its form but its fur is indicated by a stylized pattern reminiscent of overlapping feathers. The same pattern can sometimes be seen on garments worn by anthropomorphic deities. The baboon was one of the possible manifestations of Thoth, the local god at Hermopolis Magna (El-Ashmunein), but was worshipped universally as a god of wisdom, writing and medicine.

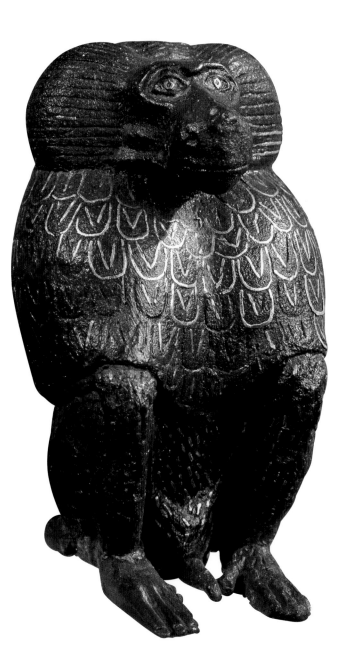

The priest Harhotep receiving offerings, from Tell el-Farain (Buto)

*c.*350 BC. Raised relief in limestone, w. 126 cm, 49 in.
Egyptian Museum, Cairo

The resurrection of raised relief in tombs in the Theban area (288–9) was mirrored by the reappearance, probably after some delay, of this decoration in tombs in Lower Egypt, especially at Memphis and certain sites in the Delta. The tomb repertoire was limited and the representations highly stylized. The procession of offering bearers before the seated Harhotep may be based on such scenes in earlier tombs but the artist's approach is quite different. The composition is a mosaic of individual figures which are only loosely connected, allowing plenty of room between them. The bodies of the people are fuller, their thighs heavy and the breasts of women much more generous. Some of the men have well-rounded stomachs. The nakedness of some of the figures adds to the impression of an unreal world with artificially contrived situations and little attempt at reflecting contemporary reality.

Women pressing lirinon ointment, perhaps from Heliopolis

*c.*350 BC. Raised relief in limestone, h. 26 cm, 10¼ in. Louvre, Paris

The harvesting and collecting of the blooms of the white lotus (*nymphaea lotus*, waterlily) and the extraction by torsion pressing of a scented ointment, the lirinon

mentioned by Pliny, is known from several Late period tombs in the Memphite area or in the Delta. The short hieroglyphic text on the illustrated relief simply states 'pressing the white lotus'. The two women in the centre are squeezing the ointment from the lotus blooms by twisting the sticks attached to the ends of a small sack. The ointment is pouring down into a large jar on a stand. It

is tempting to see such scenes as representations which record daily life, but this would be wrong. On the contrary, they are closely connected with tomb and funerary requirements. Oils and ointments were needed in the preparation of the body for burial and featured prominently among goods deposited in the tomb. Although this kind of manual work would have been carried out by lowly

servants, the women are wearing wigs with lotus diadems and a large band suspended from them. True to the Egyptian way of seeing things, the representation shows the band in full and so may be misleading. Other reliefs indicate that the band was at least to some extent flexible rather than solid and that it probably framed the back of the wig on both sides.

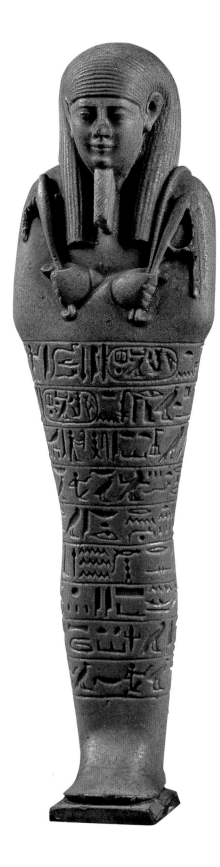

Ushebti of King Nectanebo II, location of discovery not known

*c.*342 BC. Faience, h. 24 cm, 9½ in.
Museo Egizio, Turin

Mass factory-produced works of art
became common during the first
millennium BC. These were small
figurines meant to act as deputies
should the deceased person be
ordered to take part in state-
organized projects in the realm of
the dead. Everybody, regardless
of their position in life, might have
been subject to such a command.
The statuettes were put in tombs
ready to spring into action on
hearing the name of their owner.
The concept of a proxy, a substitute
who acted on behalf of somebody
else, was very common in Egypt.
Appropriately, during the Late
period such a figurine was called an
ushebti, 'answerer' (the earlier term
was 'shabti'). A person may have
had only one ushebti or several
hundred of them. There was an
enormous variety of forms and
materials, but no attempt was
made to make the appearance of
ushebtis individual. Many of those
of the Late period were made of
faience, shaped in a mould and
with an inscription incised by hand
before firing. The Egyptian dislike
of complete repetition manifested
itself in small variations in the
choice and arrangement of
hieroglyphs. This ushebti resembles
a mummy swathed in bandages
but holds an agricultural tool in
each hand.

Cat coffin,
location of discovery not known

*c.*320 BC. Bronze, l. 52 cm, 20¼ in.
Rijksmuseum van Oudheden, Leiden

During the first millennium BC, festivals in major religious centres were attracting increasingly large numbers of pilgrims. Some of the deities were believed to manifest themselves as animals, and their temples had special places where these species were bred. The animal associated with the goddess Bastet was the cat and large catteries were attached to her temples, especially at Bubastis and Memphis. People could pay for the mummification and burial of a temple cat, and temples were keen to exploit this desire and create themselves a source of additional income. Animal coffins came in various shapes and sizes but probably the most expensive was one made of bronze in a temple workshop. It could take the form of a box with a figure of the animal on top of it. Such a coffin resembles an animal sculpture placed on a large pedestal, and there is little doubt that its creators were aware of the resemblance and consciously emphasized it. There was also a contributing factor: the standard way of showing the contents of a box was to display them on top of it.

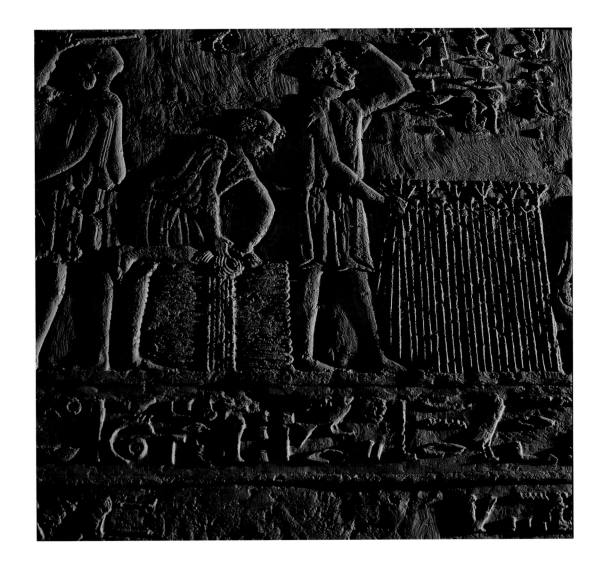

Scene showing a flax harvest, in the tomb of Pedusiri, high priest of the god Thoth, at Tuna el-Gebel

*c.*320 BC. High raised relief in limestone

Ptolemaic temples remained almost purely pharaonic, perhaps because there were also shrines for Greek deities and there was no need for the two religions to mix. The same was true, at least during the Ptolemaic period, of tombs. But there were a few exceptions, and the most notable among them is the tomb of Pedusiri at Tuna el-Gebel. It is a family tomb with a chapel which is reminiscent of a temple. Its relief decoration represents a mixture of the Egyptian and Hellenistic (Greek, but made outside Greece) styles. The Hellenistic representations are mostly in the outer part of the chapel where there are scenes showing agriculture, cattle breeding, and craftsmen at work, but also a representation of Greek sacrifice. The Egyptian style is more pronounced in the inner part where there is greater emphasis on funeral and religious scenes. Depictions of people display representational conventions which are purely Egyptian, for example the shoulder and forearm of the man binding flax in the illustration, but others are purely Hellenistic, for example people shown in full and three-quarter views. There was no attempt to modify Egyptian artistic conventions and create something completely new, but rather to use both Egyptian and Hellenistic styles.

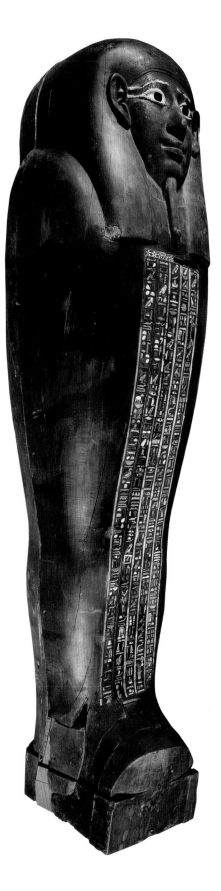

The coffin of Pedusiri, high priest of the god Thoth, from his tomb at Tuna el-Gebel

*c.*320 BC. Wood inlaid with glass,
l. 195 cm, 76¾ in.
Egyptian Museum, Cairo

The Egyptians were used to living in a very colourful environment, and strong colours did not produce the apprehension or exhilaration with which they are often greeted in modern societies. Colour played a surprisingly important part in the writing of Egyptian hieroglyphs on monuments. This was another thing which the script had in common with representations cut in relief and with statues. Practically all inscriptions were coloured, sometimes monochromatically, but often individual signs, or their parts, were painted in different colours. The colouring was not haphazard but followed well-established patterns. The decoration of Pedusiri's tomb chapel was carved in relief which is a mixture of Egyptian and Hellenistic styles (317) but his wooden anthropoid coffin is purely Egyptian. It was contained in a stone sarcophagus and the text inscribed on it was taken from the Book of the Dead. The hieroglyphs are inlaid in multicoloured glass. This is an unusual technique to use on coffins and an early indication of the advances made in the manufacture of glass inlays during the Ptolemaic period (323).

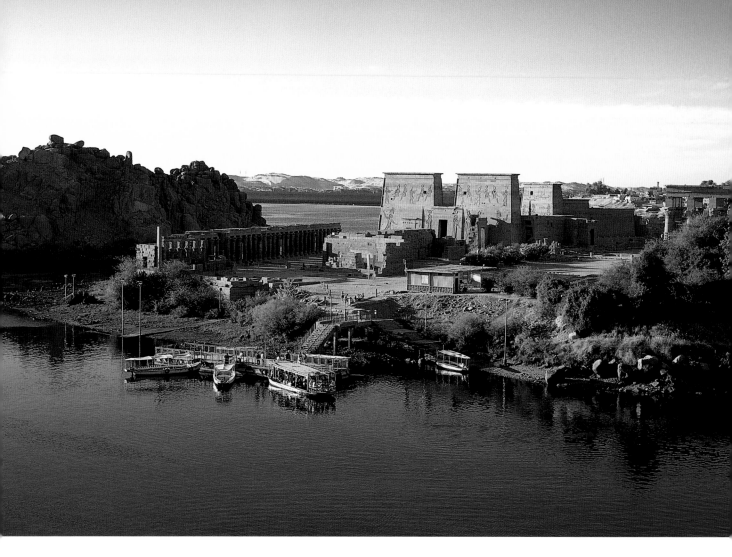

The island of Philae with the temple of Isis, and Trajan's kiosk

*c.*280 BC (the first phase of the temple of Isis) and *c.*13–12 BC. Sandstone and other materials

The relatively small island of Philae in the granite region of the first Nile cataract was once, after Karnak, the most dense complex of temples and shrines in Upper Egypt. Unlike the much earlier temples at Karnak, however, most of the buildings at Philae date to the 30th dynasty and the Ptolemaic and Roman periods. In the 1970s the main structures were dismantled and rebuilt on the island of Agilkia because otherwise they were going to be submerged in the waters of the new Aswan dam for most of the year. The largest temple, dedicated to the goddess Isis, was of the standard type with two pylons and a hypostyle. It was begun by Ptolemy II Philadelphus; other Ptolemies and Roman emperors subsequently contributed to its buildings and decoration. The approach to the temple from the south was lined with several smaller temples and chapels, including those dedicated to the Nubian deities Mandulis and Arensnuphis. A kiosk for festival processions was built to the east of the temple of Isis probably under Augustus in 13–12 BC, although the building is usually assigned to the Emperor Trajan about a hundred years later. The island was an extremely important pilgrim centre and benefited from its position between Ptolemaic Egypt and Meroitic Nubia. The temples of Philae continued to be used well into the sixth century.

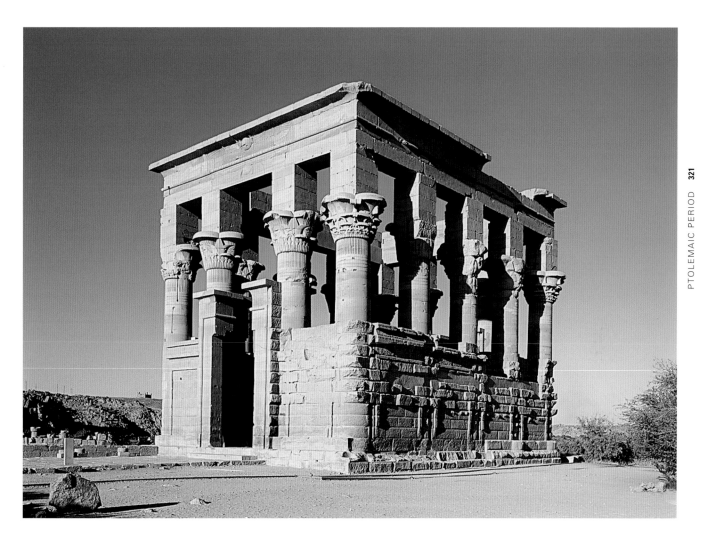

Ibis coffin,
location of discovery not known

*c.*250 BC. Wood, silver, gold,
rock crystal, w. 58.7 cm, 23 in.
Brooklyn Museum of Art, New York

During the second half of the first
millennium BC the popularity of
deities linked to animals and birds
was enormous. They were bred at
special animal farms attached to
temples and there were large
cemeteries in which their
mummified bodies were buried.
These were often in the form
of rock-cut galleries in which
small coffins or pots with animal
mummies were deposited. The
god Thoth (this is a Greek form of
the name which is in general use;
the Egyptian name was Djehuty)
was linked to the baboon and the
ibis (*Ibis religiosa*). Thoth was the
main deity worshipped at
Hermopolis Magna, now
El-Ashmunein in Middle Egypt.
He was regarded as the god of
writing, learning and medicine
and a patron deity of scribes.
Statuettes of the ibis often had a
body made of wood or cartonnage,
material resembling papier mâché,
which was manufactured by
applying successive layers of linen,
papyrus, glue and plaster. The
head and legs were of metal,
usually bronze, but silver in
the case illustrated here. Such
statuettes are, in fact, ibis coffins.
The mummified bird was inserted
through an opening on the
back of the statuette. The ibis
is represented completely
naturalistically and the details of
the head and legs are usually
made with a great deal of care.

A king,
location of discovery not known

*c.*250 BC. Glass with traces
of gilding, 13 x 6 cm, 5 x 2¹⁄₄ in.
Brooklyn Museum of Art, New York

The Ptolemaic period witnessed
considerable advances in the glass
industry and the application of
coloured glass. This inlay may
have once been an element in the
decoration of a wooden shrine. It
shows the upper part of a figure
wearing the so-called Lower
Egyptian crown (although it is
remarkable that this crown,
sometimes called the red crown, is
here shown as blue). Theoretically,
this may be either a king or a god
wearing the red crown, but the
position of the remaining right arm
suggests that the figure may have
been holding offerings or standing
in adoration in front of another
figure. So it is more likely to be a
king. The impersonally handsome
idealizing face suggests a Ptolemaic
date and so does the inlay
technique which no longer relies
on metal cells into which individual
pieces of inlay were fitted. This
figure was made in four pieces: the
crown, head, collar and body. Glass
was a much-valued material whose
standing was of semiprecious
stones. Some of the most
spectacular pieces of jewellery and
funerary equipment were inlaid
with coloured glass.

The goddess Isis,
location of discovery not known

*c.*250 BC. Plastered and painted
wood, h. 60.5 cm, 23 in.
Louvre, Paris

In Egyptian mythology, the goddess
Isis was the wife of Osiris and the
mother of Horus. When Osiris was
murdered by his brother Seth, the
goddesses Isis and Nephthys (the
wife of Seth) mourned over his
body and so became universal
figures of mourning. Wooden
statues of these two goddesses
are sometimes found in tombs of
the Ptolemaic period. The figure
shown in the illustration raises her
arms in a gesture of mourning,
perhaps throwing dust over her
head. Egyptian artists were very
inventive when they felt that it was
necessary to identify figures which
otherwise had no distinguishing
marks. Isis and Nephthys were
simply represented as women,
and in order to make them unique,
the artist used the hieroglyphic
sign with which their names
were written as though it was a
headdress: a seat (*set,* the Egyptian
form of the name was something
like Eset) for Isis, and a basket
placed on top of a plan of a building
(*nebet-hut*) for Nephthys. The
decorative frieze on the base
consists of hieroglyphic signs for
life (*ankh*) and dominion (*was*).

The god Anubis,
location of discovery not known

*c.*250 BC. Plastered and painted wood with some gilding, h. 42 cm, 16½ in. Roemer und Pelizaeus Museum, Hildesheim

Anubis, one of the most ancient deities associated with the necropolis and mummification, manifested himself as a jackal or a jackal-headed man. He was also one of the earliest gods shown, in the form of a jackal, in non-royal tombs. The iconography of semi-zoomorphic representations is not much different from that of people or fully anthropomorphic images of other gods. Such representations are purely artistic and their religious significance does not differ from fully zoomorphic images. The jackal head is almost like a mask and the transition from it to a human body is effected smoothly by means of the lappets of a tripartite wig falling down on the god's chest. In the Ptolemaic period figures of Anubis and the goddesses Isis (324) and Nephthys were included among funerary goods: Anubis as the god responsible for the mummification of the body, Isis and Nephthys as the chief mourners. The motif on the base of the statuette illustrated here probably derives from the appearance of a series of niches ('palace façade') and had been associated with the exterior of tombs since the early part of Egyptian history. It was also used as a dado (the bottom part of walls) in tombs (see 260).

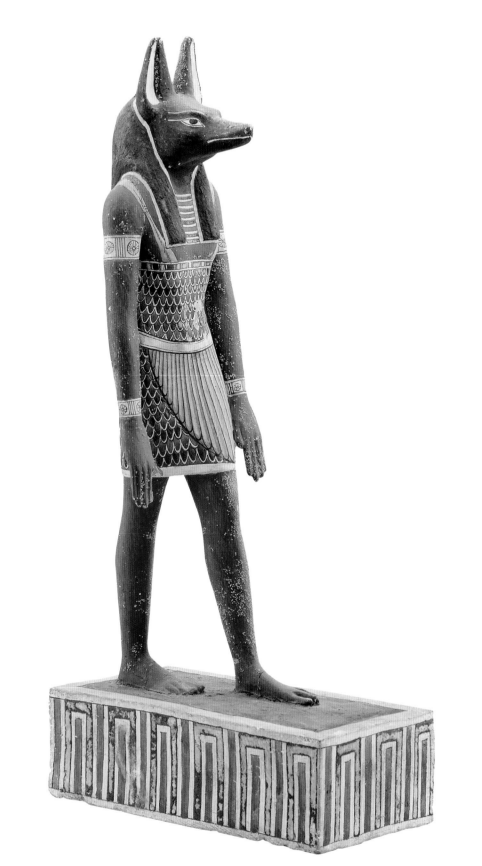

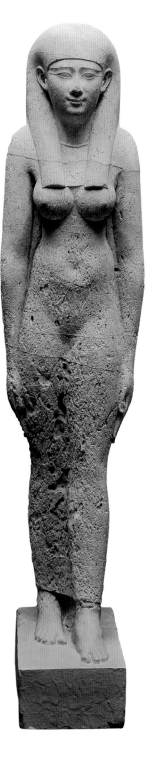

A Ptolemaic woman, location of discovery not known

*c.*250 BC. Limestone, h. 78.3 cm, 30 in.
Musées Royaux d'Art et d'Histoire,
Brussels

Although there is no inscription to help date it, there can be no doubt that this is a Ptolemaic sculpture. The number of Ptolemaic statues of women was incomparably smaller than that of men. The variety of types was therefore severely restricted but it still comes as a surprise that while the Ptolemaic period saw a very strong tendency towards naturalism in statues of men, it seems that the majority of sculptures of women were idealizing. We do not know who this lady was but there is nothing to suggest that she was of a particularly elevated status. Her features could be ticked off on a checklist of typical characteristics of Ptolemaic female statues: 1. The front lappets of her tripartite wig are so long that they touch her breasts (it is unlikely that such a wig would have been actually worn and this is probably just an artistic device). 2. There is a hint of a smile on her youthful and contented face. 3. Her body is modelled with sensitivity and care and only the hem of her ankle long garment makes it clear that she is not nude. 4. She has an almost plump figure, with heavy breasts and thighs and strong legs. 5. Her arms are hanging down alongside her body, with her hands pressed against her thighs.

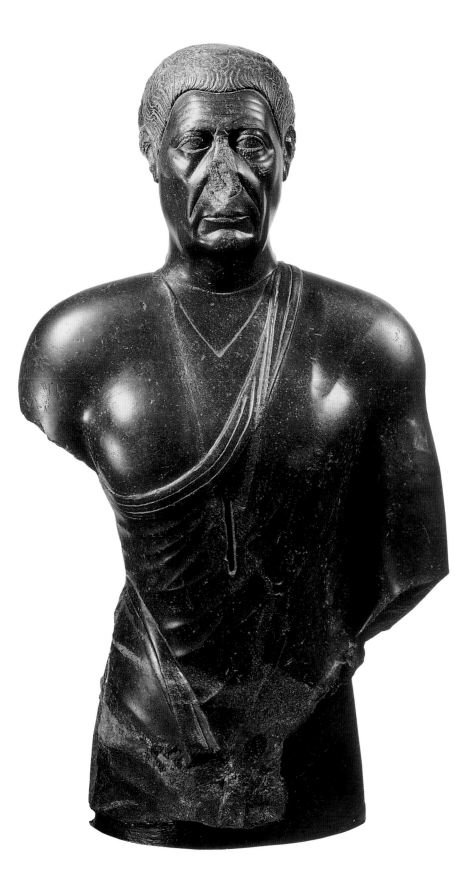

Hor, commander-in-chief in Lower Egypt, probably from Sa el-Hagar (Sais)

*c.*250 BC. Granite, h. 113 cm, 44½ in. Ägyptisches Museum, Berlin

The Egyptian identity of the man shown in the statue illustrated here is established by the inscription on its back pillar. Even a cursory glance shows that it dates to the Ptolemaic period, possibly even a little later, but the precise time when Hor lived is disputed. There is also an argument about how much of the statue is purely Egyptian and how much of it may be owed to Greek or Roman influences. The two characteristics which make the statue different from most traditional Egyptian statues are the man's short hair and his clothes: a shirt, V-neck tunic, and a large shawl (or 'cloak'), probably worn with a long skirt. They are often described as Hellenistic (Greek) but it has been convincingly argued that all these characteristics are Egyptian in origin. If this is accepted, then they are simply contemporary with the sculpture. But even if they are signs of non-Egyptian fashion in hairstyle and clothing reflected, in a stylized way, in an Egyptian work of art, this does not amount to foreign artistic influence and need not have any bearing on the main aspect of the statue, its face. This is rendered naturalistically, with a heavily wrinkled forehead and deeply furrowed cheeks, and this fits well with statues made in the Egyptian naturalistic style of the Ptolemaic period.

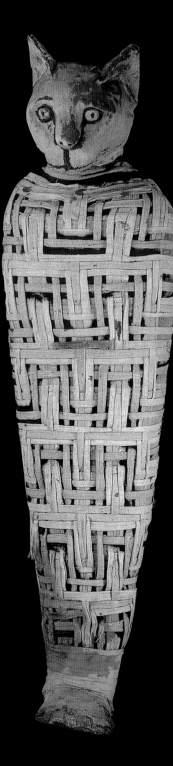

Cat mummy, from Abydos

*c.*200 BC. Linen, h. 45.7 cm, 18 in. British Museum, London

The cat was regarded as the animal of the goddess Bastet and enjoyed enormous popularity during the first millennium BC, especially in the Ptolemaic period. Temples of the goddess in various parts of the country had catteries in which cats were bred in large numbers. When the animals died, their bodies were mummified in a fairly simple way and buried in communal catacombs. Religious festivals attracted large numbers of pilgrims, and one of the ways in which they were able to express their piety on these occasions was by paying for the mummification of a deceased temple cat. Cat mummies, in themselves rather pathetic, are often rendered cheerfully attractive, with a geometric design formed by the bandages used for the wrapping of the mummies. The head of the animal is usually the only part treated separately, either shaped out of linen or covered by a mask made of wood or bronze. One of the reasons for the laborious design may have been that the person paying for the cat's mummification was probably shown the finished product for approval.

Decree of year 9 of Ptolemy V Epiphanes, from El-Rashid (Rosetta)

196 BC. Granite, 118 x 77 cm, 46 ½ x 30 in. British Museum, London

The hieroglyphic script is one of the things most closely associated in our minds with the image of ancient Egypt. It was very versatile in the way it could be written and, apart from writing in vertical columns beginning at the bottom, all directions were possible. But unless other demands had to be complied with, the main direction was starting on the right and proceeding leftwards. Human figures, animals and birds faced right, towards the beginning of the text. This was the same as the principal direction in Egyptian two-dimensional representations in general and was probably caused by the simple fact that most people are right-handed and would start drawing the face of a person first and then work to the left so that they would not obscure the drawing with their body. The slab of stone illustrated here is a decree establishing the cult of Ptolemy V Epiphanes and is written in two languages, Egyptian and Greek, and in three scripts, Egyptian hieroglyphs (top), the demotic Egyptian script (used from about mid-seventh century BC,) and the Greek script. This monument, known as the Rosetta Stone, played a crucial part in the decipherment of the hieroglyphic script by Jean-François Champollion in 1822.

Ptolemy V Epiphanes offering a field to the Buchis bull, from Hermonthis (Armant)

180 BC. Painted and gilded raised relief in limestone, h. 72 cm, 28 in. Egyptian Museum, Cairo

Many Egyptian gods were believed to manifest themselves in the form of the bull. There were several important bull cults in Upper (southern) Egypt. The Buchis bull was associated with the god Montu of Hermonthis (Armant), south of Thebes. Only one animal was kept in the temple at Armant at a time and regarded as the living form of the god. The bull was carefully selected and when it died its funeral was a great religious occasion. The king himself was involved in the funeral and often had a stela, a slab of stone inscribed and decorated in honour of the deceased bull, erected in the temple precinct or its tomb. The stela of Ptolemy V Epiphanes was made on the occasion of the death of the Buchis bull in the king's 25th regnal year. It records the bull's birth in the king's 11th year. The king stands in front of the Buchis bull and offers a hieroglyphic sign for a 'field'. This indicates that he made a donation of land for the upkeep of the bull's funerary cult. The scene shows the king in the presence of a deity and so it was necessary to make sure that the decorum required for such scenes was maintained and that the bull was the dominating figure. The artist solved this by placing the bull on a large pedestal, a method commonly employed in such situations.

The goddess Isis or a Ptolemaic queen, location of discovery not known

c.150 BC. Raised relief in limestone, with details drawn in red paint, h. 10.3 cm, 4 in. Ashmolean Museum, Oxford

One might think that all major problems in Egyptian art history have been resolved and that scholars are now only concerned with details. Far from it. There is a whole category of works of art which are crying out for a thorough investigation. These are the so-called sculptors's trial pieces or models, such as the one illustrated here. They may be three-dimensional sculptures, usually royal busts, or two-dimensional plaques with a royal head, or the head of a goddess or a queen (it is difficult to distinguish between them) cut in fine relief. Others may have representations of other deities, animals or large individual hieroglyphs. The decoration may be on both sides of the plaque. These objects are sometimes explained as sculptor's trial pieces or as items used in the training of new sculptors, especially since many display admittedly rather crude grids. But why are so many of them Ptolemaic and why do so few date from earlier periods? Was there a substantial change in the working practices of sculptors or in their training? And the subjects are limited and repetitive; for what reason? It has been suggested that these are votive items, presented in the shrine of a deity. This is supported by the inscriptions on some of them.

The outer hypostyle of the temple of Horus at Edfu

140-124 BC. Sandstone

The temple of the god Horus at Edfu was begun in 237 BC, under Ptolemy III Euergetes I, and was completed in 71 BC during the reign of Ptolemy XII Neos Dionysos. It was built in several stages but the final result is remarkably homogeneous. The inner part, which was built first, was a complete temple in its own right. It consists of a hypostyle hall, two vestibules and a shrine for the sacred barque of the god, all surrounded by smaller chapels. Most Egyptian temples were of a modular design in which all dimensions were derived from an initial unit, usually the barque shrine. The two major enlargements of the Edfu temple were typical. In the first, another hypostyle hall (shown in the illustration), was added in front of the existing hypostyle. It has twelve huge columns with capitals in the form of papyrus umbels. The columns are decorated with representations of Ptolemy VIII Euergetes II offering to the gods. One of the interpretations of a temple was to see it as a place of creation. This was thought to have taken place in a dense primeval marsh, and the columns of hypostyle halls which preceded the sanctuary were seen as monumental stalks of rushes which were part of the setting. In the second enlargement, a peristyle court and a pylon were added in front of the whole structure.

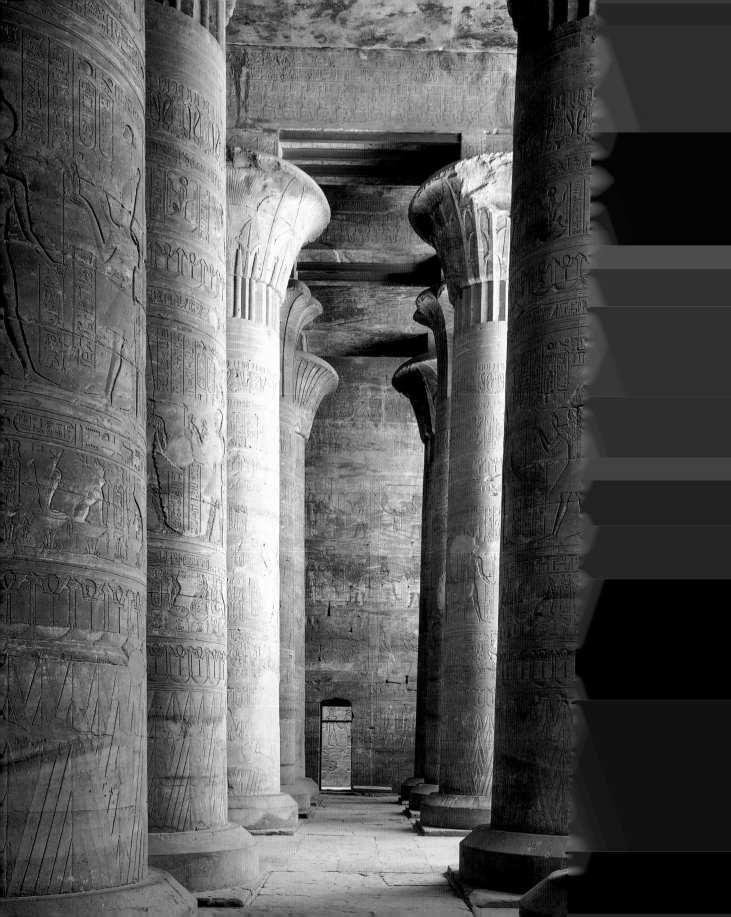

Ptolemy VIII Euergetes II crowned by the goddesses Wadjit and Nekhbet, in the temple of Horus at Edfu

*c.*120 BC. Deep sunk relief

The rulers of the Ptolemaic dynasty were not Egyptians but descendants of Ptolemy, one of the generals of Alexander the Great, who declared himself a king as Ptolemy I Soter, in 304 BC. But on the walls of Egyptian temples the Ptolemies were represented as Egyptian pharaohs. In the scene illustrated here, Ptolemy VIII Euergetes II Physcon is crowned by the two protective goddesses Nekhbet (on the right) and Wadjit. Nekhbet was a goddess of the city of Nekheb (modern El-Kab) in southern Egypt, while Wadjit was associated with the city of Buto (modern Tell el-Farain) in the Delta. These goddesses are often present as a vulture (Nekhbet) and a cobra (Wadjit) on the king's forehead. Nekhbet wears the so-called Upper Egyptian (or white) crown, Wadjit has the Lower Egyptian (or red) crown. Egyptian kings wore a crown which combined both. The goddesses are shown with fairly slim bodies but ample breasts, a characteristic of Ptolemaic representations of women. Their shoulders, in comparison with those of the king, are much narrower, almost as if they are being shown in a three-quarter view. Their arms are unnaturally long so that Nekhbet's hand can be seen behind the king's neck and Wadjit's hand can rest on his left shoulder.

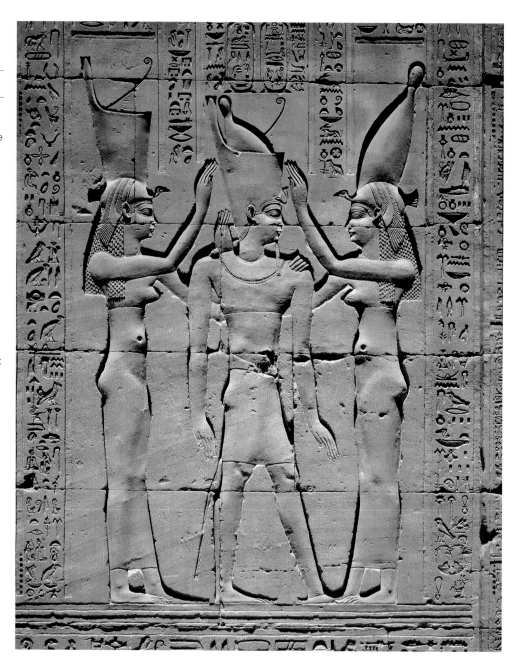

The god Bes, from the temple of the goddess Hathor at Dendera

*c.*120 BC. Very high relief in limestone.

This relief was one of several which formed rectangular pillars in the birth house of the temple of the goddess Hathor at Dendera. A birth house was a special type of small temple built in the Late, Ptolemaic and Roman periods. It was attached to temples of major deities and the god was thought to have been born there or, as at Dendera, the goddess Hathor gave birth there. There are two birth houses at Dendera and the relief comes from the earlier one, built by Nectanebo I and enlarged during the Ptolemaic period. The demigod Bes was regarded as a protector of pregnant women and children and this explains his presence in a birth house (see also 165). A lolling tongue, mane and tail are his standard characteristics. He is shown in full view which is the hallmark of his representations. The iconography of the main gods and goddesses was established early and was not much different from that of human figures in temples and tombs. But representations of the less common deities or those which, like Bes, entered the temple repertoire relatively late were often rather unorthodox. This 'full frontal' representation is an unusual aspect.

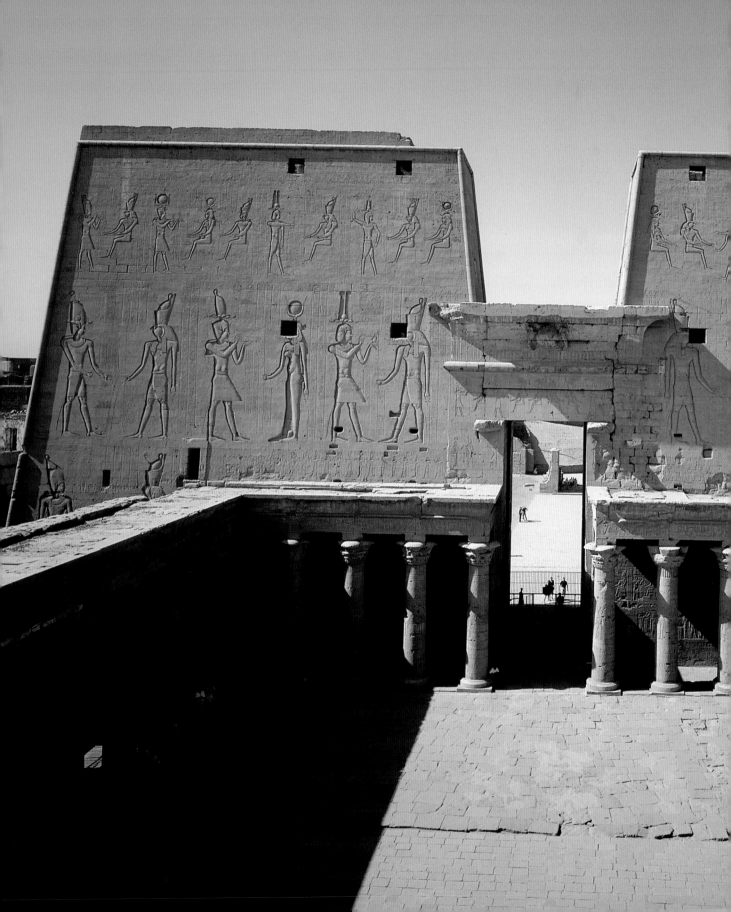

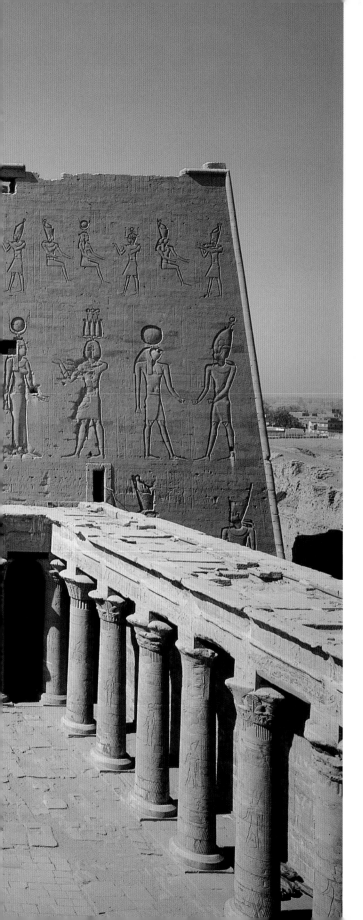

The pylon and open court of the temple of Horus at Edfu

116–71 BC. Sandstone,
h. of pylon 36 m, 118 ft

Egyptian temples were the domiciles of gods, precincts of perfect order and sober tranquillity which contrasted starkly with the less stable and potentially chaotic conditions in the world outside. There was no attempt to make a gradual architectural transition between the two spaces. A massive wall, called a pylon by Egyptologists, protects the front of the temple and contains an entrance gate. On the inner face of the pylon, seen in the illustration, the pharaoh (at Edfu mainly Ptolemy XII Neos Dionysos) is shown making offerings to gods. An open court behind the pylon, often surrounded by rows of columns forming a covered corridor around its perimeter, was as far as ordinary people may have been allowed. Egyptian temples were not places where believers would have gathered in order to have their faith re-affirmed. In theory, only the king communed there with the gods, although in practice such duties were carried out on his behalf by priests. The gap between the 'official' religion of large temples and the beliefs of ordinary people was huge. There were points where the two successfully met, for instance during religious festivals when the temple image was brought out of the temple and carried in procession, but most of the abstract concepts expressed in the temples' reliefs would probably have been incomprehensible to the majority of the Egyptian population.

A queen,
location of discovery not known

*c.*100 BC. Silver with gilding,
h. 24.5 cm, 9 in.
Brooklyn Museum of Art, New York

This idealizing depiction of this
woman's face, her tripartite wig
with long front lappets (only one is
shown), and her ample body with
a buxom bosom (again only one
breast is visible) place her firmly
in the Ptolemaic period. Her
headdress has suffered some
damage but it was, unmistakably, in
the form of a vulture (see 331, 334)
and so characteristic of a queen or
a goddess. She wears a sleeveless
garment with straps and a broad
collar and bracelets high on her
arms and above her wrists. But
the most interesting feature of
her attire is another bird, almost
certainly again a vulture, enfolding
the lower part of her body in its
spread wings (the tail feathers are
visible on her thigh). The figure is
in relief with incised details.
The queen's legs are now lost
approximately from her knees
down. The whole figure was
unusually large if, as we assume,
it was used as an inlay, perhaps
on a wooden shrine.

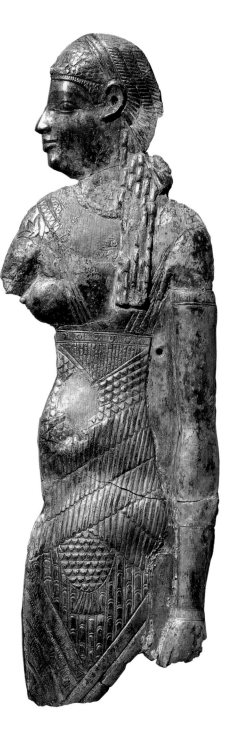

A youth,
said to come from Alexandria

*c.*100 BC. Greywacke, h. 24.5 cm, 9 in.
British Museum, London

Artistically, the Ptolemaic period
was vibrant. Sculptures which were
purely Egyptian in their style were
produced alongside others which
were made in the Greek tradition.
Many Egyptian statues were
idealizing while others were
naturalistic. The prevailing view is
that naturalistic statues were not
real portraits, in other words they
were types but not representations
of specific individuals. We can be
reasonably sure that this was true
of Egyptian statues made in the
earlier periods, during pharaonic
Egypt (although a qualification may
have to be added to this for some
royal statues), but the diversity
of faces of Ptolemaic naturalistic
statues is such that a revised
explanation may be needed. There
can be little doubt that there must
have been some interaction
between Egyptian statues and
those made in the Hellenistic
(Greek) style and that some must
contain the features of both. The
effeminate face of the youth in this
statue could be claimed by either
of the two traditions or could be
a mixture of both. The contrast
between the polished face and the
unpolished hair can be found on
many Egyptian statues.

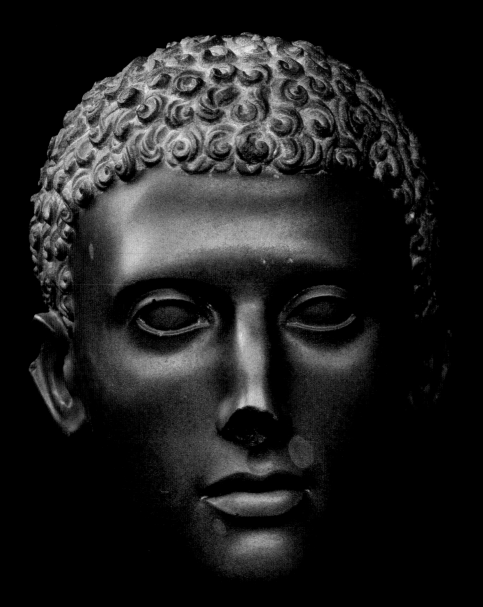

Mormyrus fish,
location of discovery not known

*c.*100 BC. Faience.
National Maritime Museum, Haifa

Oxyrhynchus, now El-Bahnasa, in Middle Egypt was an important city during the Ptolemaic and Roman periods. Strabo reports that it contained a sanctuary of the local deity, who was worshipped in the form of the Mormyrus fish. The fish has a pointed head and a high back and representations of it, in bronze and faience, were made, presumably as votive offerings for the shrine. Artistically, it is interesting to see that even such an apparently incongruous combination as a fish with a solar disc placed inside the horns of a cow, in order to indicate the deity's connection with the sun god, was found acceptable. A disregard for 'natural' proportions in representations was one of the characteristics of Egyptian art.

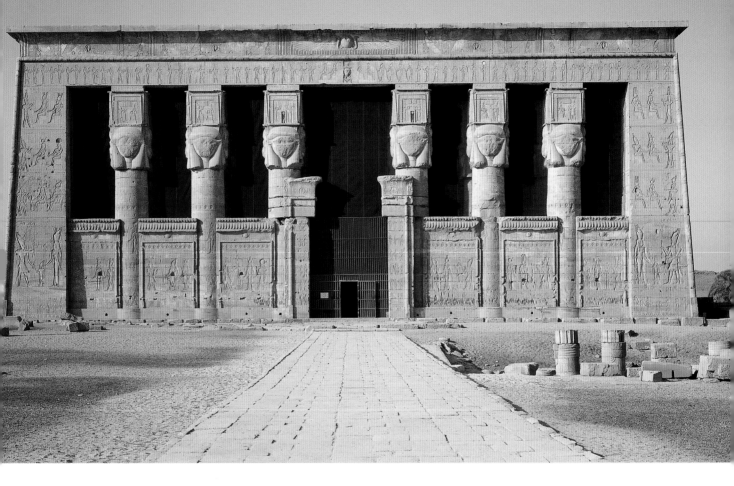

The temple of Hathor at Dendera

*c.*54 BC–60 AD. Sandstone

While there was a generally accepted standard plan and orientation for a temple, Egyptian architects were prepared to be remarkably inventive and flexible when conditions made achieving the ideal impossible. Sometimes the whole shape of the structure

was affected (the temple of Sety I at Abydos, the funerary temple of Ramesses II at Thebes), at other times it was the orientation of the temple or one of its elements (the transverse axis of the Karnak temple, the pylon of the temple of Ramesses II at Memphis). The astronomical orientation of a temple on the cardinal points which was established during the foundation ceremonies may prove

to be a remarkably accurate dating criterion. It reflects the astronomical situation at that time and so it should be possible to calculate its date with precision. This is not a problem in the temples of the Ptolemaic and Roman periods but the further back in history we go, the more useful such a method might prove. The river orientation, making access to the temple from the direction of

the Nile, is just as important as the astronomical orientation. Since the river almost always flows from the south to the north, the approach to Egyptian temples tends to be from the east or west. The temple of Hathor at Dendera is situated in the area where the Nile makes a wide bend and flows from east to west, and so is one of the exceptions where the access is from 'river east' but astronomical north.

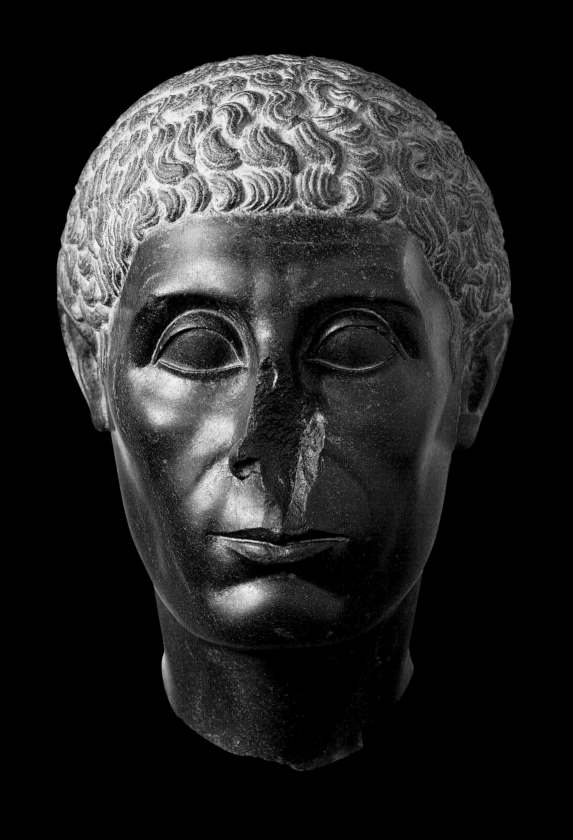

Head of a man, location of discovery not known, possibly Memphis

*c.*50 BC. Diorite, h. 41.4 cm, 16¹₄ in.
Brooklyn Museum of Art, New York

Statues made for tombs became
quite rare (see 296) during the first
millennium BC, and certain types,
especially the seated variety, were
almost non-existent. The temple
setting encouraged the tendency
towards larger, sometimes over-
life-size statues. The large head
illustrated here is known as the
'Brooklyn Black Head'. It comes
from a creation in the Egyptian
sculptural tradition, as shown by
the remains of a trapezoidal back
pillar. The man's curly hair, not seen
on pharaonic sculptures, suggests
a Ptolemaic date if not Hellenistic
influence. An Egyptian sculptor
creating in a purely Egyptian
tradition in a naturalistic style
(one which tries to show people
'as they are', without necessarily
attempting a portrait) would have
taken account of contemporary
hairstyles but this need not amount
to a Hellenistic artistic influence.
There are, however, several other
features in the face of the man
which suggest that the maker was
aware of Hellenistic sculptures,
especially the statue's wide eyes.
If this is not a contradictory way of
describing it, the face is naturalistic
but without blemishes such as
wrinkles, so it is at least to some
extent also idealizing. Egyptians
artistic styles do not always fit
into the neat categories of
art historians.

The Book of Breathing of Usiriwer, priest of Amun, location of discovery not known

*c.*50 BC. Detail of papyrus scroll, h. 30 cm, 11¾ in. Louvre, Paris

This papyrus contains one of the last of the 'books of the afterlife', texts which were thought to be helpful to the deceased person in the afterlife. It is known as the 'Book of Breathing' and is concerned with the deceased's continued existence and their sensory perception, i.e. breathing, seeing, hearing, etc. It also deals with other matters which are essential for the afterlife such as a successful outcome of the judgement process illustrated in one of the vignettes shown here. The weighing of a person's heart is often represented in tombs and on various items of funerary equipment from about 1500 BC onwards, but there it is a vignette from the Book of the Dead. Egyptian artists were able to convert even some of the most abstract ideas into a visual form. As beliefs concerning life after death became more complex they also became more conditional and exclusive. In order to be admitted into the kingdom of the dead, the deceased person made a declaration in which he denied any wrongdoing during his lifetime. This was then verified by a tribunal of judges. The heart, symbolizing the statement concerning the person's conduct, was weighed against a feather symbolizing the truth. The result is recorded by the ibis-headed god Thoth. The god presiding over the procedure was usually Osiris, here accompanied by the goddess Isis. In the second vignette, Usiriwer burns incense before Hathor as a cow.

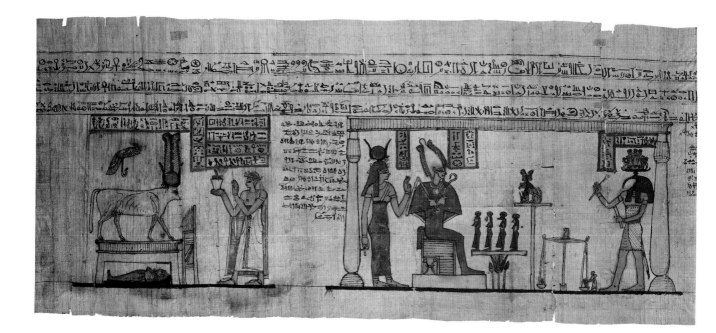

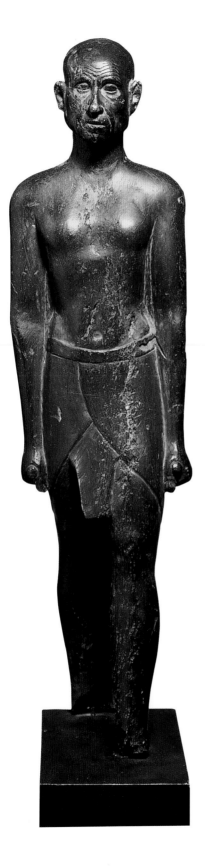

A worried man, location of discovery not known

*c.*50 BC. Basalt, h. 49.3 cm, 19 in.
Ägyptisches Museum, Berlin

The person whose statue is illustrated here may not be a particularly handsome male but the sculpture is quite remarkable. At first sight it looks as though it consists of two ill-fitting parts. From the neck down it seems to be a standard idealizing and archaizing sculpture, with the short old-fashioned kilt being the man's only garment. But on closer examination the body does not appear to be so youthful and vigorous as one might expect. The amount of modelling indicating musculature is limited and there is one unusual thing about the man's anatomy: the chest is not that of a young and vigorous man but it rather conveys the impression of being soft and flabby. The breasts are modelled separately, almost as though they belonged to a woman. The head is remarkable for its naturalistic approach, with a deeply lined forehead and conspicuously obvious folds on the sides of the nose and the mouth. The right corner of the mouth is slightly lifted. All this gives the man a rather plodding, worn out and worried look. One might be tempted to overinterpret this sculpture but the unusual treatment of the body may have been intentional in order to age it and so make it more compatible with the face.

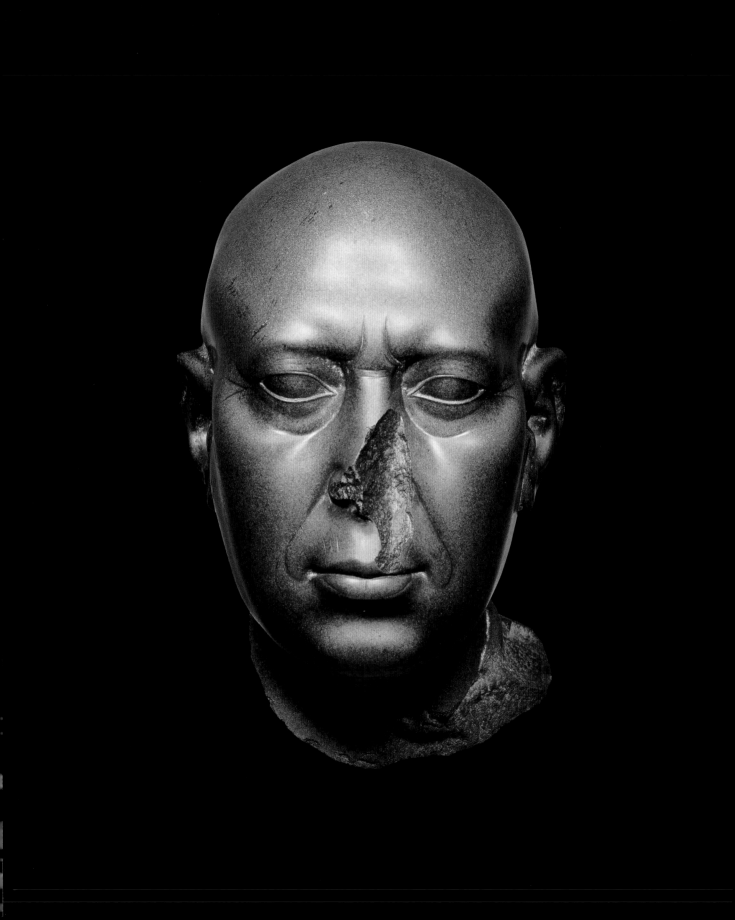

A bald man, location of discovery not known

*c.*50 BC. Greywacke, h. 21.5 cm, 8½ in.
Ägyptisches Museum, Berlin

The 'Berlin Green Head' is one of the masterpieces of late Egyptian sculpture, although the question of its date has not yet been resolved to everybody's satisfaction. The face is that of a well-fed man. It shows signs of ageing but, apart from the discreet wrinkles at the top of the nose and on the forehead above it and the puckering of the upper lip, the skin is still smooth, a quality further emphasized by the expanse of the bald head. The eye sockets are delineated by pronounced eyebrow ridges and sharply incised furrows which continue from them in a circular fashion along the nose and below the eye. There are delicately marked crow's feet near the outer corners of the eyes. Deep furrows lead from the nostrils to the corners of the mouth. Curving outwards, they reach below the level of the lips but then swing upwards and join the corners of the mouth. The lower lip is heavy. This is a completely realistic and anatomically faithful representation of a male type and nothing in it is a purely artistic device. One can meet a man looking like this in the streets of Cairo on any day. If this statue was influenced by non-Egyptian sculptures – and in spite of the date suggested here one may think of Roman rather than Greek portraits – the influence was very skilfully absorbed into the Egyptian sculptural tradition.

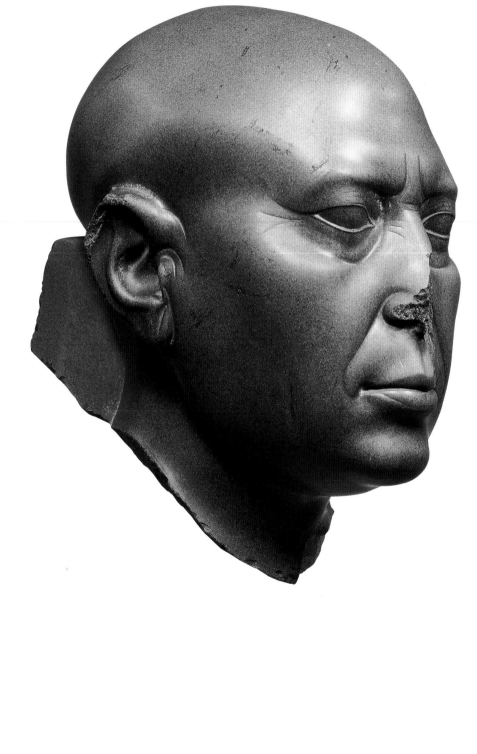

Bound prisoners on the foot end of a coffin, location of discovery not known

*c.*50 BC. Cartonnage, h. 30 cm, 11³⁄₄ in. Museo Egizio, Turin

This pair of bound prisoners is painted on the foot end of a coffin made of cartonnage. It was a material comparable to papier mâché, consisting mainly of papyrus, linen and gesso (powdered limestone mixed with glue), which was sometimes used for the making of anthropoid coffins during the first millennium BC. This was the coffin of an ordinary Egyptian but the scene derives from the traditional concept of enemies being 'under the king's sandals', i.e. being subjugated, humiliated and trampled on. The two bound men are meant to represent two different racial types, an Asiatic and a Negro, and their figures are painted against the background of two sandals, i.e. the feet of the person in the coffin. During the Ptolemaic and Roman periods a substantial reinterpretation of the original idea took place in order to make it valid for ordinary people. The likeliest explanation is that the image became linked to the concept of triumph over enemies whom the sun god had to overcome during his journey through the underworld in order to reappear the following morning. Ordinary people wished to participate in this process in order to ensure their own rebirth in the afterlife.

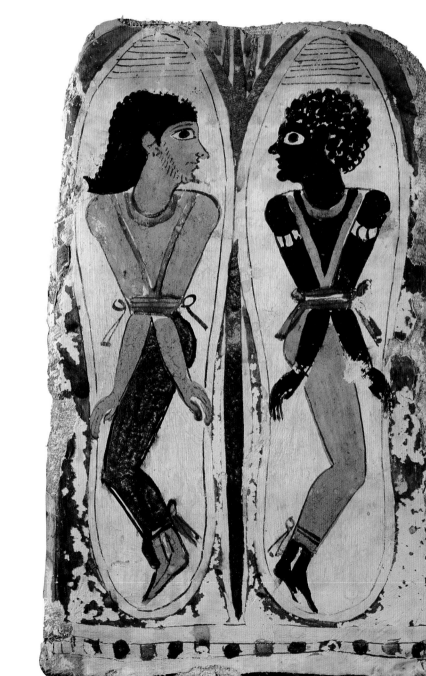

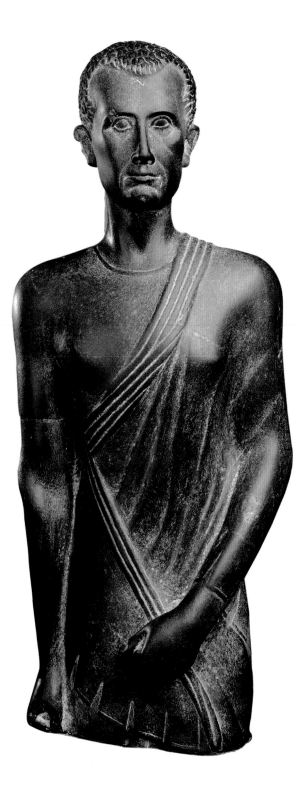

Horsahor, from Alexandria

*c.*25 BC. Basalt, h. 83 cm, 32³₄ in. Egyptian Museum, Cairo

This statue has a back pillar, an infallible sign of Egyptian sculptural tradition, and in the scene near its summit Horsahor is kneeling before the ibis-headed god Thoth. He was, therefore, an Egyptian faithful to the religion of his country. Yet the reaction of those who are not familiar with the statues made in Egypt during the Ptolemaic period and in the early years of the Roman occupation is predictable. 'Oh no, this is not what I think of as an Egyptian statue!' The features which provoke such a negative reaction are, first and foremost, the clothes. These may be Egyptian or may have been introduced from abroad, but if the latter is the case, then the statue simply faithfully reflects the current fashion. Then it is the hair, which is short and receding to form a distinctive widow's peak. But even this need not be more than a naturalistic depiction of a commonly seen hairstyle. Then the face, which is lean, long and narrow, with bags under the eyes and a horizontal furrow on the chin. But some Egyptian sculptures of the Ptolemaic and immediately following periods were profoundly naturalistic, perhaps close to being portraits, and would have recorded a man's appearance quite faithfully. There is no reason to doubt that Horsahor's statue is fundamentally Egyptian.

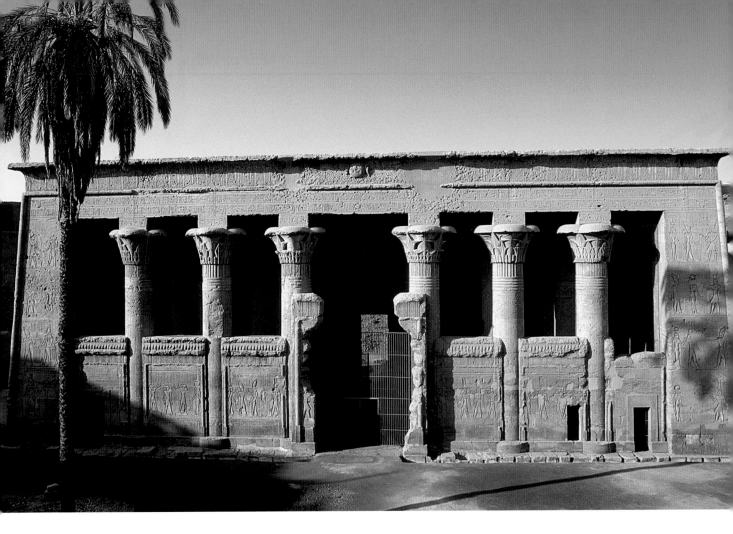

The temple of the god Khnum at Esna

41–251 AD (the visible remains).
Sandstone, w. of the façade 40 m,
125 ft, h. 17 m, 53 ft

Two centuries of excavations have changed the appearance of many sites beyond recognition. Anybody interested in art history must be aware of the fact that many monuments have changed significantly. Many of them have deteriorated, others have been restored although not always correctly. The present ground level at most archaeological sites is considerably lower than it used to be before excavations began. At Esna the visible remains of the temple dedicated to the god Khnum, the goddesses Neith and Satis, and several other deities, are some nine metres (28 feet) below the level of the modern town, which stands on a massive layer of accumulated debris. The temple was of the standard type but the only part which is fully exposed is a hypostyle hall (see 353). Its façade is formed by six columns with spectacular capitals and connected by intercolumnar walls which reach to about a half of their height. There are eighteen columns inside the hypostyle. It was built by several Roman Emperors starting with Claudius in the first century AD and ending with Decius in the third century, and this makes it the latest substantial temple structure still preserved in Egypt. The temple was enlarged in the usual way and the façade of the inner part of the temple is earlier, dated to Ptolemy VI Philometor and VII Neos Philopator.

Mummy mask,
location of discovery not known

*c.*50 AD. Gilded and painted
cartonnage, h. 44 cm, 17 in.
British Museum, London

Placing a mask over the head and
shoulders of mummified bodies
was one of the longest-lasting
funerary customs of ancient Egypt.
Masks of the Ptolemaic and Roman
periods were made of cartonnage,
(see 348) Many of them were
gilded. They were mass-produced
objects with no pretence at any
similarity to the deceased person.
They developed their own
representational conventions,
as demonstrated by the mask
illustrated here with its extra-
ordinary depiction of the lips and
chin. The continued practice of
ancient Egyptian funerary beliefs is
particularly obvious on the back of
the mask where it is not gilded.
The four sons of Horus who were
identified with the mummified
internal organs (although these
were no longer removed during the
preparation of the body for burial)
are painted there, together with a
human-headed bird symbolizing the
ba ('personality') – a protective
hawk with outstretched wings
(representing Horus as the
protector of his father Osiris) – and
hieroglyphs of doubtful meaning.
There is a winged scarab, a symbol
of resurrection, on the crown of
the head of this mask.

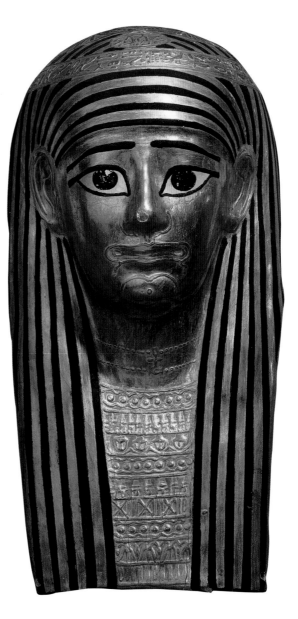

Coffin,
location of discovery not known

75 AD. Plastered and painted wood, l. 152 cm, 59 in. Ägyptisches Museum, Berlin

These scenes belong to the traditional ancient Egyptian funerary repertoire but the coffin on which they are painted is unusual, with curious echoes of funerary customs nearly 3,000 years old. Its concave cornice is a feature which was occasionally used in the third millennium BC, and there are parallels for the arrangement which allows the narrow side at its head end to be pushed up. Here, however, it may have been intended to provide access for relatives to the anthropoid inner coffin which it contains. The scene shows a woman, supported by the goddess Maet, displaying her pleasure at the successful outcome of the main part of the judgement procedure, the weighing of her heart, which will enable her to enter the realm of the dead. The god who presides over the ceremony is the hawk-headed Re-Harakhty (see also 344). The painting is authoritatively competent and there is little doubt that the artist understood the implications of what he was painting. Our imperfect knowledge of the remarkable art of Egypt during the Roman occupation is one of the main deficiencies of Egyptian art history at present.

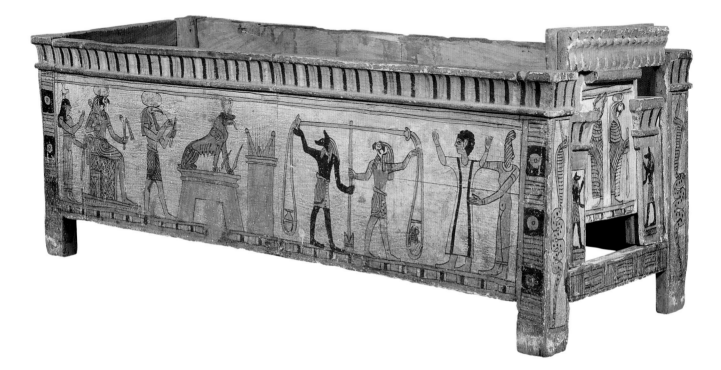

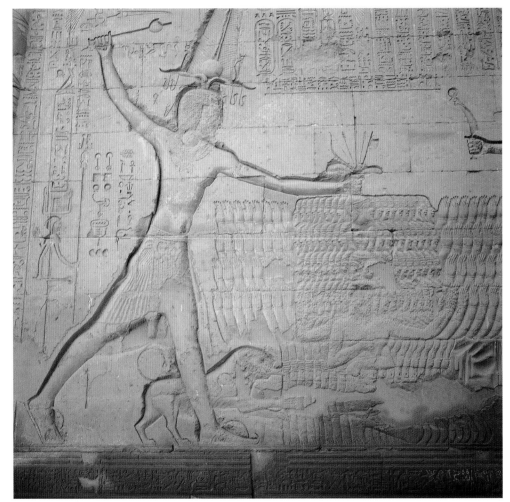

The Emperor Trajan, followed by his ka ('life energy'), smiting enemies, in the temple of the god Khnum at Esna

*c.*115 AD. Sunk relief in sandstone

The rule of the last Egyptian pharaoh, Nectanebo II, came to an end in 342 BC under the onslaught of the Persians. In 332 BC Alexander the Great conquered Egypt and his successors, the Ptolemies, ruled over Egypt until the last of them, Queen Cleopatra VII, committed suicide in 30 BC and Egypt became a province of the Roman Empire. Although foreigners were at the helm of the country, Egyptian temples continued to be built: the priesthood had to be pacified, and rulers of foreign extraction were keen to be seen as continuing in the footsteps of the pharaohs. Paradoxically, the best-preserved Egyptian temples date from the Ptolemaic and Roman periods. They are the most recent erected and so they did not suffer from later building activities. Furthermore, Upper Egypt where most of the surviving temples are situated saw relatively little Islamic building activity and so they, unlike their counterparts in the Delta and the Memphite area, were not pulled down and reused in medieval buildings. Ptolemaic rulers and Roman emperors, including some who never set foot in Egypt, had themselves represented as pharaohs (see 142–3). In the scene illustrated here, the Emperor Trajan smites enemies on the northern exterior wall of the hypostyle hall at Esna.

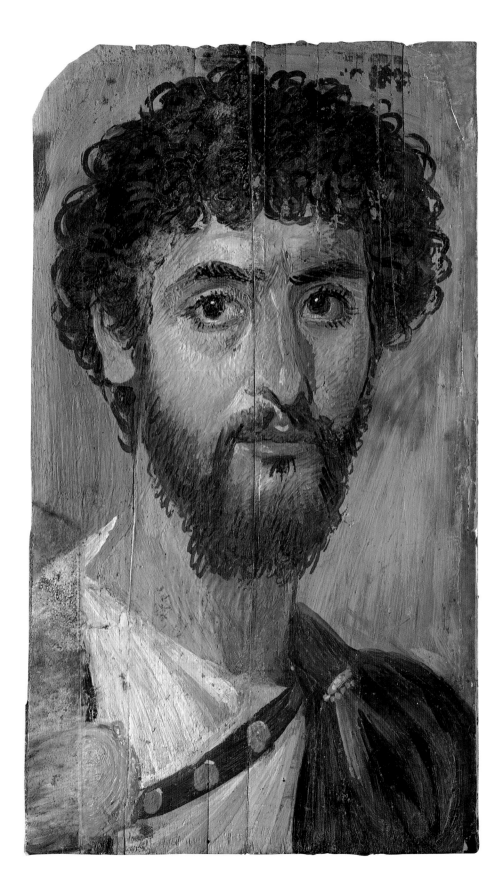

Bearded soldier, probably from Philadelphia (El-Rubaiyat) in the Faiyum

*c.*165 AD. Encaustic on wood,
h. 40 cm, 15³⁄₄ in.
Myers Museum of Egyptian and
Classical Art, Eton College, Windsor

In Roman Egypt, it was customary
to attach a painted portrait of the
deceased person over the head of
the body wrapped up in bandages.
These paintings were created by
artists working in the Greek artistic
style, and the encaustic (painting
in wax) technique used was not
known in ancient Egypt. They
represent Egypt's new art, which
sometimes drew on an earlier
pharaonic tradition but was
mostly inspired by the arts which
originated outside the country. The
paintings are known as 'Faiyum
portraits', after the area where
many were initially found, but their
distribution is much wider. There
is little doubt that they were real
portraits. Most of them date to the
first two centuries of our era and
some seem to be even later. Some
ancient Egyptian funerary customs
survived longer than the art forms
in which they were originally
expressed. In pharaonic Egypt,
attempts were always made to
preserve the person's face so
that after their death the *ba*
('personality') was able to
recognize the body to which it
belonged, and the Faiyum portraits
paralleled this ancient Egyptian
tradition. That the man in the
painting illustrated here was a
soldier is indicated by the sword-
belt hung across his shoulder.

Funerary shroud,
location of discovery not known

*c.*180 AD. Painted linen,
185 x 130 cm, 72 x 51 in.
Ägyptisches Museum, Berlin

The scenes on this funerary
shroud convey the traditional ideas
about death and the afterlife but
only parts of them were made
using ancient Egyptian artistic
conventions. The rest derives
from the arts of Greece and
Rome introduced to Egypt in the
Ptolemaic and Roman periods. The
whole representation is typical of
the fascinating amalgam of ideas
and artistic styles which appeared
in Egypt during the period of
Roman domination. The arts which
originated in different countries
were brought together by political
events but they did not just exist
side by side, as was usual under
the Ptolemies. Instead, they
actively interacted and produced
a completely new and eclectic
artistic style. The three figures are
the jackal-headed necropolis god
Anubis (on the right) who conducts
the deceased to the god Osiris, the
ruler of the realm of the dead (on
the left). Only the representation
of Anubis is close to the standard
pharaonic prototypes. The
deceased and Osiris are shown in
full view but the man's feet are
in the traditional profile. There are
small depictions in the background
which hark back to the ancient
Egyptian funerary tradition,
including mummification
and judgement scenes, and
representations of the deceased's
ba ('personality') drinking and
climbing a staircase.

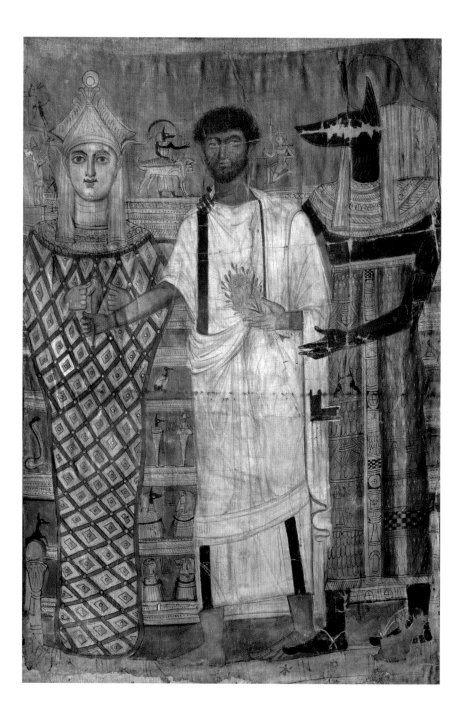

Box in the form of a shrine, probably a coffin for a hawk, location of discovery not known

*c.*180 AD. Plastered and painted wood, h. 69.5 cm, 27 in. Egyptian Museum, Cairo

The architectural form of a 'shrine', a structure with a concave cornice at the top and a flat or slightly vaulted roof which was originally created in order to house a divine image, was used in various contexts. The box illustrated here is probably a coffin which once contained the body of a mummified hawk. This is suggested by its decoration which shows scenes of adoration of a hawk-headed deity or the bird itself. The small wooden figure on the lid of the box is less significant because such statuettes, representing the necropolis god Sokar, were also placed on coffins of people. As a hawk coffin this box is exceptionally attractively decorated; the majority of box-like animal and bird coffins are fairly simple. The standard way of burying mummified birds was by placing them in pottery jars which were then carefully piled up in underground galleries (see also 322). Only larger animals, such as baboons, were usually buried in wooden coffins. The alternating symbols in the lower half of the box are the hieroglyphic signs *djed*, 'stability', and *teyet*, 'protection', 'welfare' or similar. They were meant to act as protective amulets and were often employed in funerary contexts.

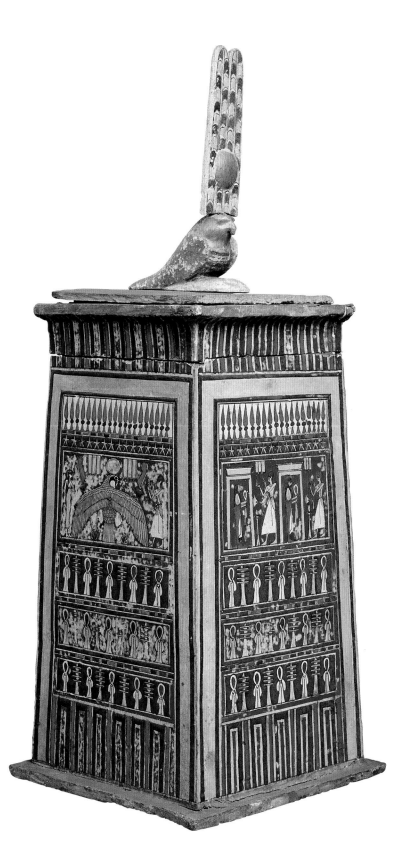

Dynasties and kings	Key events: Egypt	Key dates and events: outside Egypt	Key works: art and architecture
All dates before the seventh century BC should be regarded as approximate. The margin of error varies from some 100 years for the First Dynasty to about 15 years for the Third Intermediate period.			

Predynastic period: 5500–2972

Dynasties and kings	Key events: Egypt	Key dates and events: outside Egypt	Key works: art and architecture
		5900–4300 Mesopotamia: Ubaid period	
		5200–4500 Europe (the Balkans): Starčevo Neolithic culture	
		4500–4000 Europe (the Balkans): Vinča Neolithic culture	
Badarian period (Upper Egypt; 4400–4000)	first works of art	4300–3100 Mesopotamia: Uruk period	
Maadi culture (Lower Egypt; 4000–3200)			
Naqada I (Amratian) period (Upper Egypt; 4000–3500)	first permanent settlements	4000–3000: Iran: Susa I and II periods	[14] sheep palette
		4000–2600 Pakistan/North-western India: Early Indus period	[16] beaker with sheep and goats
Naqada II (Gerzean) period (Upper Egypt; 3500–3100)		3500–2800 Lower Nubia: A-Group culture	[17] combs
		3300–2000 Southern Aegean: Early Cycladic culture (figurines)	[18] woman mourner figure
		3200 England: Stonehenge (1st phase)	[22] 'MacGregor Man'
			[24] Gebel el-Araq knife
Dynasty 0 (Naqada III): 3100–2972	unification of Egypt under one ruler	3100–2900 Mesopotamia: Djemdet Nasr period	[28] 'Battlefield Palette'
'Scorpion'	the appearance of writing and pharaonic conventions of art	3100–2180 Syria and Palestine: Early Bronze Age	[29] King 'Scorpion' macehead
Narmer (3000–2972)		3000–2500 Iran: Proto-Elamite culture	[30–1] Narmer palette
	royal cemetery at Umm el-Qaab (Abydos)	3000–2000 Crete: Early Minoan civilization	[32–3] 'Two Dogs Palette'

The Early Dynastic period: 2972–2647

Dynasties and kings	Key events: Egypt	Key dates and events: outside Egypt	Key works: art and architecture
1st dynasty (2972–2793)			
Aha (2972–2939)	beginning of the historic (dynastic) period		
	the foundation of Ineb-hedj (later Memphis), the new state capital		
	large brick-built tombs at Saqqara		
Djer (2939–2892)			
		2900–2334 Mesopotamia: Sumerian Early Dynastic period	
Wadji (2892–2879)			[36] stela
Den (2879–2832)			[37] gaming discs
Adjib (2832–2826)			
Semerkhet (2826–2818)			
Qaa (2818–2793)			
2nd dynasty (2793–2647)			
Hetepsekhemui (2793–2765)	the royal cemetery moves to Saqqara		
Raneb (2765–2750)			
Ninutjer (2750–2707)			
Weneg (2707–2700)			
Send (2700–2690)	temporary split of the country into two kingdoms		

Sneferka (2690–2682)			
Neferkasokar (2682–2674)			
Sekhemib-perenmaet Peribsen (approximately contemporary with the preceding three kings, 2700–2674)			
Khasekhem/Khasekhemui (2674–2647)	reunification of the country		[39] statue

The Old Kingdom: 2647–2124

3rd dynasty (2647–2573)

Nebka (2647–2628)			
Netjerikhet Djoser (2628–2609)	the first monumental building in stone: the Step Pyramid at Saqqara		[40–1] Step Pyramid [43] statue [44] panel of Hesyre
Sekhemkhet (2609–2603)			
Khaba (2603–2597)		2600–2400 Mesopotamia: royal cemetery of Ur 2600–1900 Pakistan/North-western India: Mature Indus period 2600 England: Avebury henge	
Qahedjet Huni (2597–2573)			

4th dynasty (2573–2454)

Snofru (2573–2549)	the first pyramid complex and true pyramid at Dahshur, probably a reflection of the ascendancy of the sun god and Osiris rapid advances in administration an expedition to bring wood from the Lebanon miliary campaigns into Nubia	2570–2342 Mesopotamia: Lagash dynasty	[47] statues of Rahotep and Nofret [50–1] 'Geese of Maidum'
Khufu (also Kheops; 2549–2526)	the construction of the largest pyramid in Egypt		[52–3] pyramid [54–5] cache of Queen Hetepheres
Radjedef (also Djedefre; 2526–2518)			
Khephren (also Khafre/Rakhaef; 2518–2493)	the carving of the Great Sphinx at Giza	2500–1100 Iran and Mesopotamia: Elamite culture	[52–3, 58] pyramid [59] statue [60–1] Great Sphinx
Nebkare (2493–2488)			
Menkaure (also Mycerinus; 2488–2460)			[52–3] pyramid [64–5] statues
Shepseskaf (2460–2456)	signs of a religious crisis		
Thamphthis (2456–2454)			

5th dynasty (2454–2311)

Userkaf (2454–2447)	the building of the first sun temple		[67] statue [68–9] statue of Kaaper [70] 'Louvre Scribe'
Sahure (2447–2435)			
Neferirkare (2435–2425)			
Shepseskare (2425–2418)			
Raneferef (also Neferefre; 2418–2408)			
Neuserre (2408–2377)		2400–1540 Upper Nubia: Kerma culture	[74–7] tomb of Ty
Menkauhor (also Ikauhor; 2377–2369)			[80] tomb of Niankh-khnum and Khnumhotep
Djedkare Izezi (2369–2341)			
Unas (also Wenis; 2341–2311)	the appearance of the Pyramid Texts	2334–2154 Mesopotamia: Akkadian (Agade) period 2334–2279 Mesopotamia: Sargon	[82–4] tomb of Ptahhotep

6th dynasty (2311–2140)

Teti (2311–2281)			
		2300 England: Stonehenge (2nd phase)	[85–6] tomb and statue of Metjetji

Pepy I (2280–2243)	harim conspiracy led by a queen	2254–2218 Mesopotamia: Naram-sin	[87] copper statue
		2250 Syria: destruction of Ebla	[88] Hierakonpolis lion
		2250–1540 Lower Nubia:	[89] Hierakonpolis hawk
		C-Group culture	
Merenre I (2242–2237)			
Pepy II (2236–2143)	climatic changes lead	2200 England: Stonehenge (3rd phase)	[90] statue
	to worsening economic situation	2180–1540 Syria and Palestine:	
	ideological crisis	Middle Bronze Age	
Merenre II (2142–2141)			
Neitiqert, Queen (also Nitocris; 2141–2140)			

7th and 8th dynasties (2140–2124)
A number of lesser kings

The First Intermediate period: 2123–2040

simultaneous dynasties	division into Heracleopolitan and Theban kingdoms environmental changes in the Memphite area		

9th and 10th dynasties (2123–2040)

include Meryibre Akhtoy and Merykare (2065–2045)			[91] statue of Nakht
			[92–3] tomb of General Iti
		2112–2004 Mesopotamia: Third dynasty of Ur	

11th dynasty (first part; 2124–2040)

Mentuhotep I and Inyotef I (together, 2124–2107)		2112–2095 Mesopotamia: Ur-nammu	
Inyotef II (2107–2058)		2094–2047 Mesopotamia: Shulgi	
		2100 Mesopotamia: first ziggurats built	
		c.2100 Mesopotamia: Gudea, ruler of Lagash	
Inyotef III (2058–2050)			
Nebhepetre Mentuhotep II (before unification; 2050–2040)	armed clashes between Heracleopolitan and Theban kingdoms		

The Middle Kingdom: 2040–1648

11th dynasty (second part; 2040–1980)

Nebhepetre Mentuhotep II (after reunification; 2040–1999)	reunification of the country	2004 Mesopotamia: occupation of Ur by Elamites	[94] statue
		2000–1540 Crete: Middle Minoan civilization	[96–7] sarcophagus of Princess Kawit
			[98–9] Mesehti's model soldiers
		2000–1123 China: Shang dynasty	[100] V-necked dress
Sankhkare Mentuhotep III (1999–1987)			[101–3] Meketre's models
Nebtawyre Mentuhotep IV (1987–1980)			

12th dynasty (1980–1801) (overlaps due to co-regencies)

Amenemhet I (1980–1951)	foundation of a new capital and royal cemetery at Itj-tawy (El-Lisht), south of Memphis military campaigns in Nubia		
Senwosret I (1960–1916)			[105] statue
			[106] festival kiosk
Amenemhet II (1918–1884)		1900–1300 Pakistan/North-western India: Late Indus period	[109] Priness Iti's dagger
		1894–1595 Mesopotamia: First dynasty of Babylon	[110–11] collar of Princess Khnumet
Senwosret II (1886–1878)		Egypt's southern boundary established at the 2nd Nile cataract	

Senwosret III (1878–1859)

Amenemhet III (1859–1814)

Amenemhet IV (1814–1805)
Sobekkare Sobeknofru, Queen (1805–1801)

13th dynasty (1801–1648)
Many kings, including Neferhotep I (1738–1727),
Sihathor (1727), Sobekhotep IV (1727–1720),
Sobekhotep V (1720–1716), Iaib (1716–1706),
and Merneferre Ay (1706–1683)

1800–1540 Lower Nubia and Upper
 Egypt: pan-grave culture
1757 Mesopotamia:
 destruction of Mari
1700–1520 Anatolia: Hittite Old Kingdom
1700–1450 Crete: Linear A script

[113] head of statue
[115–17] tomb of Djehutihotep II
[118–19] sphinx
[120] statue
[124–5] jewellery of Princess
 Mereret

[128] faience hippopotamus
[129] companion of the dead
[131] scimitar

The Second Intermediate period (1648–1540)

simultaneous dynasties; dates of individual reigns uncertain

14th dynasty:
Many kings, at least some non-Egyptian

15th (Hyksos) dynasty (1648–1540)

Salitis	the Hyksos seize power	c.1630 Thera volcanic eruption
Bnon	from their base at Avaris	1600 Crete: palace destruction
Apakhnan		1600–1500 Greece: Mycenaean shaft graves
Apophis		1600 Syria: Hittites sack Ebla
Iannas		1595 Mesopotamia: Hittites sack Babylon
Assis		1550–1500 Greece: 'Agamemnon mask' from Mycenae

16th (Lesser Hyksos) dynasty

17th (Theban) dynasty
Includes Senakhtenre Teo I, Seqenenre
Teo II and Kamose

armed clashes with the Hyksos
 during the reigns of Seqenenre Teo II
 and Kamose

The New Kingdom: 1540–1069

18th dynasty (1540–1295)

Ahmose (1540–1525; accession 1550)	Ahmose defeats the Hyksos and besieges Sharuhen in Palestine	1540–1320 Mesopotamia: Hurrian kingdom of Mitanni 1540–1100 Crete: Late Minoan civilization 1540–1150 Syria and Palestine: Late Bronze Age	[134] bull and acrobat fresco
Amenhotep I (1525–1504)			
Thutmose I (1504–1492)	Egyptian influence reaches the Euphrates	1500–1200 Greece: Mycenaean palace civilization	
Thutmose II (1492–1479)	suppression of Nubian uprising		
Hatshepsut, Queen (1479–1457)	Hatshepsut reigns on behalf of young Thutmose III expedition to Punt in Eastern Africa		[135] statue of Senenmut and Princess Neferure [136] statue [138] obelisk [139] Deir el-Bahri temple
Thutmose III (1479–1425)	campaigns in Syria against Mitanni battle of Megiddo against a coalition led by the prince of Qadesh		[141] head of statue [142–3] 7th pylon at Karnak [146] glass vessels
Amenhotep II (1427–1401)	further military campaigns	1415–1155 Mesopotamia:	[148–9] tomb of Rekhmire

Thutmose IV (1401–1391)	against Mitanni	Kassite dynasty in Babylon 1400 Crete: Knossos Linear B tablets destruction of Knossos	[151–3] tomb and statue of Sennufer [154] statuette of Henuttaui
Amenhotep III (1391–1353)	Egypt the strongest superpower in the Ancient Near East	1363–1076 Mesopotamia: Middle Assyrian empire	[156–7, 159–60] tomb of Nebamun [161] statue [166] Luxor temple [167] Memnon Colossi [169] head of Queen Teye [172–3] tomb of Ramose
Amenhotep IV/Akhenaten (1353–1337)	religious revolution, the Aten becomes the only god Akhenaten moves to El-Amarna	1350–1200 Anatolia: Hittite empire	[175] colossus [181] Ashmolean princesses [182–3] talatat [190–1] bust of Queen Nefertiti [195] royal couple relief
Smenkhkare (1338–1336) Tutankhaten/Tutankhamun (1336–1327) Ay (1327–1323) Haremhab (1323–1295)	abandonment of El-Amarna and move to Memphis		[196–7] tomb of Haremhab [198–213] tomb of Tutankhamun [214] statue
19th dynasty (1295–1186) Ramesses I (1295–1294) Sety I (1294–1279)	military campaigns in Libya and Syria		[218–19] reliefs from Saqqara [220–1] tomb of Sety I
Ramesses II (1279–1213)	1274 battle of Qadesh against Hittites 1259 peace treaty with Hittites		[225] statue [230, 232–3] tomb of Queen Nofretari [234] pylon at Luxor [236, 238–40] Abu Simbel
Merneptah (1213–1203)	suppression of incursions from Western Asia and Libya		[248] ostracon with a monkey
Amenmesse (1203–1200) Sety II (1200–1194)		1200 Greece: destruction of Mycenae 1200 Levant: destruction of Ugarit 1200–238 Sardinia: nuraghi towers	
Siptah (1194–1186) Twosre, Queen (1188–1186)			[249] goat jug
20th dynasty (1186–1069) Setnakht (1186–1184) Ramesses III (1184–1153)	further incursions from Western Asia and Libya		[250–1] Medinet Habu temple [254] tomb in the Valley of the Kings [258–9] Deir el-Medina tombs
Ramesses IV (1153–1147) Ramesses V (1147–1143) Ramesses VI (1143–1136)			[260, 262–3] tomb in the Valley of the Kings
Ramesses VII (1136–1129) Ramesses VIII (1129–1126) Ramesses IX (1126–1108) Ramesses X (1108–1099)	removal of royal mummies from tombs in the Valley of the Kings to a royal cache	1122–772 China: Chou dynasty 1100 England: Stonehenge (4th phase)	
Ramesses XI (1099–1069)			

The Third Intermediate period: 1069–715

simultaneous dynasties, partly overlapping with the early 25th dynasty

21st dynasty (1069–945) Smendes (1069–1043)	political disintegration of the country Tanis in the Eastern Delta and Memphis the capitals		
Amenemnisu (1043–1039)			[264] funerary canopy

Psusennes I (1039–991)	the first royal tombs at Tanis	1000–700 Anatolia: Neo-Hittite (Luwian) period 1000–300 Upper Nubia: Napatan kingdom	[265] Book of the Dead of Pinudjem I [268–9, 271] gold vessels [272–3] silver coffin [274–5] gold mask [268] libation vase
Amenemope (993–984) Osochor (984–978) Siamun (978–959)		971–931 Palestine: Solomon	
Psusennes II (959–945)			[277] coffin of Bekenmut

22nd ('Libyan') dynasty (945–730)

The Lower Egyptian group: Shoshenq (also Sesonchis; 945–924)	military campaign in Palestine	931 Palestine: Israel and Judah	
Osorkon I (924–889)		911–612 Late Assyrian empire 900–600 Anatolia: Urartian kingdom	
Shoshenq II (also Sesonchis; 890)			[280] bracelet
Takelot I (889–874)		883–859 Assyria: Ashurnasirpal II	
Osorkon II (874–850)		858–824 Assyria: Shalmaneser III	[281] triad of Osiris [282] statuette of Karomama
Shoshenq III (also Sesonchis; 825–773)			
Pimay (773–767)		771–482 China: Ch'un-ch'iu period	
Shoshenq V (also Sesonchis; 767–730)		744–727 Assyria: Tiglath-pileser III	
The Upper Egyptian group: Harsiese (870–860) Takelot II (850–825) Pedubaste I (818–793) Iuput I (804–803)		814 North Africa: foundation of Carthage	
Shoshenq IV (also Sesonchis; 793–787) Osorkon III (787–759)		776 Greece: first Olympic games	
Takelot III (764–757) Rudamun (757–754)			

23rd dynasty (754–715)

	local rulers in various cities		
Pedubaste II (754–730)		753 Italy: founding of Rome	
Iuput II (754–720)		721–705 Assyria: Sargon II	
Osorkon IV (730–715)			

24th dynasty (727–715)

	local rulers of Sais, ancestors of kings of the 26th dynasty		
Tefnakht I (727–720)	a vassal of Piye of the 25th dynasty		
Bekenrenef (720–715)	defeated and executed by Sabacon of the 25th dynasty		

The Late period: 715–332

25th (Nubian or Kushite) dynasty

(partly only in Nubia) Kashta (c.760–747) Piye (also Piankhy; 747–716)			
Sabacon (also Shabako; 716–702)		704-681 Assyria: Sennacherib	
Shebitku (702–690)		700 Greece: Homer	
Taharqa (690–664)	a series of Assyrian invasions	680–669 Assyria: Esarhaddon 668–627 Assyria: Ashurbanipal	[285] head of statue [286] statue of Montuemhet
Tantamani (664–656)	sack of Thebes by Assyrians		

26th (Saite) dynasty (664–525)

Psammetichus I (also Psametek; 664–610)		647 Persia: Susa destroyed by Assyrians 625–539 Mesopotamia: Neo-Babylonian (Chaldaean) dynasty 612 Mesopotamia: Nineveh sacked by Medes and Babylonians	[287–9] tomb of Montuemhet [290] statue of Espekashuty [291] statue of Tueris

		600 Southern Russia: Scythian barrows (kurgans)	
Necho II (610–595)			[295] coffin of Tashaenkheper
Psammetichus II (also Psametek; 595–589)	Nubian military campaign		
Apries (589–570)	unsuccessful expedition into Palestine against the Chaldaeans		
Amasis (570–526)			
		559–530 Persia: Cyrus the Great	[296] statue of Psametek
		550–330 Achaemenid (Persian) empire	[298] New Year's flask
		539 Mesopotamia: Persians take Babylon	
		529–522 Persia: Cambyses	
Psammetichus III (also Psametek; 526–525)			
27th (Persian) dynasty (525–404)			
Cambyses (525–522)	Cambyses conquers Egypt		
Darius I (521–486)		512 Greece: Persians invade Thrace	[302] sarcophagus of Ptahhotep
		509 Roman republic established	
		490 Greece: battle of Marathon	
Xerxes I (485–465)		481–221 China: Chan-kuo period	
		480 Greece: Persians finally defeated at battles of Thermopylae and Salamis	
		469–399 Greece: Socrates	
Artaxerxes (464–424)		447–432 Greece: the Parthenon in Athens completed	[303] male statue
		431–404 Greece: Peloponnesian War	
Darius II (423–405)			
28th dynasty (404–399)			
Amyrtaios (404–399)	revolt against Persians		
29th dynasty (399–380)	dynasty of rulers originating from Mendes in the Delta		
Nepherites I (399–393)			
Psammuthis (393)			
Hakor (also Achoris; 393–380)		384–322 Greece: Aristotle	
Nepherites II (380)			
30th dynasty (380–343)			
Nectanebo I (380–362)			[304] 'Dattari Statue' [305] lion statue
Teos (362–360)			
Nectanebo II (360–342)	Persian invasion		[307] 'Tyszkiewicz Statue' [312–14] tomb reliefs [315] ushebti
31st (Second Persian) dynasty (342–332)			
Artaxerxes III (342–338)			
Arses (337–336)			
Darius III (335–332)			

The Ptolemaic period (332–30)

The Macedonian dynasty (332–305)

Alexander III the Great (332–323)	332 Alexander conquers Egypt		
	331 Alexandria founded		
		323 death of Alexander at Babylon	
Philip III Arrhidaeus (323–317)			[317–19] tomb of Pedusiri
Alexander IV (317–310/309)			

The Ptolemaic dynasty (304–30)

Ptolemy I Soter (304–282)		300–150 Mesopotamia: Seleucid period	
		300–AD 350 Nubia: Meroitic kingdom	
Ptolemy II Philadelphus (285–246)		264–241 Italy: First Punic War	[320] Philae
			[327] statue of Hor
Ptolemy III Euergetes I (246–222)			
Ptolemy IV Philopator (222–205)		221–207 China: Ch'in empire	
		('terracotta warriors')	
		218–201 Italy: Second Punic War	
		218 Italy: Hannibal's invasion of Italy	
Ptolemy V Epiphanes (204–180)			[329] Rosetta Stone
			[330] Buchis bull stela
Ptolemy VI Philometor (180–145)		150–146 Italy: Third Punic War	
		146 North Africa: Carthage razed	
Ptolemy VII Neos Philopator (145)			
Ptolemy VIII Euergetes II Physcon			
(145–116)			
			[333–4, 336–7] Edfu temple
			[335] Dendera temple
Ptolemy IX Soter II Lathyros			
(between 115 and 80)			
Ptolemy X Alexander I			
(between 110 and 88)			
Ptolemy XI Alexander II (80)			
Ptolemy XII Neos Dionysos Auletes			[341] Dendera temple
(between 80 and 51)			
Ptolemy XIII Dionysos (51–47)			[342] 'Brooklyn Black Head'
			[346–7] 'Berlin Green Head'
Ptolemy XIV Philopator (47–44)		44 Italy: Julius Caesar murdered	
Cleopatra VII Thea Philopator (51–30)	31 defeat of the navy of	40–4 Palestine: Herod the Great	
	Mark Antony and Cleopatra		
	at Actium		

The Roman period (30 BC–395 AD)

includes Octavian/Augustus	Egypt a Roman province	27–30 AD Palestine: Pontius Pilate	[321] kiosk at Philae
(31 BC–14 AD),			
Tiberius (14–37 AD), Nero			
(54–68 AD),			[349] statue of Horsahor
Trajan (98–117 AD) and Hadrian			
(117–138 AD)		66–70 AD Palestine:	[350, 353] Esna temple
		First Jewish Revolt	[354] portrait of a soldier
		79 AD Italy:	[356] funerary shroud
		eruption of Vesuvius	
		132–135 AD Palestine:	
		Second Jewish Revolt	

Byzantine Egypt: 395–642 AD

639–642 AD Arabs led by
 Amr ibn al-As conquer Egypt

Note: All years are in BC unless indicated as AD. All dates before the seventh century BC are approximate. The following specialized studies were used: R. A. Parker, *The Calendars of Ancient Egypt* (Chicago, 1950), J. Malek and W. Forman, *In the Shadow of the Pyramids. Egypt during the Old Kingdom* (London, 1986), K. A. Kitchen, *The Third Intermediate Period in Egypt* (1100-650 BC) (2nd edn., Warminster, 1986, and the same author in Åström, P. High, *Middle or Low?*, parts 1 and 3 (Gothenburg, 1987 and 1989), M. Roaf, *Cultural Atlas of Mesopotamia and the Ancient Near East* (New York and Oxford, 1990), J. von Beckerath, *Chronologie des pharaonischen Ägypten* (Mainz, 1997), and I. Shaw and R. Jameson, *A Dictionary of Archaeology* (Oxford, 1999).

MAP **366**

Qadesh •

Byblos •

Lake Nasser was created in 1971

Mediterranean Sea

Megiddo •
Shechem •

Rosetta •
Canopus • • Buto Behbeit el-Higara •
Alexandria • Sais • • Tell el-Baqliya
Naukratis • Busiris • • Tanis
Avaris • • Pi-Ramses
Athribis • • Bubastis
Heliopolis • Gebel Ahmar •
Giza • Abusir •
Saqqara • • Memphis
El-Lisht • Dahshur •
El-Rubaiyat • • Maidum
Medinet Madi • • El-Haraga
 • El-Lahun
FAIYUM Heracleopolis •

Oxyrhynchus •

S I N A I

• Serabit el-Khadim
• Wadi Maghara

Beni Hasan •
Hermopolis • • Deir el-Bersha
Tuna el-Gebel • • El-Amarna
Meir •
Asyut •

Red Sea

• Qaw el-Kebir

Akhmim •
Abadiya •
Abydos • • Dendera
Gebel el-Araq • • Koptos
Naqada • • Karnak
Armant • Luxor • **THEBES**
Dakhla • Gebelein •
 Esna • • El-Kab
E G Y P T Hierakonpolis • Edfu

Gebel el-Silsila • • Kom Ombo

Elephantine •
Gebel Tingar • • Aswan
 • Philae

Lake Nasser

Abu Simbel •
Buhen •
Semna • **N U B I A**

• Soleb

S U D A N • Kerma
Kawa •

Napata • • Nuri
Nile
El-Kurru • • Sanam

0 100 200 300 miles

0 100 200 300 kilometres

General works on ancient Egypt

John Baines and Jaromir Malek, *Cultural Atlas of Ancient Egypt* (New York, 2000)

Barry J. Kemp, *Ancient Egypt. Anatomy of a Civilization* (London, 1989)

Jaromir Malek (ed.), *Egypt. Ancient Culture, Modern Land* (Sydney, 1993)

Regine Schulz and Matthias Seidel (eds.), *Egypt. The World of the Pharaohs* (Cologne, 1998)

Ian Shaw (ed.), *The Oxford History of Ancient Egypt* (Oxford, 2000)

General works on Egyptian art

Cyril Aldred, *Akhenaten and Nefertiti* (exh. cat., Brooklyn Institute of Arts and Sciences, New York, 1973)

—, *Egyptian Art in the Days of the Pharaohs, 3100-320 BC* (London, 1980)

Dorothea Arnold, *When the Pyramids were Built. Egyptian Art of the Old Kingdom* (New York, 1999)

Janine Bourriau and Stephen Quirke, *Pharaohs and Mortals. Egyptian Art in the Middle Kingdom* (Cambridge, 1988)

Whitney Davies, *The Canonical Tradition in Ancient Egyptian Art* (Cambridge, 1989)

—, *Masking the Blow. The Scene of Representation in Late Prehistoric Egyptian Art* (Berkeley, 1992)

Iorwerth Eiddon Stephen Edwards, *Tutankhamun. His Tomb and its Treasures* (New York, 1976)

Egypt's Golden Age. The Art of Living in the New Kingdom, 1558-1085 BC (exh. cat., Museum of Fine Arts, Boston, 1982)

Egyptian Art in the Age of the Pyramids (exh. cat., Metropolitan Museum of Art, New York, 1999)

Richard A Fazzini, *Egypt. Dynasty XXII-XXV* (Leiden and New York, 1988)

— and Robert Steven Bianchi, *Cleopatra's Egypt. Age of the Ptolemies* (exh. cat., Brooklyn Museum of Art, New York, 1988)

Rita E. Freed, Yvonne J. Markowitz and Sue H. D'Auria, *Pharaohs of the Sun. Akhenaten, Nefertiti, Tutankhamen* (exh. cat., Museum of Fine Arts, Boston, 1999)

Gaballa Ali Gaballa, *Narrative in Egyptian Art* (Mainz, 1976)

Henriette Antonia Groenewegen-Frankfort, *Arrest and Movement. An Essay on Space and Time in the Representational Art of the Ancient Near East* (London, 1951, repr. New York, 1978)

Erik Iversen (with Yoshiaki Shibata), *Canon and Proportions in Egyptian Art* (2nd revised edn., Warminster, 1975)

Arielle P. Kozloff, Betsy M Bryan and Lawrence Michael Berman, *Egypt's Dazzling Sun. Amenhotep III and his World* (exh. cat., Cleveland Museum of Art, 1992)

J. E. Livet et al., *Private Theban Tombs. Mastabas of Saqqara* (Paris, 1993–)

Jaromir Malek, *Egyptian Art* (London, 1999)

Karol Myśliwiec, *Royal Portraiture of the Dynasties XXI-XXX* (Mainz, 1988)

Nicholas Reeves, *The Complete Tutankhamun. The King, the Tomb, the Royal Treasure* (London, 1990)

Gay Robins, *The Art of Ancient Egypt* (London, 1997)

—, *Proportions and Style in Ancient Egyptian Art* (London, 1994)

Edna R. Russmann, *Eternal Egypt. Masterworks of Ancient Art from the British Museum* (London and New York, 2001)

Heinrich Schäfer (ed. by John Baines), *Principles of Egyptian Art* (Oxford, 1986)

W. Stevenson Smith (revised and updated by William Kelly Simpson), *The Art and Architecture of Ancient Egypt* (3rd edn., New Haven and London, 1998)

—, *A History of Egyptian Sculpture and Painting in the Old Kingdom* (Oxford, 1949)

Francesco Tiradritti, *Ancient Egypt. Art, Architecture and History* (London, 2002)

Jane Turner (ed.), *The Dictionary of Art* (London, 1996)

Richard H. Wilkinson, *Symbol and Magic in Egyptian Art* (London, 1994)

Architecture

Dieter Arnold, *Temples of the last Pharaohs* (Oxford and New York, 1999)

Iorwerth Eiddon Stephen Edwards, *The Pyramids of Egypt* (London, 1993)

J. Peter Phillips, *The Columns of Egypt* (Manchester, 2002)

Steven Snape, *Egyptian Temples* (Princes Risborough, 1996)

Miroslav Verner, *The pyramids. A Complete Guide* (New York, 2001)

Three-dimensional Sculpture

Sally-Ann Ashton, *Ptolemaic Royal Sculpture from Egypt. The Interaction between Greek and Egyptian Traditions* (Oxford, 2001)

Bernard V. Bothmer, Herman De Meulenaere and Hans-Wolfgang Müller, *Egyptian Sculpture of the Late Period, 700 BC to AD 100* (Brooklyn, NY, 1960)

Biri Fay, *The Louvre Sphinx and Royal Sculpture from the Reign of Amenemhat II* (Mainz, 1996)

Julia Carol Harvey, *Wooden Statues of the Old Kingdom. A Typological Study* (Leiden, 2001)

Thomas Garnet Henry James and W. Vivian Davies, *Egyptian Sculpture* (London, 1983)

Jack A. Josephson, *Egyptian Royal Sculpture of the Late Period 400-246 BC* (Mainz, 1997)

Gay Robins, *Egyptian Statues* (Princes Risborough, 2001)

Edna R. Russmann, *The Representation of the King in the XXVth Dynasty* (Brussels and Brooklyn, 1974)

— and David Finn, *Egyptian Sculpture. Cairo and Luxor* (Austin, 1989 and London, 1990)

Wall Reliefs and Paintings

W. Vivian Davies (ed.), *Colour and Painting in Ancient Egypt* (London, 2001)

Yvonne Harpur, *Decoration in Egyptian Tombs of the Old Kingdom. Studies in Orientation and Scene Content* (London, 1987)

Gay Robins, *Egyptian Painting and Relief* (Princes Risborough, 1986)

Edward Lee Bockman Terrace, *Egyptian Paintings of the Middle Kingdom* (London, 1968)

Arpag Mekhitarian, *Egyptian Painting* (Geneva, 1954, and London, 1978)

William H Peck, *Drawings from Ancient Egypt* (London, 1978)

Minor Arts

Cyril Aldred, *Jewels of the Pharaohs* (London, 1971)

Carol Andrews, *Ancient Egyptian Jewellery* (London, 1990)

Morris Leonard Bierbrier (ed.), *Portraits and Masks. Burial Customs in Roman Egypt* (London, 1997)

Janine Bourriau, *Umm el-Ga'ab. Pottery from the Nile Valley before the Arab Conquest* (Cambridge, 1981)

Emma Brunner-Traut, *Egyptian Artists' Sketches. Figured Ostraca from the Gayer-Anderson Collection in the Fitzwilliam Museum, Cambridge* (Istanbul, 1979)

Lorelei H Corcoran, *Portrait Mummies from Roman Egypt (I-IV Centuries AD). With a Catalog of Portrait Mummies in Egyptian Museums* (Chicago, 1995)

Euphrosyne Doxiadis, *The Mysterious Fayum Portraits. Faces from Ancient Egypt* (London, 1995)

Geoffrey Killen, *Egyptian Woodworking and Furniture* (Princes Risborough, 1994)

Alix Wilkinson, *Ancient Egyptian Jewellery* (London, 1971)

Aker

An earth god mentioned in religious texts such as Coffin Texts and 'books of the afterlife'. Aker was usually represented as a double lion. One of the 'books of the afterlife' was known as the Book of the Earth (260).

Amarna period

King Akhenaten who instigated a religious revolution in the fourteenth century BC founded a new capital of the country, called Akhetaten (The Horizon of the Aten), the present El-Amarna, in Middle Egypt. Akhetaten only functioned for about twenty years and was abandoned early in the reign of Tutankhamun. The term Amarna period is used with little precision but usually describes the reigns of Akhenaten (although, if one wishes to be pedantic, it should not include his early years, before the move to El-Amarna), his successor Smenkhkare and the beginning of the reign of Tutankhamun (then still called Tutankhaten).

Amun and Amun-Re

Amun was one of the main deities who acquired universal recognition throughout Egypt from about 2000 BC. The most important temple of the god was *Ipet-isut*, present Karnak (142–3), in Thebes (Luxor), but there were other sanctuaries of Amun elsewhere. From about 1500 Amun was syncretized with, i.e. acquired some characteristics of, the sun god as Amun-Re. Amun's female companion was the goddess Mut (309) and their junior partner was the god Khons. Together they formed the Theban triad. Amun was one of the creator gods, credited with the creation of the world. His most frequent representations were anthropomorphic (human-shaped), wearing a crown with two tall plumes (138, 284), but he could also appear as the ram and even the goose. The names of many kings were formed with that of the god Amun, e.g. Amenhotep (the change from Amun to Amen is due to the presumed shift of stress in the word).

Anthropomorphic

In the form of, or resembling, human beings, especially when describing the appearance of deities. In Egyptian art this applies to gods and goddesses such as Hathor (65), Amun-Re (138) or Atum (214), as opposed to those appearing in zoomorphic (animal) forms.

Anubis

The necropolis god associated with burials and mummification. Anubis is usually represented as a recumbent jackal (223) or a jackal-headed man (227, 325).

Apis

There were several cults in which the focus of worship was a bull. At Memphis, it was the Apis bull (in Egyptian Hapy), closely linked with the god Ptah. Apis could also be shown as a bull-headed man. The burial place of Apis bulls at Saqqara is known as the Serapeum, from Osiris-Apis (Usiri-Hapy).

Apopi

The snake Apopi (Greek Apophis) is mentioned in the Coffin Texts and the 'books of the afterlife' as the most dangerous enemy of the sun god (259). The Book of Apopi, a corpus of incantations and similar texts which were meant to help defeat Apopi, is first attested in about 1180 BC.

Apotropaic

Protective. The function of some of the domestic deities, such as Bes (165), was apotropaic, to protect members of the family against accidents, misfortunes and malign beings.

Arensnuphis

A deity worshipped in Nubia during the Ptolemaic and Roman periods (320). Arensnuphis could be represented as a lion or a spear-wielding man.

Aten

The new deity promoted by King Akhenaten to be the only god during his religious revolution. The sole representation of the Aten was the sun disc with a uraeus (cobra) and a multitude of sun rays terminating in hands (176, 178, 207).

Atum

The creator god of Heliopolis (the present north-eastern suburb of Cairo), equated with the mature form of the sun god (214, 283).

Ba

Ba was the most important of the several elements which formed human beings, gods and, exceptionally, even animals. The closest term which describes it is 'personality'. In order to exist on earth, the *ba* required a visible form (manifestation) and *ka*, life energy or animating force (132). The visible form was normally provided by the body but could be substituted, for example by a statue (43). The *ba* itself could be represented (although this is, in fact, a contradiction because its visual form was the persons themselves) as a human-headed bird (277, 295, 356).

Benben stone

A pyramid-shaped stone, probably of meteoric origin, which was worshipped as a manifestation of the sun god at Heliopolis. The form was probably linked to the mound on which according to Egyptian mythology life emerged from the watery chaos. The shape of the benben may have been imitated by pyramids (52–3, 58) and pyramidia (164), and was also reflected in the summit of obelisks (138).

Bes

A household demigod whose task was to protect the family against everyday life dangers. Bes was usually represented as a dwarf with a feather crown, leonine mane and bandy legs (165, 335). He was linked to music, dancing and sex.

Book of the Dead

The most frequently occurring 'book of the afterlife' (texts concerning the underworld which were useful in the afterlife). It appeared around 1500 BC but the number and selection of spells which it contains varies from one copy to another. The term was coined by early Egyptologists; the Egyptian themselves called these texts the 'Book of Coming forth by Day'. Also the numbering of the spells is modern. The Book of the Dead was written on papyri (265). Selected spells and their illustrations ('vignettes') were written on tomb walls (227, 242, 259).

Canopic jars

Four jars (266) which contained internal organs (liver, lungs, stomach and intestines) removed from the body during the mummification process. The organs were identified with the four deities called the sons of Horus (Imset, Hapy, Duamutef and Kebehsenuf) and the jars had stoppers in the form of the heads of a man, baboon, jackal and hawk. Canopic jars were placed under the protection of the goddesses Isis, Nephthys, Neith and Selket. The name derives from Kanopos, the steersman of Menelaos of the *Odyssey*, who was said to have died in Egypt and been worshipped in the form of a jar.

Carnarvon, George Edward Stanhope Molyneux, 5th Earl of Carnarvon (1866–1923)

Lord Carnarvon financed several excavations conducted by Howard Carter on the west bank at Thebes, in Middle Egypt as well as in the Delta. His untimely death some five months after the sensational find of a largely undisturbed tomb of King Tutankhamun in the Valley of the Kings (198–213) led to the unfounded allegations of 'the pharaoh's curse'.

Carter, Howard (1874–1939)

British Egyptologist who, during excavations financed by Lord Carnarvon, discovered the tomb of King Tutankhamun (198–213) in the Valley of the Kings in November 1922. Although he had no formal Egyptological training, Carter was a brilliant and intuitive archaeologist. He was also an excellent copyist who significantly advanced Egyptian

epigraphy, the art of recording reliefs and paintings.

Cartouche

An ornamental and symbolic frame which enclosed the names of kings (124, 145) and sometimes also those of other members of the royal family and the gods. The cartouche may have expressed a symbolic protection granted to the person by the sun god Re. The earliest examples date from about 2550 BC.

Champollion, Jean-François (1790–1832)

French Egyptologist who discovered the principles of Egyptian hieroglyphic writing in 1822. Previous attempts were hindered by the belief that the script was largely symbolic. The clues to the phonetic character of some hieroglyphs were provided by royal names written in cartouches on the Rosetta Stone (329), a Ptolemaic decree found by French army engineers at Fort Julien at El-Rashid (Rosetta).

Coffin Texts

A collection of spells connected with the afterlife, often inscribed on coffins (121) between about 2100 and 1500 BC. The Coffin Texts can be regarded as successors of the Pyramid Texts, recorded inside pyramids, and predecessors of the Book of the Dead. Some of the spells are shared among these texts.

District

Egyptian local administration was based on districts (Greek *nome*), usually centred around a town which developed as a natural focus of economic and religious life (65, 115–17, 254). Each district had a standard (28) which served as its symbol as well as the writing of its name. The number of districts did not remain absolutely stable; the normal figure was 22 districts in Upper (southern) Egypt and 20 in Lower (northern, the Delta) Egypt.

Divine adoratress

The title of a priestess (282) attached to the temple of the god Amun at Thebes. It was usually combined with other designations such as 'the god's wife' and 'the god's hand' (a reference to the god's ability to procreate without a physical union with a female counterpart). The divine adoratress was the nominal head of the priesthood of Amun during the Third Intermediate and Late periods.

Electrum

An alloy of gold and silver (123, 126, 131, 269, 282) in which the gold content is between 50 and 75 per cent.

Faience

Egyptian faience was used for the manufacture of various small objects, such as statuettes (127–9), shabtis (315), amulets, rings, etc., and also for inlays (45, 140, 203, 207). It is a material with a blue or green glossy surface which is made by heating crushed quartz or sand with some additional ingredients.

Funerary temple

This was a temple for the maintenance of the royal funerary cult, and so the safeguarding of the king's continued existence after death. Funerary temples were at first built next to the pyramid with the body of the deceased ruler; these are usually called pyramid temples. From 1500 BC royal funerary temples were physically separate from the tombs (the tombs were made in the Valley of the Kings while the temples at the foot of the hills or in the plain facing the river). Rites were performed in these temples and offerings brought to their altars but the temples could function quite independently of human assistance because of their statues and reliefs. The best known funerary temples are those of Queen Hatshepsut at Deir el-Bahri (139), of Ramesses II known as the Ramesseum (246), and of Ramesses III at Medinet Habu (250–1).

Gesso

Gypsum plaster chiefly used on tomb walls before they were painted. It was made by heating naturally occurring gypsum to some 200°C. The term is also used for plaster made from powdered limestone mixed with glue and applied to wooden objects before painting (121, 204, 209–10, 217, etc.).

Hathor

A goddess who was regarded as a local deity at several places, especially Heliopolis, Memphis, Dendera and Gebelein, but also Sinai and Abu Simbel (240). She was linked to women in general and was a goddess of love, family happiness and entertainment. But Hathor was also the goddess of the Theban necropolis, especially at Deir el-Bahri (139). She was usually represented as a woman wearing a headdress consisting of cow horns and a sun disc (65, 220). Also a cow (296, 344) and a sistrum (musical instrument resembling a rattle), sometimes imitated in column capitals (341), were Hathor's manifestations.

Hellenistic period

The several centuries during which Greek culture continued to flourish in the areas conquered by Alexander the Great even after his death at Babylon in 323 BC. In Egypt, this is usually called the Ptolemaic period.

High priest

A conventional designation of the head of priesthood of a deity. The actual form of the title varied, so the high priest of Amun was 'the first prophet' (265), of Ptah 'chief of the directors of craftsmen' (164), of Re 'chief of the seers', and of Thoth 'chief of the five' (317–19).

Horus

The god closely associated with the Egyptian pharaoh who was regarded as one of his manifestations. Horus was worshipped at many places, especially at Hierakonpolis (Kom el-Ahmar) and Edfu (333, 336–7) in Upper Egypt, and at several Delta sites. He was usually represented as a hawk (59, 89) or a hawk-headed man (281), and also as a child with a finger in his mouth. In Egyptian mythology, Horus was the son of Osiris and Isis who avenged the murder of his father committed by his wicked uncle Seth.

Hyksos

The Greek form of *hekau khasut*, 'rulers of the foreign countries'. In Egypt it was not an ethnic term and did not refer to a people, only to their rulers. But following the Jewish historian Josephus the term began to be used as a designation of a people, immigrants from Western Asia who became the dominant force in Egypt after 1648 BC and formed the 15th and 16th dynasties of kings (134).

Isis

A goddess universally worshipped throughout Egypt, especially at Koptos and Philae (320) in Upper Egypt and at Behbeit el-Higara in the Delta. In Egyptian mythology, Isis was the wife of Osiris and the mother of Horus. She was usually represented as a woman with a headdress consisting of a hieroglyphic sign recording her name (294, 324), or with cow horns and a sun disc (281). She could also be shown as a tree goddess (147).

Ka

The life energy or animating force required by the ba (132). It had to be sustained by food and drink and this was the main reason for the bringing of offerings to tombs and temples.

Khons

The god Khons (see 269, 271) was the junior member of the Theban triad, together with Amun and the goddess Mut. He was usually represented as a youthful man with a sidelock of hair.

Kushite period

The Egyptian designation of Upper (southern) Nubia, present Sudan, was Kush. When at the end of the New Kingdom Egyptian influence in Upper Nubia waned, an independent kingdom centred on the town of Napata developed there and retained many Egyptian cultural and religious practices.

Around 730 BC its Kushite rulers began to be involved in Egypt's affairs and eventually became kings of the 25th dynasty, often called Kushite or Nubian (285). The Kushite period in Egypt is usually thought to represent some sixty-five years, between c.730 and 664.

MacGregor, Rev. William (1848–1937)

British antiquarian who assembled a large collection of Egyptian antiquities which was sold at Sotheby's in London in 1922. The collection included a remarkable late Predynastic male figure, now in the Ashmolean Museum in Oxford (22), and an obsidian head of King Senwosret III, now in the Museu Calouste Gulbenkian in Lisbon (113).

Mandrake (Mandragora officinarum)

The mandrake plant is famous for the length of its roots. It was cultivated in Egyptian gardens (160, 228). In folk remedies, the fruit of mandragora is credited with medicinal and hallucinogenic properties and is regarded as an aphrodisiac. This probably explains its inclusion in certain representations in Egyptian tombs and on various items of personal adornment (226) and funerary equipment (229).

Mandulis

A god worshipped at Kalabsha but also at other places in Lower (northern) Nubia during the Ptolemaic and Roman periods (320). Mandulis was usually shown in an anthropomorphic form.

Mehyt

A goddess usually shown as a lioness (209) or a lion-headed woman. Mehyt was especially worshipped in the city of This, in the vicinity of Abydos, where she was regarded as the female companion of the local god Onuris.

Memphis

Menes, the legendary first king of the 1st dynasty and perhaps the same ruler as the historical king Aha, is regarded as the founder of the city of Memphis. The original

foundation, on the west bank of the Nile, below the Saqqara desert plateau in the area of the present village of Abusir, was called Ineb-hedj (White Wall). The city expanded, spreading south, and its name Memphis derives from Mennufer, that of the pyramid of Pepy I at South Saqqara. Saqqara, in the desert further to the west, was the city's chief cemetery. Nowadays very little of Memphis survives; the remains visible around the village of Mit Rahina are mostly Ramessid. With some interruptions, Memphis remained the capital of Egypt throughout much of Egypt's history.

Meroitic

Connected with the Kushite (Nubian) kingdom centred on the city of Meroe in Upper Nubia (Sudan) between about 300 BC and 350 AD. The Meroitic period is the Nubian equivalent of the Ptolemaic and Roman periods in Egypt (320). The Meroitic period followed the Napatan (after the city of Napata) period during which the Nubians temporarily gained the control of Egypt and formed the 25th dynasty of Egyptian kings.

Modius

From the Latin for 'socket of a ship's mast', this term is used to describe an ornamental circlet, often composed of uraei (cobras) and resembling a section of a drum (245, 291). It served as a base for two plumes or similar headgear worn by queens and goddesses.

Mummification

A process which aimed at the preservation of bodies of people and animals (227, 328, 356). The most important part of the mummification process was the body's desiccation which was achieved by covering it with natron, a naturally occurring dehydrating agent. The internal organs were usually removed and placed in special containers known as canopic jars (266). The brain was removed but not preserved. The word derives from *mumiya*, Arabic for 'bitumen', the colour of which is not unlike that of old mummies.

Mut

The goddess Mut was the female companion of the god Amun at Thebes. Together with the god Khons they formed the Theban triad. Mut was usually shown as a woman (309) and her zoomorphic forms were a vulture or a lioness.

Nekhbet

Nekhbet was the local goddess of the town of Nekheb (present El-Kab) who was usually represented as a vulture (200–1, 203, 213) or a woman wearing the Upper Egyptian crown (334). Nekhbet and the cobra goddess Wadjit were 'the Two Ladies' regarded as the protective deities of Egyptian kings.

Nemes headcloth

A headcloth worn by kings, usually striped and twisted into a pigtail at the back (43, 59, 64).

Nephthys

In Egyptian mythology, Nephthys was the wife of the god Seth and sister of Isis. She was represented as a woman with a headdress formed by the hieroglyphs of her name (294, 310). Because of their mourning over the murdered god Osiris, the goddesses Isis and Nephthys were regarded as the archetypal mourners.

Nut

A sky goddess, often shown as a woman whose body stretches from one end of the earth to the other and forms the sky (262–3, 283).

Obelisk

An obelisk (138) was a rectangular pillar linked to the sun god and the *benben* stone, his manifestation at Heliopolis. A solid masonry-built obelisk was the central feature of sun temples between about 2450 and 2370 BC. Pairs of obelisks were often set up outside temple pylons from about 1500 BC onwards. The word derives from the Greek word for 'roasting spit'.

Osiris-Onnophris

Osiris came to prominence as the ruler of the kingdom of the dead

sometime around 2400 BC. He may have originally been the local god of Busiris in the Delta but from about 2000 BC he began to be associated with Abydos in Upper Egypt and became by far the most important deity linked to Egyptian ideas about the afterlife. Onnophris, from Egyptian *wenenu-nufer*, 'the good being', was one of his secondary names. Osiris was usually represented mummiform, with his arms crossed on his chest holding the crook and flail, symbols of kingship (162, 223, 230, 255, 265, 281, 344, 356). In perhaps the best-known episode in Egyptian mythology, Osiris was murdered by his brother Seth and mourned by his wife Isis (281, 294–5, 324, 331, 344) and her sister Nephthys (294, 310). The son of Osiris and Isis was Horus.

Ptah

The main deity of the Memphite region and one of the state gods (together with Amun and Re). Ptah was one of the creator gods and the patron of craftsmen. He was usually shown as a man wearing a closely fitting skullcap and holding a triple sceptre. He was associated with the Apis bull.

Ptolemaic period

This is the period between 304 BC when Ptolemy, one of the generals of Alexander the Great, declared himself king of Egypt as Ptolemy I Soter, and the death of Cleopatra VII Thea Philopator in 30 BC. All male rulers of the Ptolemaic period were called Ptolemy (330, 334) and are numbered I to XIV. Sometimes, for the sake of convenience, the term is extended to include the short Macedonian period, between the conquest of Alexander the Great in 332 BC and the accession of Ptolemy I Soter.

Pylon

The front wall of a temple with an entrance gateway (142–3, 234, 251, 336–7).

Re

The sun god, the main deity of Heliopolis and one of the creator gods (277). Re was just one of the

names of the sun god, such as Atum (214, 283), Harakhti, Khepri, etc. *See also* Amun.

Ruty
A double lion god, originally associated with the city of Leontopolis (Tell el-Yahudiya) in the Delta and later linked to the sun god. The Egyptian word *rut* (dual *ruty*) means 'gate' and this may have been the initial connection between two lions (or sphinxes) and temple gates (60–1, 88).

Saqqara
The pyramid field and cemetery which belonged to the city of Memphis. It is situated on the west bank of Nile some 16 km (10 miles) south of Cairo.

Sarapis (also Serapis)
A god artificially created by the Ptolemies in an attempt to appeal to both Egyptian and Greek sections of Egypt's population (234). The name probably derives from Usiri-Hapy (Osiris-Apis), the deceased Apis bull. Sarapis, usually represented as a man, was a god of the afterlife, fertility and healing. His temple at Alexandria was known as the Serapeum.

Scarab
The Egyptian *kheprer* was a dung beetle (*Scarabaeus sacer*). The ball of dung with an egg deposited in it and rolled by the beetle was compared to the sun moving over the sky (212, 263– 4, 294, 310). The word *kheper* means 'to come into being' and the scarab *kheprer* was compared to the morning sun and the youthful form of the sun god. The scarab was a ubiquitous motif in Egyptian art and was especially popular as a form for amulets and seals.

Serekh
An ornamental device containing the king's Horus name which identifies him as a visible form of the god Horus (30–1, 35– 6).

Setem (or sem) priest
A priest who performed an essential role in certain funerary rites, especially the opening of the mouth of a deceased person or their statues (162).

Shabti (ushebti)
A figure which was meant to act as a substitute for the deceased persons when they were called upon to take part in state-organized works (315). The most common type shows the person as a mummy but holding agricultural tools in its hands. The term shabti probably derives from the name of the persea tree wood, *shawab*, of which the early figures were made, but later it was re-interpreted to ushebti, from *usheb*, 'to answer' when called. Several hundred ushebtis may have been included in a single burial in the Late period. The most common material of shabtis was faience, but also wood, stone and exceptionally even copper were used.

Shendjut kilt
A short and sometimes pleated kilt with a front apron, at first worn mainly by kings (64–5) and later also by non-royal persons (286, 304, 345).

Skeuomorphism
Imitation in a different, usually less expensive or longer lasting, material. In Egyptian funerary architecture the forms of wooden or vegetal elements of buildings were imitated in stone (41, 45), or a less expensive material, for example limestone, was painted to look like granite. Similarly, objects of everyday use were imitated in stone for funerary purposes (38).

Sphinx
A creature with the body of a lion and the head of a king or a queen. The best known example is the Great Sphinx at Giza (60–1).

Stela
The term (the Latin version of the Greek *stele*) is used to describe a variety of secular, religious and funerary monuments. The form is usually that of an inscribed or decorated slab, usually of stone (36, 187, 330) but often also of wood (267, 283). Stelae (plural of stela) may take various forms and may be free-standing, attached to a wall or even cut in the rock. Early funerary stelae (gravestones) were in the form of a door and are known as false doors.

Sun temple
Six kings of the 5th dynasty, between about 2450 and 2370 BC, built temples which were meant to perpetuate the king's relationship to the sun god in the afterlife (67). The temples included a large obelisk and the main theme of their reliefs was the beneficial influence of the sun god on the world. These reliefs were probably imitated in non-royal tombs (73).

Thebes
The Greek version of the name of the city may derive from *Ta-ope*, the Egyptian name of the temple at Karnak (in full, *Ta-ope-isut*). The city of Thebes, called Wese in Egyptian, was on the east bank of the Nile in Upper (southern) Egypt (present Luxor). Its two major temples were Karnak and Luxor (both modern names) dedicated to the god Amun. Thebes became a religious capital of Egypt around 2000 BC; its counterpart was Memphis in the north of the country. It had a huge necropolis on the west bank of the river which included the Valley of the Kings.

Thoth
The local god of Hermopolis Magna (present El-Ashmunein in Middle Egypt) but universally worshipped, especially as a patron of scribes. Thoth was a creator god and linked to writing, sciences and medicine. He was usually shown as an ibis (322) or ibis-headed man or as a baboon (311).

Triad
A group of three. Egyptian gods were organized into family groups of three, e.g. Osiris, the goddess Isis and their son Horus (281). Most local gods formed triads, e.g. Amun, the goddess Mut and Khons at Thebes, or Ptah, the goddess Sakhmet and Nefertum at Memphis. The term can also be applied to statues which show three persons or deities (65).

Valley of the Kings
An area of the Theban necropolis which was almost exclusively reserved for the burials of Egyptian kings (147, 198–213, 220–1, 247, 254, 260, 262–3) between about 1540 and 1069 BC.

Valley of the Queens
An area of the Theban necropolis which contains a large number of tombs of Ramessid queens and princes (230, 232–3).

Valley temple
The approach to Egyptian temples, especially those connected with pyramids (52–3, 58), was often formed by a building at the water's edge called a valley temple. It was really an elaborate gateway and while its decoration played a part in the overall decorative programme of the pyramid complex (59, 64–5), there is no evidence to support earlier views which linked it to the mummification of the king buried inside the pyramid. An ascending causeway connected the valley temple with the pyramid temple adjacent to the pyramid.

Vizier
The highest official of Egyptian administration with responsibilities for both secular and religious institutions (73, 82–4, 148–9, 172–3, 289–90). From about 1450 BC there were two viziers holding the office simultaneously with divided responsibilities for the two parts of the country (Upper and Lower Egypt).

Zoomorphic
In the form of, or resembling animals, especially in reference to deities. In Egyptian art this describes representations of certain deities, such as the god Thoth when appearing as an ibis (322) or as a baboon (311), or the goddess Bastet in the form of a lioness or a cat (306).

INDEX

ACKNOWLEDGEMENTS 376

AKG London: 42, 63, 64, 65, 108, 135, 136, 145, 149, 152–3, 164, 172, 194, 197 (above), 224, 227, 228, 294, 310, 340, 348, 356

The Art Archive: 37 (below), 50–1, 60–1, 68, 69, 96, 97, 105, 110–11, 151, 167, 176, 186, 232–3, 276, 301

Ashmolean Museum: 14, 15, 16, 17, 19, 22 photo Heini Schneebeli, 29, 32, 33, 39, 88, 179, 181, 302, 331

Courtesy Dr Manfred Bietak, Institute of Egyptology, University of Vienna. Reconstruction copyright M. Bietak: 134

Bildarchiv Preussischer Kulturbesitz, Berlin: 127, 129, 150, 165, 169, 178, 184, 187, 190, 191, 195, 327, 345, 346, 347, 352

The British Museum: 20, 49, 116–17, 141, 155, 156–7, 159, 160, 189, 192, 247, 256–7, 306, 328, 329, 339, 351

Brooklyn Museum of Art: 18, 73, 79, 86, 90, 95, 112, 218, 278, 288, 289, 304, 322, 323, 338, 342

The Cleveland Museum of Art: 25, 122, 277, 287

Giovanni dagli Orti: 119, 234

Editions Gallimard, La Photothèque: 82–3, 109

Reproduced by permission of the Provost and Fellows of Eton College: 298, 354

The Fitzwilliam Museum, Cambridge:244, 248, 284

The Griffith Institute, Sackler Library, Oxford: 198, 199

Index, Florence: 236, 240

Andrea Jemolo, Rome: 30, 31, 44, 59, 67, 142–3, 175, 223, 235, 249, 285, 333, 334, 336–7, 341

Jürgen Liepe PhotoArchive: 35, 38, 43, 45, 89, 115, 118, 120, 121, 123, 124, 125, 132, 146, 170, 205, 219, 229, 238–9, 241, 245, 252–3, 286, 296, 300, 318, 319, 330

Jacques Livet, Paris: 41, 74, 75, 76, 77, 80, 84, 147, 148, 162, 166, 171, 173, 221, 242, 243, 254, 258, 259, 317, 335

Kunsthistorisches Museum, Vienna (Ägyptisch-Orientalische Sammlung): 62, 133

Liverpool Museum: 217

Lotos Films/Gudrun Thiem: 54, 58, 106, 138, 140, 196, 268, 274, 275, 291, 353

The Louvre: 24, 26–7, 36, 56, 70, 72, 91, 100, 128, 130, 144, 163, 168, 180, 188, 193, 215, 220, 226, 255, 267, 279, 281 282, 283, 292, 303, 307, 314, 324, 344

Manchester Museum: 48

Musées Royaux d'Art et d'Histoire, Brussels: 34, 326

Museo Civico Archeologico di Bologna:197(below), 295, 311

Museo Egizio, Turin: 21, 92, 93, 225, 315

Museu Calouste Gulbenkian, Lisbon: 113, 154

Phoebe Hearst Museum of Anthropology, University of California at Berkeley: 81

Rijksmuseum, Leiden: 316

Robert Harding Picture Library: 262, 263

Roemer und Pelizaeus Museum, Hildesheim: 309, 325

Royal Ontario Museum, Toronto: 85

SCALA: 305

Dr Abdel Ghaffar Shedid: 114, 214

Alberto Siliotti: 250

Staatliche Sammlung Ägyptischer Kunst, Munich: 126, 131, 158, 266

Henri Stierlin: 280

Werner Forman Archive: 28, 37 (above), 40, 55, 57, 66, 98–9, 102–3, 104, 111 (above), 182–3, 216, 269, 272–3

White Star S.r.l: 47, 52–3, 78, 87, 94, 101, 139, 161, 200–1, 203, 204, 206, 207, 209, 210, 211, 212, 213, 230, 246, 251, 260, 264, 265, 271, 290, 299, 312–13, 320, 321, 349, 350, 357